BIRMINGHAM MUSEUM of ART

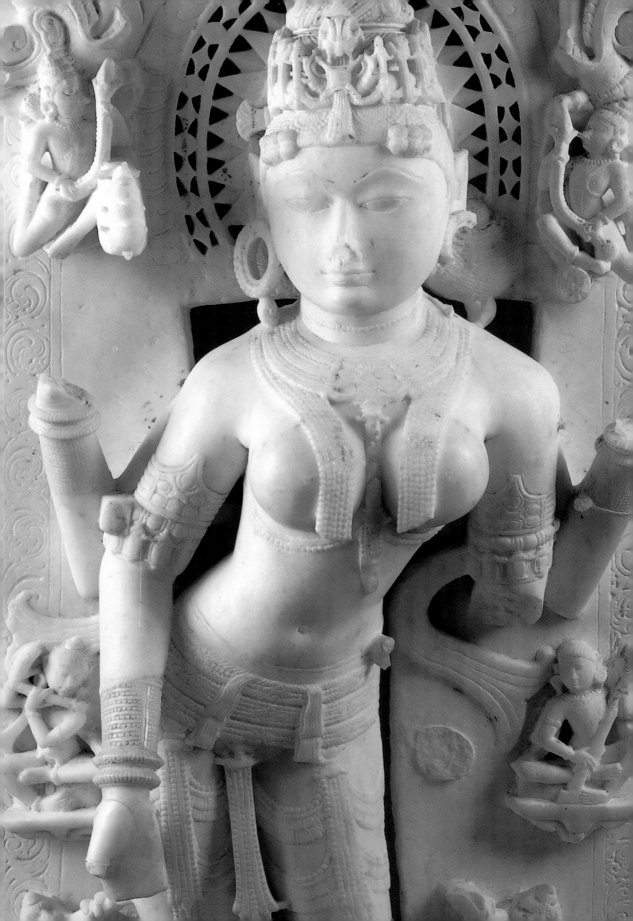

BIRMINGHAM MUSEUM of ART
GUIDE to the COLLECTION

9 2010 Birmingham Museum of Art
www.artsbma.org

First published in 2010 by GILES
An imprint of D Giles Limited
4 Crescent Stables
39 Upper Richmond Road
London, SW 15 2TN, UK
www.gilesltd.com

ISBN: 978-1-904832-77-5

The Birmingham Museum of Art gratefully acknowledges the
generous support provided by The Community Foundation of
Greater Birmingham, the Robert R. Meyer Foundation, The
Members of the Birmingham Museum of Art, Henry S. Lynn,
Jr. in memory of George Gambrill Lynn, Jr., Asian Art Society,
Collectors Circle for Contemporary Art, European Art Society,
Friends of American Art, Photography Guild, and Sankofa
Society: Friends of African-American and African Art.

For the Birmingham Museum of Art:
Authors: Gail Andrews; Graham C. Boettcher, PhD; Anne
Forschler-Tarrasch, PhD; Emily G. Hanna, PhD; Jeannine
O'Grody, PhD; Ron Platt; Tatum Preston; Donald Wood, PhD
Designed by James Edward Williams
Photography by Sean Pathasema (unless otherwise noted)

For D Giles Limited:
Copy-edited and proof-read by Melissa Larner
Produced by GILES, an imprint of D Giles Limited, London
Printed and bound in Malaysia for Imago

All measurements are in inches;
Height precedes width precedes depth unless otherwise noted.

Frontispiece: *Sarasvati,* detail, India, Gujarat, about 1153,
 marble and pigment [entry, page 55]
This page: *Matthew, Mark, Luke, John (the Four Evangelists),*
 details, Giuseppe Bernardi, called Torretto, Italian (1694–
 1774), 1730–1760s, terracotta [entry, page 182–183]
Foreword: *Wine Cooler,* Wedgwood (est. 1759), about 1950,
 stoneware (jasperware) [entry, page 202–203]

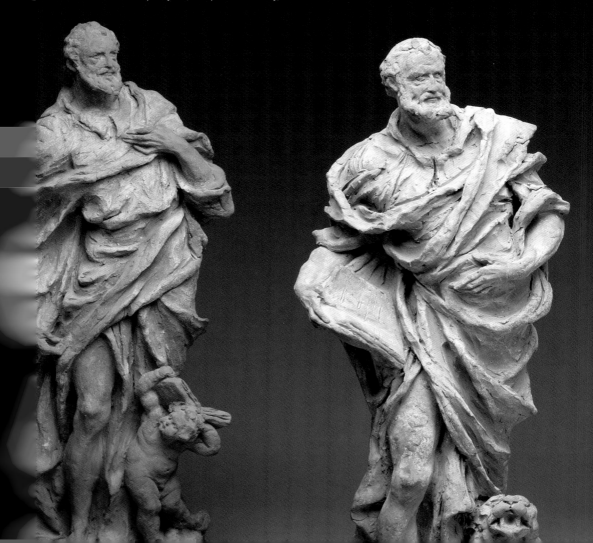

CONTENTS

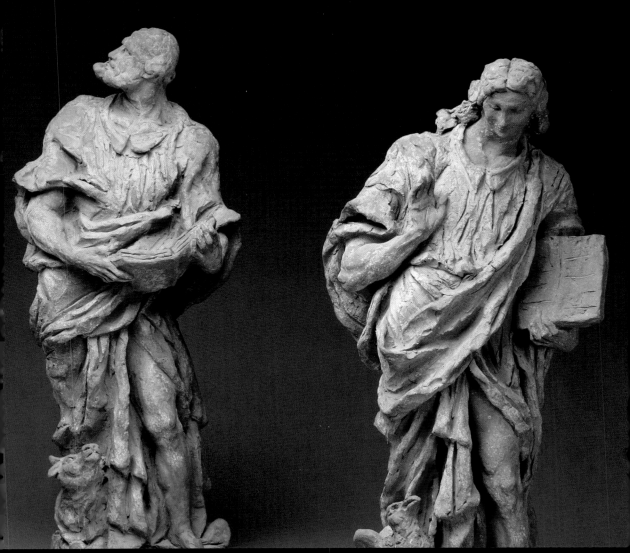

Photograph courtesy family of William M. Spencer III

This publication is dedicated to

MR. WILLIAM M. SPENCER III
10 December 1920–28 March 2010

CHAIR OF THE MUSEUM BOARD OF TRUSTEES 1986–1994

The Spencer family has been active at the Museum since its founding. Mr. William M. Spencer, Jr. was the third chairman of the Museum Board and served during the Museum's move from City Hall (where it had begun in 1951) to the present location in 1959. He chaired for twenty-three years and was succeeded by Mrs. Margaret Livingston. After her term ended in 1986, Mr. William M. Spencer III followed in his father's footsteps and chaired the Museum Board until 1994. Mr. Spencer's excellent business sense helped mastermind a $21 million capital campaign, which funded an expansion of 50,000 square feet and added the sculpture garden as well as the auditorium, café, store, new library, expanded exhibition space, family gallery, and new art studios and offices for the education department. Even though the Museum was closed for construction, the docents served 56,000 individuals through outreach initiatives and tours of a temporary gallery located in the Civic Center. Membership and support remained strong and the renovated Museum opened in 1993. Growth in the permanent collection boomed by 4,670 objects during Mr. Spencer's tenure, including outdoor sculptures for the new garden. The Hitt Collection of French eighteenth-century paintings and decorative objects was a major gift from collector Eugenia Woodward Hitt, a native of Birmingham and cousin of Mr. Spencer. He helped convince her to leave the contents of her Park Avenue, New York, apartment to Birmingham. The multi-million dollar collection was acquired in 1991, moving the Birmingham Museum of Art from a museum of regional importance to a museum garnering national attention. Mr. Spencer took a personal role in collection growth, particularly in the Museum's Asian holdings. His gift of *The Ascetic Sakyamuni* is an important addition to the Chinese collection as a rare iconographic form. Through a promised gift, the Spencers have enhanced the Museum as the leading center for the study of Vietnamese ceramics in the United States, boasting a collection of almost 250 pieces. The Spencers' commitment to museum endowment secured the position of the Asian Art Curator, showing their dedication to the stability of the Museum. The Museum is grateful to Mr. Spencer's steadfast support through governance, guidance, and personal resources.

FOREWORD

The thoughtful and much-debated selection of works presented here attempts to highlight many of the Birmingham Museum of Art's great objects, but also to provide a flavor of the collection and its development over time. This book alone cannot convey the totality of the collection, its masterpieces, or the small joys one discovers on multiple visits. We hope, however, that it serves as an enticement that will lead to those personal discoveries. It is designed to fit comfortably in one's hand, encouraging the visitor to take it along when exploring the galleries.

The last guide to the collection was published in 1993 in conjunction with the opening of a major addition to the building. The collection then encompassed 14,000 objects with 130 selected for that publication. The timing of this book also coincides with a milestone: the sixtieth anniversary of our founding. Since 1993 the Museum has added 10,000 objects to the collection, dramatically expanded its programs and outreach and, most significant for the growth of the collection, increased the curatorial departments from four areas to six by expanding the responsibility for the painting, sculpture, and graphic arts department from one curator to three: American Art, European Art to 1900, and Modern and Contemporary Art. This realignment brings the specialization, scholarship, and focus needed to allow these areas to flourish. Inevitably, only a small number of the acquisitions made since this reorganization could be included here, but they illustrate the impact that the added expertise has made on the collection.

The production of this publication has required the collaboration of many Museum staff. It is my pleasure to acknowledge the curators who selected the works and contributed entries on each piece: Graham C. Boettcher, The William Cary Hulsey Curator of American Art; Anne Forschler-Tarrasch, The Marguerite Jones Harbert and John M. Harbert III Curator of Decorative Arts; Emily G. Hanna, Curator of the Arts of Africa and the Americas; Jeannine O'Grody, Chief Curator and Curator of European Art; Ron Platt, Hugh Kaul Curator of Modern and Contemporary Art; and Donald Wood, Senior Curator and The Virginia and William M. Spencer III Curator of Asian Art. Special thanks are due also to Tatum Preston, Librarian, who invested considerable time and energy in assisting with many aspects of the book, and Curatorial Assistant, Susan Powers. The inviting design is the result of our talented Graphic Designer, James Williams. We are likewise fortunate to have a skilled photographer on staff, Sean Pathasema, who took new pictures of every piece illustrated. The cooperative nature of the Registration and Preparation departments facilitated the project enormously: Melissa Falkner Mercurio, Eric L. McNeal, Suzanne Voce Stephens, Lisa Stewart, Mary Villadsen, Denny Frank, Rashid Qandil, Priscilla Tapio, Daniel White, and intern, Mara Thomas. We are grateful to Elizabeth Lenarcic in our Development department, who was responsible for raising funds to support this endeavor. I would particularly like to acknowledge Jeannine O'Grody for the skill and deftness with which she directed this project. Her focus on quality and scholarship along with her ability to manage multiple deadlines and departments and the determination to have the publication ready for our sixtieth anniversary ensured a book that would represent the Museum to its best advantage, as well as one that would successfully herald this occasion. I am grateful to her for leading this project with grace, insight, and patience.

We are tremendously indebted to our funders who made this project possible. We extend deep gratitude to The Community Foundation of Greater Birmingham and the Robert R. Meyer Foundation. The Members of the Birmingham Museum of Art made a generous gift to support this publication, as did Henry S. Lynn, Jr. in memory of George Gambrill Lynn, Jr. The Museum has six collection support groups: Asian Art Society, Collectors Circle for Contemporary Art, European Art Society, Friends of American Art, Photography Guild, and Sankofa Society: Friends of African-American and African Art. Each contributed funds to support the catalogue, and to each we give our thanks.

Finally, I thank the founders of the Museum and all of the donors—their generosity and vision have been instrumental in creating the institution we know today. In addition, their desire to maintain free entry to the Museum continues, and our collection of world cultures remains accessible to all. We believe that the Museum presents an opportunity to visitors to learn about the world and oneself in a way that is unique. Our hope for you is to Explore the World, Discover Yourself.

Gail C. Andrews
THE R. HUGH DANIEL DIRECTOR

Birmingham Museum of Art, 1959. File photograph from the Birmingham Museum of Art archive

INTRODUCTION

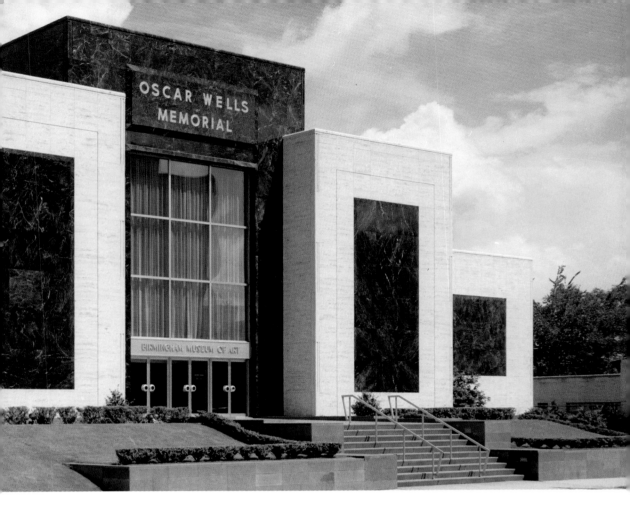

Building a collection is sometimes a matter of opportunity, but it is more often an enterprise of informed judgments, thoughtful study, and lofty dreams. The founders of the Birmingham Museum of Art dreamed of an encyclopedic collection from the world's cultures that would serve as a place of inspiration and inquiry. The collection began modestly in 1951 with a few gifts of paintings, textiles, and glass, but was quickly fortified in 1952 by a major gift from the Kress Foundation. This not only laid the groundwork for an outstanding collection of European painting and sculpture, but also became the benchmark for quality. It began to make the dreams tangible. Today, the collection includes over 24,000 objects ranging in date from ancient to contemporary and illustrating the astonishing techniques and talents of artists across time and space.

While the Museum itself is only sixty years old, its roots go back to January 1908 with the founding of the Birmingham Art Club. Its fifty-seven charter members of active and committed artists gathered on a regular basis for exhibitions, lectures, tableaux, and a wide variety of cultural activities to stimulate interest in the arts and enthusiasm for a museum. Despite the concerted efforts of these pioneers and their followers, it was not until 1948 that their desire to secure a museum for the city gained momentum. At that time a gifted painter, Rosalie Pettus Price, became president of the Art Club (renamed the Birmingham Art Association in 1951) and focused her efforts on establishing a museum. In November of that year *The Birmingham Age-Herald* endorsed the project in an editorial titled "Toward An Art Museum." With the efforts of artists, the press, and prominent members of the civic and business communities, the City Commission enthusiastically passed the ordinance that created the Museum Board of the City of Birmingham on August 1, 1950. The ordinance provided for partial funding of operations and for space in the new City Hall.

On April 8, 1951, the Birmingham Museum of Art opened in five large galleries in City Hall and welcomed 1,500 visitors on that Sunday with a dazzling exhibition of seventy-five paintings borrowed from almost every

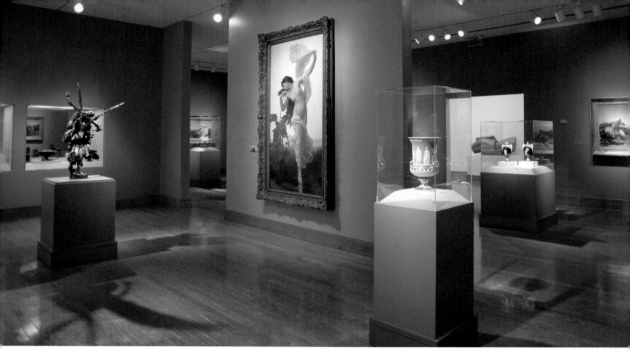

Nineteenth-century European Gallery, 2010

major museum in the United States. During the first month, the new museum welcomed over 16,000 visitors, creating indelible memories for many. One boy who attended the opening remarked later as an adult, "I'd never seen a real painting but when I came to the two Rembrandts I knew I had come to a new country."[1] Just a year later, the Samuel H. Kress Foundation gave what Museum director Richard Foster Howard called "a princely gift" of paintings to the fledging institution. The impact of that legacy has resonated throughout the Museum's history. Not only did this magnificent gift make it possible for the community to see fine examples of early Italian painting, but it bestowed a measure of confidence to the city about the new institution and inspired other patrons to follow with generous donations of objects and ultimately, the gift of a building of our own to protect, display, and interpret these works of art.

Fulfilling that aspect of the dream was Helen Jacob Wells, who left the majority of her estate to "supply an art museum for the City of Birmingham, Jefferson County, Alabama, and surrounding areas, with particular reference to its availability for use by the educational institutions located in that city and in surrounding communities in the teaching of art and its appreciation."[2] Mrs. Wells advocated a location that would accommodate expansion and access, and she further directed that the building itself should be

designed as a work of art: simple, with good lines, and containing adequate space for exhibition and storage. In addition, she left the collection of prints that she and her late husband Oscar Wells had amassed. This group of fifty-three works contains unqualified masterworks by artists including Rembrandt, Dürer and Whistler, and provided a platform for what has become an important collecting area of the Museum.

Helen Jacob Wells's gift of funds to construct the Museum was pivotal, as was the City of Birmingham's commitment to support a substantial portion of the operating costs, a commitment that has not wavered. There were, however, no dedicated funds for acquisitions. The first decade brought 2,287 wide-ranging acquisitions, primarily gifts, from numerous donors. These works set the stage for many of today's strong collecting areas—Asian, American, and European painting and decorative arts in particular—and also signaled that this was to be a collection built not by a single founder or a handful of collectors but by many, and that broad support and involvement was going to be crucial to the Museum's success.

Unfortunately, during this same period, Birmingham's economy was faltering, its population growth was slower than that of its neighboring Southern cities and "whether [or not] most would admit it, it was time to reinvent itself."[3] From 1951 to 1957 Birmingham business and civic leaders met and discussed strategies

for addressing the city's problems. The success of the fledgling Museum was not overlooked. In the spring of 1957, downtown merchants and businessmen formed the Birmingham Improvement Association (today Operation New Birmingham) with a list of fourteen goals, among them "cultural development of the central business district." *The Birmingham Post-Herald* announced, "The Rebirth of Downtown Area is Started."[4] In this spirit, the 1950s also saw the establishment of the Birmingham Civic Ballet (now the Alabama Ballet), the Festival of Arts, the Birmingham Zoo, and the Civic Symphonic Association (today the Alabama Symphony Orchestra). Birmingham was not unique in looking to the cultural community as a way to stimulate the activity and growth of an urban core, or in its recognition that the establishment of cultural institutions was one measure of a city's maturation. Community leaders understood and appreciated the sentiment, "Unimportant cities have no museums; great cities have flourishing museums."[5]

The 1960s was a time of tremendous social and political change, and Birmingham struggled as the epicenter of the Civil Rights Movement. While building the collection remained vital, creating programs and outreach into the community assumed great importance

as well. In the 1950s, the Museum had admitted African Americans only one day a week following a city policy that did not change until 1963, when in June of that year the City Council revoked all segregating ordinances. With the establishment of a civic-minded Education department in 1964, volunteers began visiting all city schools to share Museum resources. "The Junior League of Birmingham helped the Museum secure a set of Carnegie slides of American art. These slides were the basis for the tours to elementary school history classrooms. This was the first in-school volunteer classroom program ever attempted in the Birmingham community."[6] The new Artmobile (1966), funded by a Title III grant, quickly followed, providing lessons and opportunities with hands-on learning for school children throughout the city. The docent program, which had begun with a small core of volunteers when the Museum opened in 1951, became formalized with consistent training on the works of art and touring methods, and today continues to build skills of inquiry, observation, and collaboration that are transferable into the larger world. Community engagement and programs have continued to flourish, including model initiatives for the blind and visually impaired, as well as for underserved youth.

Eighteenth-century English Gallery, 2010

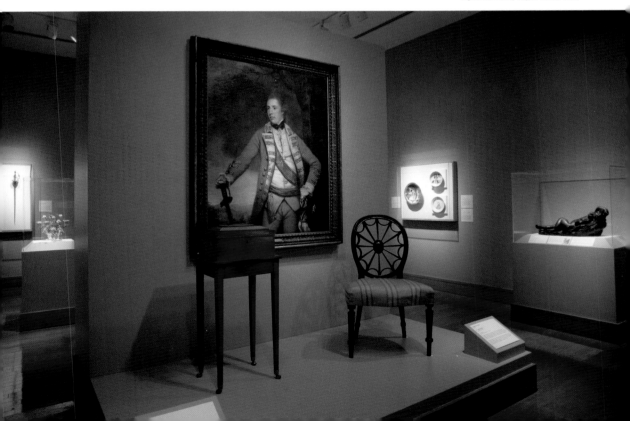

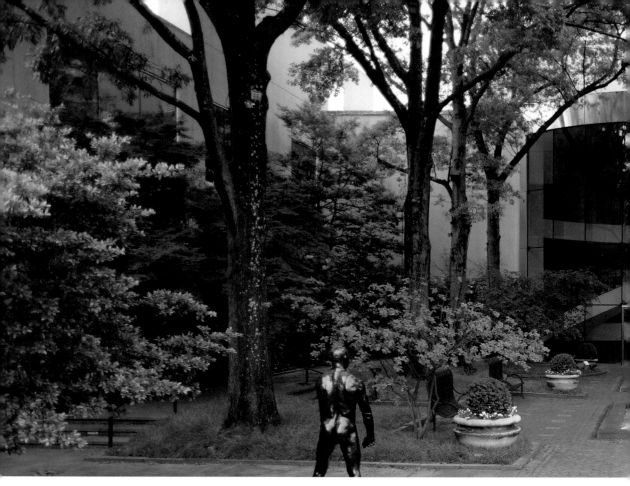

Red Mountain Garden in the Charles Ireland Sculpture Garden, 2010

In the 1970s, the Asian collection began to grow in earnest with the leadership and financial support of the Asian Art Society, the Museum's first collection support group. This collection now ranks among the top twelve in the United States and includes works from Japan, China, Korea, Vietnam, and Southeast Asia. Dwight and Lucille Beeson donated their magnificent collection of Wedgwood, creating the finest public collection of this material outside of England. There was an increased interest in building the holdings of American art at this time as well, when some of the Museum's seminal works were acquired, including Thomas Cole's drawing of Mount Etna and Georgia O'Keeffe's *The Green Apple*.

In the 1980s the Museum continued to augment its areas of strength, and also began collecting the arts of Africa and significantly expanding its holdings of photography. In addition, attention was given to the works of contemporary artists, an area that the founders had not embraced. In fact, it was not until 1971, with the purchase of Frank Stella's *Flin Flon VI* (1970) that the Museum acquired its first major contemporary

work of art. During the last ten to fifteen years, we have attempted to fill gaps and refine all aspects of the collection, while also focusing on selected areas of strength, as we create a more seamless story in our presentation of world cultures and art history.

In the mid-1980s, after thirty years of active collecting, program building, and four additions to the 1959 building, the Museum Board and staff paused to assess progress and evaluate current and future development of the collection and the facility. An intensive analysis led to the 1986 Master Plan Report, which in turn led to the hiring of Edward Larrabee Barnes as design architect of what became in 1993 a 50,000 square foot addition. It included a 24,000 square foot sculpture garden, 7,000 square feet of new exhibition galleries, a 330-seat auditorium, a café, an education gallery, two studios, and a complete renovation of the entire building. During the long-range planning process members discussed the merits of moving the Museum out of downtown (to the top of Red Mountain), with the ultimate decision that staying in

the city center was right both for the Museum and for the community. The Museum continues to serve as an anchor for the central city, and this decision to remain downtown was an important catalyst for subsequent decisions made by other cultural institutions regarding expanding and locating downtown.

The new addition and renovation provided many crucial improvements and delightful amenities, but the two aspects that changed the way the building *felt* and ultimately how it was seen and used were the new flow and light that Barnes created. He said, "I think that *flow* is everything in a museum. So often the architect's impulse and client's expectation are for a huge piece of sculpture. But the essential question is how you *move*."[7] Barnes reviewed the additions and modifications made to the original building and opened spaces, raised ceilings, clarified movement, and removed stairs in order literally and figuratively to open the Museum to the community in a way that it had not been since its original opening in 1959. The expanded and light-filled spaces provided an energy and new way of thinking

about the collection and programming, an engagement that has continued for the staff and the visitor.

The Museum's collection of decorative arts is extensive and has been exhibited with that of painting and sculpture for many years, well before the opening of the new wing in 1993. However, the remodeled and reconfigured galleries gained a new sense of space and clarity, giving the integrated installations of these objects an even greater resonance. Visitors delight in the opportunity to gain a fuller understanding of a culture or period when viewing these works together, seeing connections between formal qualities and sometimes techniques or subject, regardless of medium.

While the desire to build the broad-based collection envisioned by our founders continues, several other objectives now also guide our thinking. Our collecting has responded to and hopefully reflects the interests of the community. We have identified areas that we see as opportunities for distinction based on who and where we are. In particular, we are building a collection of art that documents and reflects the Civil Rights

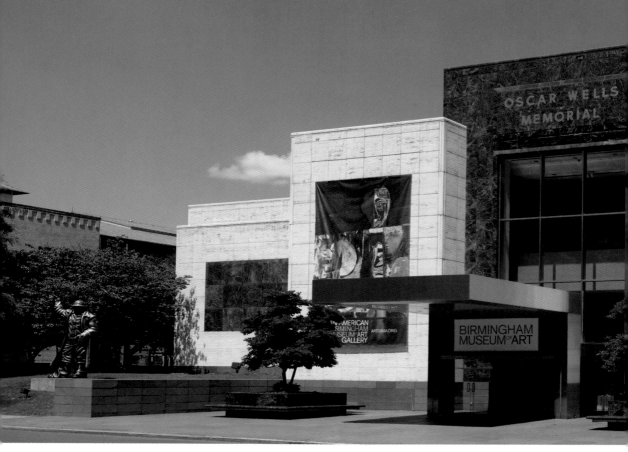

Birmingham Museum of Art, 2010

Movement and works by significant Alabama artists. We want to showcase and support the arts of our place by identifying Alabama artists to be collected in depth, and to be recognized as the primary center for their exhibition and research.

Our mission is to provide an unparalleled cultural and educational experience to a diverse community by collecting, presenting, interpreting, and preserving works of art of the highest caliber. Looking forward, the Museum will continue to build its collection, and its role as a civic institution and community partner. Museums across the country, of all disciplines, embrace the goal of being a necessary part, not just another part, of their community; a defining place. We have grown tremendously over the last sixty years. As we imagine our future, our dreams include expansion to provide more space for our large collection and for an increased engagement with the community. This will help us fulfill our vision—to continue to be recognized as a Museum of significance and a cultural center of our community, where people come to be stimulated and refreshed, intellectually, aesthetically, spiritually, and socially.

Museums are known and appreciated for many reasons—scholarship, programs, exhibitions—but the deepest and most lasting contribution to their communities is the collection. The objects acquired through gift and purchase that are available for the visitor on a regular basis are the constant. Luckily, museums are never "finished," for collections are never complete, and research and scholarship continue to reveal new information about the objects in their care. The joy and the challenge is to explore ways to present our collections to our communities and engage them

with the treasures that belong to us all as citizens. A quiet moment contemplating art offers solace, pleasure, inspiration, renewal, and a sense of self-discovery. This is the unique role of museums.

Gail C. Andrews
THE R. HUGH DANIEL DIRECTOR

1 Margaret Livingston, *A Short History of the Birmingham Museum of Art: The First Fifty Years 1951–2001* (publication forthcoming), p. 12.

2 The Will of Helen J. Wells (executed on December 22, 1954).

3 Pamela Sterne King, *50 Years and Counting: A History of Operation New Birmingham 1957–2007* (Birmingham: Operation New Birmingham, 2008), unpaginated preface.

4 Ibid, pp. 9–10.

5 Alfred C. Parker, quoted in *Riches, Rivals, and Radicals: 100 Years of Museums in America*, Marjorie Schwarzer (Washington, D.C.: American Association of Museums, 2006), p. 14.

6 Livingston, op. cit., p. 52.

7 Philip Morris, "A Grand Opening," *Southern Accents* (Sept.–Oct. 1994), p. 120.

ASIAN ART

Asian art has formed part of the Museum collection since its inception. Chinese textiles and ceramics, along with Japanese prints and decorative arts, are all included in the inventory of the collection from 1951 on. Subsequent years witnessed the continued growth of this aspect of the Museum's holdings in a steady but undefined manner. Important gifts of Chinese Tang dynasty (618–906) tomb figures, Buddhist sculpture, Chinese jades, Japanese prints, ceramics, and textiles were all donated in these early years.

However, with the founding of the Asian Art Society in 1975, the Asian art collection began to develop in a methodical and purposeful manner. A visit to the Museum and a public lecture by Dr. Sherman E. Lee, Director of The Cleveland Museum of Art, promoted an early collecting interest in Southeast Asian ceramics, resulting in what is now considered to be the finest collection of Vietnamese ceramics in the United States. Subsequent visits and advice from Dr. Pratapaditya Pal, Dr. Thomas Lawton, and Dr. Hiram Woodward interested various members of the Society in Chinese painting, Chinese ceramics, Japanese ceramics, Korean art, and works from India and Tibet. Over the years, members of the Asian Art Society have given the Museum the majority of its holdings in Asian art.

Other generous gifts of art and acquisition funds have come from the William M. Spencer III family, the Eivor and Alston Callahan family, Dr. and Mrs. William T. Price (Amarillo, Texas), Coleman Cooper (Palm Beach, Florida), Dr. and Mrs. Aubrey C. Land (Athens, Georgia), Dr. Roy T. Ward (Watkinsville, Georgia), Stan and Marita Murphy (Tuscaloosa, Alabama), Thaddeus H. Crenshaw (Paris, France), as well as a host of others. In the mid-1980s, the Museum began to devote serious acquisition funds to the purchase of Asian art. Monies from the Museum Dinner and Ball were used in several years for Asian art acquisitions, as well as funds provided by bequests and memorials. Now, with over 4,000 objects from Asia, the collection is the most comprehensive and finest in the southeastern United States.

Within the cultural pluralism of the Asian collection, areas of depth and specialization have developed. Ceramics constitute one such strong point. Neolithic Chinese pots are among the oldest works in the Museum, while contemporary Japanese and Korean pieces are some of the newest. Highlights include not only Vietnamese ceramics, but also an outstanding collection of Chinese blue and white porcelain from the thirteenth through the nineteenth centuries, as well

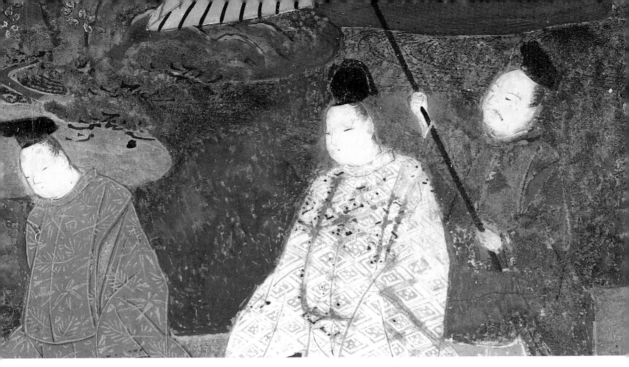

Tale of Genji, detail, Japan, Edo period (1615–1868), about 1610, ink, color and gold on paper (six leaves) [entry, page 49]

as Korean works from the Joseon period (1392–1910), superb pieces from the Ban Chiang culture of northern Thailand, and a growing collection of Japanese stonewares.

Japanese woodblock prints have also been part of the collection since its inception. As a result, there are now hundreds of prints at the Museum, with classic examples of all types from all periods. A remarkable group of lacquered tomb wares and vessels from third-century BC China through nineteenth-century Japan is another feature of the galleries.

There are also significant Buddhist, Shinto, Hindu and Jain sculptures and paintings on display that allow the Museum to teach lessons in religious tolerance and cultural diversity to the thousands of school children and adults who annually tour the Asian collections. Because of these collections, the Museum is the primary center for Asian art studies in the southeastern United States.

The first Asian art galleries at the Museum opened in 1979. Housed on the third floor, they highlighted early acquisitions to the collection. The rapid growth of the collection necessitated the complete redesign and reinstallation of these galleries in 1988. With the expansion and total renovation of the Museum in 1993,

the collection was moved into seven spacious new galleries. Support for these galleries came from friends and patrons from around the world, plus generous grants from the National Endowment for the Arts, the Getty Grant Program of the J. Paul Getty Trust, and in 2001 the Korea Foundation funded a new Korean Art Gallery. The galleries closed again in 2008 for yet another reinstallation. While no square footage was added, new cabinetry and rethinking of the original design added significant additional display space for old and recent acquisitions. The Asian art collection now enjoys national and international recognition, a remarkable achievement given its short history.

It is also exceptional that the collection is not the result of one major gift, but rather, a group effort on the part of so many individuals in Birmingham, Alabama, the United States, Asia, and Europe. The Department of Asian Art at the Birmingham Museum of Art looks forward to continued growth and development in the years to come.

Donald Wood, PhD
SENIOR CURATOR AND THE VIRGINIA AND WILLIAM M. SPENCER III CURATOR OF ASIAN ART

Tomb Guardian

Chinese, Warring States Period (475–221 BC), State of Chu, Hubei province | About 300 BC | Lacquer, wood, antler, pigment | 40 x 40 x 40 inches | Collection of the Art Fund Inc., at the Birmingham Museum of Art; Gift of Virginia and William M. Spencer III, AFI 3.2000

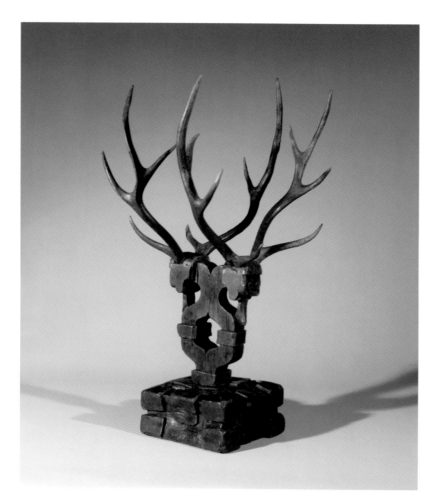

O Soul come back!
Why have you left your abode
And sped to the Earth's far corners?
Deserting the place of your delight
To meet with all those things of evil omen?
O Soul come back!
 "The Summons of the Soul," THE SONGS OF CHU

The Songs of Chu is a collection of third-century BC poems from the south China state of Chu. It provides a treasure trove of information about how the Chu people lived at the time. For example, we learn that they believed the soul had two parts, one that remained on earth and another that departed at death to be with the immortals. At the time of death, a shaman climbed onto the roof of the departed and recited "The Summons of the Soul" to entice the second soul back to rejoin its earthly counterpart.

 Tomb guardians such as this were placed inside the doors of tombs, either to protect the first soul of the departed, or perhaps to escort the second soul on the journey to the afterlife.

Tomb Tile

Chinese, Han dynasty (206 BC–AD 220), Sichuan province | About 100 | Earthenware | 44 x 18 ½ x 4 ¾ inches | Gift of Mr. and Mrs. James E. Breece III, 2008.116

Hollow clay tiles were used as doors and walls in tombs in China during the Han dynasty (206 BC–AD 220). Cheaper than carving blocks of stone, tiles could be easily made and then decorated with designs stamped into the wet clay. The tiles then either dried in the sun or were fired in a kiln at a low temperature.

There are holes in the top and bottom of this tile that would allow it to pivot, suggesting that it was used as a door for a tomb. The decoration is a combination of auspicious and popular motifs of the time. Tiles with similar stamped designs have been found in the Chengdu area of Sichuan province in south-central China, pointing to a possible place of origin for this tile.

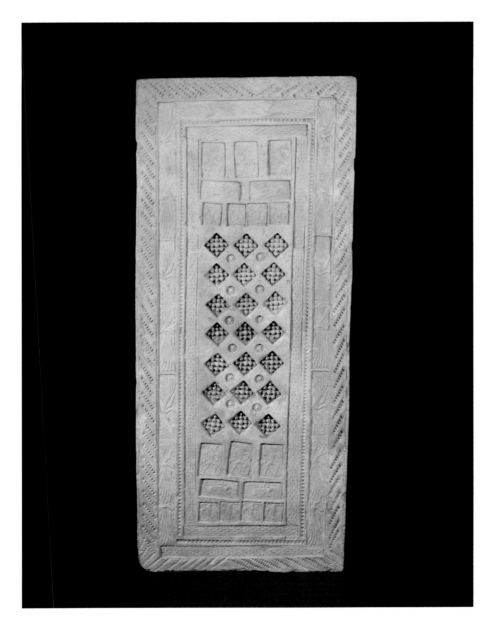

Jar (*Hu*)

Chinese, Warring States period (475–221 BC) | About 350 BC | Bronze | 18 x 14 ½ inches | Gift of Paul and Emily Bourne Grigsby, 2006.301

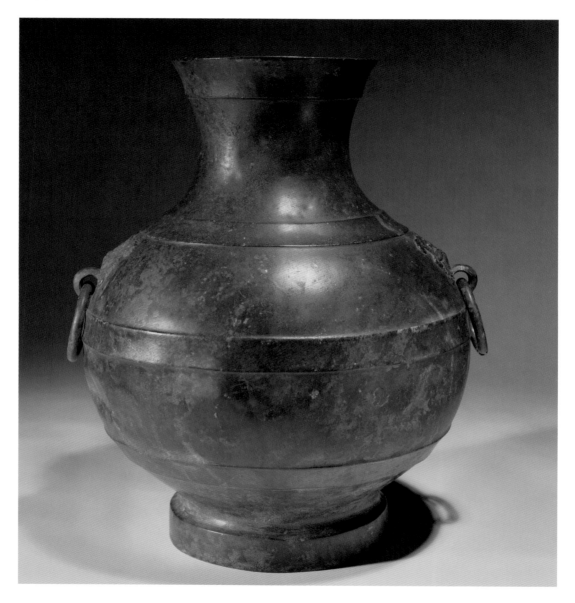

Hu are ceremonial vessels used to hold wine or other liquids for ceremonies, and as funerary offerings in ancient China. They are usually quite large and often have ring handles, real or simply representational, on either side, which made them easier to lift and move. The decoration of this bronze Hu is simple yet elegant. Four raised bands circle the body with two ring handles supported by *Taotie* masks on either side. The *Taotie* is a zoomorphic motif found on many early Chinese bronzes. Two eyes, eyebrows, a nose, and a lower jaw are clearly defined, yet the exact significance of the mask is unknown.

The Museum is fortunate to have a variety of early *Hu* in its collection. Bronze, glazed, and painted earthenware examples from China, and even a Vietnamese ceramic *Hu* dating from the first to the third century, show the widespread popularity and utilitarian aspect of this vessel.

Buddha

Chinese, Northern Qi dynasty (550–577) | Sixth century | Limestone with traces of pigment | 27 x 6 ¼ x 4 ½ inches |
Museum purchase with funds provided by the Estate of Ron Robel, 2008.6a-b

This serene statue of the Buddha is a classic example
of sculpture from the Northern Qi dynasty (550–577).
Markedly different from earlier images of the Buddha,
Northern Qi statues tend to be somewhat small, around
three feet tall, and columnar in shape. The cascading
drapery of the robe was inspired by styles from northern
India, and is sometimes compared to wet cloth that
clings to the body beneath. Passed along the trade routes
of the Silk Road, this style also influenced the arts of
Korea and Japan.

The right hand of the Buddha is shown in the
Abhya-mudrā (Have no Fear) position, with the left in
the *Varada-mudrā* (Wish-Granting) mode. The face is
calm and tranquil, with half-closed eyes and the hint
of a smile indicating great inner contemplation. As
with most Buddhist sculpture, this piece was originally
brightly painted. Much of the original red pigment on
the robe is still visible.

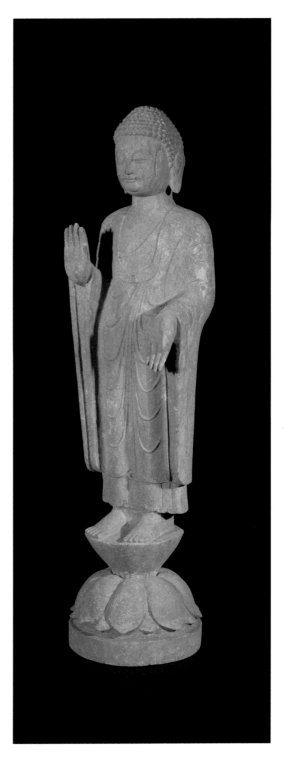

Ewer

Chinese, Tang dynasty (618–906) | About 720 | Glazed earthenware | 12 ½ x 5 ¼ x 5 inches | Collection of the Art Fund, Inc. at the Birmingham Museum of Art; Purchase with funds provided by Helen Hudgens, Dr. and Mrs. Jack Geer, and the Birmingham Asian Art Society, AFI3.2005

Chang-an (modern Xi'an) was the capital of China during the Tang dynasty (618–906). In the late seventh/eighth century it was the largest and most cosmopolitan city in the world. Chang-an had a large foreign population of not only people from all over Asia, but also from as far away as the Middle East, particularly Persia.

Persian textiles and metal work had a marked influence on the arts of Tang China. The mounted archer looking back and shooting over his shoulder on one side of this ewer is a classic example. Brought to China via the Silk Road, the design was particularly popular in Chinese decorative arts of the early eighth century. The other side of the ewer is decorated with a phoenix taking flight.

This ewer was made in a mold in a large workshop as a grave good. It was never meant to be seen after the funeral, but was instead placed in the tomb for the deceased to use in the afterlife. It was, however, inspired by everyday pieces that were popular with the upper classes of imperial China. Several examples of this exact same ewer are known, indicating the popularity of the design.

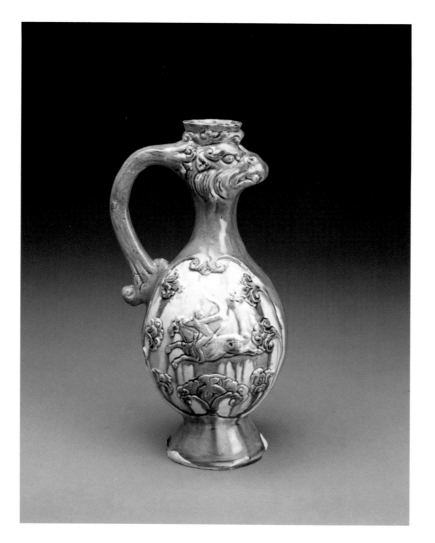

Horse

Chinese, Tang dynasty (618–906) | About 700 | Glazed earthenware | 25 x 26 x 7 inches | Partial gift from Dr. and Mrs. M. Bruce Sullivan and Museum purchase with funds provided by the 1988 Museum Dinner and Ball, 1989.51

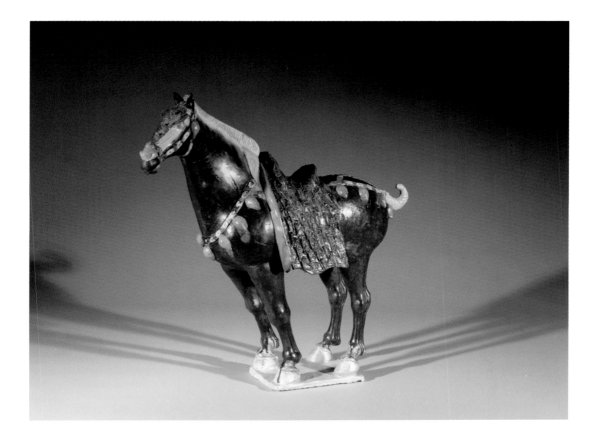

Horses were of tremendous importance to the ancient Chinese. Invested with sanctity by tradition and revered as a relative of the dragon, the horse became an instrument of military and diplomatic policy, as well as a status symbol by the Tang dynasty. Imported from various parts of Central Asia and even further afield, horses of many breeds were represented in Chinese art during this period of prosperity and power. Horses are often included as burial objects. However, large, spirited, beautifully finished examples such as this are rare.

Mold-made, this horse was put together from numerous pieces that included the head, torso, legs, tail, and the decorative details that enliven the work. Many tomb-figure horses were quickly decorated with splashes of glaze that provide an almost abstract patterning to the animals. This horse, however, was very carefully and realistically glazed, and posed in a noble stance.

Procession

Chinese, Tang dynasty (618–906) | About 710 | Earthenware with pigment and gilding | About 12 x 12 x 3 in each |
Collection of the Art Fund, Inc. at the Birmingham Museum of Art; Purchase with funds provided by Dr. and Mrs. Clifford Porter
Powell, AFI7.2008.1-.14

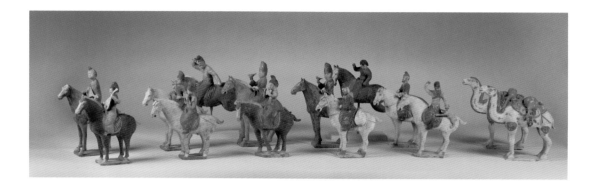

Tomb figures were an important part of Chinese funerary practices. The deceased were provided with everything that their families thought they might need in the afterlife: animals, servants, entertainers, hunters, homes, and officials.

A number of the people shown in this procession are non-Chinese. The female musicians at the very front of the group are most likely from one of the oases in Central Asia. These groups of dancers and musicians who traveled with the caravans were always welcome, since they brought with them the current music, dances, and fashions of the various kingdoms along the Silk Road. The facial features and heavy beards of the hunters at the rear of the procession indicate that they too are non-Chinese.

Bottle

Chinese, Yuan dynasty (1279–1368) | About 1300 | Porcelain with underglaze red | 9 ½ x 4 ¾ inches | Gift of Mr. and Mrs. William M. Spencer III, 1979.351

Bottle

Chinese, Yuan dynasty (1279–1368) | About 1300 | Porcelain with underglaze blue | 11 ⁷⁄₁₆ x 5 ¾ inches | Gift of Bartlett G. Bretz and Olive Bretz Crawford in memory of their mother, Eunice Grippin Saunders Bretz, 1997.99

The name of these bottles, *Yuhuchun,* is translated as "Jade-vessel Spring" and is thought to have been taken from a thirteenth-century play in which the beautiful heroine composes a poem of the same title. The shape became a favorite in China from the fourteenth century on.

Early examples of Chinese blue and white porcelain, such as this bottle, are characterized by visible impurities in the cobalt oxide used to obtain the blue color, which burned a darker blue or gray during the firing. Often, the decoration of these early examples is somewhat confused or congested. The systematic use of underglaze copper as a colorant on porcelain also began during the Yuan dynasty. Copper red was much more difficult to control in the kiln than blue and tended to burn a faded gray. The red color of this bottle is unusually deep and rich, indicating a completely successful firing.

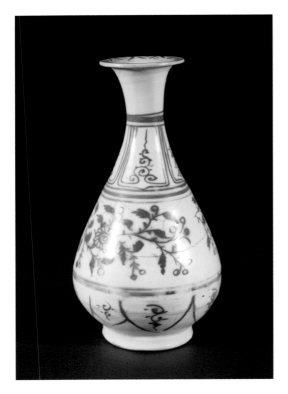 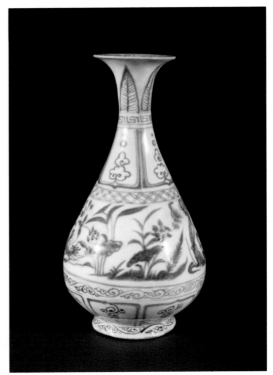

Plate

Chinese, Yuan dynasty (1279–1368) | About 1300 | Lacquer, wood, fabric | 1 ⅜ x 13 ¾ inches | Gift of Mr. and Mrs. William M. Spencer III, 1986.811

The parrot is a symbol of fidelity to the Chinese. Due to the bird's ability to mimic human speech, it was thought to be the perfect companion for a woman whose husband was away, informing him of her activities during his absence.

The peony is regarded as an emblem of female virtue. In full bloom it is a token of love, affection, and feminine beauty.

The manufacture of the best lacquer (sap from the *Rhus vernicifera* tree) can require many years, with the number of layers of lacquer on some pieces numbering several hundred. Each coat must be brushed on and dried completely before another can be added. Lacquer can be applied directly to the body of an object or, more commonly, to an intermediary layer of cloth. It can also be colored while still in its liquid state by the addition of cinnabar, cassia juice, or other colorants. The piece is then decorated through carving, incising, or inlaying with mother-of-pearl and precious stones and metals.

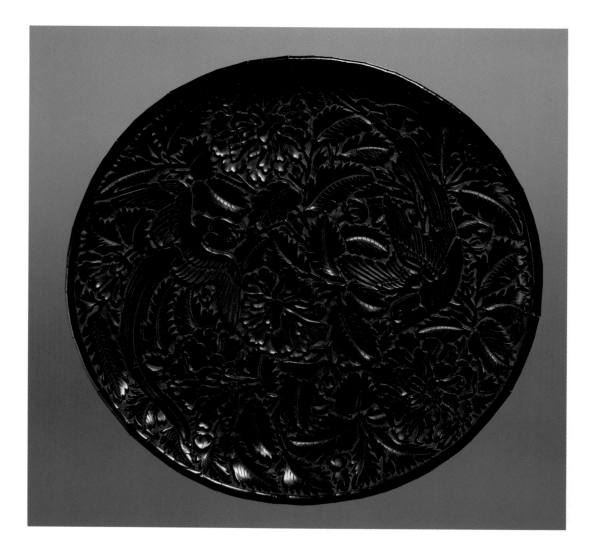

The Ascetic Sakyamuni

Chinese, Yuan dynasty (1279–1368) | About 1300 | Wood, fabric, lacquer, pigment | 10 ½ x 14 ¼ x 7 ¼ inches | Gift of Mr. and Mrs. William M. Spencer III, 1979.316

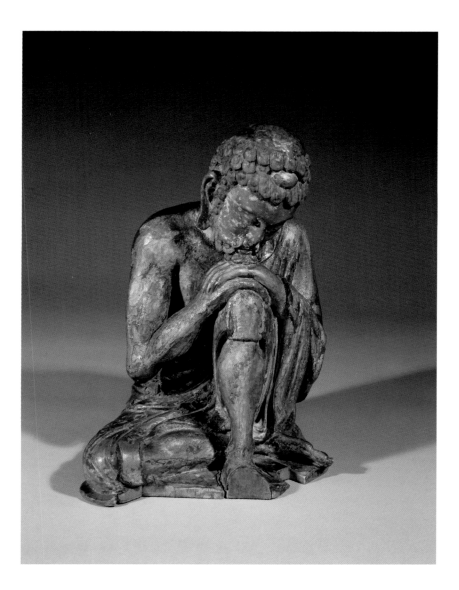

During his search for enlightenment, Sakyamuni spent many years traveling from one holy man to another, seeking guidance. Lost in meditation for days at a time, he lived in the open and ate very little. Only when he realized the futility of self-denial did he attain enlightenment and become the Buddha. This sculpture depicts the exact moment of this understanding. Images such as this were used as an aid in meditation and to help commemorate the date of the Buddha's awakening (traditionally celebrated on December 8).

The figure was carved from a single piece of wood that was hollowed out from the bottom. The resulting chamber would originally have held sutras or other relics to sanctify the image. The whole was then covered with lacquered cloth and finally gilded and painted. Traces remain of blue and red pigment that highlighted the hair and other features. The result is an introspective figure of great spirituality.

The Pure Land of Amitabha

Chinese, Ming dynasty (1368–1644) | About 1450 | Polychrome, gilding, and gesso on plaster and bamboo | 126 x 127 $^3/_{16}$ inches | Museum purchase with funds provided by the 1987 Museum Dinner and Ball, 1987.34.1-.2

Amitabha is the Buddha of Infinite Light, one of the most popular of the Buddhist gods. He lives in the Western Paradise (*Sukhavati* Paradise), the Pure Land created by Amitabha, where the faithful pray to be reborn. The figures and imagery of this mural were easily understood by the followers of Amitabha, and gave concrete form to the visions of paradise presented in the holy texts. The Pure Land is described in chapter 15 of the *Sukhavativyuha-sūtra* (Sūtra on the Buddha of Eternal Life) as a land of infinite beauty, peopled with many gods and men, rich in a variety of flowers and fruits, and adorned with jeweled wish-granting trees where rare birds come to rest.

These two panels weigh approximately one ton and are the outer parts of what was probably a much larger composition of the Pure Land of Amitabha. The wall on which the mural is painted is made of mud mortar bound with chopped straw and rush, covered with a layer of cloth and fine plaster. Since there are paintings on both sides, it must have been an interior wall within the temple. Murals such as this served as backdrops for sculpture in Chinese Buddhist temples, forming an important part of the temple teachings. Sacred paintings and sculptures were usually done by itinerant groups of craftsmen who traveled from temple to temple, working on commission. In Buddhist painting, the central Buddha is always shown as a very calm, serene figure. The various surrounding figures, however, are livelier in their expressions and more animated in their gestures.

It is not known from which temple in China this mural came. The delicate textile patterns, the lavish use of gold, and the subtle expressions of the faces are all of the highest quality, suggesting that it was part of an important temple in a large metropolitan area. Because of natural and manmade disasters, very few murals survive in temples in China. Only a handful remain, and are now for the most part preserved in museums in the United States.

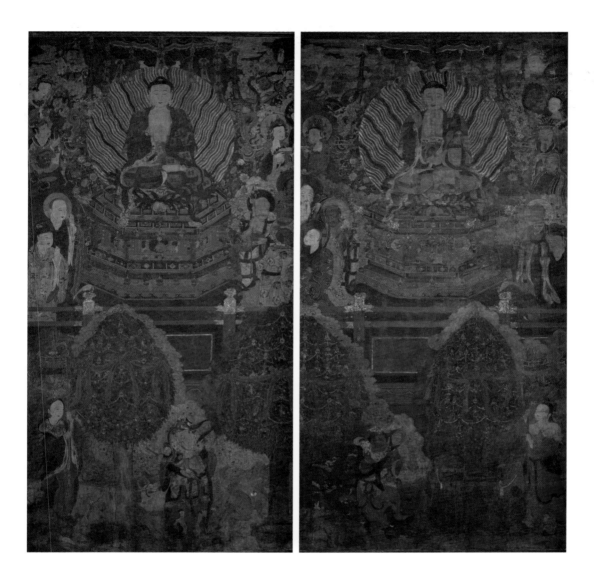

Wheel of Existence

Eastern Tibetan | About 1800 | Appliqué and embroidery on silk | 111 ½ x 80 inches | Gift of Mr. Joseph Rondina, 1979.350

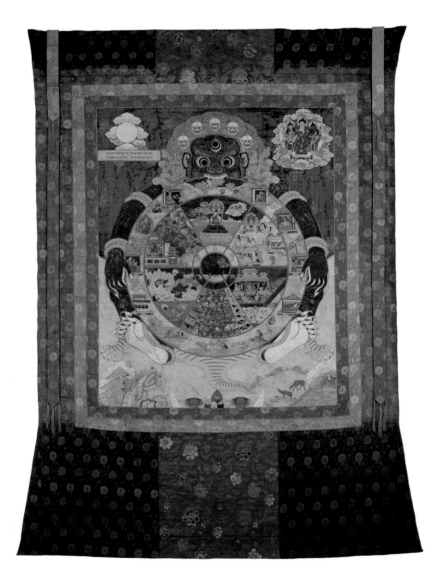

"Make a beginning and renounce the world. Enter into the path of the enlightened ones. As a great elephant would crush a reed hut, destroy the armies of death."

So reads the inscription in the upper-left cartouche in this picture of the Buddhist universe, or the Wheel of Existence. Within the complex iconography of this wheel are shown the "Six Realms of Existence." Clockwise from the top these are: Gods, Creatures in Hell, Titans, Animals, Ghosts, and Humans.

A pig, a snake, and a bird represent the "Endless Cycles of Rebirth" at the hub of the wheel while its rim is divided into twelve parts symbolizing "The Twelve Independent Causes of Rebirth." Sakyamuni Buddha is shown in the upper-right cartouche. Yama, holding the wheel, is the Lord of Impermanence and Death.

Known as *thangkas,* these large pictures were brought out only on special holy days. They were displayed in the temple or outside, hanging from the walls of a building so that they were easily seen by the faithful.

Thousand-Armed Avalokitesvara (Sahasrabhuja Avalokitesvara)

Tibetan | About 1750 | Gilt bronze | 21 ½ x 12 ½ x 7 ⅛ inches | Museum purchase with funds provided by the 1998 Museum Dinner and Ball, 1999.9

Within the Buddhist pantheon, the Thousand-armed Avalokitesvara is one of the most beneficent and compassionate of deities. The multiple arms and heads represent the ability of the god to see in all directions in every universe at any time, and to assist all beings in trouble in all directions in every universe at any time. First popularized in Tang-dynasty (618–906) China, images of the deity quickly proliferated throughout China, Japan, and the Himalayan region and remain immensely popular to this day.

Tibet and China enjoyed a close spiritual relationship during the Qing dynasty (1644–1912). The Mongols were followers of Tibetan Buddhism, and monks and dignitaries frequently traveled between the two countries, exchanging gifts of texts, textiles, and sacred images. Tibetan craftsmen worked both in Beijing and Lioaning (Mukden), creating images specifically for this exchange. This statue most likely originated as part of the spiritual dialogue between the two countries.

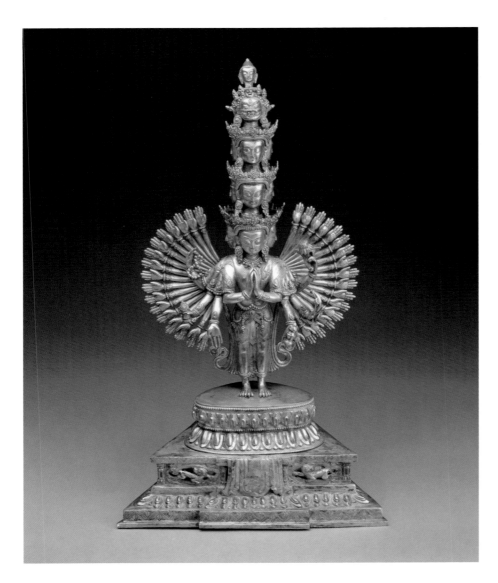

The Buddha of Eternal Light (Amita Buddha)

Korean, Unified Silla dynasty (668–935) | About 700 | Gilt bronze | 7 ⅜ x 2 ⅜ x ¾ inches | Anonymous gift, 1988.64

It is traditionally thought that Buddhism was introduced to Korea from China some time during the Three Kingdom period (57 BC–AD 668). The influx of material culture that ensued provided the impetus for an artistic florescence in the Three Kingdoms of Goguryeo, Baekche, and Silla.

The Unified Silla dynasty (668–935) saw the influence of the international Tang-dynasty (618–906) style from China take hold in Korea. The round, full form of this figure, the rather stern expression of the face, and the drapery that clings to the body are all hallmarks of the Tang style. However, elements of the native Korean propensity for an indigenous stylistic orientation are also pronounced. This aesthetic favors a block-like concept of spatial development with little desire to expand into space, a constrained linear schematization of the drapery, and a strict sense of bilateral symmetry.

Jar *(Dal Hang-ari)*

Korean, Joseon period (1392–1910) | About 1700 | Porcelain, *Bunwon-ri* ware | 14 ½ x 14 inches | Museum purchase with funds provided by the Estate of Carolyn Quinn, 2002.4

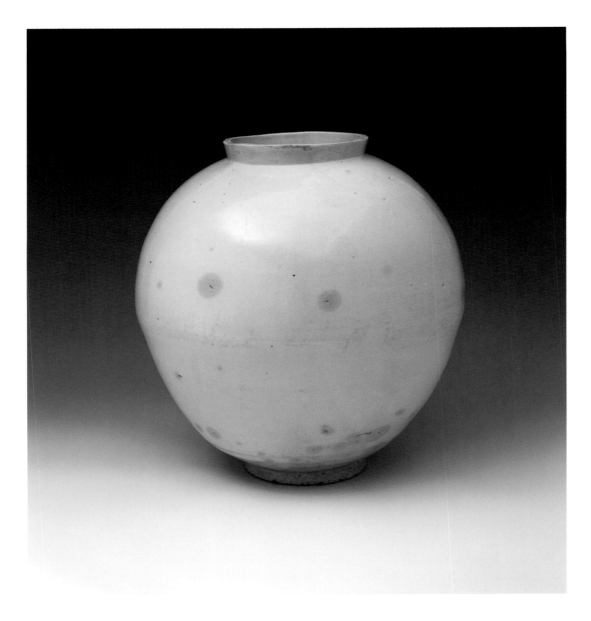

Large white jars are among the most prized of Korean ceramics. The color and shape have many meanings on many levels. Koreans see the full moon, with its soft glow that lights the way at night, as a gentle spirit, and the white color also reminds Koreans of the Confucian virtues of purity and modesty.

White porcelain has been made in Korea since the tenth century. Overshadowed for a long time by the popularity of celadon (pale green) ceramics, it was not until the fifteenth and sixteenth centuries that white porcelain became one of the preferred wares. The kilns that produced these exquisite pieces were strictly controlled by the bureau *(Bunwon)* that oversaw the meals and court banquets of the royal family. Only the finest clays and glazes were employed for the white porcelains that were used by the king and his court.

Bottle

Korean, Joseon period (1392–1910) | Eighteenth century | Porcelain with cobalt decoration | 5 x 4 ⅝ x 2 ⅞ inches | Museum purchase with funds donated in memory of Dr. M. Bruce Sullivan, 2004.38

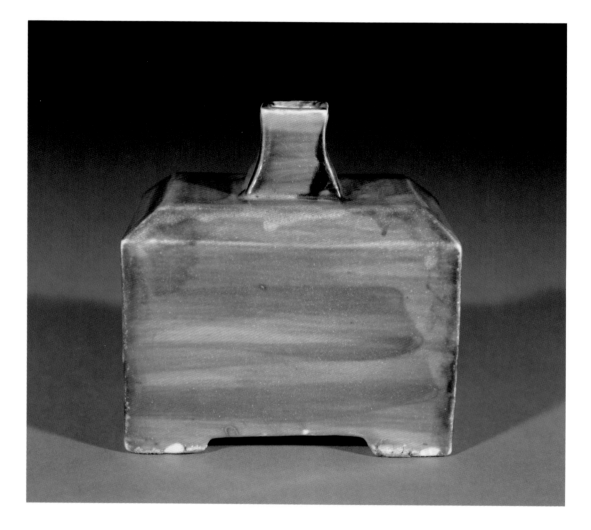

The first mention in Korean records of underglaze blue decorated porcelains is an official entry that records a gift of such ceramics from the Xuande Emperor of China (reigned 1426–1435) to the Joseon court. Korean potters greatly admired this new ware and set out to copy it. The first cobalt that the Koreans used for such decoration was imported from China. As such, it was expensive and sparingly applied. In 1463, local sources of cobalt were discovered, but the material was of inferior quality and the potters and their patrons preferred the deep blue of the more expensive imported cobalt.

This bottle is somewhat of a contradiction to the official Neo-Confucian doctrine of the Joseon period (1392–1910), which encouraged an orderly, frugal, moderate life. The boldly brushed overall blue decoration and the lavish use of an expensive imported color are an unusual demonstration of a strong, more personal taste.

Bottle

Korean, Joseon period (1392–1910) | Eighteenth century | Porcelain with underglaze copper red | 7 ⅝ x 6 inches | Museum purchase with funds provided by the Estate of Carolyn Quinn, 2004.1

The shape and color of this jar are extremely unusual in Korean ceramics. The multi-faceted body and neck of the piece are identical to an example in The Museum of Oriental Ceramics, Osaka, Japan, that is decorated in an elaborate floral pattern in underglaze cobalt blue (Acc. No. 20501).

The other extraordinary aspect of this bottle is that it is covered entirely with boldly applied copper-red underglaze. This type of glazing is among the most difficult to produce successfully, with many objects turning a dull gray during the firing. It is debated whether red wares were an official product of the Bunwon-ri kilns, or came primarily from provincial kilns. Ceramics with underglaze copper-red details date as far back as the twelfth century in Korea, but the more common use of this glaze came in the second half of the Joseon period (1392–1910).

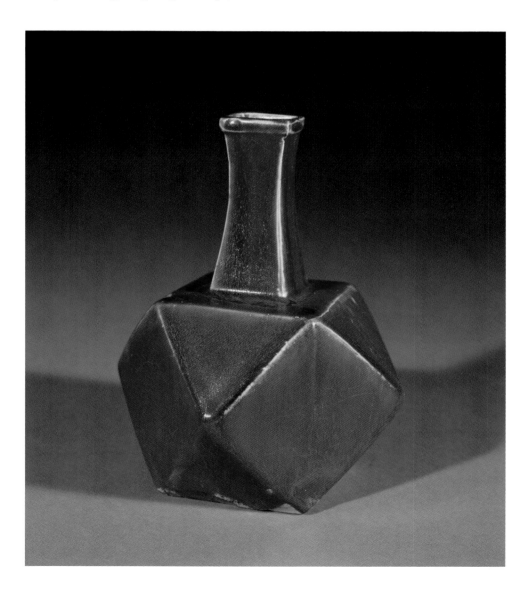

Jar

Korean, Joseon period (1392–1910) | Eighteenth century | Porcelain with underglaze blue decoration | 11 ½ x 11 ¼ inches | Museum purchase with funds provided by the Estate of Carolyn Quinn, 2004.2

Jars decorated with cut-out panels filled with landscape pictures are some of the most charming wares of the Joseon period (1392–1910). Court painters were sent to the official kilns to decorate royal porcelains, and the landscapes painted in underglaze blue on these wares often closely resemble paintings done on paper and silk at this time.

This jar is an exceptional piece, not only for its large size, but also for the quality of the painting. The neck is decorated with beautifully painted floral and Korean *youi* (Chinese *ruyi*) scepter designs. However, the main decoration is two panels on the body of the jar that are painted with scenes from the famous Chinese series of poems *Eight Views of the Xiao and Xiang River.* These poems are named after the two famous tributaries that flow into one of China's largest lakes, West Lake. The scenery around this confluence has been celebrated in poems and paintings since the Southern Song dynasty (1127–1279).

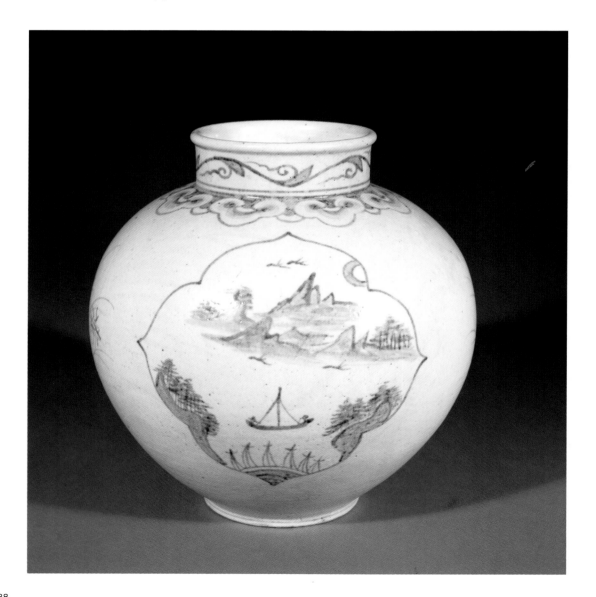

Jar

Korean, Joseon period (1392–1910) | Seventeenth century | Porcelain with underglaze iron decoration | 20 x 19 ½ inches |
Gift of Dr. and Mrs. Richard H. Cord, 1979.330

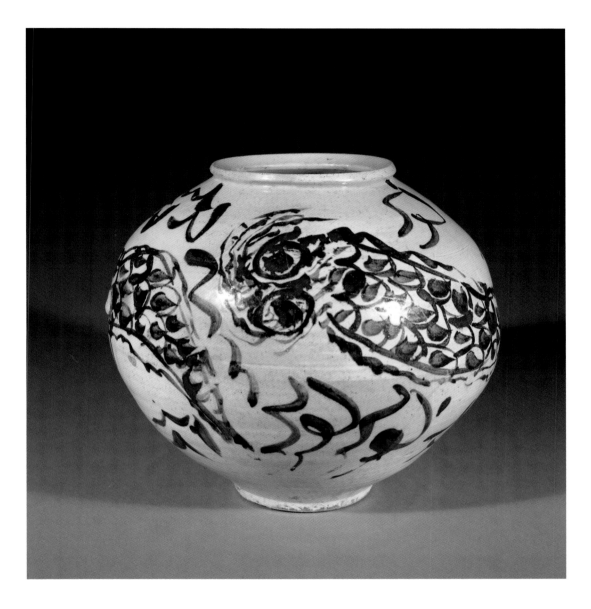

Large jars decorated with dragons painted in under-glaze iron are among the most winsome of Korean ceramics. Utilitarian, everyday pieces, they were quickly made, painted, and fired. The dragons are drawn in a spontaneous and lively manner, using rapid brushwork to depict the mythical animal soaring amidst clouds.

These jars were made in two halves, as evidenced by the groove in the center where the pieces were joined.

The numerous imperfections in the clay body are typical of seventeenth-century pieces and in the Korean mind give character to each jar. Likewise, the brown painting displays subtle gradations and variations in texture that enliven the picture of the dragon. The overall shape and design of this jar suggest that it was perhaps made in a provincial kiln.

Jar

Japanese, Jōmon period (about 10,000–300 BC) | About 5,000 BC | Earthenware | 27 x 17 x 14 ¾ inches | Museum purchase, 1989.61

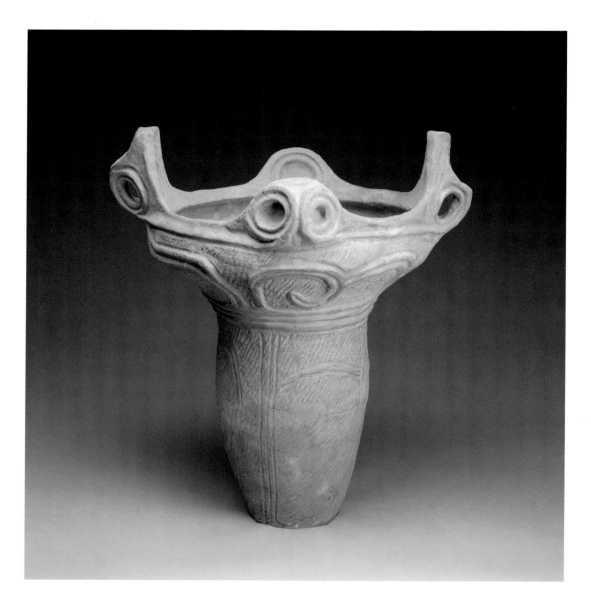

The art tradition of the Jōmon period of Neolithic Japan lasted over 8,000 years. It was a period rich in tools, jewelry, figures, and pottery. This jar is a product of the Middle Jōmon period, dating to about 3,500 BC. The piece was excavated in 1969 in Aomori prefecture in northern Japan.

Jōmon pottery is a low-fired earthenware with either a coarse, polished, burnished, or painted surface. Many of the pots are characterized by cord-impressed designs that range from simple incised zones of decoration to dense, circuitous markings with carved spiral patterns near the rim. The work of the Middle Jōmon period is particularly plastic, with sculpted rim decorations in elaborate shapes that project into space. These tall, narrow-waisted jars were perhaps used for food storage.

Jizō Bosatsu (Ksitigarbha)

Japanese, Heian period (794–1185) | About 1100 | Wood | 36 x 10 x 5 ½ inches | Museum purchase with funds provided by the Estate of Carolyn Quinn, 2005.16a-b

This Jizō is beautifully carved. The sensitive handling of the face, the perfect proportions, and the amazing thinness and elegance of the drapery edge are all hallmarks of the finest sculpture of the late Heian period (794–1185). Unfortunately it is not known from what Japanese temple it came.

Jizō first appears in Indian Buddhism around the fourth century in the *Mahavaipulya-sūtra* (Flower Adornment Sutra). However, he was never very popular in that country. While there are numerous paintings of him that survive from seventh- and eighth-century sites in Central Asia and China, it was in Korea and especially Japan that he became most popular.

While large important temples are dedicated to Jizō throughout Japan, he is primarily a benefactor for the common people. He is found in every Japanese neighborhood, tucked away in a small shrine squeezed between homes or shops, where neighborhood organizations take care of him, offering food and flowers.

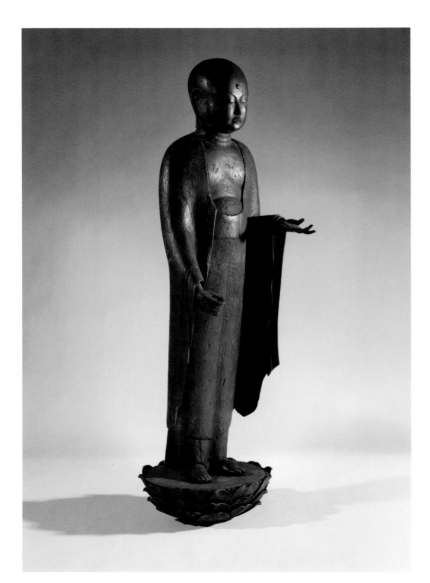

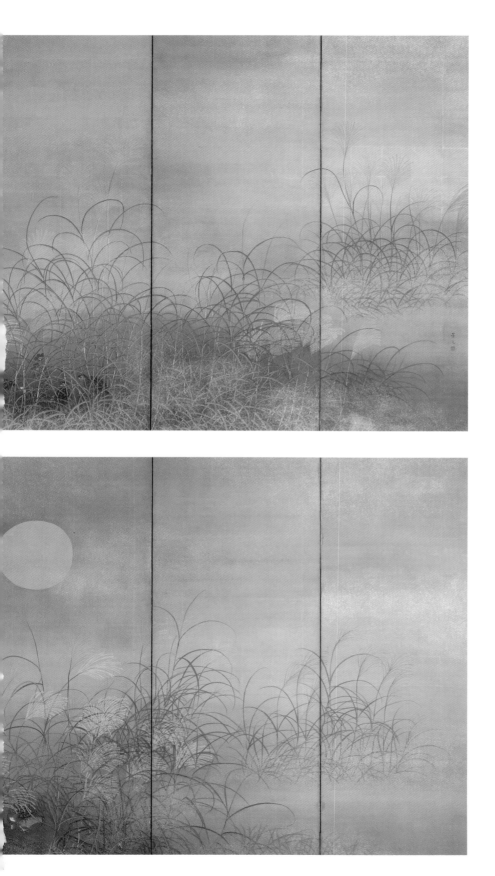

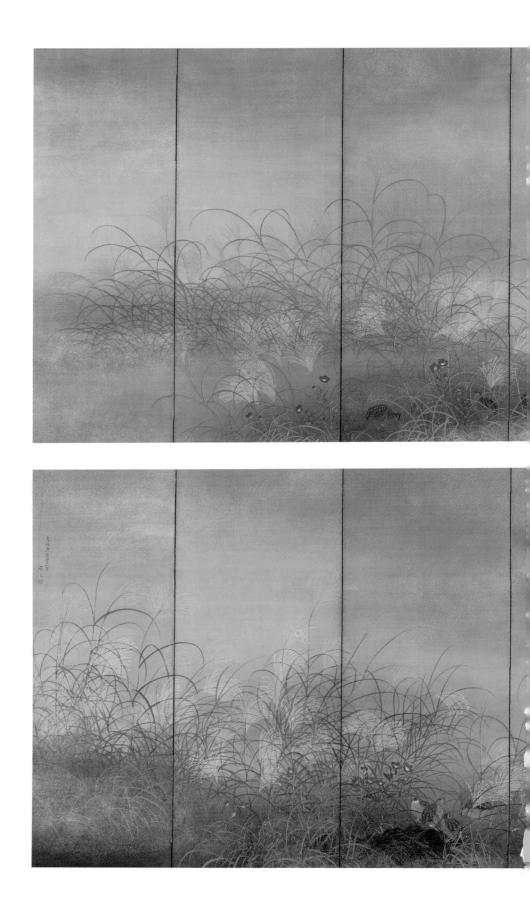

Quail Feeding Amidst Susuki and Kikyō | **Matsumura Keibun** Japanese (1779–1843)

Edo period (1615–1868) | 1830 | Ink, color, gold, and silver on silk | 67 ¾ x 76 inches (each) | Gift of Mrs. Benjamin C. Russell in memory of Mr. and Mrs. Karl Landgrebe, Sr., 1990.6.1–.2

Matsumura Keibun was one of the most respected painters of his day. He was particularly noted for his realistic paintings of birds, flowers, and animals. Here he has depicted a bevy of quail feeding by moonlight amidst *susuki* (pampas grass) and *kikyō* (Chinese bellflowers). The scene evokes a rich autumnal mood, steeped in the traditional Japanese aesthetic concept of austere and refined simplicity. The glimmering light of the wan moon in the dawn sky and the quail calling its plaintive cry from the pampas grass on a withered plain create a scene of desolate beauty that is rich in poetic allusion.

The screens are inscribed "The third month of the *kanoe-tora* year of *Bunsei*" (1830), reflecting the best of Keibun's mature period.

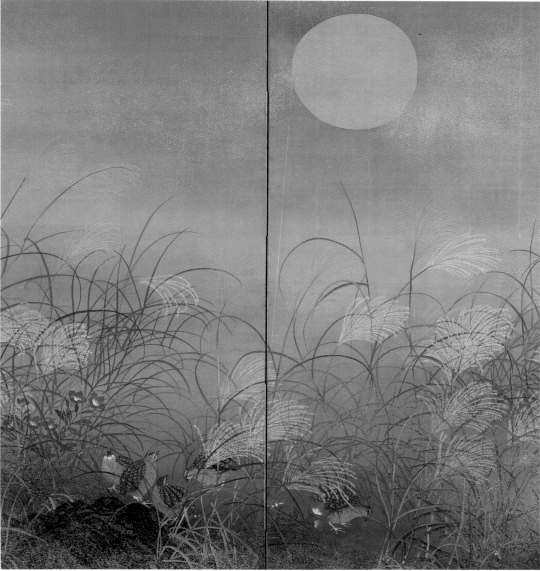

DETAIL

Ewer *(Yuto)*

Japanese, Muromachi period (1392–1573) | About 1450 | Red and black lacquer on wood, Negoro ware | 15 x 11 ¾ x 6 ¾ inches | Collection of the Art Fund, Inc. at the Birmingham Museum of Art, AFI2.2000a-b

The term "Negoro ware" comes from the name of a Buddhist temple, the Negoro-dera in Kii Province (modern Wakayama prefecture), where large quantities of this type of lacquerware were made prior to the destruction of the temple in 1585. The name usually specifies lacquer with a red surface superimposed over an undercoating of black lacquer. The red lacquer wears away gradually and irregularly with use, producing a mellow effect of natural aging for which Negoro ware is highly appreciated.

The original use of Negoro ewers such as this is uncertain. It has been suggested that they were used in Zen temples to hold hot water for the preparation of tea.

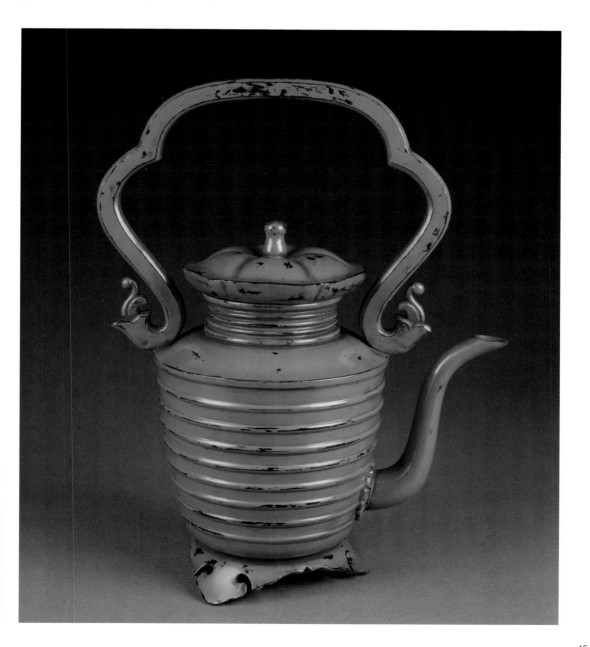

Kasuga Deer Mandala (*Kasuga Shika Mandala*)

Japanese, Nambokucho period (1336–1392) | About 1350 | Ink, color, and gold on silk | 40 x 15 inches | Museum purchase with funds provided by Dr. and Mrs. Austen L. Bennett III, Dr. and Mrs. Thomas A.S. Wilson, Dr. and Mrs. Thomas W. Mears, Dr. and Mrs. Lawrence J. Lemak, and Dr. Richard H. Cord, by exchange, 1993.15

The deer that roam the grounds of the Kasuga shrine in Nara, Japan, are believed to be messengers of the Shintō gods that inhabit the shrine and the surrounding mountains. Founded in 709 by Fujiwara Fuhito (659–720), the shrine is one of the most ancient and venerated in Japan.

By the eleventh century the Japanese believed that their native Shintō gods had universal counterparts among the imported Buddhist deities. Buddhist art forms were accordingly adapted to Shintō practices to represent this synthesis, including the making of ritual paintings, or mandala. Within this tradition, images of a white, saddled deer represent the Kasuga shrine. Descending from the mountains on a cloud, the deer carries a large mirror supported by the branches of a *sakaki* tree (*Cleyera japonica*), both sacred emblems of Shintō. Entwining the branches of the tree are wisteria (*fuji*), the symbolic flower of the shrine and the Fujiwara family. Seated in the mirror are five Buddhist deities (Sakyamuni Buddha, Ekadasamukha Avalokitesvara, Ksitigarbha, Bhaisajyaguru Buddha, and Manjusri), the transformed manifestations of the Shintō gods of the Kasuga shrine.

From ancient times the Kasuga area of Nara has been known for its natural beauty. Nestled in these picturesque mountains, the shrine itself is depicted above and behind the mirror in a bird's-eye view of six small buildings set in a mist-filled landscape. The distinctive crossed roof beams of the Kasuga shrine buildings peek through the stylized bands of mist, while a full moon looms over the low rolling hills of Mt. Mikasa, dotted with flowering cherry trees. The landscape element of this painting is significant in that it depicts an actual place in a style that appealed to the indigenous Japanese sensibility.

The reverse of the mandala bears an inscription that translates, "Painted by Rokkaku Jakusai." A member of the *Edokoro* (Painters of the Court), Jakusai (1348?–1424) painted in the Japanese style known as *Yamato-e*. Based on a purely Japanese aesthetic, paintings of the *Yamato-e* school depict gentle landscapes with low hillocks, dotted with flowering trees and other aspects of the four seasons, which were popular with the aristocracy. Whether or not Jakusai actually painted this mandala, the association of his name with a work of native religious subject matter done in a native style is not inappropriate.

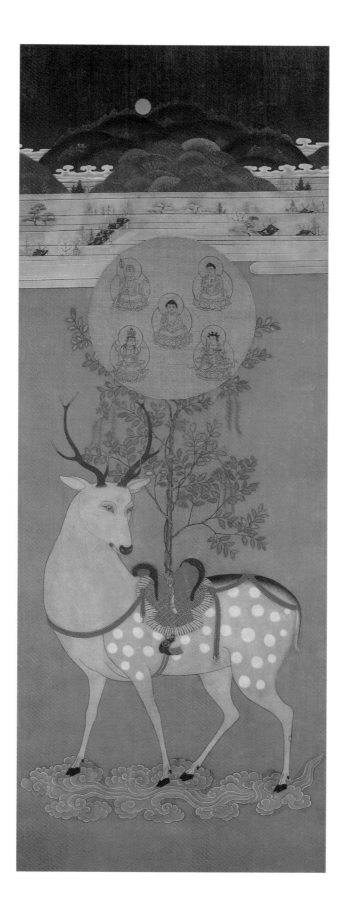

Suigetsu (Intoxicated by the Moon) | Sen no Rikyū Japanese (1522–1591)

Muromachi period (1392–1573) | About 1575 | Ink on paper | 9 x 16 inches | Gift of Mr. Kazunori Tago to the People of Alabama, 1997.25

The hanging scroll sets the aesthetic tone for a tea ceremony, influencing everything from the selection of the tea utensils to the conversation that will take place. The phrase written here, *suigetsu,* can be translated variously as "intoxicated by the moon" or "hazy moon." To Edo-period followers of tea, the phrase conveyed a sense of romantic melancholy and would have been suitable to display during an evening tea ceremony.

Sen no Rikyū is the most revered figure in the history of the Japanese tea ceremony. His sensibilities defined the taste of tea connoisseurs of the late sixteenth and early seventeenth centuries. Through the utensils and artwork he chose to use in the tea ceremony, he was the first to acknowledge the rustic simplicity, directness of approach and honesty of self that continue to govern the aesthetics of the tea ceremony today.

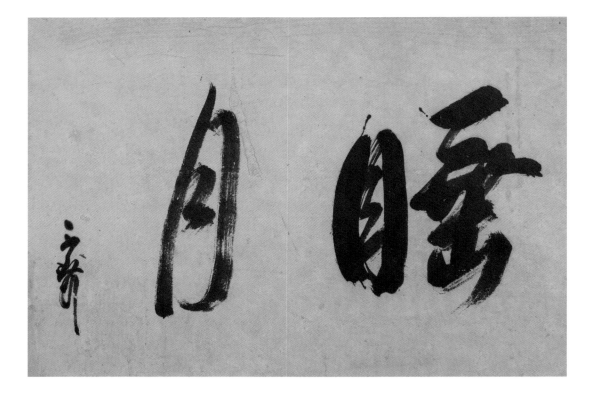

The Tale of Genji

Japanese, Edo period (1615–1868) | About 1610 and 1620 | Ink, color and gold on paper (six leaves) | 11 ⅞ x 10 inches and 10 ½ x 9 inches | Museum purchase with funds provided by the Estate of Caroline Quinn, 2003.28.1-.3 and 2003.29.1-3

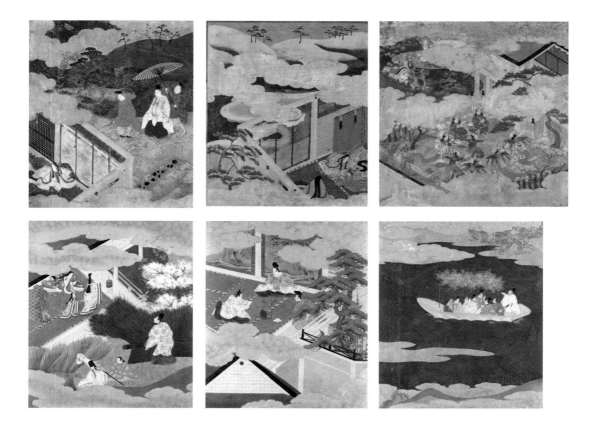

The Tale of Genji dates from about the eleventh century and is recognized as the world's first novel. Its author, Murasaki Shikibu, a lady of the Imperial Court, was about thirty years old when she composed it.

The tale describes the life and loves of an erstwhile prince known as "The Shining Genji," and later, after his death, the less successful loves of a youth who passes before the world as his son, but is in fact the grandson of his best friend. However, the work is far more complex than this outline would suggest, and has been described as a psychological novel. *The Tale of Genji* provides us with a unique window into the lives and minds of the high courtiers of early eleventh-century Japan.

Each of these seventeenth-century paintings was originally part of a larger album that illustrated the many chapters of *The Tale of Genji*. Sometimes the paintings were interspersed with the text; at others the albums contained only pictures, with the text on a separate scroll or album.

Momoyagusa (A World of Things) | **Kamisaka Sekka** Japanese (1866–1942)

Meiji period (1868–1912) | 1909–1910 | Ink and color on paper (three volumes) | 11 ¾ x 17 ⅝ inches | Museum purchase, 1998.2.1-.21 | Promised gift of Virginia and William M. Spencer III, 36.1998.1-43

Kamisaka Sekka was one of the most important artistic figures in early twentieth-century Japan. Born in Kyoto into a Samurai family, his talents for art and design were recognized early and so began his studies. He eventually allied himself with the traditional Rimpa school of art, based on the artistic and literary traditions of the Heian period (794–1185). He is now considered the last great proponent of this artistic tradition.

The *Momoyagusa* is considered Sekka's woodblock-print masterpiece. Commissioned by the publishing firm Unsōdō in Kyoto, the three-volume set came out between 1909 and 1910. The sixty images constitute an amazing variety of landscapes, figures, classical themes, and innovative subjects, captured in a small space. They show a complete mastery of traditional Rimpa subject matter combined with his own style and understanding of the many innovations that were influencing Japan at this time.

Buddha

Afghan, Gandhara, Kushan period (50–320) | About 250 | Schist with traces of pigment | 29 x 17 ½ x 5 inches | Gift from the Asian Art Collection of Dr. and Mrs. William T. Price, 2001.58

Ancient Gandhara was one of the great crossroads of civilization during the first to the fifth centuries. It was an important center along the Silk Road of international trade and communication between ancient Iran and Central Asia. The Gandharan civilization peaked during the Kushan period (first to third centuries). During this time, Mahayana Buddhism flourished and the Buddha was shown in human form. Numerous monasteries and burial mounds were built, all requiring imagery as part of their iconographic plan.

The images of Gandhara are famous for their strong combination of Greek, Syrian, Persian, and Indian styles. Heavy drapery, curly hair and pronounced Western-looking features are hallmarks of this style. The many images that survive were all originally brightly painted and gilded. As in this figure, traces of the pigments can often be found in the deep folds of the drapery.

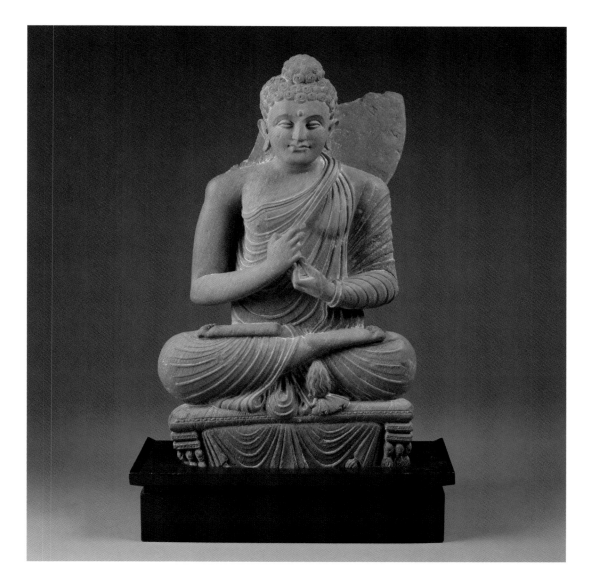

Vishnu

Indian, Uttar Pradesh | About 875 | Sandstone | 37 x 29 x 11 ¾ inches | Collection of the Art Fund, Inc. at the Birmingham Museum of Art; Gift of Eivor and Alston Callahan, AFI3.2004

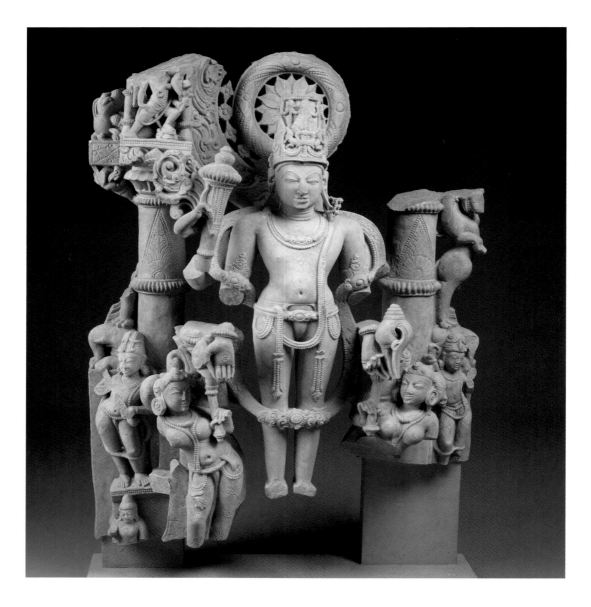

As the preserver of the universe and cosmic order, Vishnu is one of the most popular of the Hindu deities. Here he is shown as the ruler of *sattva*, the cohesive nature that binds everything in the universe. In his hands he holds (from top to bottom, left to right) a mace (the power of knowledge), a lotus (the universe), a now lost item, possibly a bow (the destructive aspect of existence), and a conch shell (symbol of the origin of existence). Vishnu is flanked by various male and female attendants and to his right and left are the Boar Avatar and perhaps the Lion Avatar (now lost), two of his twenty-four forms of being.

The carving of this piece is exceptionally deep and detailed. All of the components of Vishnu's elaborate crown and the jewelry of the attendants are shown in meticulous detail. Although seen today as a fragment of a larger work, this is still an impressive and moving depiction of Vishnu, the preserver of the universe.

Twenty-third Jain Great Teacher (Parshvanatha)

Indian | About 950 | Sandstone | 30 x 15 ½ x 7 inches | Gift from the Asian Art Collection of Dr. and Mrs. William T. Price in honor of Betty Jane Price McGiffert and David Garrett McGiffert, 2003.49

Parshvanatha (877–777 BC?) lived as a nobleman before giving it all up to become a monk. After prolonged meditation he achieved *Nirvana* and became the twenty-third great teacher of the Jain tradition. Like all great Jain teachers, he is always shown nude and usually standing in front of a large Nāga, or Cobra. The Nāga has three, five, or seven heads that shade the teacher in return for his prayers for their afterlife.

Jainism is one of the most ancient Indian religions. Its goal is divine consciousness attained through meditation and ascetic practices and the renunciation of all property and wealth. Believing that even the smallest of organisms has a divine soul, the Jains sweep the path before them as they walk and filter the water they drink to remove any living entities. Images such as this were used to help focus meditation and were an integral part of Jain ceremonies.

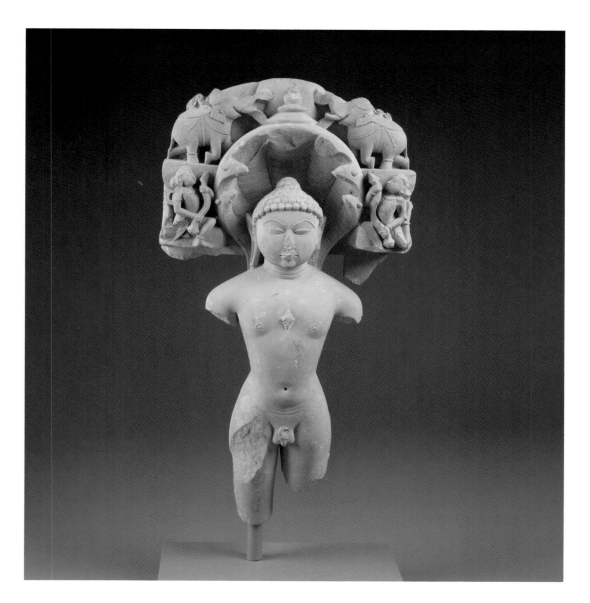

Shiva Manifesting within the Pillar of Flames (Lingodhbhavamurti)

Indian, Tamil Nadu, Chola dynasty (850–1310) | About 1150 | Granite | 45 x 16 x 9 inches | Collection of the Art Fund Inc. at the Birmingham Museum of Art; Purchase with funds provided by the Estate of Eivor and Alston Callahan, AFI10.2008

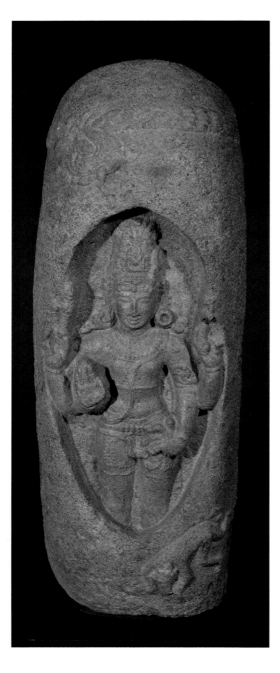

According to legend, Vishnu and Brahma were quarrelling in the absence of time between two eons when they were interrupted by the radiance of a pillar of fire that arose from the ocean in the dark flood of the cosmic night. The two gods rushed to see the flame, which was infinite in size. Overwhelmed by the presence of the pillar, they sought its beginning and end. Brahma, shown as a goose in the upper left of this sculpture, flew upwards, but could not see the top of the column. Vishnu, as the boar in the lower right, dove down for 1,000 years, but could not discover the foundation of the pillar. Returning to where they started, the two bewildered gods witnessed the pillar splitting open to reveal Shiva inside in all his glory. The primal sound "OHM" thundered forth from the pillar, and Vishnu and Brahma bowed in the presence of Shiva.

Sarasvati

Indian, Gujarat | About 1153 | Marble and pigment | 48 x 18 ½ x 11 ¼ inches | Gift of Eivor and Alston Callahan, 2003.21

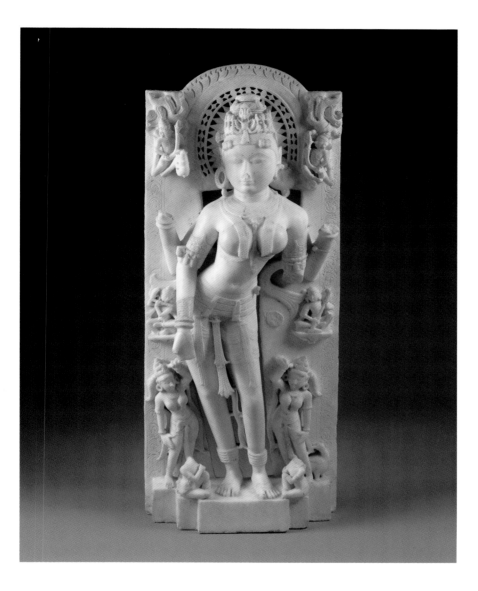

The goddess of knowledge, poetry, and learning, Sarasvati is a particularly popular deity in the Jain religion in west and central India. Jains believe that an immortal and indestructible soul resides in every living thing, no matter how small, and that human existence is a continuous cycle of life, death, and rebirth that is governed by *karma,* the results of all past deeds and actions. The Jains share with Buddhism and Hinduism a number of deities such as Sarasvati.

Carved in white marble, the deity is particularly voluptuous; with one hip thrust out and her left foot forward she seems about to break into dance. The heavenly musicians to her sides accentuate this notion. Although now largely missing, her four hands may originally have held lotus flowers, a book, or may have formed gestures such as the *mudra* for charity. A similar statue in the Los Angeles County Museum of Art is firmly dated to 1153 by inscription (M.86.83). A much-effaced inscription on the base of the Birmingham statue has yet to be deciphered and may bear a similar date.

Shiva and Parvati (Uma-Mahesvara)

Indian, Helebid region, Karnataka, Hoysala period (1111–1318) | About 1150 | Chloritic schist | 38 ½ x 23 ½ x 11 inches |
Museum purchase with funds provided by the 1990 Museum Dinner and Ball, 1990.109

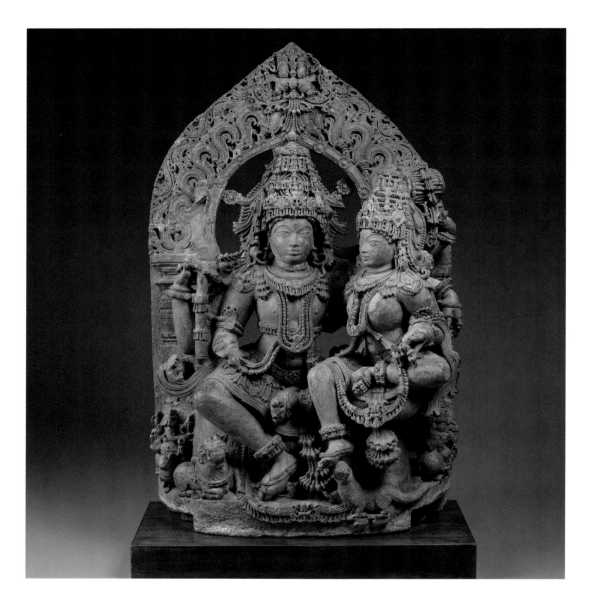

Uma-Mahesvara is the combined imagery of Mahesvara, the Great Lord Shiva, and his wife, Uma, the Great Goddess Parvati. A symbol of release within the spiritual and physical unity of divine love, the image of Uma-Mahesvara was a popular form in the hierarchy of Hindu iconography.

This image is a superb representation of the divine couple seated with their children, Ganesha and Karttikeya, shown lower left and right respectively, and their animal avatars: the bull for Shiva and the iguana for Parvati.

Master builders, the Hoysalas, constructed a number of distinguished Hindu temples in the area of their capital, Halebid. The stone carvers who brought to life the surface of these many temples were masters in the rendition of fine detail that caught the bright sunshine and cast dramatic shadows.

Bodhisattva Avalokitesvara

Sri Lankan, Late Anurādhapura period (eighth/ninth–twelfth centuries) | About 750 | Bronze | 20 ⅛ x 8 x 10 inches | Museum purchase with funds provided by Claire Fairley and the Endowed Funds for Acquisitions, 2001.285

Sri Lanka (formerly Ceylon) is an island nation that has served throughout its history as a crossroads of political, cultural, and religious influences from mainland India and countries along the maritime trade routes of South Asia. Merchants from as far afield as the Hellenistic west and China in the east anchored in the ports of Sri Lanka, helping to develop a sophisticated society. However, because it was an island, Sri Lanka also maintained a strong indigenous culture.

Anurādhapur was the ancient capital and religious center of north-central Sri Lanka for well over 1,000 years (fourth century BC–AD eleventh century). The royal family and nobility strongly supported Buddhism, commissioning great works of art from workshops and donating them to various temples to accumulate merit for this and the next life. In turn, the Buddhist establishment supported the role of the king, giving legitimacy to his rule. Within this context, images of Avalokitesvara, the Bodhisattva of Mercy and Compassion, were especially popular offerings. This particular statue is perhaps from such patronage.

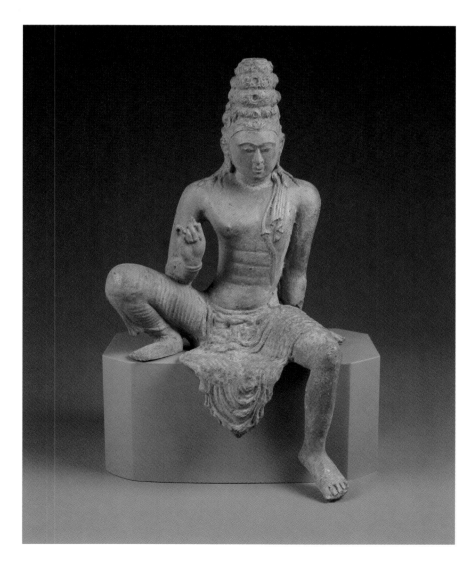

Ganesha

Cambodian, Angkor style | Tenth century | Sandstone | 27 ¾ x 17 x 10 ½ inches | Gift of Dr. and Mrs. Charles B. Crow, Jr. and Mr. and Mrs. William A. Grant, Jr., 1978.73

One of the most ubiquitous of Indian gods, Ganesha appears in images in all walks of Hindu life; he is found by the roadside, in household shrines, in temples and shops, and on the frontispieces of books. Both placing and clearing away all obstacles, he is the god of wealth and patron of all merchants. The son of the Hindu gods Shiva and Parvati, Ganesha is always shown with the body of a potbellied dwarf and the head of an elephant.

This statue is from Cambodia and is carved from a single block of sandstone. The figure wears the royal attire of the Khmer people, with crown, elaborate jewelry, and skirt. The elephantine nature of the deity is aptly reinforced by the architectonic solidity of the composition.

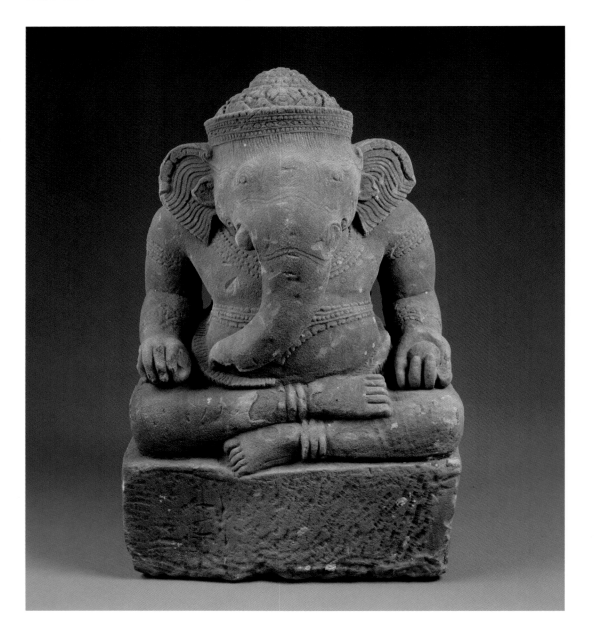

Incense Burner

Vietnamese | Seventeenth century | Glazed stoneware | 12 ½ x 9 ½ x 5 ⅛ inches | Collection of the Art Fund, Inc. at the Birmingham Museum of Art; Gift of the Multiple Sclerosis Foundation in honor of Mr. William M. Spencer III, AFI6.2008

Ewer

Vietnamese | Thirteenth–fourteenth centuries | Glazed stoneware | 7 ⅝ x 7 inches | Promised gift of Virginia and William M. Spencer III, 416.2005a-b

Offering Stand

Vietnamese | Fifteenth century | Glazed stoneware | 8 x 11 ⅝ inches | Museum purchase, 1975.5

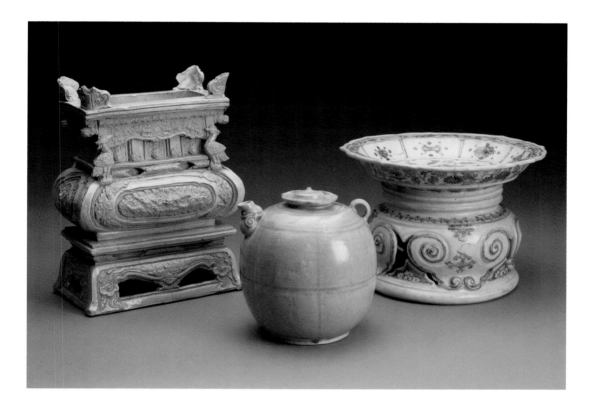

The Birmingham Museum of Art has the finest collection of Vietnamese ceramics in the United States. Beginning in the 1970s, the collection was carefully assembled so that it would cover the entire range of Vietnamese ceramic production.

The Vietnamese had close contact with their powerful neighbors to the north, the Chinese, from the third century BC. Ruled by China for 1,000 years (111 BC–AD 938) the Vietnamese had direct exposure to Chinese civilization and its overwhelming ceramic tradition. Yet Vietnamese potters did not simply copy Chinese prototypes. They combined indigenous and Chinese elements in original and individual ways, experimenting with new ideas and adopting features from other cultures as well, such as Cambodia, India, and Champa. Using the fine smooth white clay of the Red River Valley, the Vietnamese created the most sophisticated ceramic tradition in Southeast Asia.

This tradition, however, does not appear to have developed during the period of direct Chinese rule; rather, it evolved during the native Ly and Tran dynasties (1009–1400), after the expulsion of the Chinese, when Vietnamese culture flourished.

Avalokitesvara

Thai, Pre-Angkor period (before 802) | About 800 | Bronze | 15 ⅛ x 4 ½ x 3 ½ inches | Gift of Dr. and Mrs. M. Bruce Sullivan in honor of Douglas and Tita Hyland, 1991.958

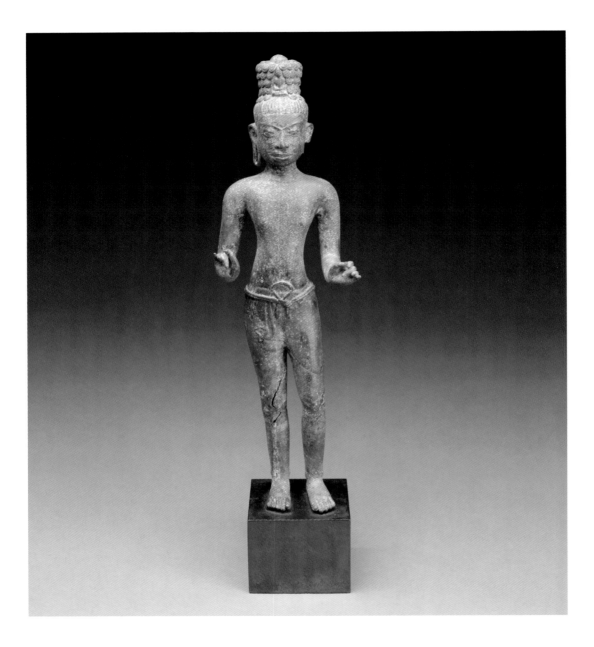

Images of Avalokitesvara from the Pre-Angkor period in Thailand are among the most beautiful ever produced in Southeast Asia. Distinguished by light and graceful forms, they reflect Indian styles, as transmitted through the Cambodian tradition of the Chenla period (550–802).

The most famous of the Pre-Angkor period Buddhist images come from a group discovered in 1964 in the village of Prakonchai in the Buriram province of Thailand. While similar in style, slight differences in the hairstyle and overall patina of this piece suggest a comparable time frame, but perhaps a site of origin other than Prakonchai.

Water Dropper

Thai | Fourteenth century | Glazed stoneware | 2 ½ x 3 ¼ inches | Gift of Dr. Chandler H. and Jane Paris Smith, 1980.434

Pitcher

Thai | Fifteenth century | Glazed stoneware | 10 ³⁄₁₆ x 7 inches | Gift of Dr. and Mrs. M. Bruce Sullivan, 1977.245

Water Dropper

Thai | Fifteenth century | Glazed stoneware | 3 x 2 ½ inches | Gift of Mr. and Mrs. Howard G. Clark, 1977.204

Plate

Thai | Fourteenth–fifteenth centuries | Glazed stoneware | 11 ¾ x 2 ½ inches | Gift of Mr. and Mrs. Harris Saunders, Jr., 1980.424

A ceramic tradition has existed in Thailand since at least the third millennium BC. Despite sometimes experiencing a strong influence from abroad, Thailand still managed to retain an indigenous artistic style and preference for certain shapes, colors, and decorative motifs.

The great kilns at Sukhothai and Sawankhalok were traditionally founded in 1294, when King Ramkhamhaeng returned from a trip to China, bringing with him a gift of Chinese potters. The potters quickly became recognized for their spontaneous brushwork and their love of animal decorations. These gained popularity at home and abroad and were exported to neighboring countries in large numbers.

Production at these kilns ended when the capital was relocated to Ayuthaya in 1438. Finally, in the 1460s, conflict between the kingdoms of Ayuthaya and Chiang Mai virtually ended ceramic production in north Thailand.

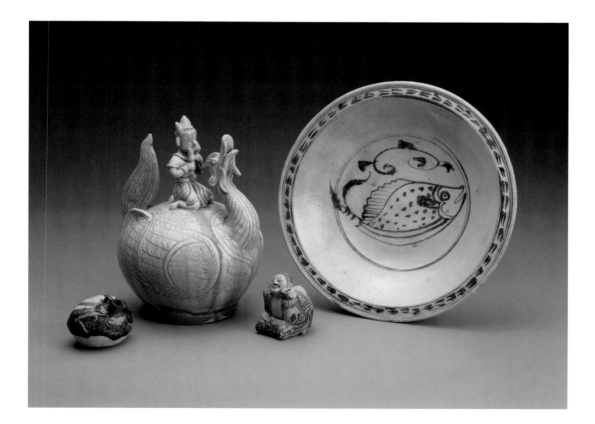

ARTS of AFRICA and the AMERICAS

The Department of the Arts of Africa and the Americas includes African, Native American, Pre-Columbian, and more recent Central and South American works of art. Formerly the Department of Traditional Arts, its name was changed in 1994, to describe the Museum's holdings more accurately. The first significant works—a group of Native American objects from the Pacific Northwest Coast—entered the collection in the mid-1950s, but it wasn't until the Museum hired its first curator specializing in this field during the early 1980s that the collection began to grow and develop more systematically.

The African collection at the Museum is the largest curatorial area within the Department, and consists of about 1,600 objects. Africa is a continent of enormous diversity, with a landmass of almost twelve million square miles, and topography ranging from savannah, tropical rain forest, and desert, to snow-capped mountains. The continent is home to over fifty countries, and hundreds of ethnic groups, cultures, languages, religions, and traditions. African art, in its many forms and functions, embodies this diversity. The Museum has sought to build a collection that represents all of the major regions of Africa, as well as reflecting ethnic and cultural diversity within those regions across time. The majority of works come from West and Central Africa; Nigeria and the Democratic Republic of Congo (two of the most prolific art-producing countries on the continent) are represented in the most depth.

The collection ranges in date from several millennia BC to the present. The oldest work is a false door from Old Kingdom Egypt, given by the late Dorothy L. Steiner. Egyptian art, often installed apart from Sub-Saharan art in other museums, is exhibited in the African gallery, and helps tell the story of the continent's extraordinarily rich history and the interconnectedness of its cultures. Other more historic works include ceramics and metalwork, some of which date from the fifteenth to the eighteenth centuries. The majority of the objects are from the nineteenth to early twentieth centuries, and include masks, figure sculpture, textiles, ceramics, household and ritual objects, jewelry, musical instruments, furniture, clothing, and costume. Because traditional African art is primarily functional, it is displayed with material such as field photographs, video, and other didactic materials that help contextualize the works.

The Museum has a small but growing collection of work by modern and contemporary African artists such as Magdalene Odundo, Malick Sidibe, Wosene Worke Kosrof, Odili Donald Odita, Sue Williamson, and Zwelethu Mthethwa.Whether these artists reside and work in Africa or in other countries, all reference the culture or experience of Africa in their art in some way. These works are exhibited both in the Museum's contemporary and African galleries.

The African collection has been supported by many individuals who have given gifts of artworks or funds. These include Sol and Josephine Levitt, Drs. Jean and Noble Endicott, Margaret and Bruce Alexander, Bill and Gale Simmons, Martha Pezrow, Mortimer B. and

Chilkat blanket, detail, Native American, Tlingit people, Ketchikan, Alaska, Nineteenth century, Goat wool, cedar bark [entry, page 100]

Sue Fuller, Ed and Cherie Silvers, and Drs. Daniel and Marian Malcolm.

The Pre-Columbian collection features about 500 objects primarily from ancient Mexico, Costa Rica, Nicaragua, Panama, Ecuador, Colombia and Peru. The term "Pre-Columbian" refers to the arrival of Italian explorer Christopher Columbus to the Americas in 1492, and has come to describe art produced by Native American cultures of Central and South America prior to European contact and colonization.

The collection represents all of the regions and major culture groups of Meso and South America. Highlights include Meso-American and Peruvian ceramic vessels, figural ceramics, several important examples of Sican gold, and mesas and figural works in volcanic stone from Costa Rica. More contemporary ethnographic works from Central and South America, such as Kuna textiles from Panama, reflect the artistry of living Native American cultures of Central and South America.

Some of the earliest objects in the Museum's collection were Pre-Columbian, reflecting the interest of the first director, Richard Howard. Important contributions were made by the late Dr. Charles Ochs and his wife Mrs. Mary Ochs, Mr. T. Randolph Gray Sr., Mrs. Mary Cumming, Dr. Bertel Bruun, and The Betty Parsons Estate, among many others. A major gift in 2001 from Mrs. Rita Judge Smith added fifty-six important works to the collection.

The Native American collection consists of about 450 works primarily from the Plains, Southwest, and Pacific Northwest Coast. One of the strongest components of the museum's collection is a group of objects from the Pacific Northwest Coast acquired in the 1950s from the Rasmussen Collection. Another is a large group of Navajo rugs and blankets given to the Museum by Coleman Cooper. Southwestern ceramics are also represented, and include a magnificent nineteenth-century storage jar from San Ildefonso, and works by renowned contemporary artists such as Margaret Tafoya and Jake Koopee. Objects from the Plains include beaded moccasins, belts, pouches, and head-dresses, along with pipes, parfleches (animal-skin containers), and other ornaments. Noteworthy recent acquisitions include a Creek bandolier bag purchased with funds from the Museum's Annual Ball in 2000, and a magnificent beaded Kiowa cradleboard purchased with Museum Ball funds in 2005.

A museum support group called The Traditional Art Society was established in the mid-1980s for community members who wished to deepen their involvement with the Museum and support the study, exhibition, and acquisition of the arts of Africa and the Americas. Dues from the group were used to support the purchase of several important works for the collection. In 2002, this group evolved into the Sankofa Society, whose primary focus is African-American and African art.

Emily Hanna, PhD
Curator of the Arts of Africa and the Americas

False Door

Egypt | Old Kingdom, First Intermediate period (3050–2250 BC) | Limestone | 30 ½ x 23 ½ x 3 ¾ inches | Gift of Mrs. Bernard Steiner, Sr., 1981.122

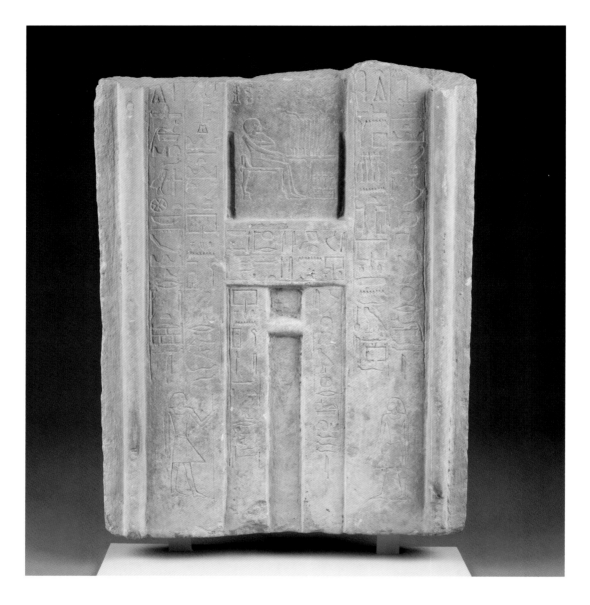

This sculpted limestone panel, called a false door, would have been found inside a tomb chapel or the offering chamber of a tomb, appearing as a niche on a western wall. These thresholds, through which only deities and the spirits of the dead could pass, were focal points where prayers as well as food, drink, and incense were offered to the dead. The low-relief sculpture imitates actual architectural features, with jambs and a lintel framing the "door," and a cylinder below the lintel representing the rolled reed mats that appear in actual doorways. A portrait of the deceased, a general named Fefi, is located at the top. He is seated before an offering table holding loaves of bread, and the surrounding hieroglyphs on the panel include blessings upon him and descriptions of the abundant provisions supplied to him for his journey to the afterlife.

Ibis

Egypt | Late Period, twenty-sixth dynasty (664–332 BC) | Wood, bronze, paint | 9 ½ x 15 x 4 inches | Museum purchase, 1961.83

The ibis is a wading bird that uses its long, curved beak to search for food along the muddy river bottom. In Egyptian mythology, the ibis was associated with Djehuty (Thoth in Greek), the deity responsible for the development of writing, mathematics, measurement, and time, and god of the moon and magic. In art, Thoth appears as an ibis-headed man, often in the act of writing, since he is considered the scribe of the gods.

In the *Book of the Dead,* Thoth is depicted recording the weighing of the heart of the deceased against a feather. Ibises became particularly important in the Late Period in the city of Hermopolis, where hundreds of the mummified birds have been recovered from the city's necropolis. Mummification is the act of preserving the body of a deceased person or animal in such a way that the spirit, or *ka,* is given eternal life.

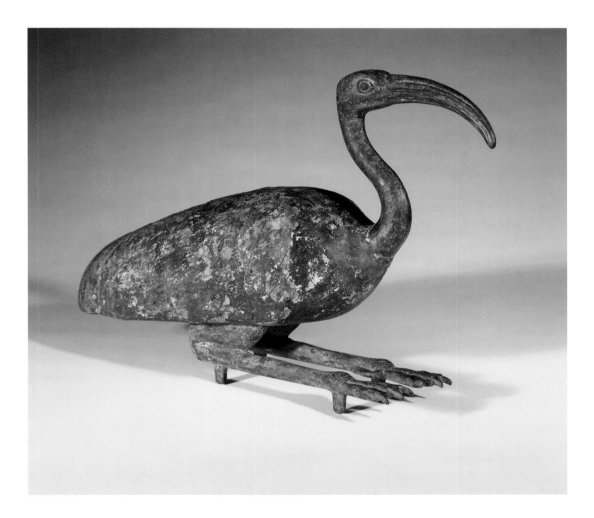

Furnishing Textile

Fulani people | Niger | Late nineteenth–early twentieth century | Wool | 188 x 66 inches | Museum purchase, 2008.121

Furnishing textiles such as this were given as gifts to newly married Fulani couples, and used as tent dividers to create privacy, or hung over marriage beds. The lozenge and triangle patterns, as well as the wide strips that compose the cloth, are similar to those woven into North African textiles, particularly those from Tunisia, Libya, and Morocco.

The Fulani people (related to the Berbers) are semi-nomadic and herd sheep and cattle across the African *Sahel*—a band of savannah grasslands just south of the Sahara desert spanning the distance between the Atlantic Ocean and the Red Sea. The Fulani, along with other Sahelian peoples, controlled for millennia the trade routes that connect the great North African cities of the Mediterranean, with large trading centers at the southern edge of the Sahara. This textile was produced at an important, historic trade center called Tillaberi, at the bend of the Niger River in the present-day country of Niger.

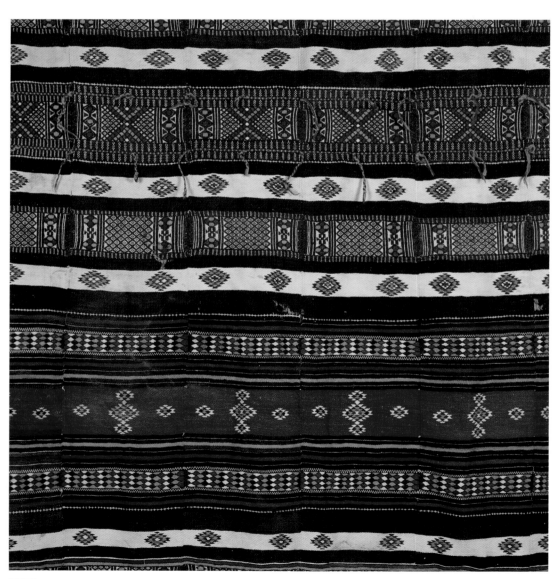

DETAIL

Plank Mask

Yacouba Bonde, Bwa people | Burkina Faso, Village of Boni | Late twentieth century | Wood, pigment | 77 x 14 x 12 inches | Museum purchase with funds provided by Martha Pezrow, 2004.54

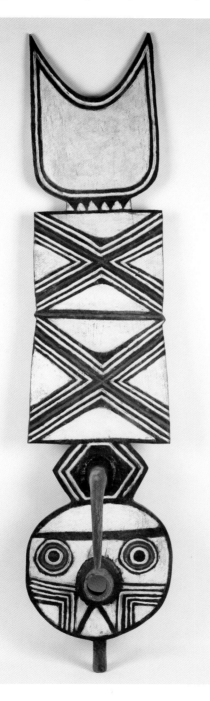

The Bwa people live in small villages and towns in the West African countries of Burkina Faso and Mali, and are primarily subsistence farmers. Many cultural and ritual activities take place during the dry season, when farmers can afford time away from their fields. Rites of passage such as initiations and funerals are celebrated with spectacular masquerades, featuring wooden masks painted in red, white, and black. Some of the masks represent animals that are easily recognizable, but others like this plank mask are more abstract and are covered with geometric patterns such as zig-zag lines, chevrons, Xs, concentric circles, and checkerboards, all of which are symbolic. Mask performance enables the Bwa to acknowledge and connect with ancestors, as well as the divine forces that exist in the invisible realm, and govern the natural world.

Helmet Mask

Mende People, Sande Society | Sierra Leone | Twentieth century | Wood, raffia, pigment | 13 ¼ x 7 ½ x 9 ½ inches | Gift of Sol and Josephine Levitt, 1990.165

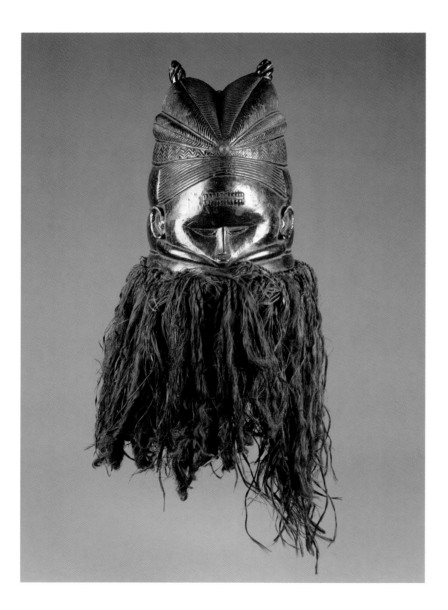

The Sande Society is a women's organization among the Mende people of Sierra Leone. The Society educates and mentors girls and women throughout their lives, and requires its members to go through one or more initiations. The nature of Sande Society education, rituals, and initiations has evolved over time, but the group is still a powerful force, both in rural and urban society.

This type of mask, called *bundu,* is worn at initiation ceremonies celebrating the successful transition of a group of girls from childhood to womanhood. The shiny, smooth, black surface of the mask, the elaborate coiffure, the lowered eyes, and the rings of fat around the neck all represent ideals of feminine beauty among the Mende. Sande Society masquerades constitute one of the few instances in Africa in which masks are made for and worn by women.

Queen of Women Mask (*Eze Nwanyi*)

Northeastern Igbo people (Ezza or Izzi sub-group) | Nigeria | Late nineteenth–early twentieth century | Wood, pigment | 19 ½ x 7 x 11 ½ inches | Museum purchase with funds given in memory of Mrs. Dorothy Steiner, 2009.3

This mask, known as the Queen of Women (*Eze Nwanyi*), was made and used by the Igbo people of Nigeria. It is one of the most important masks worn in a performance that occurs at funerals and ceremonies that purify the village and other communal places. An important context for the appearance of *Eze Nwanyi* is a festival called Otutara, which reunites living people with their ancestors.

The Queen of Women mask represents a wealthy, senior, titled wife—a mother and grandmother—a woman who commands enormous respect in the village. She embodies Igbo feminine ideals of strength, wisdom, beauty, stature, and dignity, and is a leader among women. As Igbo scholar Chike Aniakor has noted, "her wealth and title remind us that all are not equal, for her achievements are outside the reach of most."

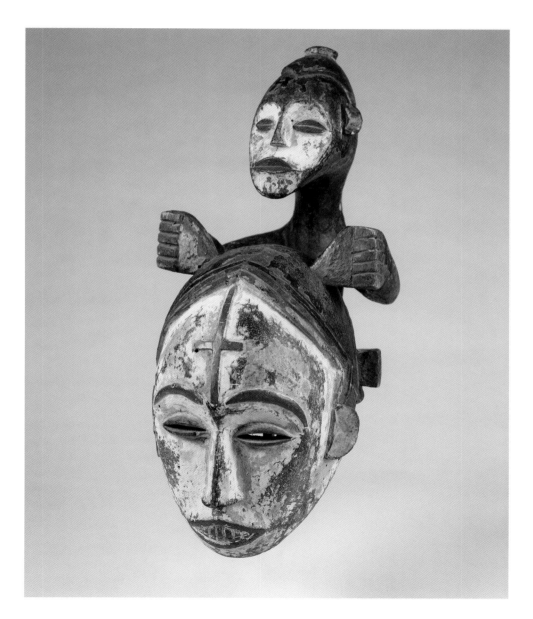

Epa Mask

Yoruba people | Nigeria, Osi-Ilorin region | Late nineteenth century | Wood, pigment | 50 x 20 x 18 inches |
Museum purchase, 1984.112

The masquerade known as Epa celebrates important social roles among the Yoruba people of Nigeria. The subject matter of this particular Epa mask is a warrior on horseback, and other typical subjects include priests, hunters, farmers, kings, and mothers. The masks do not represent individuals, but types, and the performance of the masquerade allows the community to acknowledge and honor the people in their midst who are fulfilling these pivotal roles, as well as ancestors who did so in the past.

The proportion of the figure, with its large head, refers to Yoruba beliefs about the literal and metaphorical importance of a person's head in determining his or her destiny. When Epa masks are not being used in performance, they are located on shrines, where they are the focus of prayers and offerings from community elders.

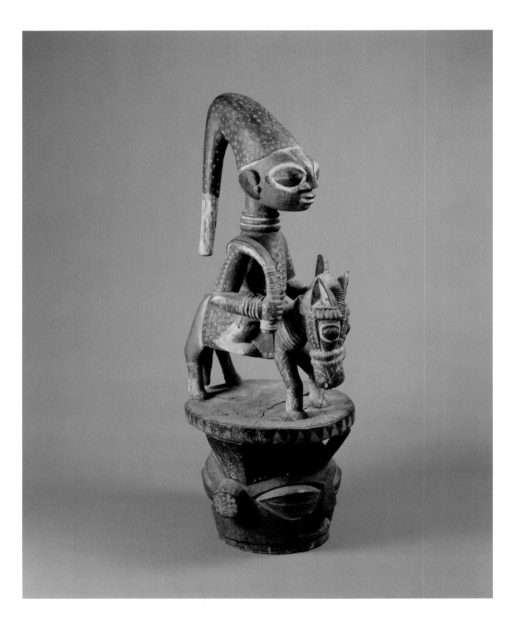

Mask *(Gelede)*

Yoruba people | Nigeria | Twentieth century | Wood, textile, pigment | 13 x 13 x 11 inches | Gift of Dr. Robert Goldenberg and Kathleen Nelson, 1986.783

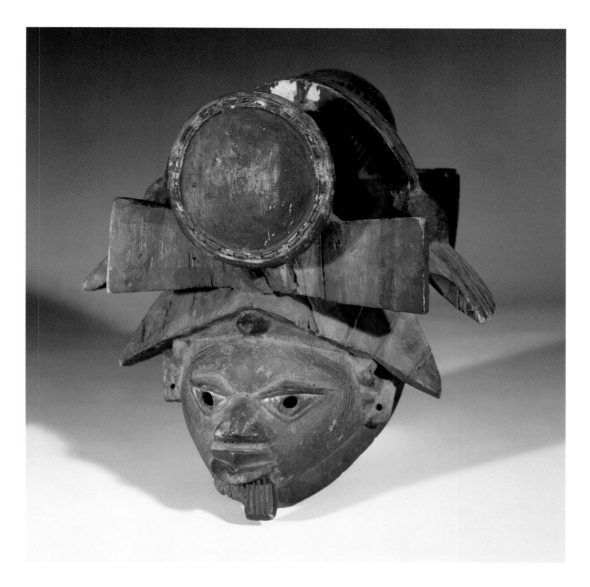

The Gelede masquerade is a cultural institution that celebrates the power and spiritual capacity of women in Yoruba society. The performers are men, and the masks they wear feature many different sculpted images on top, ranging from scenes of animals or people interacting, to commodities such as a sewing machine, or in the case of this mask, a "talking drum." The variety of subjects represented on the masks prompts conversation, commentary, and laughter among the audience members.

The capacity of women to give birth is linked to other powers they possess—both creative and destructive. Elderly Yoruba women in particular, collectively called "mothers," are believed to have the ability to act supernaturally—both consciously and unconsciously—and to influence or create situations for good or for ill. The institution of the Gelede performance allows for men and the entire community to acknowledge this power embodied by women.

Female Power Figure (*Nkisi Nkonde*)

Vili people | Democratic Republic of Congo | Late nineteenth century | Wood, textile, metal, small animal skull | 22 x 7 x 7 inches | Museum purchase with funds provided by The Junior Patrons, the Committee for Traditional Arts, Mrs. Bernard Steiner, and Museum visitors, 1997.67

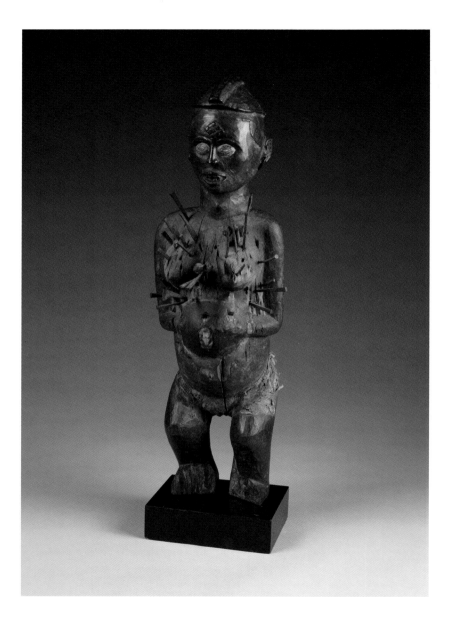

Power figures, called *nkisi,* are made and used by numerous groups in the Democratic Republic of Congo and neighboring countries. They represent and embody the power of the ancestors, and provide a point of focus and ritual action for healers (called *nganga*) and their clients, who may be individuals, groups or entire communities. Power figures with nails or blades are called *nkisi nkonde*. A healer drives a nail into the figure as part of a petition for help, healing, or witness—particularly of contracts or pledges. It has been noted that Portuguese missionaries to Central Africa brought images of Christ nailed to the cross, and the martyred Saint Sebastian impaled by arrows to a tree, and that this iconography may have influenced the *nkisi* tradition.

Power Figure (*Nkishi*)

Songye people | Democratic Republic of Congo, Lubao Territory | Early twentieth century | Wood, hide, horn, metal, fiber, glass beads | 35 x 7 ½ x 8 inches | Museum purchase with funds provided by the Birmingham City Council through the Birmingham Arts Commission, and the Endowed Fund for Acquisitions, 1989.64

Every African community has ritual specialists who are trained to interact with powerful, invisible forces, both malevolent and benevolent. This specialist, called *nganga,* commissions *nkishi,* which are used in addressing individual and community problems. Materials such as clay, shells, animal claws, quills, and other objects from the wilderness are added to the figure. Called *bashimba,* these materials are considered medicine, and both symbolize and embody power, strength, and protection. The animal horn emerging from the top of the head draws attention to that powerful connecting point between human and divine forces. The umbilical area is also emphasized, acknowledging the physical point of connection to maternal ancestors, and the abdomen in general as an important center of intuition.

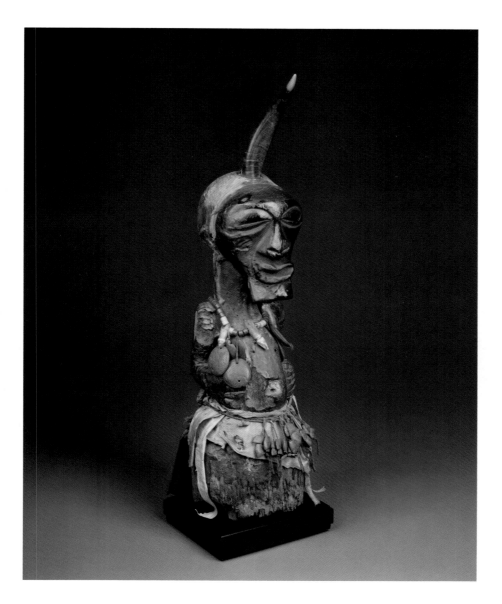

Mask (*Mukenga*, or *Mukyeem*)

Kuba people | Democratic Republic of Congo | Nineteenth or early twentieth century | Wood, woven fiber, fabric, cowrie shells, beads, feathers, palm fiber, cord | 35 x 23 x 26 inches | Gift of Margaret and Bruce Alexander, 2007.122

Organized into a federation of chiefdoms, the Kuba, who number over 200,000, constitute a diverse group of over eighteen different peoples. The king, or *nyim,* is considered divine and is always chosen from those with a royal lineage. This elephant mask, *mukenga,* is one of a group that enacts both the mythical history of the Kuba and the origins of Kuba kingship. The mask represents Woot, the first human and the bringer of civilization, and also stands for the king. Other masks in the group symbolize the many non-royal Kuba peoples, who are thought to have spiritual authority, or the land itself. The performance of the masks enacts the merging of many groups under one king, and the sharing of land and power over time.

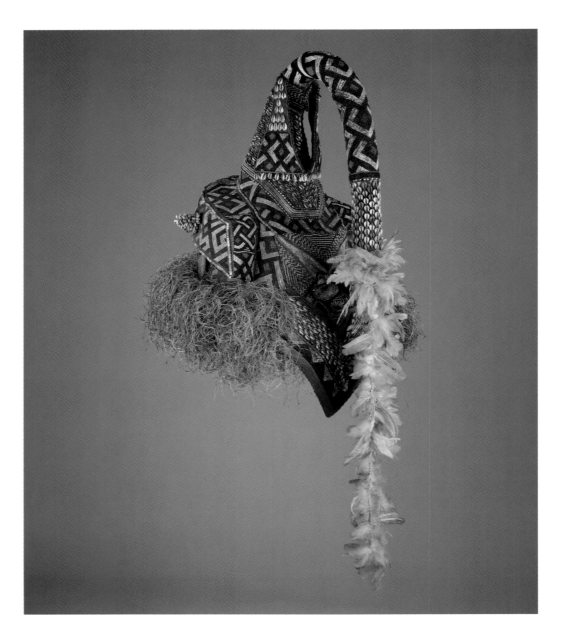

Chief's Chair or Throne

Chokwe people | Angola | Late nineteenth – early twentieth century | Wood, animal skin, metal tacks | 38 ½ x 15 x 20 inches | Gift of Rita Judge Smith, 2001.104

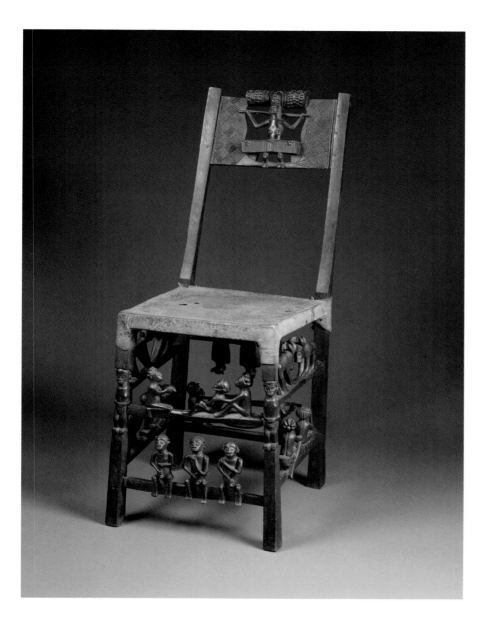

The power of a chief is sacred to the Chokwe, and he or she not only serves as leader of the people, but also as an intermediary between the visible and invisible worlds. Chairs or thrones are among the most important objects of regalia that belong to and identify the chief. The earliest royal seats were fashioned as ornate stools, but this more recent Western-style chair reflects the influence of the Portuguese and other Europeans who arrived to this area of Central Africa in the sixteenth century. The chair is adorned with many sculpted images that refer to the chief's power. The central figure on the chair's back represents a masked performer in full costume, whose presence refers to the royal ancestry of the chief. On the rungs of the chair there are groupings of animals as well as scenes of humans, possibly engaged in initiation, coronation, healing, or funerary rites.

Apron *(Meputo)*

Ndebele people | South Africa | Late nineteenth – early twentieth century | Hide, glass beads, metal beads, straw | 18 ½ x 20 inches | Museum purchase with funds provided by the Traditional Arts Acquisition Fund, 1989.71

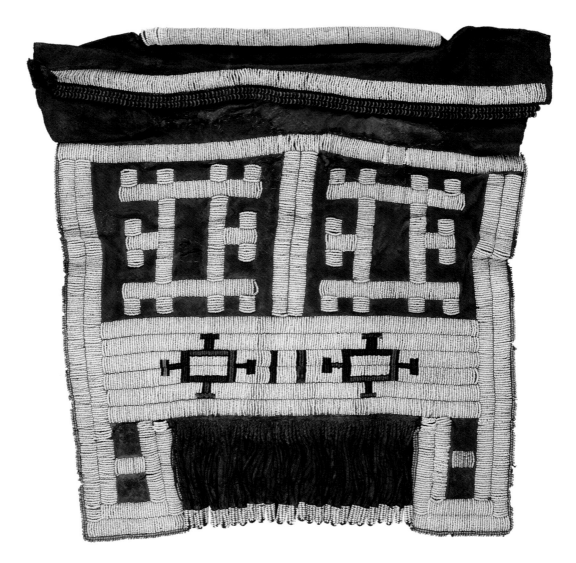

Ndebele women are renowned for two art forms, both of which are highly visible and have come to identify the Ndebele as a people: they create the brilliant painted exteriors of their homes, and the beaded garments, jewelry, blankets, and headware still worn by many Ndebele women for both daily and ceremonial use. The Portuguese introduced glass beads to South Africa in the sixteenth century. Early Ndebele beadwork is characterized by tiny white seed beads, of the type that adorn this animal-hide skirt, while more recent examples feature brilliantly colored beads of either glass or plastic, sometimes sewn onto canvas or other commercial textiles rather than hide. This type of beaded, fringed apron is for everyday use by married Ndebele women. Traditional geometric beadwork motifs often depict the floorplan of a home, and refer to the sacred spaces within the homestead.

Covered Vessel

Lobi people | Burkina Faso | Late nineteenth–early twentieth century | Fired clay | 23 x 17 inches | Anonymous gift, 1999.62a-b

Vessel

Bozo people | Mali | Nineteenth century | Fired clay | 18 ½ x 20 ½ inches | Anonymous gift, 1999.74

Vessel

Lobi people | Burkina Faso | Twentieth century | Fired clay | 15 ½ x 15 x 18 inches | Gift of Mortimer B. and Sue Fuller, 2006.35

Archeologists believe that pottery has been produced in Africa for at least 10–15,000 years. Much pottery is made for everyday use, such as cooking and storage of water, beer, and food. However, ceramics are also integral to rituals associated with childbirth, baptism, initiation, healing, marriage, and death. Special ceramic jars serve as abodes for the spirits of the deceased, and vessels are often important components of grave decoration.

Throughout the continent, pottery is mostly made by women, who are responsible for all stages of ceramic production. Raw clay is considered spiritually potent and the shaping and firing processes are enfolded by ritual. Ceramics, among the most ubiquitous and utilitarian art forms in Africa, are also the most varied and expressive.

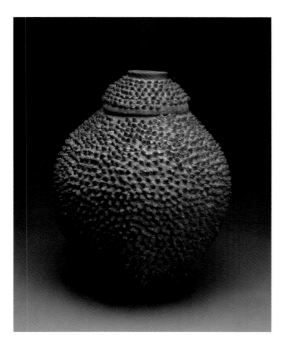

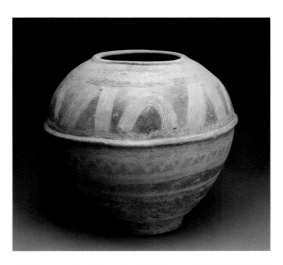

Currency Blade

Afo people | Nigeria | Eighteenth or nineteenth century | Iron | 32 ⅞ x 21 x 3 inches | Gift of Mortimer B. and Sue Fuller, 2006.185

Percussion Instruments (also currency tokens)

Unknown group | West Africa | Nineteenth or early twentieth century | Iron | 13 ½ – 15 1/8 x 2 – 3 ¼ x 1 – 2 ¼ inches | Gift of Mortimer B. and Sue Fuller, 2006.71, 72, 73, 74

Snake

Lobi people | Burkina Faso | Nineteenth century | Iron | 1 x 12 x 4 ½ inches | Gift of Mortimer B. and Sue Fuller, 2006.58

Africans did not receive iron technology from the Near East, as formerly thought, but developed their own smelting techniques as early as the third millennium BC. Blacksmiths in village communities today continue to work at the forge, and iron remains central to African societies. Blacksmiths are usually born into their occupation, and work in cooperation with kings or chiefs, farmers, and other occupational groups. They craft a wide range of objects from tools and weapons to jewelry, lamps, musical instruments, currency tokens, and figure sculptures.

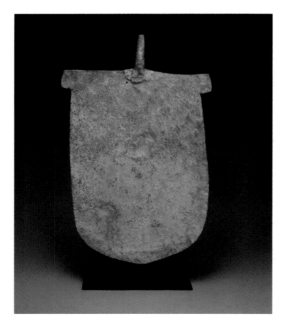

Words of Justice II | Wosene Worke Kosrof Ethiopian (born 1950)

2005 | Acrylic on canvas | 42 ¾ x 32 inches | Museum purchase with funds provided by the Birmingham Chapter and the Magic City Chapter of The Links, Inc., and the Sankofa Society, 2007.15

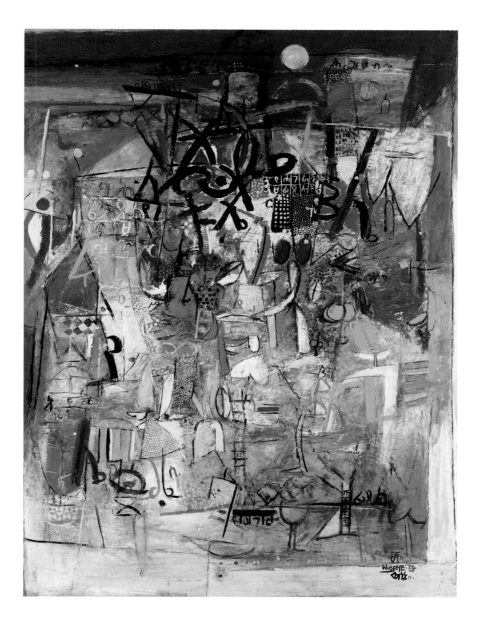

Born in Ethiopia, Wosene Worke Kosrof mines the culture and history of his country of origin for the subject matter of his paintings. He is particularly interested in the concept of sacred script, and words from his native Amharic language, as well as Ge'ez (the ancient liturgical language of the Ethiopian Orthodox Church), are foundational to his works. He also draws upon broader African cultural and visual references, in addition to his experiences in the United States, which began when he was admitted to the Art Department of Howard University, where he earned a Master of Fine Arts degree. Kosrof is particularly interested in the relationship between sound and color, and cites the importance of music and especially jazz in his creative process.

Vessel | **Magdalene Odundo** English (born Kenya, 1950)

1993 | Red clay | 15 ¼ x 10 ½ inches | Museum purchase with funds provided by Mrs. Harold E. Simon, by exchange, 1993.43 | © Magdalene Anyango Namakhiya Odundo

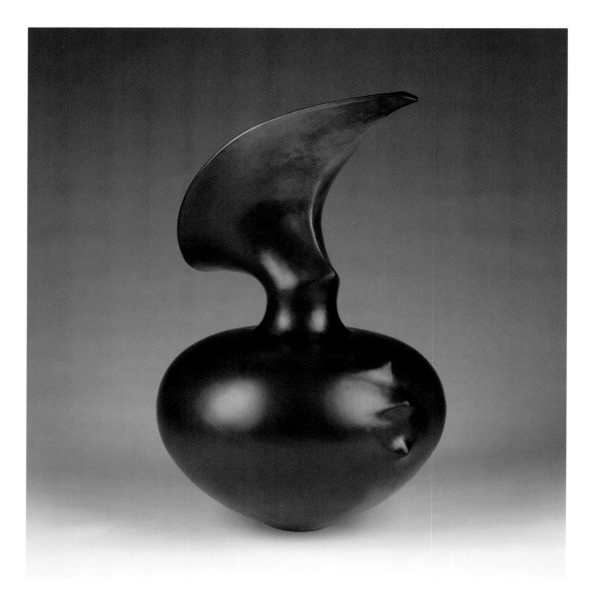

Magdalene Odundo was born in Nairobi, Kenya, and lived there and in India as a child. In 1971 she moved to England, where she earned her Bachelor's Degree from St. Joseph's College of Art and Design, and a Master's Degree at the Royal College of Art in London. Her early training was in graphic design, but she ultimately turned her attention to ceramics. Following her graduation, she visited Nigeria, Kenya, and San Ildefonso Pueblo in New Mexico to study ancient pottery-making techniques. Her own pots are hand-built using the coiling technique, and carefully burnished and slipped several times before firing. This vessel was reduction-fired, smothering the oxygen and causing the clay to turn black. Odundo's vessels often evoke the human form with details that refer abstractly to the curve of an abdomen or a spine. The flaring mouth of this vessel suggests an elaborate hairstyle, reminiscent of certain coiffures in Central Africa.

Female Figure

Jalisco culture | Mexico | 200 BC–100 AD | Earthenware | 17 ½ x 14 x 5 ½ inches | Museum purchase with funds provided by Mr. and Mrs. E. M. Friend, Jr., Mrs. James D. Foster and Mrs. Sidney B. Finn, by exchange, and the Traditional Arts Acquisition Fund, 1987.5

In the highlands cultures of ancient West Mexico, power and social status were associated with the ownership and inheritance of land. Societies were hierarchical, and ancestry and genealogy were of extraordinary importance in claiming land, as were the actual graves of ancestors. The cultures of West Mexico are noted for burying their dead in shaft tombs, some as deep as 16 meters. A number of tombs had multiple chambers, and held numerous human remains, as well as resplendent grave goods including carved beads and jewelry made of quartz, obsidian, and jade, obsidian mirrors, shell ornaments, precious materials acquired through trade, vessels for food and drink, and many large, hollow ceramic figures of men, women, ballplayers, musicians, and warriors.

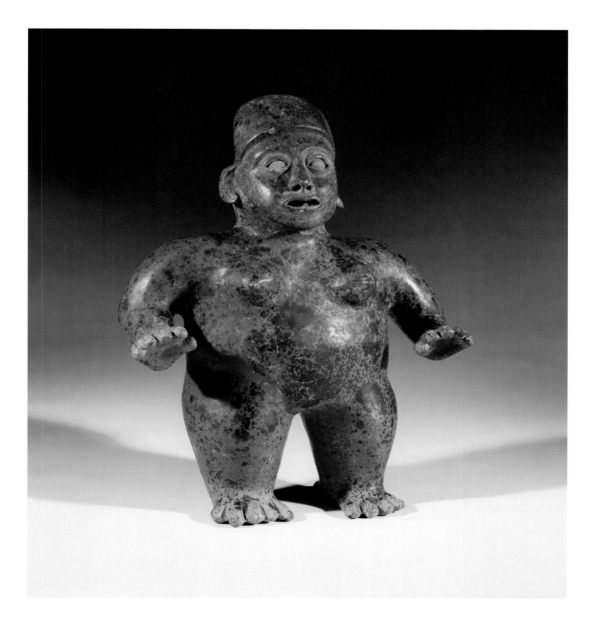

Urn Representing Cosijo, the God of Rain

Zapotec Culture (200 BC–750 AD) | Mexico (Oaxaca, Monte Alban) | About 450 AD, Epoch III | Fired clay | 21 x 12 x 11 inches | Museum purchase, 1965.33

Cosijo was among the most important gods of the Zapotec people because of his association with rainfall. The ancient Zapotecs were farmers and relied on the timely arrival of rain for their survival. The word *cosijo* means "lightning" in the Zapotec language, and the deity was invoked as "great spirit within the lightning." He shares attributes with Tlaloc, the water deity of the Aztec, and Chaac, worshipped by the Maya.

Representations of Cosijo combine elements of the earth-jaguar and sky-serpent, both associated with fertility. His eyebrows depict the heavens, and his lower lids represent clouds, while the forked serpent's tongue represents a bolt of lightning. Cosijo's ears are adorned with ear spools, and he wears a necklace, both probably meant to represent jade. Urns such as this were placed in Zapotec tombs.

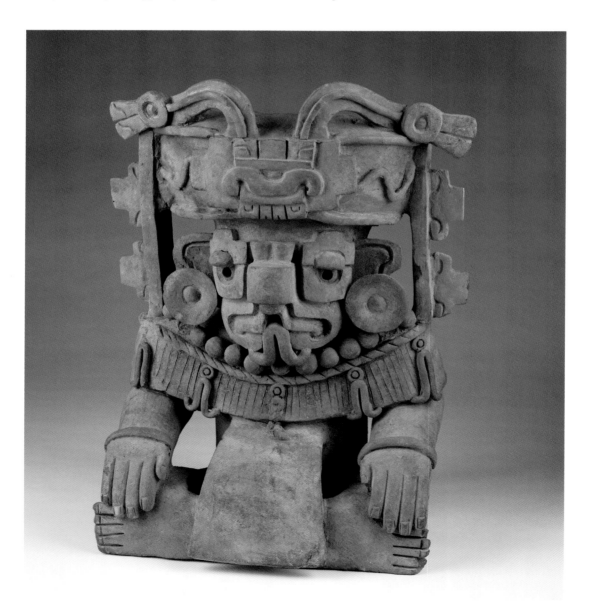

Mask

Teotihuacan culture (200 BC–750 AD) | Mexico | About 700 AD | Stone | 6 x 7 x 3 inches | Collection of the Art Fund, Inc. at the Birmingham Museum of Art; Gift of Mrs. Gay Barna, in memory of her mother, Rose Montgomery Melhado, AFI25.1982

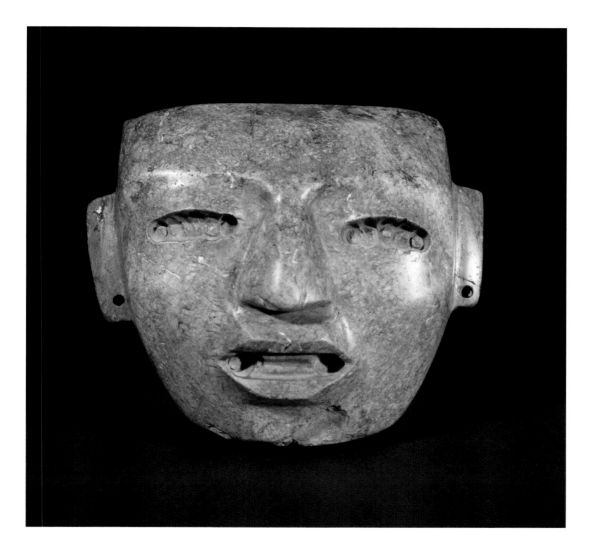

The ancient site of Teotihuacan was a major urban center in central Mexico, which at its height in about 600 AD was the sixth-largest city in the world with between 125,000 and 150,000 residents. The site is best known for its ritual precinct consisting of colossal stone pyramids and temples located along a central avenue, and spectacular works of art. Teotihuacan lasted for 700 years before it was attacked and burned around 750 AD. The site was never reinhabited, and neither the ethnicity nor the language of the people of Teotihuacan is known. Numerous stone masks such as this have been found at Teotihuacan, and are thought to have functioned in a funerary context.

Cylinder Vessel

Maya Culture (200 BC–1000 AD) | Petén (present-day Guatemala) | 700–800 AD | Earthenware and slip | 6 ½ x 4 ¼ inches | Museum purchase with funds provided by the Committee for the Traditional Arts and the Traditional Arts Acquisition Fund, 1991.781

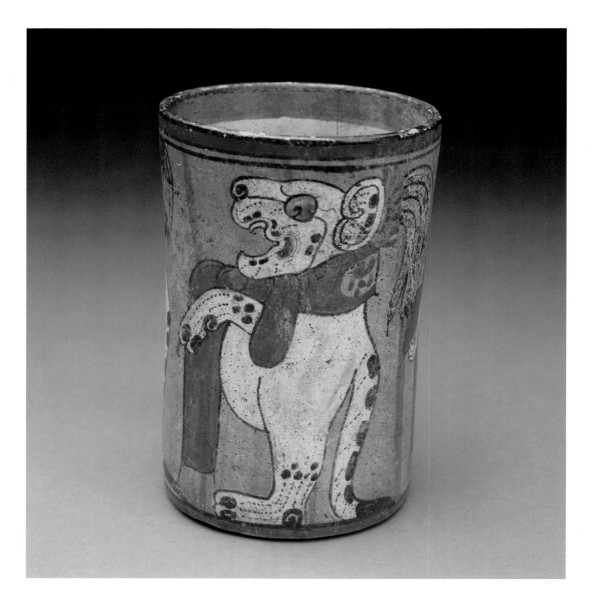

This Maya polychrome cylinder vase depicts a procession of three upright animals: a monkey, a jaguar, and a coatmundi (similar in appearance to a raccoon). The group moves from right to left—the direction of the sun as it travels through the underworld at night.

The red scarf knotted around each animal's neck is a reference to death and possibly sacrifice. Another allusion to death and the underworld is the jaguar pattern on the front and rear paws. These figures are not actual animals, then, but supernatural beings called *ways*—spirit entities that co-exist as alter-egos to human beings. Other odd or humanized characteristics identify them as companion spirits as well, including the jaguar's blood-shot eyes, and the monkey's disproportionately long ear. Maya cylinder vessels were buried in tombs, but some were also used in the service of food and drink, and for ritual purposes.

Standing Figure of a Lord

Maya culture (200 BC–1000 AD) | Jaina Island, Mexico | About 750 AD | Fired clay and slip | 9 ½ x 3 ¼ x 2 ½ inches | Gift of Mrs. Rita Judge Smith, 2001.107

The island of Jaina is located off the Campeche coast of Mexico. It was once a peninsula whose connection to the mainland came and went with fluctuations in the sea level. The Maya imported tons of earth and stone to create a level surface on which to build, and constructed a plaza and multiple pyramidal platforms—a ceremonial center—surrounded by dwellings. The name Jaina translates as Temple in the Water.

Figures such as this were buried with the dead, who were interred in pits in the earth, sometimes within ceramic jars. The precise modeling of the figures, their variety, and the level of detail in their costumes and gesture provide a window onto Maya physical appearance, dress, material culture, and social roles. High-ranking members of society practiced scarification, thus the marks on this figure's face, as well as his clothing and jewelry identify him as a nobleman.

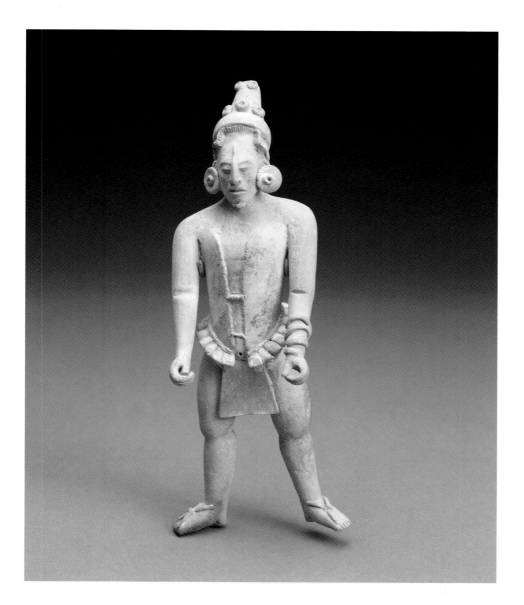

Head of Old God, Huehueteotl

Veracruz Culture (600–900 AD) | Mexico | 600–900 AD | Fired clay | 8 x 7 x 5 inches | Gift of Mrs. Rita Judge Smith, 2001.122

Many Meso-American groups, including the coastal people of Veracruz, the Aztec, and the Zapotec, honored the deity known as Huehueteotl, or Old God. The deity's heavily lined face is usually depicted as nearly toothless. Many representations of Huehueteotl are in stone rather than fired clay, and take the form of a figure seated with crossed legs, wearing a flat, disk-shaped hat. The stone versions serve as incense braziers. As opposed to most other examples of deity sculptures, which have been excavated primarily from temples or ritual precincts, figures of Huehueteotl are most often discovered in residences; Huehueteotl was a household deity, and was considered the god of fire and the guardian of the hearth. The deity Xiuhtecuhtli is also associated with fire; however, he is typically depicted as youthful and vigorous, and is associated with young warriors.

The Feathered Serpent Deity, Quetzalcoatl

Aztec culture (1325–1521 AD) | Mexico, Tenochtitlan | 1450–1500 AD | Stone | 7 ¾ x 5 x 8 inches | Museum purchase with funds provided by Dr. and Mrs. Keith Merrill, Jr., Mr. and Mrs. F. Dixon Brooke, Jr., the bequest of Mrs. G. F. McDonnell, Mrs. Margaret Steeves, Mr. and Mrs. Charles Grisham, Mr. and Mrs. Hugh Jacks, the Hess Endowed Fund, and the Acquisition Fund, 1989.144

This sculpture represents the Aztec deity Quetzalcoatl, a sky god believed to have created human beings in the cycle of the fifth world. Many Meso-American rulers associated themselves with Quetzalcoatl, and the history of men has become enmeshed with that of this deity. One prevailing story tells of a great Toltec ruler named Quetzalcoatl, tricked by a sorcerer called Smoking Mirror into committing incest with his sister. Quetzalcoatl sailed away, promising to return in the Aztec year 1 Reed. When the ship of Spanish Conquistador Hernan Cortés arrived at the Aztec capital in 1519 (1 Reed), it was believed to be Quetzalcoatl returning, and thus Cortés was initially treated as a god.

Ceremonial Bird Effigy Grinding Stone *(Metate)*

Nicoya culture, (Period IV–Period V) | Costa Rica | 300–700 AD | Carved volcanic stone | 15 x 27 ½ x 9 ¾ inches | Museum purchase, 1971.41

This tripod *metate* was sculpted from a single piece of volcanic stone, which although heavy is extremely brittle and difficult to carve. The legs, pierced through and adorned with interlocking geometric motifs, appear abstract, until it becomes evident that each depicts a bird, whose body is inverted with the head touching the ground—facing the earth. This was not a utilitarian object but a ceremonial one, whose ritual purpose and symbolic meaning nonetheless derive from the act of transforming a material (corn) from one state of being to another. Ceremonial *metates* were placed in burial sites, where they were thought to serve the deceased in the afterlife. The upside-down orientation of the birds, which are thought to be parrots, may reference the use of the object in the underworld.

Vessel

Piartal culture (750–1250 AD) | Colombia, Highland Nariño area | 750–1250 AD | Earthenware and slip | 21 ¾ x 10 inches | Gift of T. Randolph Gray, 1969.159

This graceful vessel was produced by the Piartal culture, which flourished in the mountainous region on the Colombia-Ecuador border for 500 years. The patterns, which evoke animal or snake skins, were achieved using a resist method whereby resin was applied where patterns were desired, resisting later applications of slip. When the resin was removed the lighter colored patterns were revealed. This kind of vessel was created for use in secondary burial, the practice of reburying the bones of the dead after the flesh of the body has decomposed. The urns held relics and jewelry belonging to the deceased.

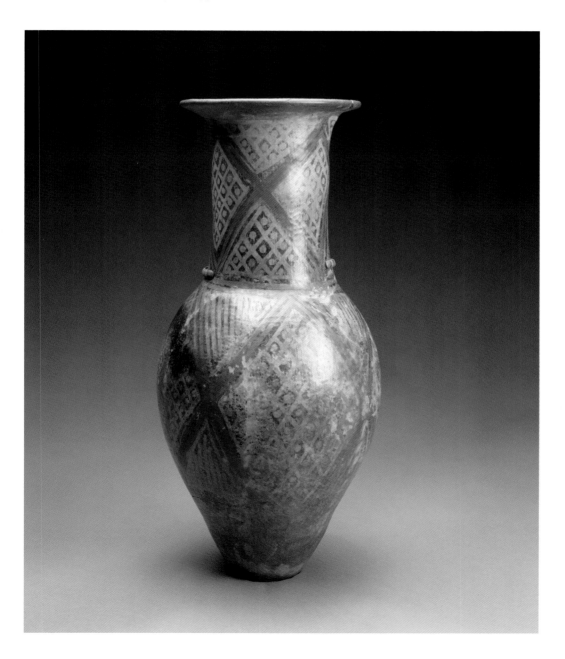

Bowl

Nazca culture (1–700 AD) | South Coast, Peru | Fifth century AD, Middle Nazca Period | Earthenware and slip | 4 ⅛ x 6 ⅜ inches | Museum purchase, 1967.243

The Nazca culture, which developed in the Ica and Nazca valleys of the South Coast of Peru, is probably best known for the colossal earth drawings called the Nazca Lines, which can be seen better from the air than from the ground. The culture also produced exquisite painted ceramic vessels decorated with abstracted figures of flying shamans, animals, and supernatural creatures. Nazca ceramics are known for their thin, even walls and the visually complex compositions that wrap around the vessels. Artists used the coiling technique to hand-build their pots, but employed a turntable device to apply the painted slip decoration, and pots were carefully burnished before firing. This vessel from the Middle Nazca period features a two-headed supernatural creature whose serpentine body wraps around the bowl. Geometric design elements in a rich variety of colors fill the space around the whiskered creature.

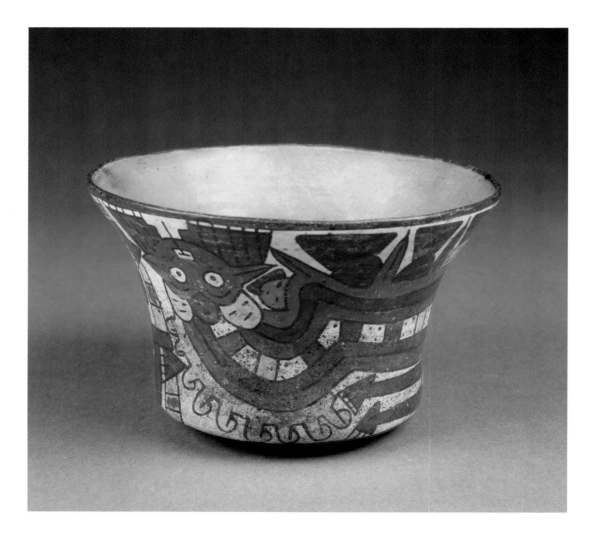

Ceremonial Knife (*Tumi*)

Sican Culture (750–1375 AD) | Peru | 900–1100 AD | Gold, copper and silver alloy (tumbaga) and turquoise | 13 ⅝ x 5 ¼ inches | Museum purchase, 1964.100

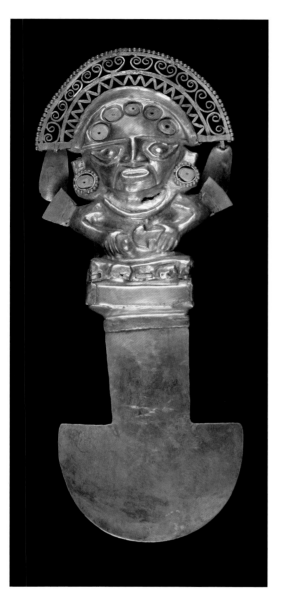

The Sican culture was located on the north coast of Peru in the region presently called Lambayaque. This ritual knife, known as a *tumi,* was produced in the Middle Sican period, considered the society's height economically and politically, but also in terms of technology, arts, architecture, and culture in general. The *tumi* depicts the being known as the Sican Deity, who wears a crown inlaid with turquoise, jeweled ear spools, and who holds in his hands a *tumi* and a trophy head. This all-powerful deity is associated with life-giving water, as well as the sun and the moon. Sican culture was renowned for its metalsmithing, and the remains of numerous smelting sites have been found throughout the Lambayaque region. Objects such as this were produced for ritual use, and for burials of the most elite members of society.

Cup *(Qero)*

Colonial Period Inca culture (1532–1821 AD) | Peru, Ecuador, Bolivia, Chile, and Argentina | Eighteenth century |
Wood and lacquer | 8 x 6 ⅞ inches | Museum purchase with funds provided by John M. Harbert III, by exchange, 1994.28

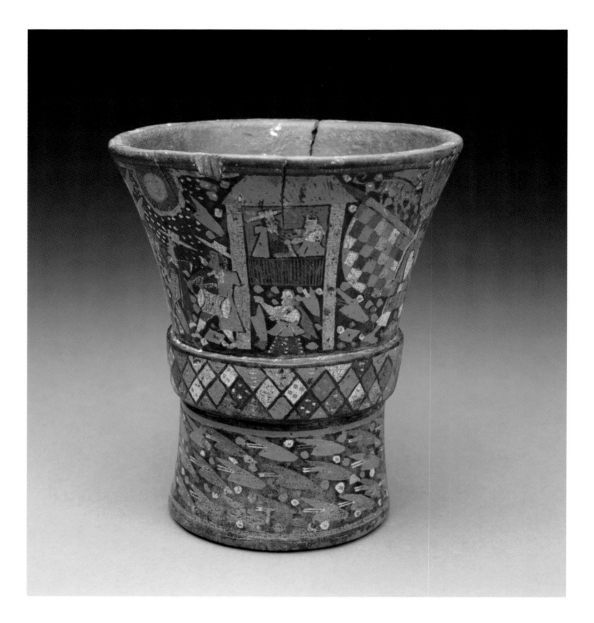

A *qero* is a vessel used for drinking beer made from maize, and the same basic shape was adopted by various ancient Andean cultures well into the period of Spanish colonization. Some versions are fashioned from silver or gold, some from ceramic, and others like this are made of wood. Colonial-era wooden *qeros* of this type are distinguished by their painted surfaces. Pigments such as cinnabar were mixed with plant resin to create a durable, waterproof medium. Shallow patterns on the surface of the cup were first carved out, then filled in with pigment. The scene on this cup is fascinating: it depicts a procession of seven Inca men in full-feathered regalia meeting two men wearing colonial Spanish apparel—the light-skinned man playing a horn and a darker-skinned man beating a drum.

Bandolier Bag

Native American, Creek people | Southeastern Woodlands region | About 1820 | Cloth, cotton, silk, beads | 31 ½ x 12 ⅛ inches | Museum purchase with funds provided by the 2000 Museum Dinner and Ball, 2000.131

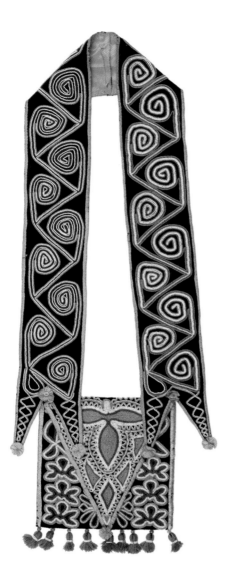

This elaborately beaded bag was a prestigious component of a Creek man's ceremonial dress in the early nineteenth century. Influenced by the design of British military pouches, bandolier bags began to be made by various Native American groups in the eighteenth century, and were constructed with materials acquired in trade from Europeans, including wool, silk, and cotton fabrics, ribbon, glass beads, and thread. Worn over the shoulder and across the body, the beaded straps of the bag resembled the crossed straps of a soldier's cartridge belt, and thus were christened "bandolier" bags. The beadwork designs on this example, particularly the repeating spirals on the strap, resemble designs on early Southeastern pottery. The organic floral motifs on the bag and flap are more reminiscent of European fabric patterns, which inspired and strongly influenced beadwork made by Native American women in the later nineteenth century.

Cradleboard

Native American, Kiowa or Comanche people | Plains region | About 1850–1870 | Animal hide, textile, glass beads, tin | 45 ¾ x 12 ¾ x 11 inches | Museum purchase with funds provided by the 2004 Museum Dinner and Ball and general acquisition funds, 2005.103

This exquisite full-sized, lattice-style cradleboard was probably made sometime between 1850 and 1875. It is constructed from buffalo hide on a wood and rawhide framework, with mattress ticking lining the interior. Cradleboards, along with tipis and rawhide bags, bear witness to the nomadic nature of early Native American cultures of the Great Plains. Constructed by women to transport their treasured infants, they were considered family heirlooms. While the cradleboard is an ancient object type, the practice of adding ornate beaded embellishment only began once the Kiowa and other peoples of the Plains had been confined to reservations, effectively ending their nomadic lifestyle. By the late 1800s, women on Plains reservations were abandoning cradleboards altogether. However, over the last few decades there has been a revival of cradle-making among the Kiowa and Comanche.

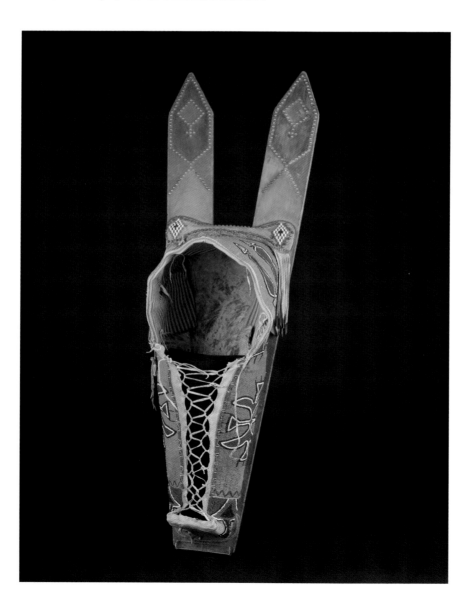

Rug

Native American, Navajo people | Southwest region | 1900–1920, Early Crystal style | Wool with aniline and vegetal dyes | 83 x 53 inches | Gift of the Estate of Coleman Cooper, Palm Beach, Florida, 1986.847

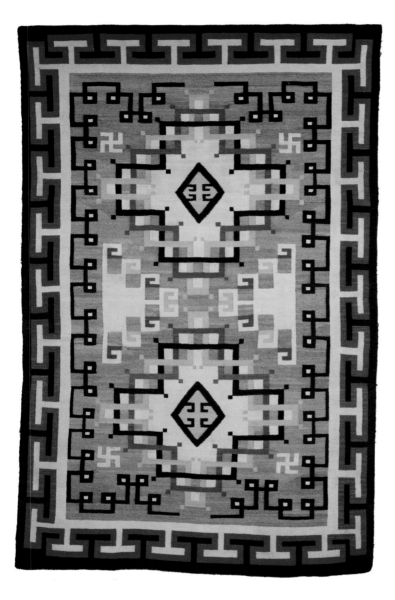

The Navajo, who call themselves *Diné* (The People), migrated to the American southwest from the Athabascan tribal areas of Canada and Alaska between 1300 and 1500. Traveling bands of hunters, they wore clothing made of animal skins, and did not begin weaving until they learned the skill from the Pueblos—tribes who had been farming cotton and weaving for centuries in New Mexico and Arizona. Spanish conquerors imported sheep to the American southwest in the sixteenth century, introducing the possibility of weaving with wool. The art form became so central to their identity that Navajo mythology links it to their very beginnings as a people. Early Crystal refers to the Crystal Springs trading post operated by John B. Moore in the Chuska Mountain Range of New Mexico from 1896 to 1911. In 1903, Moore was the first to publish a catalogue to market Native American arts to consumers in the eastern United States.

Bowl | **Margaret Tafoya** Native American, Tewa people (1904–2001)

Santa Clara Pueblo, New Mexico | Twentieth century, before 1951 | Fired clay and slip | 5 x 10 inches | Gift of Dr. and Mrs. Paul Frank Boon, 1985.4

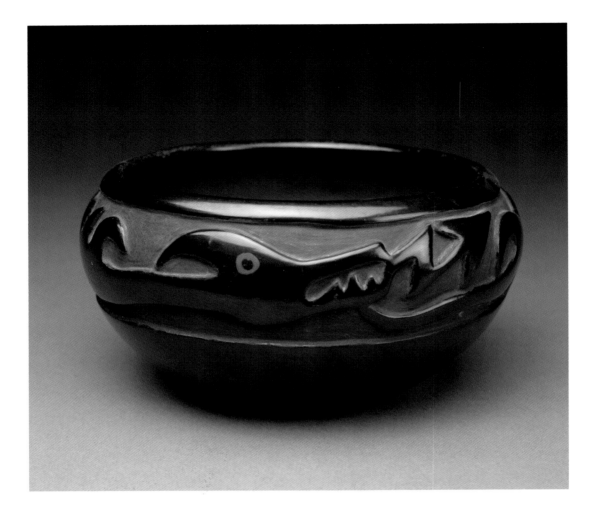

Margaret Tafoya is considered one of the ancestral matriarchs of the modern era of Pueblo pottery. Her mother Sara Fina, born in 1863, made pottery during the extraordinary period of expansion when the transcontinental railroads opened up the west and Pueblo material culture began to be collected by outsiders as works of art. Tafoya was trained by her mother and then worked for years at perfecting her art, eventually becoming one of the most respected and recognized Native American artists in the country.

This deeply carved blackware bowl, so typical of the style she developed, depicts a water deity called Avanyu. His tongue, a jagged bolt emerging from his mouth, is a symbol for lightning. The glossy surface was achieved by carefully burnishing the pot with a smooth stone after it had been painted with clay slip and before being fired.

Jar | **Jacob Koopee** Native American (born 1970)

Hopi Pueblo (Sichomovi Village, First Mesa), Arizona | 2005 | Fired clay and slip | 8 ½ x 8 ⅛ inches | Promised gift of Martha Pezrow, 16.2009.5

Jake Koopee is the great-great nephew of Nampeyo of Hano, the renowned Hopi-Tewa matriarch credited with engendering a revival of Pueblo pottery in the early 1900s. His aunt is Dextra Quotskuyva, Nampeyo's great-granddaughter, and one of the most highly regarded Pueblo potters working today. Koopee takes inspiration from his female forbears, and from the iconography of traditional Hopi culture and historic pottery, but moves well beyond the traditional. In this pot, a Hopi Katsina dancer shares space with abstract shapes and dynamically swirling graphics. Katsinam are spirits around which Hopi religious life revolves. The name also refers to clouds that bring life-giving rain, as well as to the masked dancers who embody the spirits and allow them to enter into the human realm during rituals and ceremonies. Koopee's extraordinary pottery has earned him some of the top awards in the Native American contemporary art world.

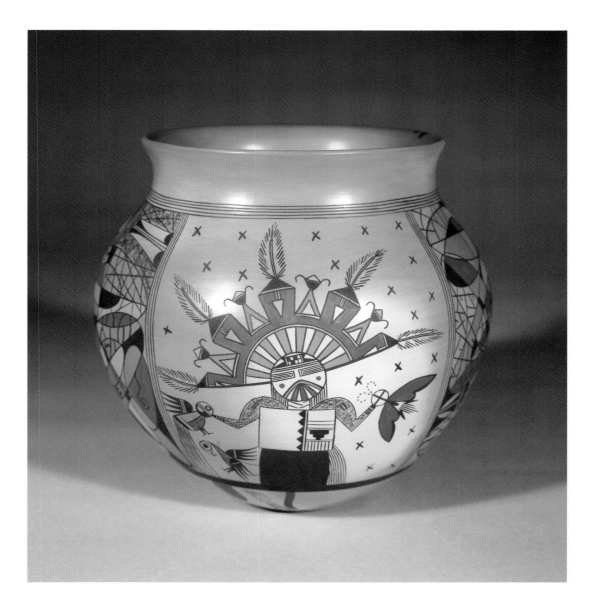

Frontlet

Native American, Tlingit people | Gambier Bay, Alaska | 1880–1920 | Leather, abalone shell, wood, flour sack, ermine skin, sea-lion whiskers, flicker feathers, swan's down, paint | 7 ¾ x 5 ½ inches | Museum purchase, 1956.48.24

A frontlet headdress is an important component of ceremonial regalia worn by Tlingit chiefs and other high-ranking men at ceremonies such as a Potlatch— an important gift-giving event. The animal imagery on the sculpted and painted wooden portion depicts the official family crest of its owner. The tall curving sea-lion whiskers that once emerged more abundantly from the top of the headdress formed a sort of cage filled with feathers, which floated gently down from the head of the chief as he danced. Remnants of ermine remain sewn onto the lengthy fabric train, and shimmering abalone shell is inlaid into the eyes and teeth of the animals. The regalia would have been complete with a Chilkat blanket draped around the wearer's shoulders, and a rattle held in one or both hands.

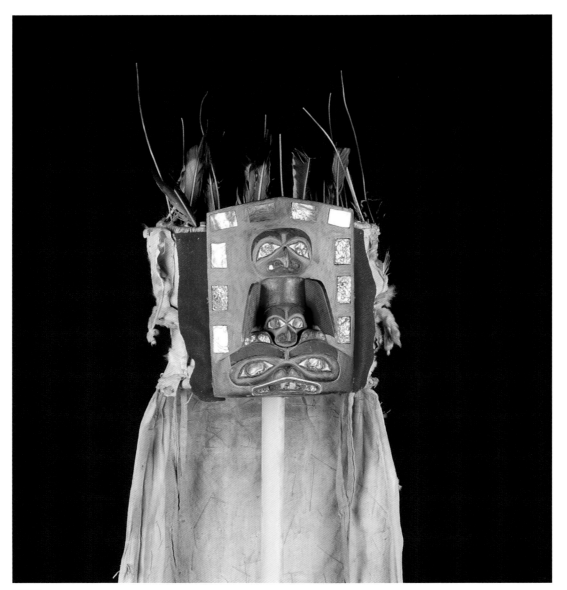

DETAIL

Raven Rattle

Native American, Tlingit people | Alaska | 1875–1900 | Wood and pigment | 13 x 4 ½ x 3 ½ inches | Museum purchase with funds provided by the Traditional Arts Acquisition Fund, 1989.53

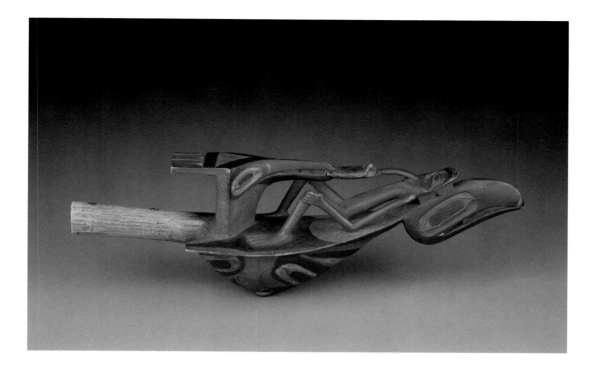

The raven is a sacred character in many Native American cultures, and is the subject of myths associated with the origin of human beings and their customs, but also of the transformation of the physical world. A trickster, the raven frequently changed form, taking the shape of other animals and even human beings. Tales of his exploits involve theft and deception—acts that ultimately resulted in the alteration of nature for the benefit of humankind. In one story, Raven steals fresh water, spilling a few drops and thus creating lakes and rivers. In another he steals the sun from its hiding place in a dark box, allowing the world to be illuminated. The object held in the beak of the raven in this rattle may represent the sun, being carried to the sky. The group of figures on the raven's back includes a shaman joined by his tongue to a frog and a kingfisher, a bridge along which supernatural power flows.

Chilkat blanket

Native American, Tlingit people | Ketchikan, Alaska | Nineteenth century | Goat wool, cedar bark | 35 ¼ x 65 ¾ inches | Museum purchase, 1956.48.48

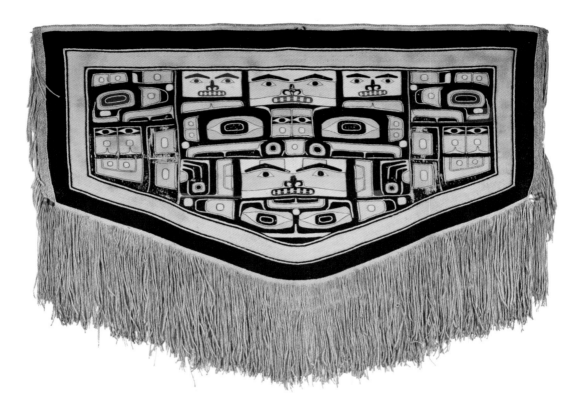

A Chilkat blanket is worn draped over the shoulders of chiefs or high-ranking men during important ceremonial occasions. The graphic, bold design elements are derived from family crests, and are composed of abstracted animals' faces, eyes, snouts, fins, beaks, and wings, which fill the design field with perfect bilateral symmetry. Women weave the robes from goat wool and soft cedar bark, working from design boards painted by men. Their looms have a top frame and side supports, but the warp threads hang freely at the bottom. Historically, Chilkat robes were items of great prestige, and were treasured gifts when received at a Potlatch ceremony. During the nineteenth century, when Tlingit and other Northwest Coast individuals became wealthy by way of the fur trade, the Potlatch reached new extremes of gift-giving and display. According to some accounts, Chilkat robes were burned as a demonstration of the host's wealth and largesse.

Button Shirt

Native American, Tlingit people | Ketchikan, Alaska | 1880–1920 | Hudson's Bay blanket, broadcloth, buttons | 41 ⅜ x 30 inches | Museum purchase, 1956.48.16

During the first half of the nineteenth century, the Hudson's Bay Company established trading posts at various locations along the Pacific Northwest Coast, making new commodities available to the Native American populations of this area. Trade goods became vitally important to the Potlatch—the traditional ceremony of gift-giving among tribes of the Pacific Northwest Coast—and among the most coveted gifts were Hudson's Bay woolen blankets. Photographs of Potlatch ceremonies taken at the turn of the twentieth century show stacks of blankets several meters high, for display or gifts. Dark blankets such as this were used to create prestige garments—shirts, or wearing blankets—adorned with other trade materials such as mother-of-pearl buttons and red felt or broadcloth. The materials and appliqué technique reflect exchange and innovation, but the patterns and designs on Northwest Coast button garments, such as the frog crest on this shirt, are traditional.

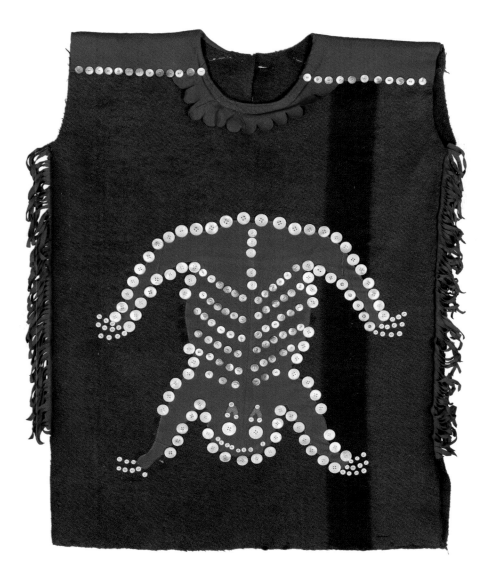

AMERICAN ART

American art has been a strength of the Museum's permanent collection since its doors opened to the public in 1951. Among the earliest works to enter the collection were paintings by important Alabama artists including the miniaturist Hannah Elliott and the landscapist Carrie Hill. Throughout its history, the Museum has continued its commitment to the arts of Alabama. In 1995, it organized *Made in Alabama,* a groundbreaking survey of artistic production in the state during the nineteenth century. In addition to collecting the works of academically trained native artists, the Museum has built an impressive collection of folk art, including painting, sculpture, quilts, and pottery. Thanks to the generosity of Robert and Helen Cargo, the Museum possesses the most comprehensive collection of Alabama-made quilts and the only public collection that documents a state's entire quilt history. Similarly, several private collectors are helping the Museum build the most significant repository of Alabama pottery in the State.

In 1956, Childe Hassam's *Building the Schooner, Provincetown* (1900) became the first important American painting to enter the Museum's permanent collection. This early commitment to landscape painting established a tone for the Museum's collecting habits, and landscape has emerged as the collection's single greatest strength. The Museum has works by Thomas Doughty, Robert Scott Duncanson, Jasper F. Cropsey, Martin Johnson Heade, William Louis Sonntag, Sr., and George Inness, to name just a few. However, no painting has made a greater impact on the permanent collection than Albert Bierstadt's massive and commanding canvas, *Looking Down Yosemite Valley,*

California (1865). The painting first came to the Museum as a loan from the Birmingham Public Library in 1974, and was permanently given to the Museum in 1991. It has provided a clear focal point, prompting the Museum to acquire two additional Yosemite views by Bierstadt, as well as a sketch album from his first trip to the scenic valley. The Museum has also acquired Yosemite views by other artists including Hermann Herzog, Carleton Watkins, Eadweard Muybridge, and Ansel Adams.

The art of the American West is also well represented. In this area, the generosity of Dr. Harold and Mrs. Regina Simon had a transformative effect. The Simons were nationally known collectors of Western art, who over nearly two decades gave the majority of their collection to the Museum. The Simons's gifts provided a core group of objects that has been enriched by the kindness of other donors. The Museum has significant Western paintings by Henry F. Farny, James Everett Stuart, Joseph Henry Sharp, and De Cost Smith. The Museum also has a fine collection of graphic works by George Catlin, Frederic Remington, Charles M. Russell, and Will Crawford. Most important, perhaps, are the Museum's Western sculptures, including a rare cast of James Earle Fraser's *The End of the Trail* (1918), works by Charles Schreyvogel and Adolph Weinman, and important bronzes by Frederic Remington, the most significant of which is the first cast of *The Wounded Bunkie* (1896).

In addition to the art of the American West, the Simons avidly collected American genre painting, which has given the Museum fine examples of the work of Thomas Hovenden, John George Brown, Enoch Wood

A Dream of Italy, detail, Robert S. Duncanson, American (1821–1872), 1865, oil on canvas, [entry, page 122]

Perry, and Thomas Waterman Wood. These have been supplemented by acquisitions of genre pieces by Charles Courtney Curran and Francis D. Millet, among others. The Simons also established a generous acquisition fund that has allowed the Museum to collect American art in perpetuity. In 2007, the fund enabled the Museum to acquire a significant history painting, Asher B. Durand's *The Capture of Major André* (1845). This acquisition complements an already excellent group of historical and literary subjects, including works by Benjamin West, Thomas Sully, Francis William Edmonds, and George Bellows. The Museum is also fortunate to have—thanks to the generosity of John Meyer—Gilbert Gaul's twelve-painting Civil War series, *With Confederate Colors* (1882–1911). The paintings, which formerly hung in Nashville's Hermitage Hotel, are Gaul's best-known works, and are perennial favorites with the Museum's visitors.

The Museum houses a fine group of American portraits by Gilbert Stuart, members of the Peale family, John Neagle, and Mary Cassatt, but its most significant portrait by an American artist is John Singer Sargent's *Lady Helen Vincent* (1904), one of three works by Sargent in the permanent collection. The work was acquired in 1984, with funds donated through the Museum's annual dinner and ball. The previous year, those funds were used to acquire a major work by Georgia O'Keeffe, *The Green Apple* (1922). Not only does this painting serve as the most important example of early modernism in the American collection, but it also adds to an excellent collection of still lifes, including works by John Peto, William Mason Brown, and Joseph Decker. Of particular note is William Mer-

ritt Chase's *Still Life with Watermelon* (1869), believed to be his earliest extant work.

The Museum has a strong and growing collection of nineteenth- and early twentieth-century American decorative arts, including silver by Tiffany & Co. and Gorham, glass by Tiffany Studios and Steuben, and ceramics by the Union Porcelain Works, George Ohr, and the Newcomb College Pottery. Most important, perhaps, are the works by Frank Lloyd Wright: a window from the Joseph Jacob Walser House in Chicago, and a chair from Unity Temple in Oak Park, Illinois. In 2009, the Museum made two major acquisitions of eighteenth-century Boston silver: a porringer by John Coney and an armorial teapot by Jacob Hurd.

While the character and breadth of the Museum's collection of American art has been shaped by the generous contributions of many donors, there are several who deserve particular mention. Mr. and Mrs. Crawford L. Taylor, Jr. have been steadfast supporters, donating key works by Raphaelle Peale, Theodore Butler, and Albert Bloch. Since 2007, Mr. and Mrs. William C. Hulsey have provided invaluable service to the Museum as the co-chairs of the Friends of American Art, a group that supports the growth of the American collection. In 2008, the Hulseys provided the funds to endow the William Cary Hulsey Curatorship of American Art, ensuring that this area will continue to be a major focus of the institution for generations to come.

Graham C. Boettcher, PhD
THE WILLIAM CARY HULSEY CURATOR OF AMERICAN ART

Erasistratus the Physician Discovers the Love of Antiochus for Stratonice |
Benjamin West American (1738–1820)

1772 | Oil on canvas | 49 ½ x 72 inches | Museum purchase with funds provided by Mr. and Mrs. Houston Blount; Mr. and Mrs. Michael Bodnar; John Bohorfoush; Mr. and Mrs. Percy W. Brower, Jr.; Mr. and Mrs. Thomas N. Carruthers, Jr.; Catherine Collins; Mr. and Mrs. Henry C. Goodrich; Mr. and Mrs. Hugh Kaul; Harold and Regina Simon Fund; Mr. and Mrs. William M. Spencer III; Mr. and Mrs. Lee Styslinger; and other donors, 1987.4

Like many young, aspiring artists of his day, Benjamin West embarked on a "Grand Tour" of Europe, spending three years in Rome studying the works of classical antiquity and the Renaissance masters. In 1763, he settled in London, where he eventually won the favor of King George III, who in 1772 appointed him historical painter to the king. Drawing from his time in Rome, West derived the subjects of many of his works from ancient history and classical mythology. Here he paints a legend loosely based on Greek history. West's picture tells the story of Seleucus, the king of Syria, who has summoned the eminent Greek physician Erasistratus to diagnose a mysterious ailment afflicting his son Antiochus. After observing the prince's behavior, the doctor concludes that Antiochus is suffering from unrequited love. West depicts the moment when Erasistratus—taking Antiochus's pulse—discovers that Antiochus longs for his own stepmother, Stratonice. According to legend, the king gave his wife to his beloved son, saving his life.

John Jones of Frankley | **Gilbert Stuart** American (1755–1828)

About 1785 | Oil on canvas | 28 ½ x 23 ¾ inches | Collection of the Art Fund, Inc. at the Birmingham Museum of Art; Purchase in honor of Gail Andrews with funds donated by supporters of the Birmingham Museum of Art, AFI25.2006

Born in Rhode Island, Gilbert Stuart became one of the leading American portraitists of the late eighteenth and early nineteenth centuries. In 1775, with the Revolutionary War severely affecting his business, he left for London, where he became principal assistant to Benjamin West, the Pennsylvania-born court history painter to King George III. Stuart exhibited at the Royal Academy from 1777 to 1785, garnering critical attention that resulted in numerous commissions from the aristocracy and other prominent individuals. He painted this portrait of John Jones, an English naval officer, around 1785, shortly before mounting debts forced the artist to flee to Dublin. Stuart returned to the United States in 1793 and became known for his numerous depictions of George Washington, including the iconic *Athenaeum Portrait,* which served as the basis for his likeness on the one-dollar bill.

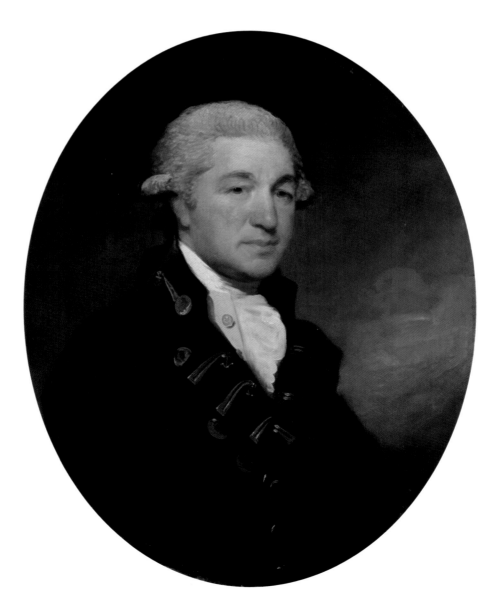

Porringer | John Coney American (1656–1722)

About 1710 | Silver | Height: 2 ⅛ inches; diameter: 5 ³⁄₁₆ inches; length of handle: 2 ⅞ inches | Museum purchase with funds provided by the Friends of American Art, 2009.16

The porringer—a forerunner of the modern bowl—was a popular form in eighteenth-century American silver. The earliest object in the Museum's American decorative arts collection, this porringer was made by John Coney, who is considered one of the most significant silversmiths in early eighteenth-century Boston. The intricately pierced handle, with its bold scrolling lines, not only displays Coney's skill as a silversmith, but also the influence of the Baroque style.

Coney can be considered the "artistic grandfather" of Paul Revere, since he taught Revere's father, Apollos Rivoire, the silversmith's art. Comparable examples of Coney's work can be found in the collections of the Yale University Art Gallery and the Museum of Fine Arts Boston. He was also known for his skilled engraving and is responsible for the plates used for printing some of Massachusetts's earliest currency, as well as designing the seal of Harvard College.

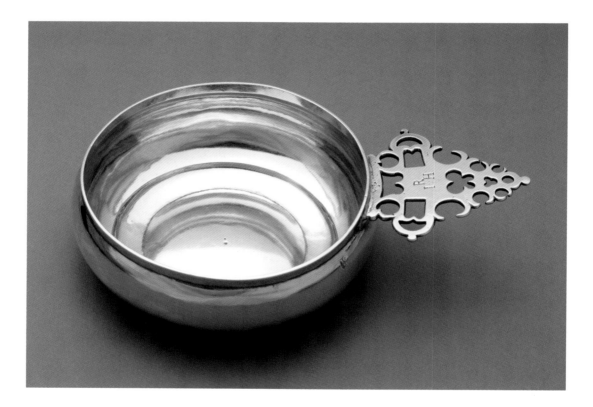

Teapot | **Jacob Hurd** American (1702–1758)

About 1745 | Silver and fruitwood | Height: 5 ³/₁₆ inches; diameter (base): 3 ³/₈ inches; length: 9 ³/₄ inches | Collection of the Art Fund, Inc. at the Birmingham Museum of Art; Purchase with funds provided by the National Multiple Sclerosis Society, Alabama-Mississippi Chapter, and the Art Fund, Inc., in honor of Mr. Thomas N. Carruthers, Jr., the 2008 Legacy of Leadership Recipient, AFI9.2009

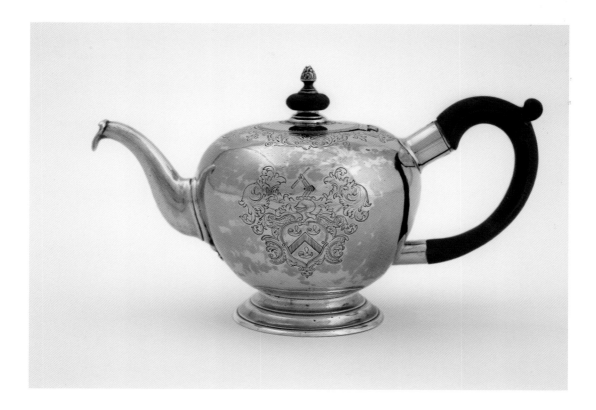

In the eighteenth century, Boston was the center of colonial silver production. Four major families dominated the city's silver trade: Edwards, Revere, Burt, and Hurd. According to the colonial silver expert Patricia Kane, "Jacob Hurd was the most talented and prolific of all Boston silversmiths who made silver objects in the late baroque style. He made more than 50 percent of the surviving silver produced by Boston silversmiths of his generation." This elegant teapot, bearing the coat-of-arms of the Gardiner family, is a fine example of Jacob Hurd's craftsmanship and his skill as an engraver. After his death in 1758, the elder Hurd's work was carried on by his sons, Nathaniel (1729–1777) and Benjamin (1739–1781).

Margaret George McGlathery | **Raphaelle Peale** American (1774–1825)

About 1817 | Oil on canvas | 29 ½ x 24 inches | Collection of the Art Fund, Inc. at the Birmingham Museum of Art; Gift of Mr. and Mrs. Crawford L. Taylor, Jr., AFI5.2009

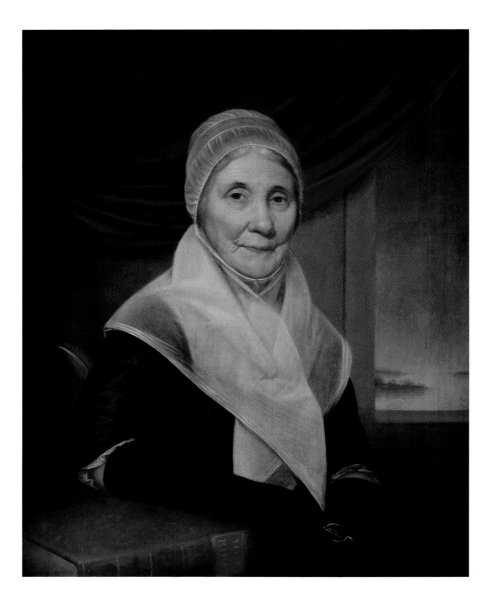

The son of the preeminent Philadelphia portraitist Charles Willson Peale, Raphaelle Peale was born into an artistic dynasty that included his aptly named siblings Rembrandt, Rubens, Titian Ramsay, and Angelica Kauffmann Peale. In 1797, Raphaelle married Martha McGlathery, the daughter of Matthew McGlathery, a master builder, and his wife Margaret George. In this portrait of his mother-in-law, a devout Irish Catholic, Peale underscores her devotion to the Scripture by depicting her arm resting on the *Holy Bible*, which—evident from the folded spectacles in her hand—she has just been reading. The sunset in the background suggests that Mrs. McGlathery is in the twilight of her years. Although Raphaelle Peale was an able portraitist, much to his father's dismay he engaged in that genre only sporadically, preferring to paint the still lifes of fruit and vegetables for which he is best known.

Caroline Louisa Pratt Bartlett | **Rembrandt Peale** American (1778–1860)

1835–1836 | Oil on canvas | 35 ½ x 28 ½ inches | Collection of the Art Fund, Inc. at the Birmingham Museum of Art; Purchase with funds provided by Mr. and Mrs. William C. Hulsey, AFI7.2007

The son of Charles Willson Peale, the eminent painter and patriarch of a distinguished family of American artists, Rembrandt Peale followed in his father's footsteps, becoming one of this country's leading portraitists. On September 7, 1835, Peale wrote to John Pratt of Boston, accepting a commission to paint portraits of three of his seven daughters, among them, this richly colored portrait of Caroline Louisa Pratt Bartlett (1805–1891). According to period standards of beauty, Peale has accentuated Mrs. Bartlett's neck, giving it a graceful swan-like appearance. Her thoughtful pose and pensive gaze, coupled with the book and sheet music beside her, emphasize her cultivation and refinement, while her sumptuous fur collar suggests that she is a woman of means.

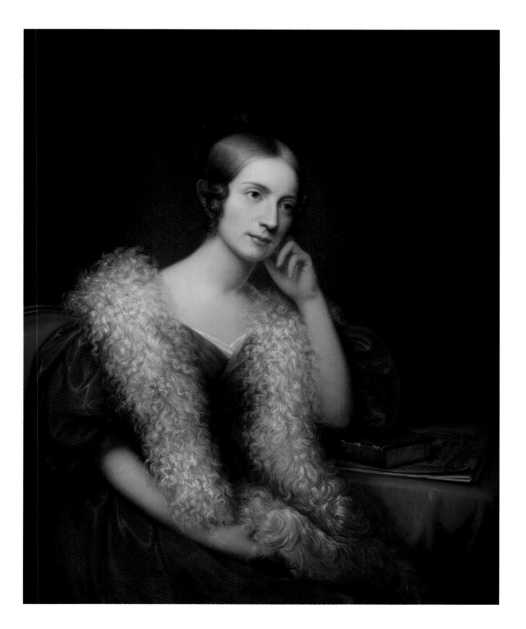

Study for Landing of Columbus | **John Vanderlyn** American (1775–1852)

About 1840 | Chalk and graphite on paper | 23 ¼ x 18 ¼ inches | Museum purchase, 2007.7

John Vanderlyn, the first American painter trained in Paris, was one of five artists selected by Congress to create historical paintings for the Rotunda of the U.S. Capitol. This drawing of Christopher Columbus looking heavenward is a study for Vanderlyn's *Landing of Columbus*, which Congress commissioned between 1836 and 1837. Vanderlyn completed the canvas in 1842, and it was installed in the Capitol in 1847, where it remains to this day. In this preparatory drawing, Vanderlyn uses graphite shading and white chalk to carefully define the features of Columbus's face. The colossal size of the finished canvas, which measures 12 by 18 feet, may account for the chiseled, almost sculptural appearance of Vanderlyn's figure, since it would have a nearly life-size presence in the Rotunda.

The Capture of Major André | **Asher Brown Durand** American (1796–1886)

1845 | Oil on canvas | 25 x 30 inches | Museum purchase with funds provided by the Harold and Regina Simon Fund, 2007.64

Major John André (1750–1780) was a British spy hanged during the American Revolution for assisting Benedict Arnold's failed plot to surrender the fort at West Point, New York, to the British Army. This painting, commissioned by the American Art-Union, depicts the moment on September 23, 1780, when André was detained by armed militiamen near Tarrytown, New York. They discovered incriminating papers in his boot, revealing Arnold's scheme to hand the fort over in exchange for £20,300 and a brigadier's commission. Sentenced to death, André accepted his fate with a dignity that endeared him to his enemies. Alexander Hamilton wrote, "Never perhaps did any man suffer death with more justice, or deserve it less." The painting, with its lush natural setting, marks an important transition in Durand's career, when he was shifting from history painting to the landscapes for which is he best remembered. This work was included in the Art-Union's annual members' lottery in December of 1845, and won by Cornelius Van Horn of New York. For years, its location was unknown to scholars, only recently resurfacing in a private collection.

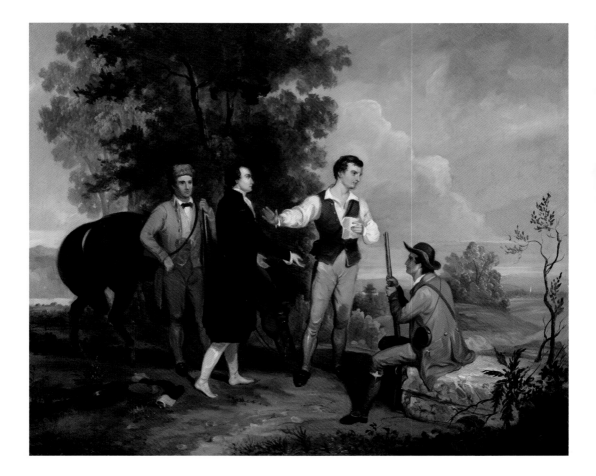

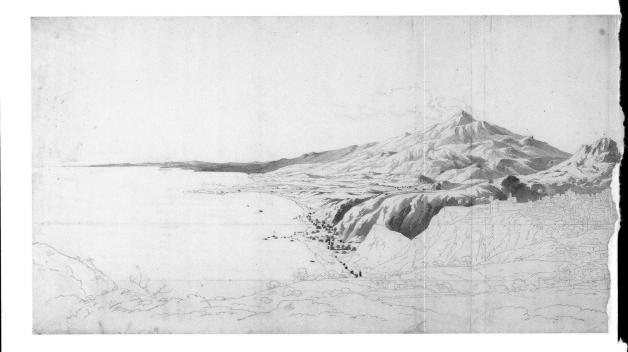

View of Mount Etna | **Thomas Cole** American, born England (1801–1848)

About 1842 | Graphite and wash on paper | 20 x 70 ½ inches | Museum purchase with funds provided by the 1979 and 1980 Museum Dinners and Balls, 1980.351

Measuring nearly six feet wide, this carefully delineated, panoramic view of Sicily's Mount Etna by Thomas Cole is the largest known drawing by the artist. Cole, hailed as "the father of the Hudson River School," was the originator of this country's first unique painting style, which looked to the American wilderness for its subject matter. Despite his commitment to native landscapes, Cole made a Grand Tour of Europe to study the work of the Old Masters and to paint its scenery. He first visited Mount Etna in 1842, and was so captivated by its beauty that he made several drawings and at least six paintings of the volcanic peak. Of the experience, he later wrote, "What a magnificent site! Etna with its eternal snows towering in the heavens—the ranges of nearer mountains—the deep romantic valley . . . I have never seen anything like it."

DETAIL

Storage Jar | **Charles King Oliver** American (1825–1895)

1852 | Ash-glazed stoneware | 17 ½ x 10 ¾ x 16 ½ inches | Museum purchase with funds provided by the Frank and Nelle Newton Acquisition Fund, 2007.63

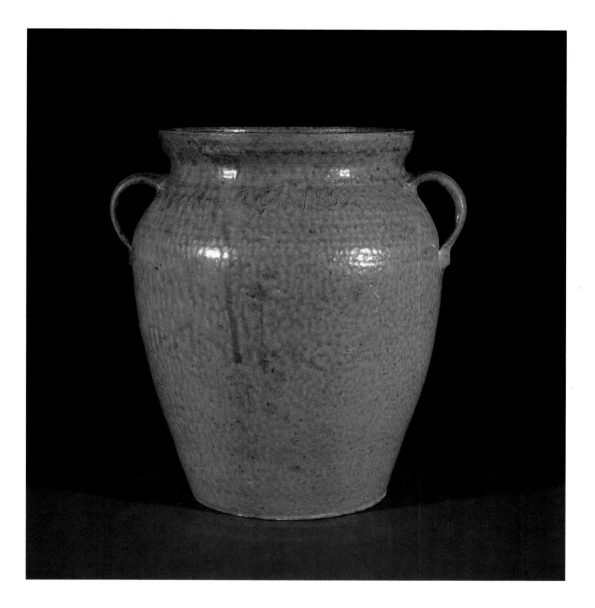

The state of Alabama has a rich history of pottery making that continues to the present day. To complement its superb holdings of European, Asian, and African ceramics, the Museum is working to build the most comprehensive collection of Alabama pottery in the nation. Among the finest examples of Alabama stoneware in the collection is this rare signed and dated storage jar by Charles King Oliver. Born in Georgia, Oliver worked in Rock Mills, Randolph County, Alabama. By 1850, he had relocated to Tuscaloosa County, where he initially continued making ash-glazed pottery, such as this jar. Eventually, Oliver switched to salt glaze, as was the norm for Tuscaloosa potters. Whereas salt glazes give the finished piece a glassy appearance with the texture of an orange peel, ash glazes provide a mottled, sometimes streaky surface, as seen in this example.

Sofa | **John Henry Belter** American, born Germany (1804–1863)

About 1850–1855 | Laminated rosewood with upholstery | 48 x 88 ½ x 27 ½ inches | Gift of the family of Dr. and Mrs. Jackson Leonard Bostwick, Sr., 1989.185

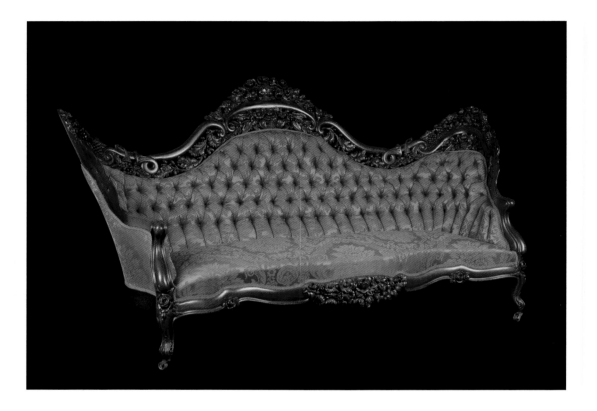

A German immigrant, John Henry Belter became one of the most successful American furniture makers of the mid-nineteenth century. As the leading manufacturer of Rococo Revival furniture, his name has become nearly synonymous with the style. Known at the time as the Louis XIV style, the Rococo Revival was introduced to America around 1840. While emulating the sensuous curves and florid motifs of eighteenth-century French design, American Rococo pieces tend to incorporate bolder lines and more naturalistic decorative elements. In his New York factory, Belter manufactured a wide variety of furniture, but is best known for his parlor suites. This exuberant sofa—made in the "Fountain Elms" pattern—is lavishly embellished with grapevines, scrolling oak leaves, baskets of flowers, and birds. Belter furniture was particularly popular in the Deep South and graced the parlors of many fashionable antebellum plantation homes.

Barking Up the Wrong Tree | **Francis William Edmonds** American (1806–1863)

About 1850–1855 | Oil on canvas | 16 x 20 ¼ inches | Museum purchase with funds provided by Mrs. Allen A. Johnson, Coleman Cooper, Jeanne Adler Scharff, Norine S. Bodeker, and Dr. and Mrs. M. Bruce Sullivan, by exchange, 1989.124

Francis William Edmonds worked as a banker before enrolling in night classes at the National Academy of Design in 1826. He became increasingly involved in New York's artistic circles and was active in the American Art-Union and National Academy of Design. Known for his humorous scenes of American life, here Edmonds depicts an older suitor trying unsuccessfully to woo a young woman. The theme probably derives from the Scottish poet Robert Burns's popular song "To Daunton Me," in which a girl vows that an old man should never daunt her with his "false heart" and "flattering tongue." With its distinct characters and stage-like setting, it is perhaps no coincidence that this highly theatrical painting was once owned by Edmonds's friend, the famous Shakespearean actor Edwin Forrest.

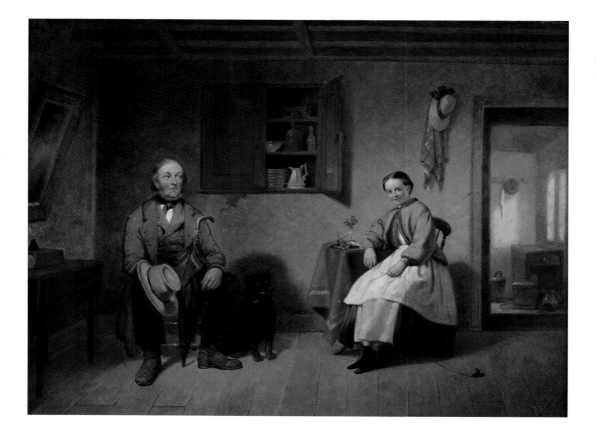

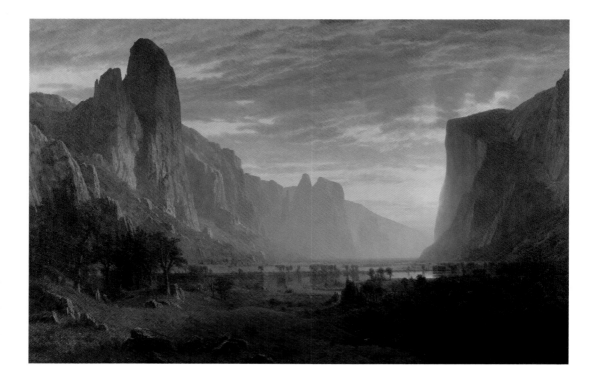

Looking Down Yosemite Valley, California | **Albert Bierstadt**

American, born Germany (1830–1902)

1865 | Oil on canvas | 64 ½ x 96 ½ inches | Gift of the Birmingham Public Library, 1991.879

Measuring more than five by eight feet, Albert Bierstadt's *Looking Down Yosemite Valley, California* presents a breathtaking view of one of America's most scenic spots. Using sketches made during a visit in 1863, Bierstadt paints the valley from a vantage point just above the Merced River, looking due west. A sunset bathes the valley's rock formations in a warm, golden light, with the prospect framed by El Capitan on the right, and Sentinel Rock on the left; the spires of Cathedral Rocks are visible in the distance.

Painted in 1865, the dramatic picture is Bierstadt's first large-scale Yosemite picture, a subject for which he would become well known. Bierstadt was born in Germany, immigrating to the United States in 1830. In 1853, he returned to his homeland, studying at the Düsseldorf Academy, a school that advocated a clear, linear style, which Bierstadt would incorporate in his own work. *Looking Down Yosemite Valley* possesses an almost uncanny clarity: from a distance, the painting could easily be mistaken for a photograph, and even up close, one can scarcely detect a single brushstroke. Equally absent is any sign of animal or human life. Since the work was painted at the end of the Civil War, scholars have interpreted this dead calm as a commentary on the national tragedy. Indeed, the painting's unveiling at the National Academy of Design had to be postponed by two weeks because of the assassination of Abraham Lincoln.

After its debut, the painting was exhibited around the country before being purchased by Uranus H. Crosby in 1866 for the princely sum of $20,000. Crosby was the proprietor of a lavish opera house in Chicago, which had a picture gallery to house his personal art collection. Crosby's excessive spending habits soon forced him to find a creative means of satisfying his debts. He held a nationwide lottery, offering his opera house as the grand prize, and Bierstadt's masterpiece as the second prize. The lottery was so successful that Crosby was able to pay off his creditors and buy back the opera house from the winner. Fortunately for Crosby, he retained the winning ticket for *Looking Down Yosemite Valley*.

In 1871, Crosby's Opera House was completely destroyed in the Great Chicago Fire, but the painting was rescued before flames engulfed the building. Over the next two decades, it was exhibited periodically in Chicago, but eventually disappeared from view. It resurfaced in 1929, when it was purchased at a Chicago auction for $300 by a Birmingham woman, who anonymously donated it to the Birmingham Public Library. It hung in the reading room of the library until 1974, when it was transferred to the Birmingham Museum of Art on long-term loan. The Library permanently donated the work in 1991. It has become the anchor of the Museum's American collection and is among the most highly regarded American landscape paintings in the country.

A Dream of Italy | **Robert S. Duncanson** American (1821–1872)

1865 | Oil on canvas | 20 ⅝ x 35 inches | Collection of the Art Fund, Inc. at the Birmingham Museum of Art, AFI10.2009

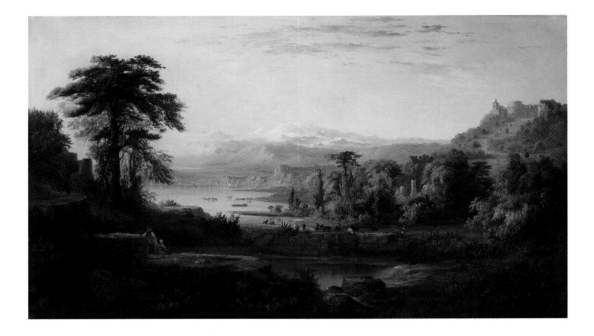

The son of former slaves from Virginia, Robert Scott Duncanson was born in Fayette, New York. In 1828, the family moved to Monroe, Michigan, where Robert and his brothers apprenticed in the family house-painting and carpentry business. Around 1840, he relocated to Cincinnati to pursue a career as an artist. Duncanson initially painted portraits, but found his greatest success when he turned to landscape painting. In 1853, he journeyed to Italy and upon returning home the following year, began a series of romanticized landscapes based on his travels. Duncanson continued to enjoy critical success, and in 1861 one critic hailed him as "the best landscape painter in the West." In 1863, owing to the growing racial strife stirred by the Civil War, Duncanson moved to Montreal, where he remained until after the war. *A Dream of Italy* is among the most significant works that he painted during his exile.

Mount Vesuvius at Midnight | J. Jehenne French (active 1869–1878), lithographer
and Etienne Isidore Hangard-Maugé French (active 1849–1875), printer,
after Albert Bierstadt American, born Germany (1830–1902)

1869 | Chromolithograph | 17 x 24 inches | Museum purchase, 2009.10

In late 1867, Albert Bierstadt was in London when he learned of the eruption of Mount Vesuvius, and immediately set out for Italy to paint the volcano in action. He witnessed the eruption in January of 1868, and the resulting painting—*Mount Vesuvius at Midnight*—was exhibited in England and America later that year. A critic for the *New York Herald* described the scene, writing, "It represents Vesuvius in one of the grandest phases of her late volcanic fury, and so real, vivid and startling are the colors that it is difficult to believe it a mere illusion." Unfortunately, the painting is now lost, although a smaller version survives in the collection of the Cleveland Museum of Art. In 1869, Bierstadt authorized a color lithograph to be produced from his painting. This is the only surviving example of that lithograph in an American collection and one of only two in the world.

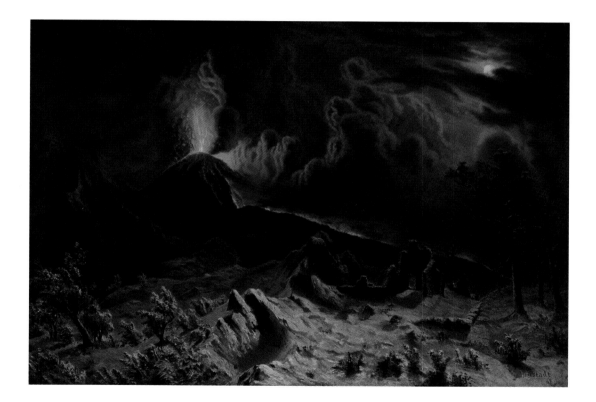

Mt. Aetna from Taormina | **William Stanley Haseltine** American (1835–1900)

1871 | Oil on canvas | 14 x 24 ⅜ inches | Museum purchase with funds provided by the Harold and Regina Simon Fund, 2008.16

Like other American artists of the nineteenth century, William Stanley Haseltine spent much of his career in Europe. In 1855, he traveled to Germany to study landscape painting at the Düsseldorf Academy, and spent several years on a "Grand Tour" of the continent. In 1869, following a return to the United States, he settled permanently in Rome. The Haseltine home—a sixteenth-century villa filled with art and antiques—became a gathering place for artists, writers, and foreign visitors. From this home base, Haseltine spent the next two decades traveling and working throughout Italy and the rest of Europe. He painted this view of Mount Etna while standing amid the ruins of an ancient theater in Taormina, a small village on the east coast of Sicily. The stunning prospect of the volcano across the Bay of Naxos had long attracted artists, including Thomas Cole, who painted it in 1843.

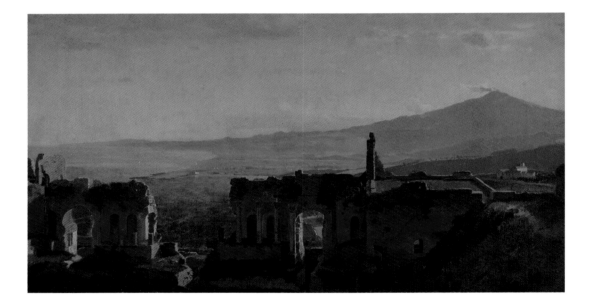

Pitcher | Designed by **Karl L. H. Müller** American (born Germany, 1820–1887)
Union Porcelain Works Brooklyn, New York (1863–about 1922)

Designed 1875, manufactured 1876 | Molded and polychromed porcelain | 9 ¾ x 10 ⅝ x 6 inches | Museum purchase, 2007.57

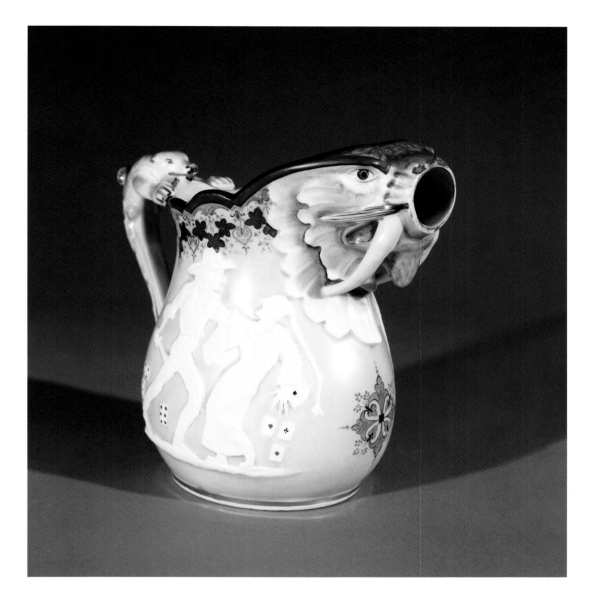

Known as the "Heathen Chinee pitcher," this unusual vessel takes its name from the popular Bret Harte poem of 1870, chronicling life in California's rough-and-tumble mining camps. The pitcher is decorated with an unusual combination of motifs: the Flemish King Gambrinus, unofficial patron saint of beer, is paired with Brother Jonathan, the forerunner of Uncle Sam, while the figures of Bill Nye and Ah Sin are characters from "The Heathen Chinee."

In the poem, although both are equally guilty of cheating at cards, Nye attacks Ah Sin for his deceit, remarking, "We are ruined by Chinese cheap labor." Harte calls attention to Nye's hypocrisy and probably intended the poem as a criticism of the prejudice endured by immigrants in California at that time. Ironically, it perpetuated and reinforced negative stereotypes in the minds of the American public, who misread the poem as an indictment of Chinese laborers.

Tea Set | Tiffany & Company New York City (established 1837)

About 1877 | Silver and ivory | Creamer: 2 ¾ x 2 ¾ x 3 ⅝ inches; sugar bowl: 3 ¾ x 4 x 4 inches; teapot: 4 ⅜ x 3 ¼ x 6 inches |
Museum purchase with funds provided by Bill Mason and Bob Scharfenstein, 2000.116.1-.3

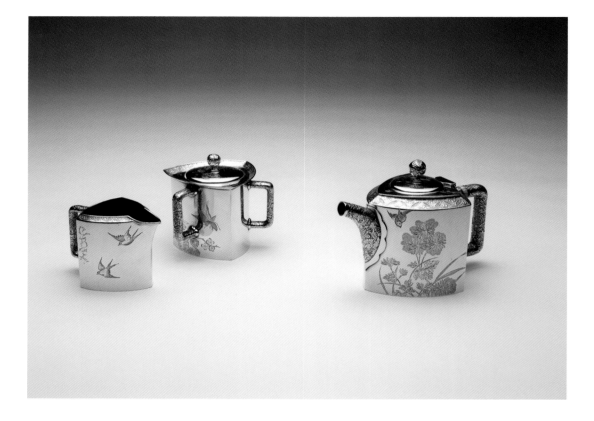

The influence of Japanese culture on the United States dates back to 1854, when Commodore Matthew C. Perry signed a treaty of friendship with Japan, opening the country to trade with the West after centuries of isolation. Americans became increasingly fascinated by Japanese art, a phenomenon that grew even greater in the wake of the Philadelphia Centennial International Exhibition of 1876, where Japanese metalsmiths displayed their work to critical acclaim. That same year, in an effort to reduce the power of the feudal lords known as *samurai*, the Japanese government banned the wearing of swords. This move had an adverse impact on metalworkers, many of whom made their living fashioning ornamental fittings for swords. Seeking new markets, Japanese silversmiths began producing fine wares for export, which profoundly impacted American manufacturers such as Gorham and Tiffany & Company, who were inspired to produce silver, such as this dainty tea set, in the *japonais* style.

Grand Canyon, Yellowstone River, Wyoming | William Louis Sonntag, Sr.

American (1822–1900)

1886 | Oil on canvas | 55 ½ x 40 inches | Gift of Mr. and Mrs. John M. Harbert III, 1986.628

A native of Pennsylvania, William Louis Sonntag spent his formative years as an artist in Cincinnati, Ohio, where he became a highly regarded landscape painter. In 1853, he made the first of several trips to Europe, traveling to Florence, Italy, with his friend, the landscape painter Robert Scott Duncanson. In 1856, Sonntag settled permanently in New York, where he flourished as a painter of romantic Hudson River landscapes and Italian scenes.

In 1886, Sonntag painted this large vertical panorama of the Grand Canyon of the Yellowstone, a majestic gorge located on the Yellowstone River in the Yellowstone National Park. Despite its detailed appearance, there is no evidence that Sonntag ever visited Yellowstone. The composition is based on an 1885 photograph of the canyon taken by Frank Jay Haynes (1853–1921), who established a studio and gallery in Yellowstone in 1884, and became the park's official photographer.

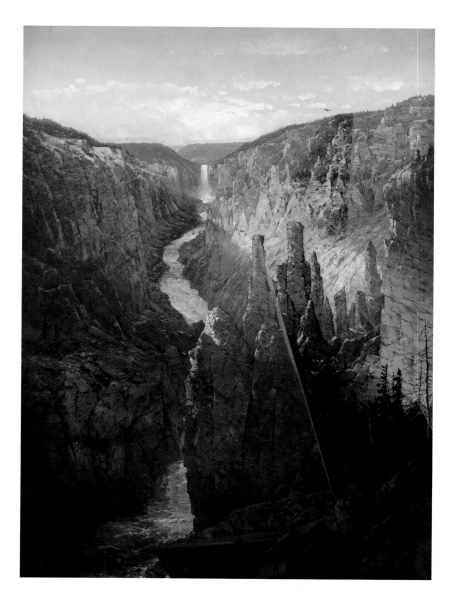

Lady with a Bouquet (Snowballs) | **Charles Courtney Curran** American (1861–1942)

1890 | Oil on panel | 12 ⅞ x 15 ⅞ inches | Gift of Mr. W. Houston Blount, Jr.; Dr. and Mrs. Walter D. Clark; Dr. and Mrs. Orville W. Clayton; EBSCO Industries; Mr. and Mrs. Raymond Gotlieb; Estate of Mr. Clarence B. Hanson, Jr.; Mrs. W. W. McTyeire, Jr.; Estate of Mr. George H. Mathews; Mr. Joshua R. Oden, Jr.; Mr. William M. Spencer III; Mrs. Alys R. Stephens; Mr. Elton B. Stephens; Mr. Elton B. Stephens, Jr.; Mr. James T. Stephens; Mrs. Martee Woodward Webb; and Mr. Thomas M. West, Jr., 1985.134

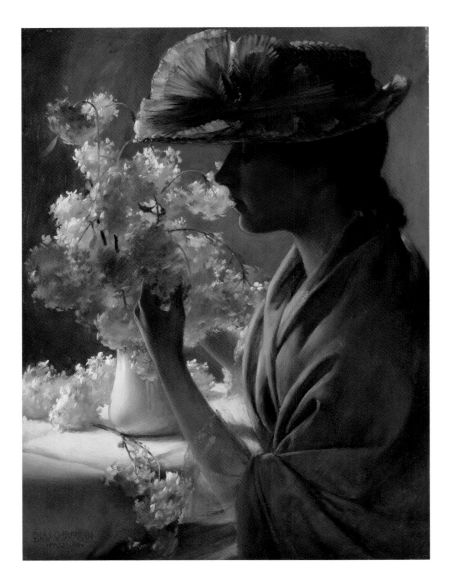

The genre painter Charles Courtney Curran is best known for his canvases depicting beautiful ladies in pleasant settings. Here, a young woman—the artist's wife Grace Wickham Curran—arranges a bouquet of snowballs, pausing to take in their sweet fragrance. The small scale of the painting matches the intimacy of the moment. Her delicate features, light green shawl and blossom-like hat equate her to a flower, suggesting that she is as lovely and dainty as the blooms she savors. Curran's choice of flower is likely a deliberate one. At the time this work was painted, bouquets were used to convey messages, with each flower having a specific symbolic meaning. According to the Victorian "language of flowers," the snowball symbolized "thoughts of heaven," adding an air of Christian piety to this work.

Three for Five | **John George Brown** American (1831–1913)

1890 | Oil on canvas | 60 x 35 inches | Collection of the Art Fund, Inc. at the Birmingham Museum of Art; Gift of Mr. and Mrs. Charles W. Ireland, AFI1.1980

J. G. Brown became famous for his numerous depictions of street urchins, including bootblacks, street musicians, and posy sellers. He found his young subjects on the streets of New York City. Intent upon depicting these ragamuffins as they appeared on the streets, Brown once complained, "They *will* change their dress, as though to show the extent of their wardrobe. Being cautioned expressly on Saturday, and told to return in the same fustian jacket, your boy will appear on Monday morning, if he appears at all, in a red woolen shirt. And they are constantly having their hair trimmed—perfect dandies!" Brown's paintings, like Horatio Alger's novels, focus on the pluck of these young entrepreneurs as they "pull themselves up by their bootstraps." In later years, Brown even claimed that many of the young urchins he portrayed had gone on to become successful businessmen.

An East-Side Politician | **Frederic Remington** American (1861–1909)

About 1894 | Pen and ink and watercolor on paper | 13 ⅛ x 7 ⅛ inches | Gift of Dr. and Mrs. Harold E. Simon, 1976.64

In addition to his work as a painter and sculptor, Frederic Remington was known as a talented and prolific illustrator, his pictures appearing in many leading periodicals of the late nineteenth and early twentieth centuries. A popular and oft-published author, Remington frequently illustrated his own stories, but sometimes provided images for articles by other authors. This picture of a puff-chested New York politician appeared in *Harper's Weekly* on January 27, 1894. It accompanied an article entitled "The Shoe that Pinches" by Julian Ralph, a close friend and frequent traveling companion of the artist. The article details the pair's rambles through Manhattan. At one point, they encounter a young politician, who bemoans the economic woes and poverty of his fellow New Yorkers. Remington's image of the proverbial fat cat—obviously well-heeled and well-fed—suggests that the artist may have believed the politician's empathy to be less than sincere.

The Wounded Bunkie | **Frederic Remington** American (1861–1909)
Henry-Bonnard Bronze Co. New York City (1882–1926)

Copyright 1896 | Bronze | 20 ¾ x 11 x 31 inches | Gift of Dr. and Mrs. Harold E. Simon, 1973.148

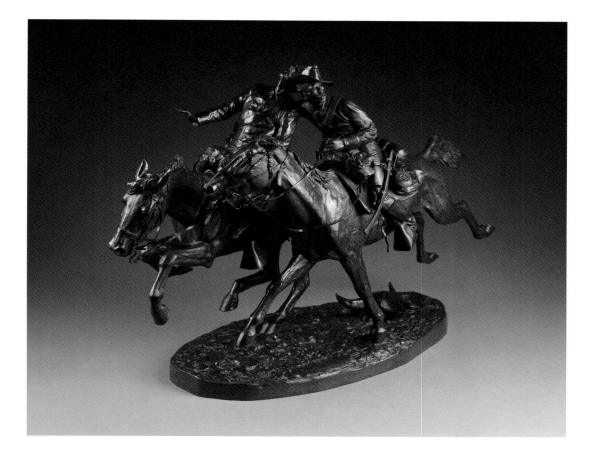

Following the success of Remington's first sculpture, *The Bronco Buster,* which depicts a cowboy taming a wild horse, the artist created *The Wounded Bunkie,* an emotionally charged work in which a U.S. Cavalry soldier supports his wounded brother-in-arms. Here Remington deftly accomplishes a difficult task: rendering two figures in a moment of intense action, while realistically portraying a pair of horses in full gallop. The composition masters a delicate balancing act—only one leg of each horse touches the base. The realism of the horses' gait was undoubtedly informed by the photographer Eadweard Muybridge's well-known motion studies, published in the album *Animal Locomotion* in 1887. An artistic tour de force, *The Wounded Bunkie* is the most significant sculpture in the Museum's American collection, owing not only to the composition's raw power, but also to the fact that this is the first cast in the series, as indicated by the letter A incised on its base.

Building the Schooner, Provincetown | **Childe Hassam** American (1859–1935)

1900 | Oil on canvas | 20 ½ x 22 inches | Museum purchase, 1956.22

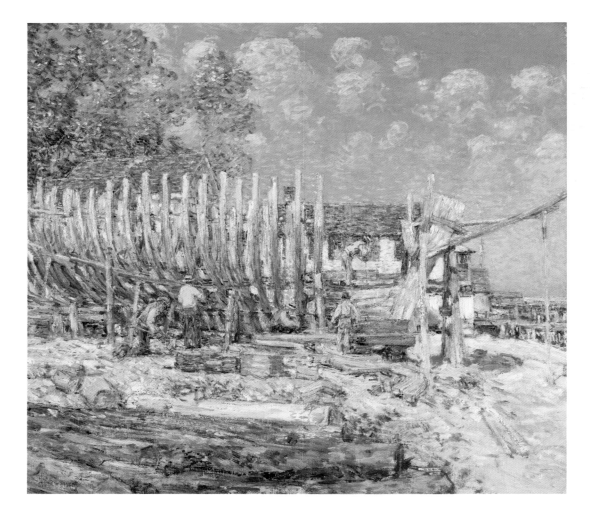

This colorful and light-filled masterpiece by the American Impressionist Childe Hassam held a special place within the artist's home. In a 1956 letter to Richard Howard, first director of the Birmingham Museum of Art, Joseph Gotlieb, a New York art dealer, explained, *"Building the Schooner, Provincetown* was one of Mrs. Hassam's personal favorites, and the painting was never for sale while Mr. or Mrs. Hassam lived. I personally remember seeing it there on the wall."

In 1900, Hassam visited Provincetown, Massachusetts, the historic and picturesque village at the tip of Cape Cod. Once a thriving center for fishing, whaling, and shipbuilding, by the time Hassam visited, the town had begun to rely heavily on tourism. Here, he depicts a once frequent, but now rare event: the building of a schooner. Commissioned as a luxury yacht by a Chicago millionaire, the *Charlotte* was the first large ship to be built in Provincetown in a quarter of a century.

Lady Helen Vincent, Viscountess d'Abernon | John Singer Sargent

American (1856–1925)

1904 | Oil on canvas | 62 x 40 inches | Museum purchase with funds provided by John Bohorfoush, the 1984 Museum Dinner and Ball, and the Museum Store, 1984.121

John Singer Sargent was the preeminent portraitist of the Gilded Age. With his brilliant bravura brushwork, flair for rich colors, and dramatic juxtaposition of light and dark tones, he made striking images of the American and European elite. Born to American parents in Italy, Sargent spent most of his life in Europe, where he traveled extensively, studying the work of the Old Masters. He greatly admired Diego Velázquez's realism and Frans Hals's painterly brushstrokes, both of which he would incorporate into his own work. Sargent painted this portrait of Lady Helen Vincent in Venice. A glimpse of the Grand Canal is visible through the balustrade in the lower-left corner. He elongates Lady Helen's limbs, underscoring her gracefulness, while the black dress emphasizes her milk-white skin, a sign of her nobility. Her direct but pensive gaze suggests her intellect: she was a member of "The Souls," a salon of prominent intellectuals that included Henry James and Edith Wharton.

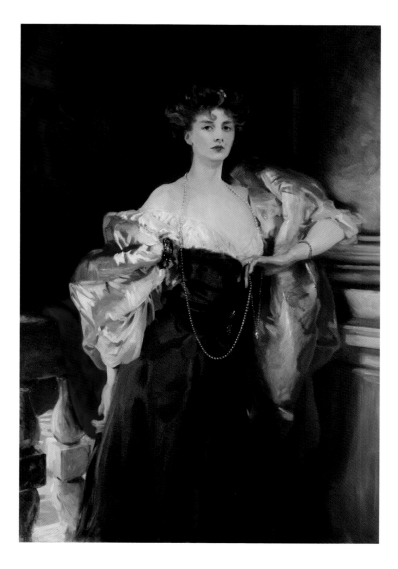

Kit Carson | **Frederick William MacMonnies** American (1863–1937)
Roman Bronze Works Brooklyn, New York (est. 1899)

Modeled 1906; cast about 1936 | Bronze | 24 ¼ x 12 ⅛ x 16 inches | Gift of Dr. and Mrs. Harold E. Simon, 1964.122

Frederick MacMonnies was among the most successful American sculptors of the late nineteenth and early twentieth centuries. In 1891, he was awarded the commission to design the monumental central fountain for the 1893 World's Columbian Exposition in Chicago. The notoriety garnered from this prominent work led to commissions for other major public sculptures, including the Denver Pioneer Monument, his only Western subject. Begun in 1906 and unveiled in 1911, the monument marks the end of the Smoky Hill Trail, which led gold-seeking pioneers to Colorado in 1859. MacMonnies crowned the fountain with a figure of Christopher Houston "Kit" Carson (1809–1868), the renowned frontiersman, who made his final home in Colorado. This reduced version of the sculpture is one of several cast shortly before MacMonnies's death.

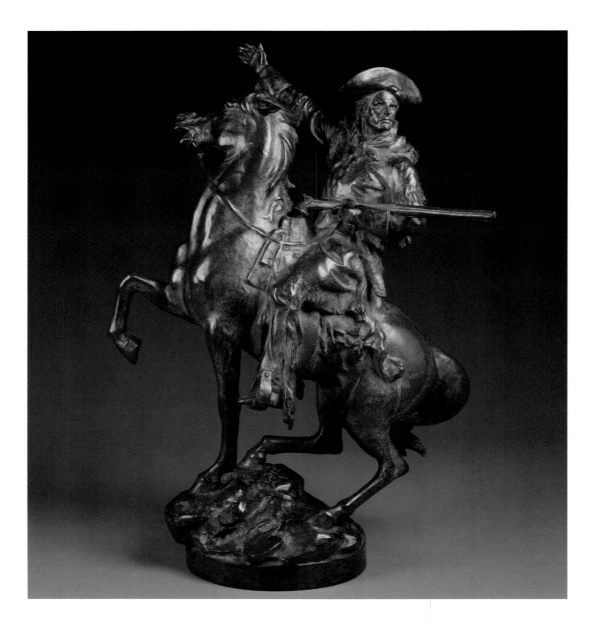

The Gardener | **Maxfield Parrish** American (1870–1966)

1906 | Oil on paper | 19 ½ x 15 ⅞ inches | Gift of Dr. and Mrs. Harold E. Simon, 1981.27

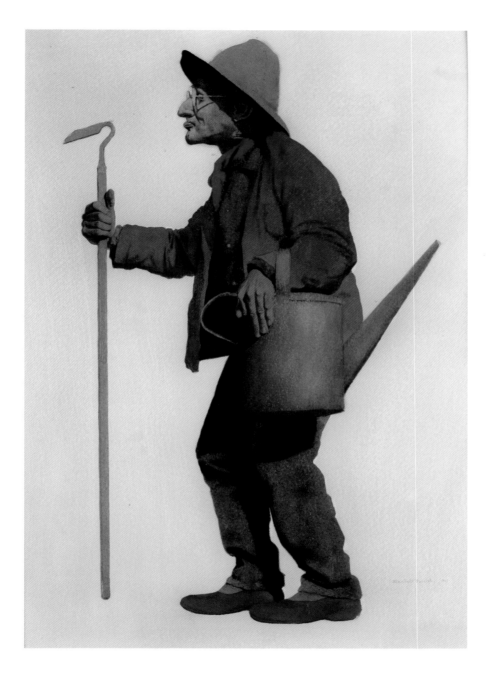

Known for his whimsical subjects and use of dazzling colors—including the brilliant "Parrish blue" that bears his name—Maxfield Parrish was among the most popular American artists of the twentieth century. Although a gifted painter, he is perhaps best remembered for his illustration work, providing cover art for leading magazines such as *Life, Scribner's* and *Collier's,* and now-iconic advertisements for Edison-Mazda light bulbs and JELL-O® gelatin. Although dated 1907, this wry image of a steadfast gardener adorned the cover of the June 23, 1906 issue of *Collier's Weekly* magazine.

USS *Birmingham* Punch Service | Gorham Manufacturing Company

Providence, Rhode Island (1865–1961)

1908 | Silver with wooden and plaster platform | Bowl: 14 x 18 ½ inches; ladle: 19 ¼ inches; cups: 3 ½ inches each | Gift of the Department of the Navy, United States of America 1957.122.1-.4

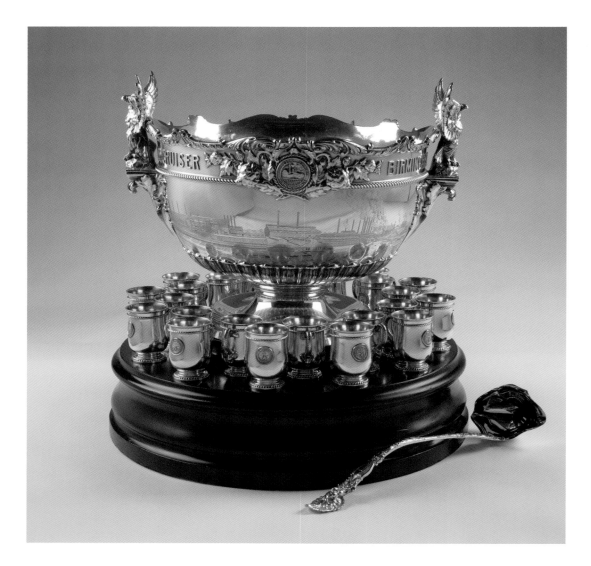

The cruiser USS *Birmingham* was launched on May 29, 1907. This ornate punch service, engraved with views of the ship and the "Fairfield Steel & Iron Works," was commissioned by the citizens of Birmingham, Alabama, as a gift to the U.S. Navy. Mayor George Ward presented the elaborate service at a ceremony in Mobile on March 31, 1909, remarking,

> "The people of Birmingham have watched with proud and intense interest the various stages in the career of the cruiser that bears the city's name. . .

We have thought it singularly appropriate that the cruiser should be so christened, for ship and city alike are new types—one in naval construction, the other in city building. Speed is the pre-eminent quality of each—one unequalled in covering the seas, the other unrivalled in covering the land."

The USS *Birmingham* was decommissioned in 1923. A second *Birmingham* was launched in 1942, but decommissioned in 1947. The Navy returned the silver to its namesake in 1957.

The Laughing Boy (Jopie van Slouten) | **Robert Henri** American (1865–1929)

1910 | Oil on canvas | 24 x 20 inches | Gift of the Friends of American Art in honor of Edward Weeks, former curator of the Birmingham Museum of Art, 1991.704

Robert Henri, a painter and influential art teacher, was one of the leading figures of the Ashcan School. This group of artists depicted scenes of everyday life in New York, gravitating to poor and working-class neighborhoods such as the Bowery and Greenwich Village. During the summers of 1907 and 1910, Henri worked in the Netherlands, where he became captivated with the work of Frans Hals (1580–1666), the Dutch painter known for using lively brushwork to create animated portraits. Hals made a number of pictures of laughing children, which Henri sought to emulate in his own paintings of Dutch youths. Henri described the subject of this canvas, Jopie van Slouten, as "a great, real human character to paint." A second portrait of the boy entitled *Dutch Joe* can be found in the permanent collection of the Milwaukee Art Museum.

Crazy Quilt

Maker Unknown | American | About 1910–15 | Wool and cotton blends | 79 x 84 inches | Collection of the Art Fund, Inc. at the Birmingham Museum of Art, gift of Helen and Robert Cargo, AFI128.2006

During the last quarter of the nineteenth century there was a significant stylistic departure in the traditional bed quilt. The crazy quilt, popular from about 1876 to 1890, broke from the geometric patchwork and floral appliqué patterns common during the previous decades. Instead, makers embraced a very modern, irregular, and totally original approach that emphasized a random arrangement of fabrics.

At its apex, this style favored silks, satins and elaborate and costly materials, but as the popularity of the quilts waned, they were more often made of wool, woolen blends, and cotton, since the purpose was more utilitarian than decorative. The maker of this Alabama bedcover used large blocks of fabric but disguised their size with the rows of embroidered lines stitched across the surface. This piece also exhibits characteristics identified with African-American quilts, with its bold colors and large abstract design elements.

Moroccan Scene | **Henry Ossawa Tanner** American (1859–1937)

About 1912 | Oil on canvas | 18 ¼ x 15 ¼ inches | Gift of the Mahdah R. Kniffin Estate, 1971.30

A leading painter of the late nineteenth and early twentieth centuries, Henry Ossawa Tanner was the only African-American artist of his generation to garner widespread acclaim. He began painting as a teenager, and by the age of twenty was granted admission to the Pennsylvania Academy of the Fine Arts. There he studied under the realist painter Thomas Eakins, who became a lifelong friend and mentor. Frustrated by racial prejudice and mistreatment, Tanner left Philadelphia in 1889, moving first to Atlanta, then to Paris, which became his permanent home. Tanner is best known for his reverent depictions of African Americans and religious subjects. In 1912, he spent several months in Morocco, a trip that inspired a great number of works including *Moroccan Scene,* which displays the dramatic handling of light that became his trademark. Remarkably, Tanner has a tie to Alabama: in 1891, his sister, Halle Tanner Dillon Johnson, became the first woman to practice medicine in the state.

Seacoast, Gloucester | John Sloan American (1871–1951)

1915 | Oil on canvas | 20 x 23 ¾ inches | Gift of Kay Blount Miles, given in celebration of the life of her father, Wynton M. Blount, on his 75th birthday, 1996.2 | © 2010 Delaware Art Museum / Artists Rights Society (ARS), New York

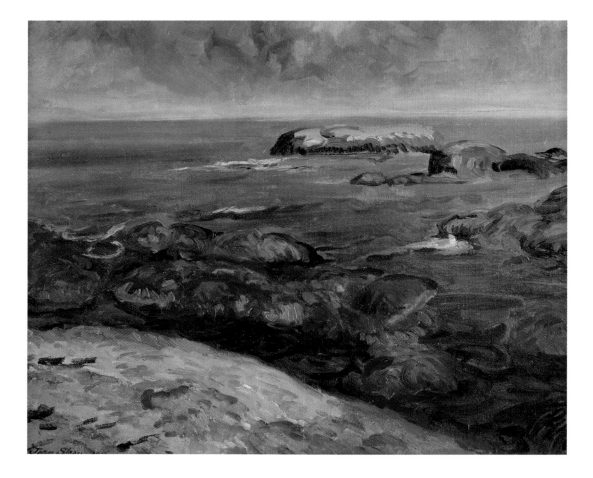

John Sloan is associated with the Ashcan School, a group of realist painters who made daily life in New York City a frequent subject of their work. Sloan arrived in New York in 1904, taking up residence in Greenwich Village, where he painted many of his best-known works. Sloan's work was not confined to the city, however. He was also a gifted landscape painter, evident in this view of the coast of Gloucester, Massachusetts.

Sloan first visited the scenic fishing village in 1914, returning for the next four summers. In the city, Sloan worked from memory in his studio, but in Gloucester he painted in the open air. Sloan later recalled, "My first summer in Gloucester afforded the first real opportunity for continuous work in landscape and I really made the most of it. Working from nature gives, I believe, the best means of advance in color and design."

The End of the Trail | James Earle Fraser American (1876–1953)
Gorham Company Founders Providence, Rhode Island (1865–1961)

Modeled 1915; cast 1918 | Bronze | 46 x 13 x 38 inches | Gift of Mr. and Mrs. A. H. Woodward, Jr., 1976.86

The sculptor James Earle Fraser grew up on the frontier. His father Thomas was a civil engineer charged with building railroads in the Dakota Territory. Fraser's early exposure to Plains Indians in the Dakotas may account for the sensitivity of his depictions of Native Americans. In 1913, he designed the so-called "Indian Head" or "Buffalo" nickel. Two years later he created his now iconic sculpture, *The End of the Trail*, for San Francisco's Panama-Pacific International Exposition. In the following decades, the sculpture's fame was proliferated through smaller replicas in bronze, countless prints, calendars, bookends, cartoons, and even china and silverware patterns. Despite this commercialization, it serves as an important, albeit romanticized, emblem of the fate of the American Indian at the outset of the twentieth century.

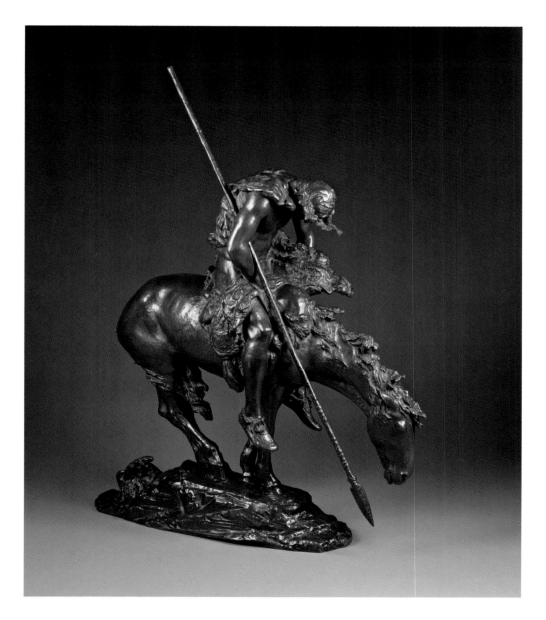

The Barricade | **George Wesley Bellows** American (1882-1925)

1918 | Oil on canvas | 48 ⅛ x 83 ½ inches | Museum purchase with funds provided by the Harold and Regina Simon Fund, the Friends of American Art, Margaret Gresham Livingston, and Crawford Taylor, 1990.124

A member of New York's Ashcan School, Bellows achieved prominence for his bold depictions of the bustling city, which did not shy away from showing the seamier side of urban life. In 1918, moved by reports of atrocities committed against civilians during the First World War, Bellows departed from his typical subjects and painted five large-scale canvases to call attention to their plight. *The Barricade* derives from an incident during the invasion of Belgium in August 1914, when German soldiers used townspeople as a human shield. Bellows presented the victims as nudes, simultaneously underscoring their vulnerability and recalling depictions of martyred saints from the history of art. Because Bellows had not witnessed these events firsthand, the artist Joseph Pennell charged that he had no right to paint them. Bellows replied that he was not aware that Leonardo da Vinci had "had a ticket to paint the Last Supper."

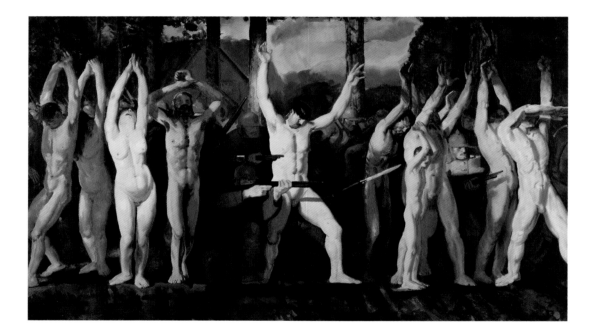

Flags | **Theodore Earl Butler** American (1860–1936)

1918 | Oil on canvas | 42 ¼ x 27 ¼ inches | Collection of the Art Fund, Inc. at the Birmingham Museum of Art; Gift of Mr. and Mrs. Crawford L. Taylor, Jr., AFI20.2005

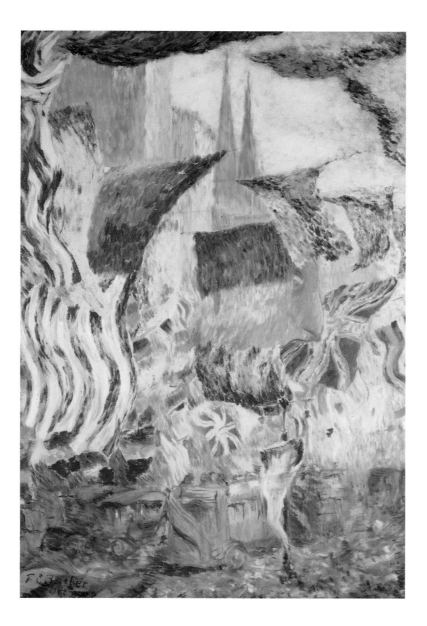

The painter Theodore Butler trained in New York, but like many American artists of the period was drawn to France to continue his studies. Butler made his way to Giverny, where he studied with the Impressionist master Claude Monet, with whom he developed an intense friendship. Butler settled permanently in Giverny in 1892, marrying Monet's stepdaughter, Suzanne Hoschedé. In 1900, following Suzanne's death, Butler married her sister, Marthe. He returned to New York in 1913, where his work was exhibited at the Armory Show. Due to the outbreak of World War I the following year, the artist was forced to remain in the United States. This exuberant painting, filled with effusive light and lively brushwork, is one of Butler's few canvases to refer to the war. It was painted in October of 1918, during an Allied flag celebration on New York's Fifth Avenue.

The Green Apple | **Georgia O'Keeffe** American (1887–1986)

1922 | Oil on canvas | 14 ⅛ x 12 ½ inches | Museum purchase with funds provided by the 1981 and 1982 Museum Dinners and Balls, the Museum Store, Donors, and matching funds from Mr. and Mrs. Jack McSpadden, 1983.28 | © Georgia O'Keeffe Museum

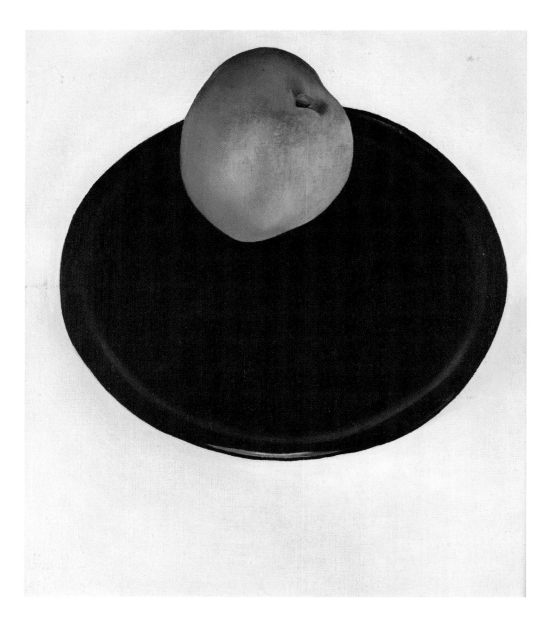

The most significant early modern painting in the Museum's American collection is this composition by Georgia O'Keeffe depicting a green apple on an austere black plate against a stark white background. Although O'Keeffe is best known for her flower pictures and striking desert landscapes, in her early career she devoted herself to Precisionism, an artistic movement that sought to exploit and capture the inherent geometry in natural and man-made things, reducing them to their basic forms. In a 1922 article in the *New York Sun,* O'Keeffe declared, "It is only by selection, by elimination, and by emphasis that we get at the real meaning of things." In this simple but elegant still life, she has reduced both apple and plate to their essence, bringing the two objects into a harmonious balance.

Windmill | **Thomas Hart Benton** American (1889–1975)

1926 | Oil on canvas on board | 29 x 24 inches | Gift of Mr. and Mrs. John F. Breyer, 1997.72 | Art © T.H. Benton and R.P. Benton Testamentary Trusts/UMB Bank Trustee/Licensed by VAGA, New York, NY

Born into an influential family of Missouri politicians, the painter Thomas Hart Benton—along with Grant Wood of Iowa and John Steuart Curry of Kansas— became part of the so-called "Regionalist Triumvirate." In the 1920s and 1930s, at a time when artists such as Charles Sheeler and Georgia O'Keeffe turned their attentions to the modern city, Regionalists drew their inspiration from rural life, creating powerful representations of the American heartland, such as this lonely windmill. Although Benton was a self-professed "enemy of modernism," his most famous student, the Abstract Expressionist painter Jackson Pollock (1912–1956), went on to become a seminal figure in modern art. Benton introduced Pollock to the work of the Mannerist painter El Greco, which had a profound effect on the young artist. Benton's traditionalism provided Pollock with something to rebel against. As Pollock once recalled, Benton "drove his kind of realism at me so hard I bounced right into non-objective painting."

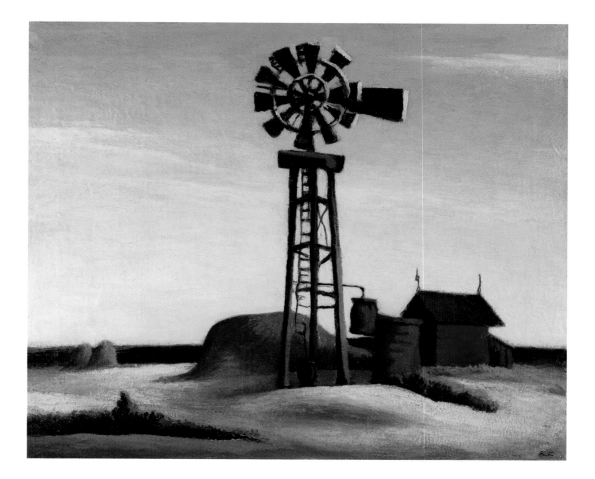

Vase | Designed by **George Sakier** American (1897–1988) **Fostoria Glass Company**
Moundsville, West Virginia (1887–1986)

1930 | Pressed glass | 8 x 5 x 3 ¾ inches | Museum purchase in memory of Jack Bulow with funds provided by the Friends of American Art, 2008.120

"Ruba Rombic" Bowl | Designed by **Reuben Haley** American (1872–1933)
Consolidated Lamp and Glass Company Coraopolis, Pennsylvania (1893–1932 and 1936–1963)

1928–1932 | Pressed glass | 4 ¼ x 12 ¼ x 6 ¼ inches | Museum purchase in memory of Jack Bulow with funds provided by the Friends of American Art, 2008.20

"Modernistic" Vase | Designed by **Nicholas Kopp** American; born Germany (1865–1937)
Kopp Glass, Inc. Swissvale, Pennsylvania (est. 1926)

1928 | Pressed glass | 6 ¾ x 3 ¼ x 3 ¼ inches | Museum purchase in memory of Jack Bulow with funds provided by the Friends of American Art, 2008.98

Responding to the Cubist paintings that he saw at the 1925 Paris Exposition of Decorative Arts, Reuben Haley designed the distinctive "Ruba Rombic" pattern, incorporating the two-dimensional principles of Cubist painting into three-dimensional forms. Haley patented the line in 1928. That same year, his competitor Nicholas Kopp patented the "Modernistic" glass vase, which employs some of the same geometric principles but in a more uniform fashion. The artist and architect George Sakier served as the primary consultant to the Fostoria Glass Company from 1929 until 1979, and was responsible for most of the company's Art Deco and high-style modern designs. This vase uses concentric parabolas to give a sense of surging upward motion.

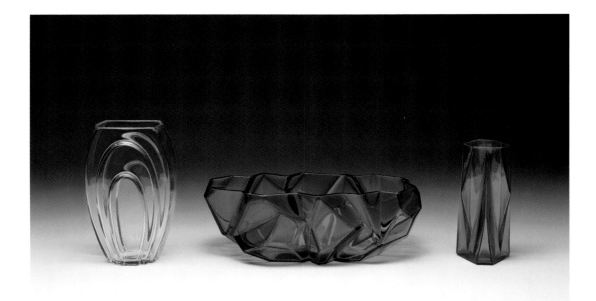

Tea Service | **William Spratling** American (1900–1967)

1962–1964 | Silver and rosewood | Tray: 18 ½ x 15 ½ inches; teapot: 6 ½ inches; sugar bowl: 3 ¼ inches; creamer: 3 ¼ inches | Gift of Antiques and Allied Arts Association and William M. Spencer, Jr., 1965.19.1-.4

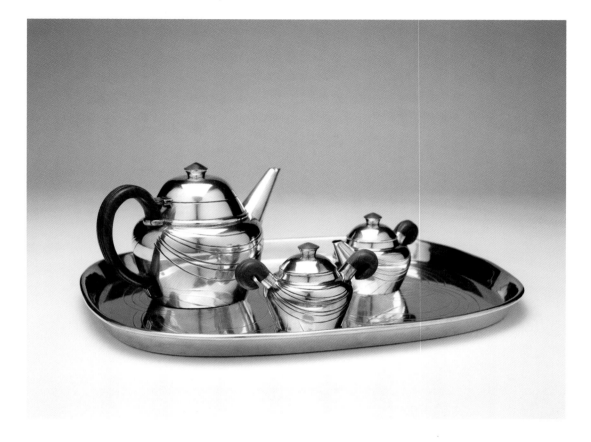

Born in New York, William Spratling was the grandson of an Alabama planter. In 1914, following the deaths of his mother and sister, Spratling moved to Alabama to live with a cousin in Auburn, where he attended high school and later studied architecture at Auburn University. Spratling expanded his artistic training during summer visits to New York to study at the Art Students League and the Beaux Arts School. In 1926, he made his first trip to Mexico, spending summers there until settling permanently in Taxco, an old colonial silver-mining center, in 1929. In 1933, he opened his first silver shop, *Las Delicias* (The Delights), which sold jewelry, hollowware, and flatware of his design, produced by local metalsmiths. His fledgling endeavor quickly grew into a large workshop modeled on the apprentice system. Spratling revolutionized Mexico's silver industry, combining traditional craftsmanship with innovative designs incorporating Pre-Columbian motifs and modern aesthetics. Here, Spratling uses a profusion of repeated and intersecting lines to animate the entire service, offering a unique take on streamlined modernism.

EUROPEAN ART

The department of European art forms the core of the Museum's permanent collection. Comprised of several individual groups of objects bequeathed to the Museum over the past sixty years, this "collection of collections" contains more than 16,000 pieces dating from the Renaissance period to the present day, including painting, sculpture, works on paper, ceramics, metalwork, furniture, and glass. The strengths and breadth of the collection allow the Museum to provide a survey of Europe's artistic achievement as seen through developments in both the fine and the decorative arts. Community support for the department has continually been strong—Birmingham has always had an affinity for European art—and its development follows that of the Museum in general; as the Museum flourished, so, too, did the department of European art.

During the early years of the Museum, there were a number of active, local collectors, who tailored their collections to the wants and needs of the fledgling Museum. Oscar Wells, for example, a prominent Birmingham banker, collected Old Master prints. With his love of the material and an eye for quality, he assembled an excellent collection of etchings and engravings by Rembrandt and other artists working during the seventeenth, eighteenth, and nineteenth centuries. Helen Jacob Wells, Oscar's wife, bequeathed their collection to the young Museum, and over the years others have followed suit, allowing the collection of European prints to expand.

In addition to the Wells's gift, early on the Museum also received an outstanding collection of Old Master paintings, sculpture, and decorative arts objects through the generosity of the Samuel H. Kress Foundation. Not a local collector, but certainly one with local ties, Samuel Kress, a successful businessman and philanthropist, established his Foundation to promote an understanding and appreciation of Italian Renaissance art. Through this Foundation, he donated hundreds of important works of art to regional museums around the country—all in cities that contained one of his "five and dime" department

stores. In 1951, the Birmingham Museum of Art was the recipient, originally on long-term loan, of twenty-seven Renaissance and Baroque paintings including masterworks by Paris Bordon and Canaletto. When the Museum's first building—the Oscar Wells Memorial Building, erected in 1959 with a generous bequest from Mrs. Wells—was completed, the Kress Foundation gifted these and twelve additional works to the Museum.

In the same year that the Museum received the Samuel H. Kress Collection, it also received the Gustav Lamprecht Collection of nineteenth-century European cast iron, again as a long-term loan. The Lamprecht Collection, formed during the late nineteenth and early twentieth centuries, is one of the largest and most comprehensive of its kind and the only such collection known in the United States. Comprised of delicate objects produced in Central Europe, it includes household utensils such as plates and bowls, as well as decorative objects like watch stands, paperweights, and small sculpture. The Lamprecht Collection was acquired by Birmingham's American Cast Iron Pipe Company in 1939; after thirty-five years on loan, it was gifted to the Museum in 1986.

Yet, the decorative arts collection did not really begin to grow until the early 1970s. During that period the Museum underwent an expansion, and the original building acquired a new wing. In 1972, long-time Museum patron Frances Oliver bequeathed her eclectic collection of decorative arts, including English silver and ceramics and continental porcelain. Some of the most important objects in the European collection were gifted by Miss Oliver, a modest woman who lived frugally and worked as a secretary for most of her life.

In 1976, the Frances Oliver Collection was joined by a larger bequest made by Dwight and Lucille Beeson, Birmingham natives and passionate collectors of Wedgwood pottery. The Dwight and Lucille Beeson Wedgwood Collection includes more than 1,400 pieces of Wedgwood—primarily jasperware and black basalt—and provides an overview of all factory production from

Platter from the *Frog Service*, detail, Wedgwood (est. 1759), Staffordshire, England, 1773–1774, lead-glazed earthenware (creamware) with enamel decoration [entry, page 197]

its inception in 1759 through the death of its founder, Josiah Wedgwood, in 1795.

In 1991, two years before the growing Museum expanded again, The Eugenia Woodward Hitt Collection of eighteenth-century French art—a major assembly of more than 500 works—came to the Museum. This collection debuted in 1993, upon the opening of the Museum's last expansion and renovation. Eugenia Woodward Hitt was born and raised in Birmingham, but spent most of her adult life in New York. Her love of all things French led her to form an important collection of paintings, with works by masters Nicolas Lancret, Jean Baptiste Pater, François Hubert Drouais, among others; drawings; and furniture and gilt bronzes of the Louis XIV, XV, and XVI periods. The collection also includes twenty-seven exceptional porcelain figures modeled by Johann Joachim Kaendler for the Meissen porcelain manufactory in Germany.

The European collection grew extensively again in 1998, when the Catherine H. Collins Collection of eighteenth-century English ceramics was bequeathed to the Museum. A local collector, Mrs. Collins focused her collecting goals on the types of ceramics that suited the Museum's growing collection. As a result, the Museum today houses a collection of more than 800 pieces of non-Wedgwood English pottery and porcelain. The collection illustrates the development of ceramic production in Britain and perfectly complements the Museum's collection of eighteenth-century English portraits and silver.

In 2008, the Museum acquired another significant ceramics collection: the Buten Wedgwood Collection, with more than 8,000 pieces of pottery dating from the eighteenth through the mid-twentieth centuries. Formed by Harry and Nettie Buten, contemporaries of the Beesons, the Buten Collection is strong in those objects produced during the nineteenth and twentieth centuries. Together, the Beeson and Buten collections form the largest assemblage of Wedgwood ceramics in the country.

The department of European art at the Museum is also home to a number of smaller collections, formed over the years object by object, either through purchase or through the generosity of individual patrons. The collection of Dutch and Flemish art of the seventeenth century is small, but growing. Highlighted by works that illustrate the popular themes and genres painted by artists of the period, the collection provides an overview of the art of the Northern Baroque period and the work of artists such as Balthasar van der Ast and Jacob van Ruisdael. The Museum's eighteenth-century English portrait collection includes works by Thomas Lawrence, Thomas Gainsborough, and Henry Raeburn. The collection of eighteenth-century English silver, which numbers more than 300 pieces and includes works by masters Paul de Lamerie, Paul Storr, and Hester Bateman, illustrates the depth and range of silver production and use during the eighteenth century.

Today, the department of European art is active and thriving. As the Museum looks to the future, so, too, does the department of European art. Its mission to grow the collection and to help the visitor gain an appreciation for European art—to understand its connection to our lives today and its relevance to our cultural heritage—is realized through targeted acquisitions, exhibitions, and the activities of the European Art Society. Established in 2001, the European Art Society furthers awareness and appreciation of thirteenth- to early twentieth-century painting, sculpture, and works on paper. The group is devoted to the continued growth and development of the Museum's collection, and to educating its members about European art in general, and the Museum's collection specifically.

Anne Forschler-Tarrasch, PhD
THE MARGUERITE JONES HARBERT AND JOHN M. HARBERT III
CURATOR OF DECORATIVE ARTS

Jeannine O'Grody, PhD
CHIEF CURATOR AND CURATOR OF EUROPEAN ART

Madonna and Christ Child with a Bishop Saint, Saint John the Baptist, Saint Michael, and an Unidentified Saint | Goodhart-Ducciesque Master

Italian (active first quarter of the fourteenth century)

About 1310–1320 | Tempera on panel | Central panel 30 x 19 ½ inches; side panels 24 ⅛ x 13 ⅝ inches each | Gift of the Samuel H. Kress Foundation, 1961.104

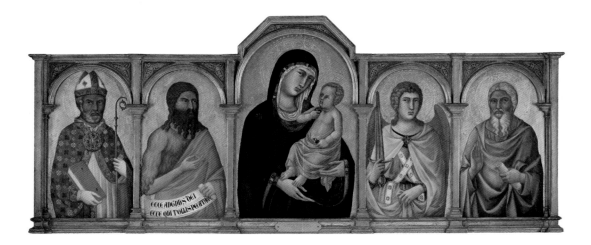

This is a fragment of a dismantled polyptych, or multi-paneled altarpiece. Originally it likely had pinnacles above, and a predella (base) below, painted with scenes from the life of Christ, or perhaps the lives of the saints depicted directly above. The unknown patron who commissioned the altarpiece, probably for a family chapel, would have chosen the saints according to their special significance to him. In the central panel the Child reaches to tug on the Virgin's cloak with his right hand, while in his left he holds a goldfinch, a symbolic allusion to the Passion.

The Goodhart-Ducciesque Master is the name given to the artist who painted a *Madonna and Child,* owned at one time by Mrs. A. E. Goodhart (now in the Robert Lehman Collection in the Metropolitan Museum of Art, New York), and whose style derives from the Sienese master, Duccio di Buoninsegna (about 1255–1318).

Madonna and Christ Child with Angels and Saints Mary Magdalene, Francis, Dorothy, and Anthony Abbot | Mariotto di Nardo Italian (active 1394–1424)

Late fourteenth–early fifteenth century | Tempera on panel | 26 ¾ x 17 ⅛ inches | Gift of the Samuel H. Kress Foundation, 1961.98

In the late fourteenth and early fifteenth centuries the seated Madonna and Child raised on a dais, flanked by adoring angels and saints symmetrically aligned, was a formula followed repeatedly by Tuscan artists. Mariotto's attempts to create a convincing space by rendering volumetric, overlapping figures and a patterned floor with receding lines, reveals an artist aware of his contemporaries' experiments with optical illusionism, although he falls just short of accurate perspectival construction.

The formal, stage-like setting of this composition is in contrast to the intimacy between the Madonna and sturdy Child, whom she gently cradles. As the Christ Child raises his right arm to caress her neck, they gaze intently into one another's eyes. He wears a resplendent orange gown richly decorated with punched flower motifs revealing the gold ground beneath. The exuberant flourish of the Child's fluttering cape provides added visual appeal to this beautifully preserved painting.

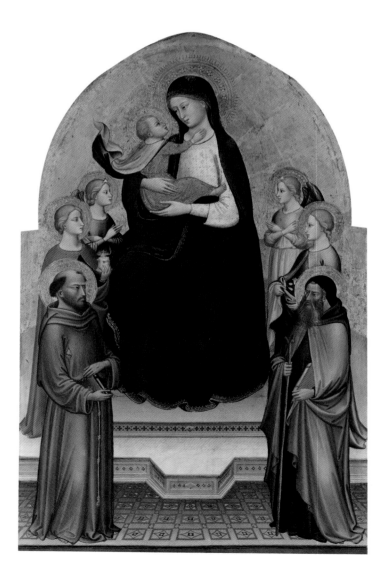

Profile of a Young Woman | **Mino da Fiesole** Italian (1429–1484)

About 1455–1460 | Marble with traces of gilding; modern resin surround | 21 5/8 x 15 3/4 x 3 1/4 inches | Museum purchase with funds provided by a bequest from Nina Miglionico in memory of her father and mother, Joseph Marion and Marianna Miglionico, 2010.5

An early work by Mino da Fiesole, this elegant relief of a young woman in classical dress is evidence of the artist's engagement with the antiquities of Rome early in his career. Mino worked primarily in that city and Florence, although his many commissions around Tuscany and as far south as Naples testify to the esteem with which he was held. He particularly excelled in relief carving and in portraiture.

While the young woman's head is shown in profile, her torso is turned slightly toward the viewer. The filmy fabric of her gown, gathered in a knot at the breast, is fastened at the shoulder and upper arm with round buttons. The smooth texture of her skin contrasts sharply with the finely pleated folds of the diaphanous garment. Her hair, tied with a narrow ribbon, is covered with a nearly-transparent veil edged in pearls. Mino's treatment of the woman's delicate features gives the impression of a fullness atypical in a relief. Debate continues as to whether the subject is an idealized portrait of an actual person, or a generic type.

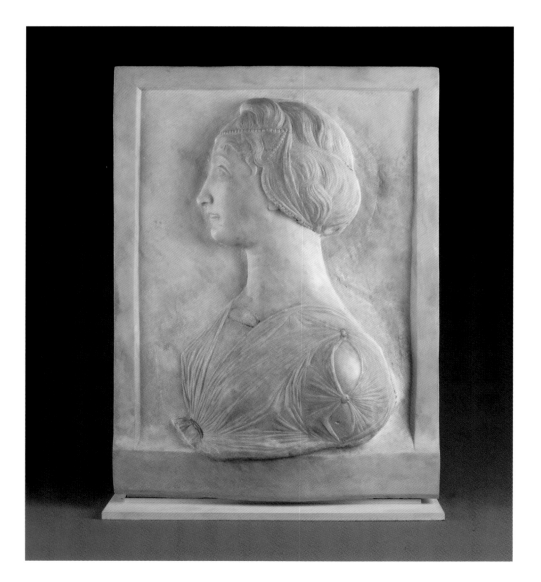

Madonna and Christ Child with Infant Saint John the Baptist and Three Angels | Workshop of Domenico Ghirlandaio Italian (1449–1494)

About 1485–1494 | Tempera on panel | Diameter: 33 ⅝ inches | Gift of the Samuel H. Kress Foundation, 1961.97

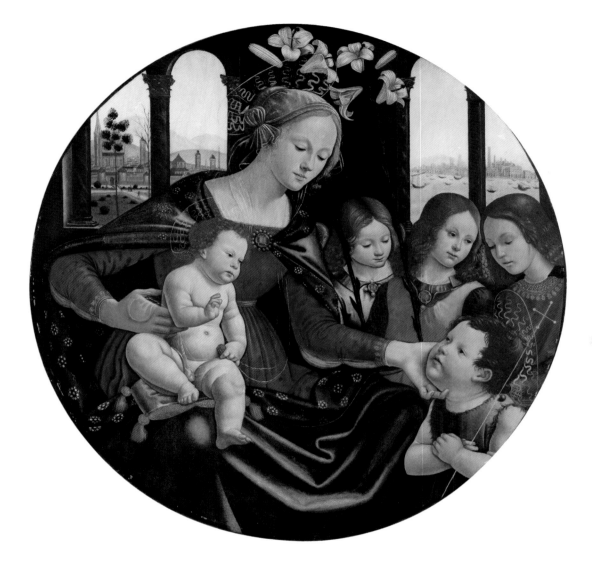

This composition, known in a number of variants, was extremely popular in the late 1480s and early 1490s. It derives from a prototype by Domenico Ghirlandaio, master of one of the largest and most important workshops in late fifteenth-century Florence. The high quality of this painting suggests that it was painted under the master's close supervision. Ghirlandaio's workshop recycled this composition with slight differences, such as changing the number of angels or the backgrounds glimpsed through the double-arched arcade. Commercial production of admired compositions was quite common during the Renaissance, especially for private devotional use. The *tondo* (round) format was particularly favored for the Florentine home in the late fifteenth century, as was the inclusion of the young John the Baptist, here holding his reed cross and connected to the Christ Child through the Madonna's loving gesture.

Saint Elizabeth of Hungary | **Master I.E.** German (active about 1480–1500)

End of fifteenth century | Engraving (single state) | 8 ½ x 5 ⅝ inches | Museum purchase with funds provided by the European Art Society, 2005.12

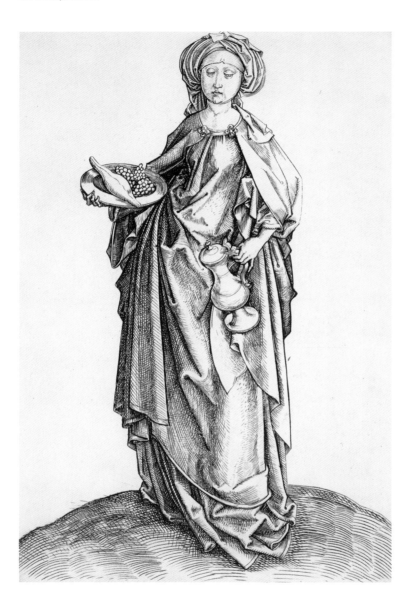

The name "Master I.E." is derived from the inscribed monogram found on one of the fifty-five engravings attributed to this artist. Little is known of him other than that he was a follower of the great early German engraver, Martin Schongauer (about 1450–1491).

Elizabeth, born in the thirteenth century to the King of Hungary, devoted herself to caring for the poor. She is recognized here by the platter of food and pitcher that she bears. The artist imparts a sculptural, monumental quality to the saint, emphasized by the lack of setting and abundance of drapery. Indeed, the complete lack of narrative underscores the devotional aspect of the image. The elegant, controlled lines of this strong impression contribute to its powerful simplicity. This work was made perhaps as a part of a series of saints, to be collected as a set. Today, this extremely rare print exists in only nine known impressions.

Enthroned Madonna and Christ Child with Angels, Saints Paula and Agatha | Michele Ciampanti, called Stratonice Master Italian (1463–1511)

About 1500 | Tempera on panel | 55 ¾ x 43 ⅛ inches | Gift of the Samuel H. Kress Foundation, 1961.124

This type of composition with a Madonna and Child amidst saints and angels in a unified space, called a *sacra conversazione* (Holy Conversation), was introduced in Florence in the early fifteenth century. Ciampanti was active in Lucca, not far from Florence. He knew the carefully balanced, triangular groupings of his contemporaries there, particularly those of Sandro Botticelli and Filippino Lippi. The heavy-lidded, almost lethargic figures are distinctly his own, however.

The inclusion of the two female saints indicates that the patron of the altarpiece may have been a woman. On the right, Agatha is easily recognized as the martyr who was tortured by having her breasts cut off. The identification of the figure on the left has been debated, but recent scholarship suggests that she is the early Christian matron Paula, founder of the monastery in Bethlehem where Saint Jerome produced his Vulgate translation of the Bible. Just as Paula receives her heavenly crown from the Child, the devout patron hopes to receive her own heavenly reward for having commissioned this important altarpiece.

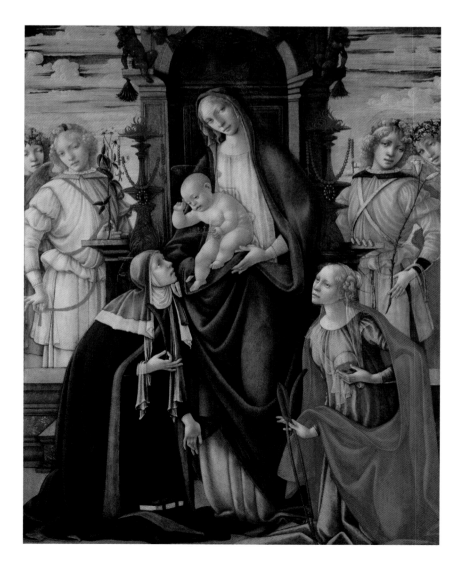

Saint Bartholomew | Pietro di Cristoforo Vannucci, called Pietro Perugino

Italian (about 1450–1523)

About 1512–1523 | Oil on panel | 34 ¾ x 27 ⅞ inches | Gift of the Samuel H. Kress Foundation, 1961.103

Saint Bartholomew, one of the twelve apostles, is identified by the knife he holds in his right hand; he was martyred by being flayed alive. This painting was one of about thirty panels comprising a monumental, double-sided altarpiece commissioned in 1502 for the church of Sant'Agostino in Perugia, Italy. The polyptych, comprised of fifteen panels facing the nave, and fifteen facing the choir, was painted intermittently over a period of more than twenty years and was Perugino's last major work. *Saint Bartholomew* was probably made for an upper register on the choir side, during the later phase of the project. The broad, fluid brushstrokes and lack of detail in the painting indicate that it dates to the last years of Perugino's career, and also that it needed to be clearly legible from far below. Although the altarpiece was dismantled in the seventeenth century and various parts removed from the church by the eighteenth century, most of the panels have been identified in museums in Perugia and France.

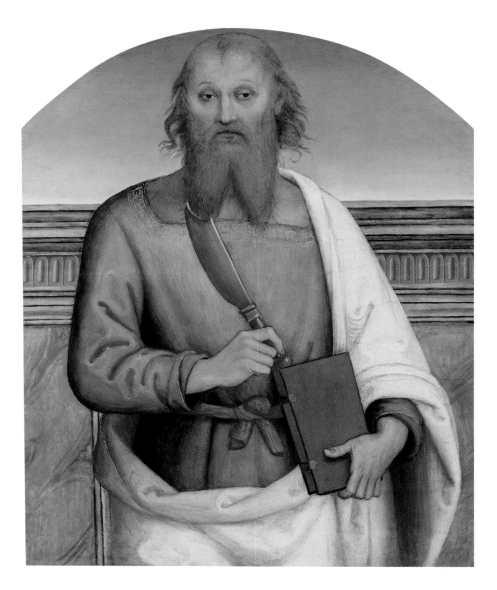

Madonna and Christ Child | Francesco di Cristofano Giudicis, called Franciabigio Italian (1484–1525)

Early 1520s | Oil on panel | 33 ½ x 26 ½ inches | Gift of the Samuel H. Kress Foundation, 1961.109

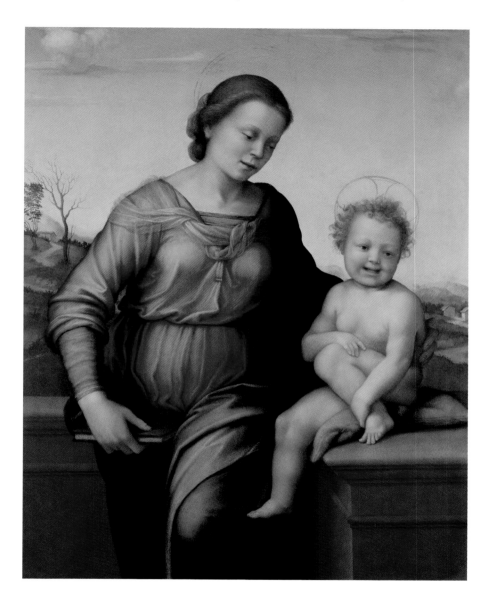

Franciabigio's harmonious *Madonna and Child*, set against a continuous landscape, owes much to the influence of Raphael Sanzio, the great master who arrived in Florence from his native Urbino in 1504. Above all, though, the artist with whom Franciabigio had the greatest affinity was his friend, Andrea del Sarto. Starting about 1506 the two shared a workshop, and reflections of one another's work are found repeatedly during the years when they worked in such close proximity. This painting is an almost exact mirror image of one now in the Museo Nazionale, Rome, the attribution of which has swung between the two artists. Scholarly consensus, however, gives Birmingham's painting squarely to Franciabigio. The casual, fluid poses of the solidly modeled figures, particularly that of the Christ Child who gazes out almost playfully at the viewer, characterize the Florentine search for naturalism in the early decades of the sixteenth century.

Baptism of Christ | **Benvenuto Tisi, called Garofalo** Italian (1481–1559)

1520–1525 | Tempera on panel | 23 ¾ x 15 ⅞ inches | Gift of the Samuel H. Kress Foundation, 1961.94

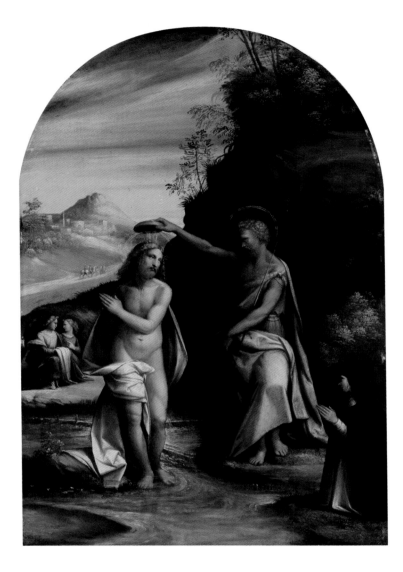

This work from the middle of Garofalo's career demonstrates his distinctive synthesis of several artistic currents: the work of the High Renaissance master, Raphael, in the contrapposto poses of the two main figures; and that of Venetian and Ferrarese contemporaries in elements of the carefully observed landscape. Among the most established artists of his generation in the region, he worked in a softly classicizing manner that was eminently agreeable to his sophisticated patrons in Northern Italy.

Garofalo uses landscape elements to silhouette and emphasize the sacred figures. John the Baptist is placed against a dark bluff, which signifies his self-imposed isolation in the wilderness. In contrast, Christ is placed in the lighter half of the composition, which underscores the divine nature of His baptism. The gracefulness of the figures, coupled with the skillfully rendered *sfumato* (hazy) effects in the distant landscape, impart a delicate beauty to this painting. The Dominican nun kneeling in the right foreground suggests that it was commissioned by one of the many Dominican convents in the region.

Saint Sebastian | Francesco d'Ubertino Verdi, called Bacchiacca

Italian (1494–1557)

About 1530s–1540s | Oil on panel | 51 ¾ x 21 ¾ inches | Collection of the Art Fund, Inc. at the Birmingham Museum of Art; Purchase with funds provided by the Members of the Birmingham Museum of Art, AFI7.2001

Active in Florence, Bacchiacca became a successful court painter to Duke Cosimo I de' Medici. He was greatly influenced by his first master, Pietro Perugino, and by a number of his contemporaries. This panel may once have been a wing of an altarpiece, although today nothing is known of its history.

Sebastian, a Christian nobleman condemned to death by the Roman emperor Diocletian in the third century, has been shot with arrows. His martyrdom was a popular subject in Italian art from at least the fourteenth century. Patrons commissioned devotional images of the saint to invoke his protection during times of plague, or in thanksgiving for having been safeguarded from disease. Bacchiacca paints a stylized musculature enhanced by the saint's elegant, mannered pose. The mood is a calm acceptance of his fate as he turns his gaze toward the gilded rays in the upper-right corner, symbolic of heaven. Bacchiacca's gift for color is evident in the lovely shifting hues in the loincloth, the minutely rendered violet iris, and the cool bluish tints of the landscape.

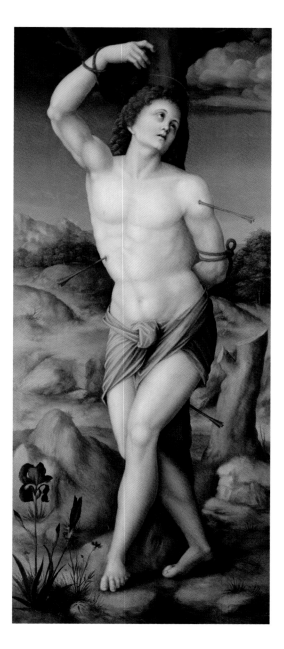

Battle of Pavia

Anonymous Flemish artist | After 1525 | Oil on panel | 45 x 67 ½ inches | Gift of the Samuel H. Kress Foundation, 1961.125

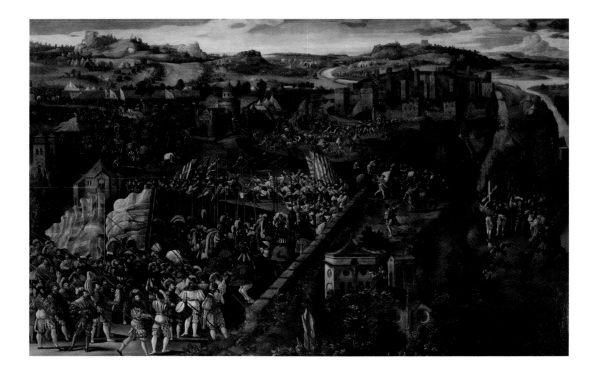

This painting commemorates the military engagement on February 24, 1525 between the armies of Charles V, Holy Roman Emperor, and Francis I, King of France. The Battle of Pavia was one of many conflicts that sought to resolve the issue of control over the Lombardy region in northern Italy. The victorious imperial army is depicted at the lower left with its procession of troops, including the infantrymen, mounted knights, and pikemen. The French are identified by their flag, which bore white lilies on a blue field. Francis, who was captured by the imperial army, is shown being led away on a mule in the center right. Although the authorship of the painting remains uncertain, it is considered an accurate visual record, probably based on eyewitness accounts of the events. The impressively documented provenance of the painting can be traced to the early seventeenth century, when it was given an untenable attribution to Albrecht Dürer.

Doge Leonardo Loredan | **Circle of Danese Cattaneo** Italian (1509–1573)

Mid-sixteenth century | Terracotta with traces of gilding | 17 ⅜ x 10 ¼ x 10 ¼ inches | Museum purchase with funds provided by the Beaux Arts Krewe, 2010.1

Venetians delighted in pomp and tradition. Their leader, the doge, was elected to office for life by the city's aristocracy. Portraits of doges were common, but Leonardo Loredan (1436–1521), ruler from 1501 until his death, was one of the most frequently depicted of all. Here Loredan wears the doge's traditional *corno ducale*, a horn-shaped hat with an opulent jeweled border. Hints of the garment below reveal his sumptuously patterned formal state robes. This incisive portrait captures the solemn, worn features of a leader whose state was constantly in conflict over its territories. The artist is unknown, but he likely worked in the orbit of Danese Cattaneo, who was responsible for the posthumous monument to the doge in the church of SS Giovanni e Paolo. The talented modeler sensitively defines the wrinkles, folds of skin, and details such as the ears covered by the close-fitting cap worn under the *corno*. The purpose of this bust is unknown, but its careful finish suggests that it was made as a work of art in itself, rather than a model for marble or bronze.

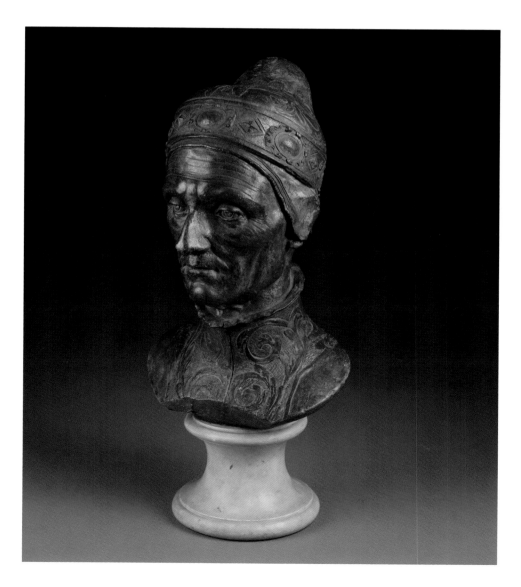

Perseus Armed by Mercury and Minerva | **Paris Bordon** Italian (1500–1571)

About 1545–1555 | Oil on canvas | 40 ¾ x 60 ⅜ inches | Gift of the Samuel H. Kress Foundation, 1961.117

According to ancient myth, the warrior Perseus was given powerful armor to aid him in executing the snake-haired Gorgon, Medusa. On the left, Mercury, identified by the caduceus (winged staff) held in his left hand, presents the helmet of Pluto, which granted its wearer invisibility and gave Perseus access to Medusa's cave. The reflective shield donated by Minerva allowed Perseus to approach and behead the monster without gazing directly upon her deadly countenance, which turned all who saw her into stone.

Bordon painted many mythological subjects for wealthy, sophisticated patrons all over Europe. One of Titian's first pupils, Bordon absorbed the Venetian master's dynamism and emphasis on color, though he intensified both to produce his own idiosyncratic style. The exaggerated musculature, convoluted poses, and sharp coloration found here brilliantly exemplify Bordon's work.

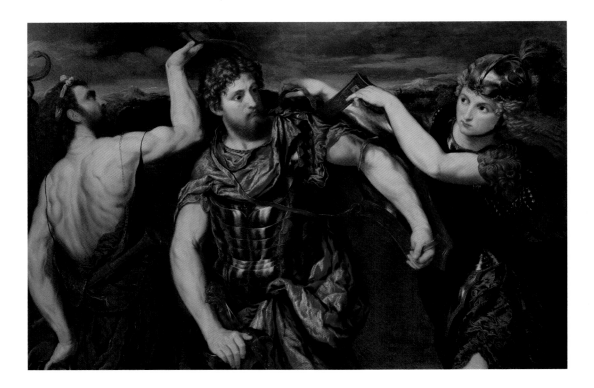

Last Judgment | **Leandro dal Ponte, called Leandro Bassano** Italian (1557–1622)

About 1596–1605 | Oil on copper | 28 x 19 inches | Gift of the Samuel H. Kress Foundation, 1961.114

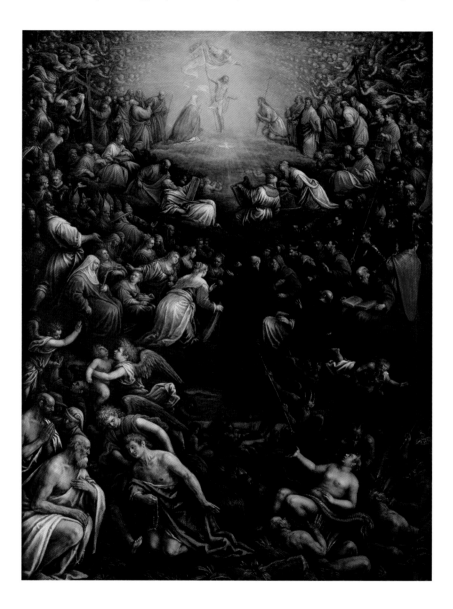

The figures in this highly detailed masterpiece are organized according to celestial hierarchy, which, along with their iconographic attributes, helps to identify a great number of them. The Holy Trinity, flanked by the Virgin and Saint John the Baptist, is ringed in two registers by Old Testament prophets and saints. In the lower half, closest to the viewer, figures on earth are still being judged.

Leandro Bassano's reputation suffers when compared to his father, Jacopo, the master of the family's extensive workshop. This carefully composed and meticulously painted work, however, indicates the artistic heights that the son could reach. Bassano signed the painting in the lower right using his title "EQUES" or "knight," given to him by the Doge of Venice in 1595 or 1596. In the painting, Bassano also included a portrait of this ruler, Marino Grimani, whose term expired in 1605. These dates provide a timeframe during which the painting was probably made.

Door Knockers

North Italian (probably Venetian) | Early seventeenth century | Bronze | 19 x 8 x 7 ½ inches each | Museum purchase with funds provided by the 2005 Museum Dinner and Ball, 2005.9a-d

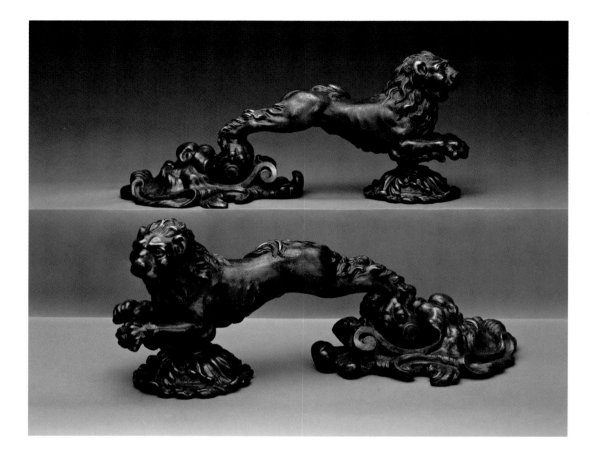

These door knockers are formed by leaping lions hinged to fantastic leonine mask backplates, which attach the knockers to the door. The visitor announces himself by grasping the lion's head and rapping the foliate bosses also bolted to the doors. Each component of the knockers is exceptionally finely cast and finished. The lions are elaborately detailed, with long, flame-like manes, and tails that pass between the rear legs, wrap along the underbellies, and settle over the top of the buttocks. The lions' heads turn towards one another.

The burnished highpoints of the manes, tails, and faces further attest to the unusual attention lavished upon these very utilitarian objects. Made for a set of monumental doors, their size and exceptionally high quality confirm the wealth and status of the unidentified patrons. Functional objects such as door knockers were often mass-produced, but these outstanding examples seem to be unique. They may originate from the Veneto: lions, the symbol of Venice, might allude to the family's loyalties and civic pride.

Liberation of Saint Peter | Giovanni Lanfranco Italian (1582–1647)

About 1620–1621 | Oil on canvas | 60 ⅝ x 48 ⅛ inches | Partial collection of the Art Fund, Inc. at the Birmingham Museum of Art; with funds provided by Henry Lynn, Mrs. R. Hugh Daniel, and The Illges-Chenoweth Foundation; additional funds provided by John Bohorfoush, Mrs. Elizabeth M. Drey, Ward Eggleston, Thomas L. Fawick, Thomas R. Ford and Robert C. Ford, Mr. and Mrs. Victor Hanson II, Ingalls Foundation, Mr. and Mrs. John S. Jemison, Jr., Dr. and Mrs. Fritz Kant, Mahdah R. Kniffin Estate, Mr. Frank Lankford, Dr. and Mrs. William Murray, 1976 and 1977 Museum Dinners and Balls, Dr. Geofrey J. Roscoe, Mrs. Theodore Roth, Scharff Estate, Colonel and Mrs. M. R. Scharff, Sidewalk Art Show, Mr. and Mrs. William M. Spencer, Jr., and Dr. M. Bruce Sullivan, by exchange, AFI8.2007

The dynamic image of an angel arriving in a blaze of illumination, cloak billowing behind, is characteristic of Lanfranco's interest in depicting light and motion in his works. This painting is unfinished: the angel's extra limbs, not yet painted out, provide a glimpse into the mind of the artist as he made changes on the canvas.

Lanfranco faithfully followed the biblical source for the subject of the painting, from the book of *Acts* 12: 6–7. While Peter was imprisoned in Jerusalem, an angel arrived to free him. He tapped Peter on the side and awakened him, saying, "Get up quickly." The chains fell from Peter's wrists. The angel's left hand now touches Peter's shoulder, whereas it only hovered above in the earlier composition. This change conveys a feeling of immediacy. The angel's grand gestures and Peter's vigorous pose, all placed close to the picture plane, are highly characteristic of Italian painting during this period.

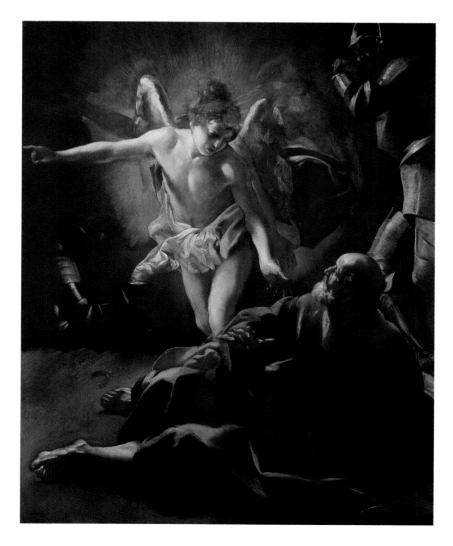

Still Life of Flowers, Fruit, Shells, and Insects | Balthasar van der Ast

Dutch (1593/4–1657)

About 1629 | Oil on oak panel | 17 x 29 inches | Collection of the Art Fund, Inc. at the Birmingham Museum of Art; Purchase with additional funds provided by an Anonymous Gift, Mrs. Peter G. Smith, The Illges-Chenoweth Foundation in honor of Barbara Derr Chenoweth and in memory of Arthur Illges Chenoweth, Mr. and Mrs. Victor H. Hanson II, Mr. and Mrs. Thomas N. Carruthers, Jr., Mr. and Mrs. James A. Livingston, Jr., Mr. and Mrs. James S. Snow, Jr., Mr. and Mrs. Daniel H. Markstein III, Edgar B. Marx, Jr., Dr. and Mrs. Jack Geer, Henry E. Simpson, and James E. Simpson, AFI3.2002

Van der Ast is a master of the combined still-life composition. He had an exceptional ability to join flowers, fruit, and exotic shells into one vivid image. The elements here are intricately arranged on a stone ledge close to the picture plane, with a background light that gradually intensifies from left to right. The sense of spatial illusion is heightened by the unerring realism of the lizard and carnation at the edge of the table. Van der Ast worked in thin, transparent oils, rendering each object with such exactitude that even the species of shells are readily identifiable. During his lifetime, his reputation as a still-life painter was concisely summarized by an Amsterdam doctor who commented, "In flowers, shells and lizards, beautiful."

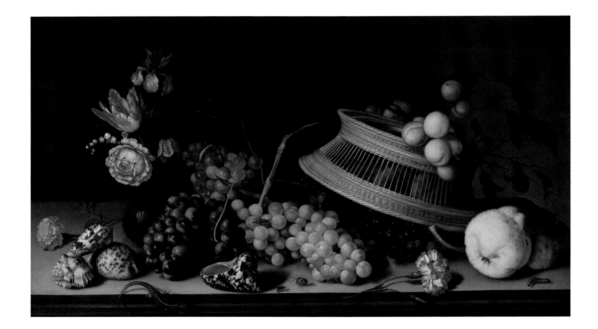

Saint Paul Shipwrecked on Malta | **Laurent de La Hyre** French (1605–1656)

About 1630 | Oil on canvas | 41 ½ x 63 ¾ inches | Collection of the Art Fund, Inc. at the Birmingham Museum of Art; Purchase with funds provided by Mr. and Mrs. William T. Ratliff, Jr., AFI1.2004

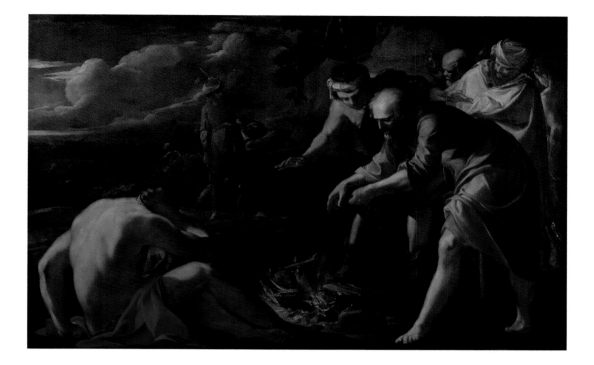

La Hyre was an innovative artist, often using his superior skills as a storyteller to narrate rarely depicted subjects. Here he illustrated *Acts* 28:1-6. Paul was in the custody of soldiers on a ship bound for Rome. A shipwreck occurred off the coast of Malta and a fire was made for the survivors. Roused by the heat, a snake fastened onto Paul's hand. The local inhabitants initially concluded that Paul must be a criminal and was receiving retribution, but when he did not fall ill they decided instead that he must be a god.

The arresting use of color and elegantly posed figures are hallmarks of La Hyre's early, painterly style. He was influenced by the work of Italian artists who came to Paris, and by the return of several French compatriots who completed lengthy sojourns in Rome or Venice.

A Kitchen Interior | **Attributed to Isaack Koedijck** Dutch (1617/18–1668)

About 1650 | Oil on panel | 31 ¾ x 25 ⅞ inches | Museum purchase with funds provided by the 1976 and 1977 Beaux Arts Krewe, 1976.303

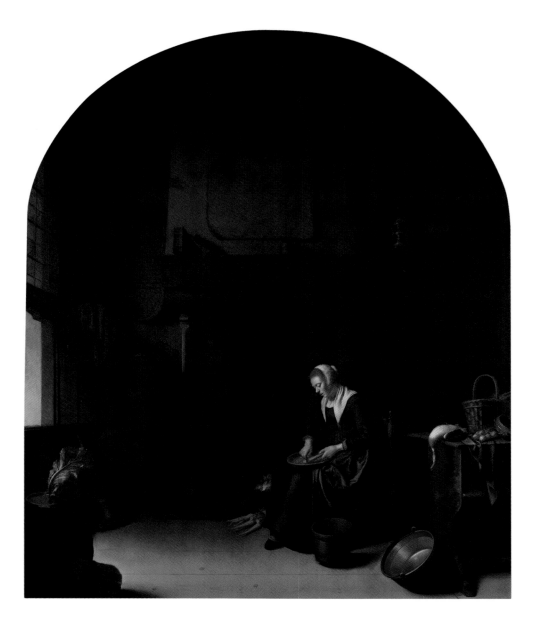

Koedijck was a pupil of Gerrit Dou, who founded the Leiden school of Fijnschilders (fine painters). This group was noted for its use of tiny brushes to produce paintings with polished surfaces, filled with extraordinarily fine detail. Here the artist provides a glimpse into a seventeenth-century middle-class Dutch kitchen, where the wife devotes her attention to a domestic task. The room is filled with intimate details of everyday life, including a map over the mantel, a bellows for the fire, and even the sleeping loft accessible by a ladder to the right. And yet the scene is remarkable in its serenity and simplicity. The subtle rendering of light and shadow serves to illuminate the variety of textures depicted with great verisimilitude by the painter: the polished metal bucket, the weave of the wicker baskets, the downy plumage of the bird.

Van der Graeff Family | **Jan Mijtens** Dutch (about 1614–1670)

1654 | Oil on canvas | 55 ¼ x 64 inches | Museum purchase with funds provided by Mrs. Bernard Steiner, 1985.279

Mijtens specialized in group portraits presented within a landscape. This painting depicts Pieter and Sophia van der Graeff with their daughters Machtild, who holds a basket of flowers, and Cornelia, who holds a nautilus shell. A third daughter, Petronella, hovers in the clouds above, a Dutch convention for representing deceased children. She directs a crown of laurel toward her father's head, who himself died before the painting was completed. Additional symbolic elements include the dog, indicative of marital fidelity, and the act of passing pearls from mother to child, which alludes to virtue. Mijtens was particularly adept at rendering the details of the fashionable and elegant clothing worn to reflect the affluence of Dutch burghers in the seventeenth century. This painting is signed and dated in the lower right.

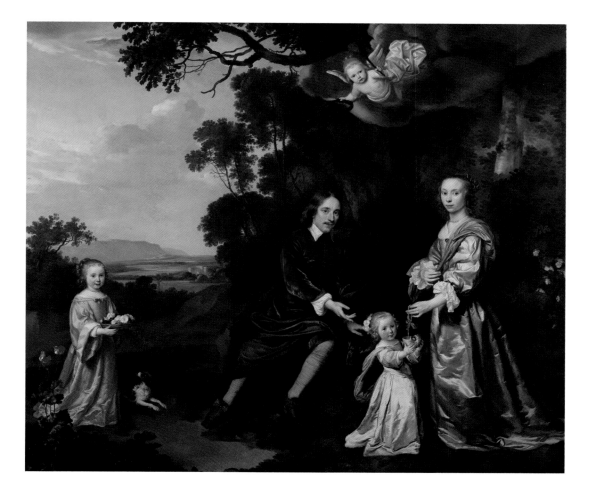

Christ Presented to the People (Ecce Homo) | Rembrandt van Rijn

Dutch (1606–1669)

1655 | Drypoint (state 8 of 8) | 13 ⅞ x 17 ¾ inches | Bequest of Mr. and Mrs. Oscar Wells, 1957.97

This scene depicts the moment when a turbaned Pontius Pilate, Roman governor of Judaea, presents Jesus to the public below, who condemn him. In the history of printmaking this work is notable for its medium, large size, and the remarkable number of revisions it underwent. Rembrandt made it entirely in drypoint (lines drawn with a needle directly onto the copper plate, rather than on a ground of wax or resin, as in etching). Earlier states included a large crowd of onlookers in the foreground, but by this final state

Rembrandt had dramatically reworked the plate by obliterating the spectators and replacing them with two arches and a male figure in between. Although it was probably the wearing down of the delicate drypoint burr that necessitated the changes, in altering the composition Rembrandt completely shifted the focus of the scene. Rather than the viewer being drawn into the subject through the crowd, emphasis is now directly on the Presentation itself and the gravity of the moment.

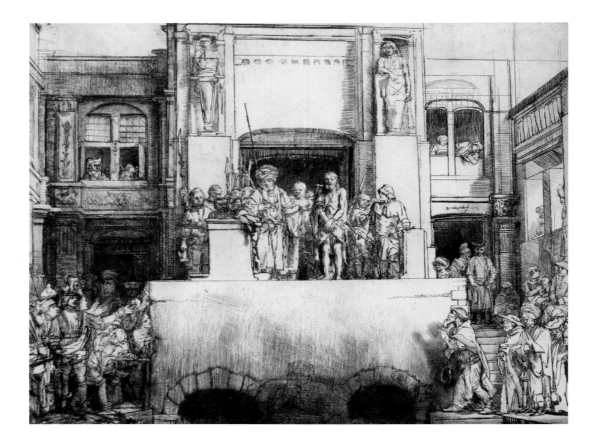

Quirinus Stercke | **Ferdinand Bol** Dutch (1616–1680)

1658 | Oil on canvas | 42 x 35 ¼ inches | Gift of Mr. David R. Silver, 1980.359

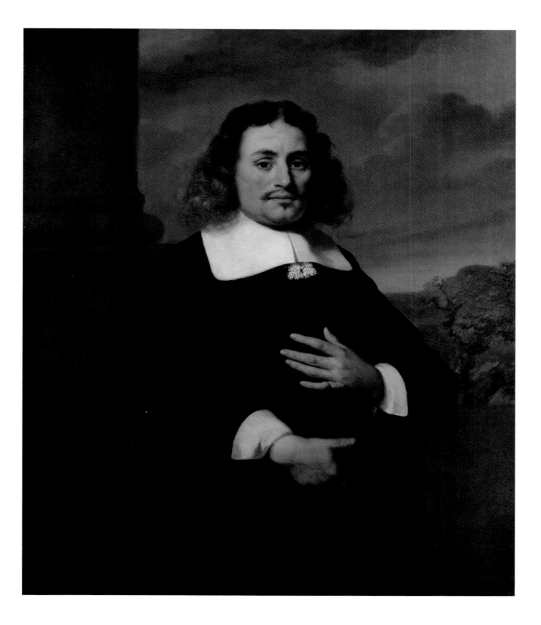

Ferdinand Bol was one of Rembrandt's most accomplished pupils. He painted many fashionable portraits of the leading burghers, whose newfound wealth and prestige fueled an insatiable desire for likenesses of themselves. Quirinus Stercke, chief clerk at the Admiralty of Amsterdam, married Helena Eckhout (whose corresponding portrait resides in the collection of the Herbert F. Johnson Museum of Art at Cornell University) in 1648. The two paintings are dated 1658 and therefore commemorate the couple's ten-year marriage, rather than their wedding, as was often the case for double portraits. These paintings are typical of Bol's style: three-quarter-length figures, well-dressed but not flamboyant, posed in front of a classical column with a landscape in the background. Husband and wife are placed at slight angles to one another and are seen slightly from below, so that the viewer's gaze moves effortlessly to their faces.

Canal in Winter | **Jacob van Ruisdael** Dutch (about 1628–1682)

1660s | Oil on canvas | 14 ⅜ x 12 ¾ inches | Gift of Mr. and Mrs. William M. Spencer, Jr., 1968.43

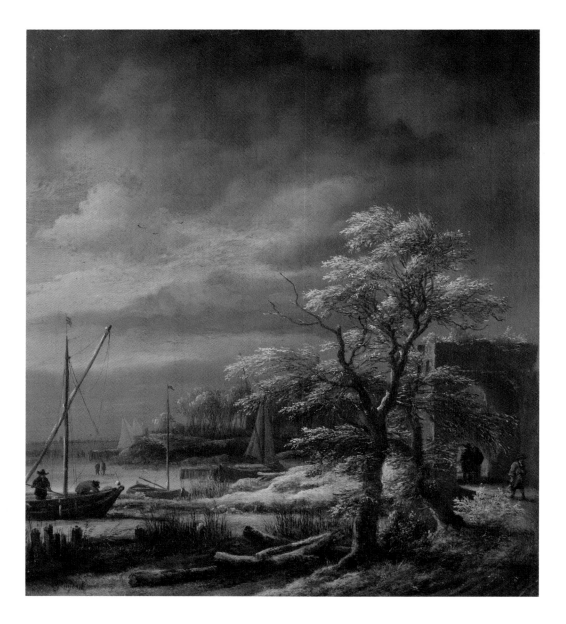

Ruisdael is considered one of the greatest Dutch landscape painters. Of the nearly 700 paintings in his oeuvre, this work, signed on the lower left, is one of only about thirty winter scenes. Like this painting, most are small in scale. Although none are dated, this example is judged on stylistic grounds to be from the 1660s, based upon its compact composition and the deeply contrasting lights and shadows that predominate. Here Ruisdael aptly captured the hushed, late-afternoon chill of a Dutch winter day. Every element amplifies the mood, from the subdued palette to the blustery storm clouds fast approaching, and to the feathery foliage, white with frost. Yet people still go about their daily business, unperturbed by the severe weather. Ruisdael's paintings are sometimes interpreted as expressing an underlying moral theme. Here the decayed vegetation at the water's edge might embody the inevitable transience of nature, and correspondingly, of human life.

Garden Vase

Nevers, France | 1660–1680 | Tin-glazed earthenware (faïence) with blue and white enamel decoration | 21 x 15 ½ x 13 ⅜ inches | Gift of Robert Sistrunk, 1980.346

The name "Nevers" refers to a group of faïence (tin-glazed earthenware) factories in the Bourgogne region of France. The first was founded around 1588 by three brothers from Italy, who brought with them the Italian majolica tradition. By the mid-seventeenth century, the potteries were producing objects in a distinctly French style, but also designs influenced by those found on imported Chinese porcelain. The quality of Nevers pottery is exceptionally high and reflects the best of the seventeenth-century French pottery tradition.

This large vase was used to hold a bush or small tree, probably of some exoticness or rarity, which would have been housed over winter in an orangery, or greenhouse. It is decorated with lively *chinoiseries*—imitations of Chinese art that were seldom accurate and always rendered with deference to the European stylistic ideals of the time. The molded handles are unusual in the oeuvre of the Nevers potteries.

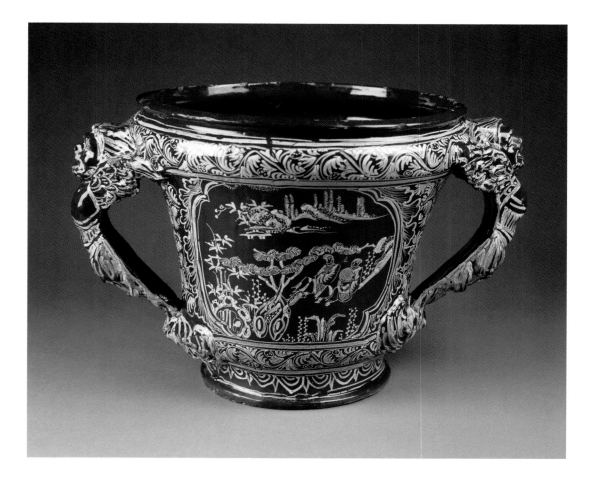

Allegory of Charles I of England and Henrietta of France in a Vanitas Still Life |
Carstian Luyckx French (1623–well after 1658)

After 1669 | Oil on canvas | 57 ½ x 47 ¼ inches | Museum purchase with funds provided by Martee Woodward Webb; Mr. and Mrs. Edmund England; Dr. and Mrs. Rex Harris; Mrs. William McDonald, Jr.; Mr. and Mrs. Stewart M. Dansby; and Ms. Pauline Tutwiler, 1988.28

Vanitas still-life paintings, which carried messages of transience and the inevitability of death, became increasingly popular in the seventeenth century. The subject here refers to the troubled reign of Charles I (1625–1649) and eventual execution. His attempts to expand monarchical power led to two civil wars and a subsequent conviction for high treason. His widow, Henrietta Maria of France, returned to her homeland, where she spent much of the remainder of her life. Many of the elements in this painting are common to *vanitas* works and symbolize the fragility of life, such as the bubbles, skull, and just-snuffed candle.

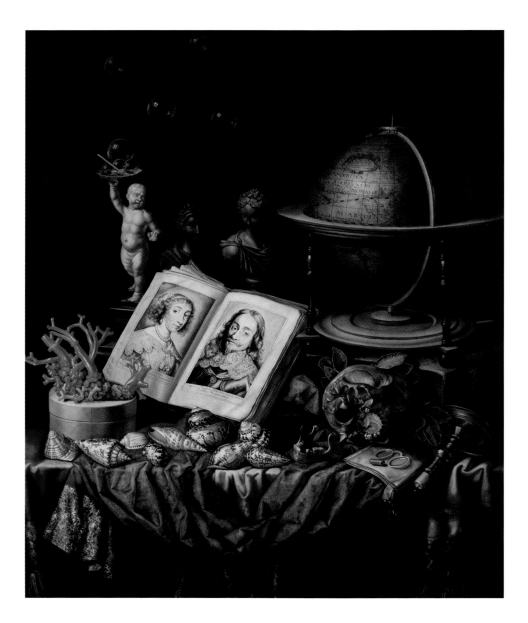

Goblet

Southern Netherlands | Seventeenth century | Blown and diamond-engraved clear glass | 8 ½ x 3 ⅝ inches | Gift of the families of Mr. and Mrs. D. Lawrence Faulkner, Mr. and Mrs. Thomas M. Boulware III, and Mr. and Mrs. Ehney A. Camp III in memory of their mother, Mildred Tillman Camp, 2005.6

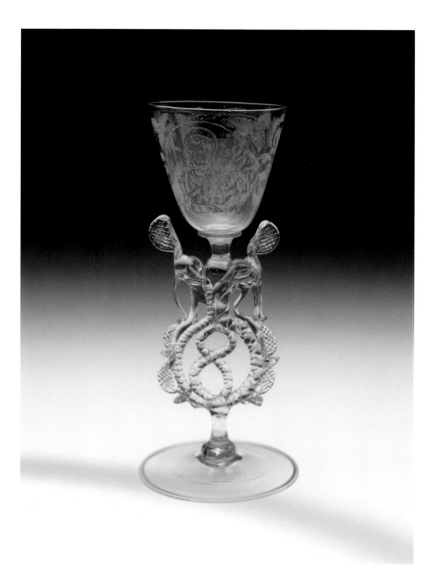

Venetian glassware reached its height in the sixteenth and seventeenth centuries and was copied throughout Europe as *Façon de Venise* (Venetian-style), most notably in Germany and the southern Netherlands. This type of drinking vessel is known as a winged goblet because of the designs flaring outward from the stem. An extremely popular form that was widely reproduced, the winged goblet is often represented in Dutch still-life paintings of the period.

This goblet is further distinguished by the engraving on its bowl, which depicts St. Paul with the sword and St. John the Baptist holding a cross, Bible, and lamb. Because the southern Netherlands was primarily a Protestant region, it is unusual to see Roman Catholic imagery on Dutch glass of the period.

Flora | **François van Bossuit** Flemish (1635–1692)

Late seventeenth century | Ivory | 4 ⅞ x 3 ⅞ inches | Gift of Patty McDonald, 2005.13

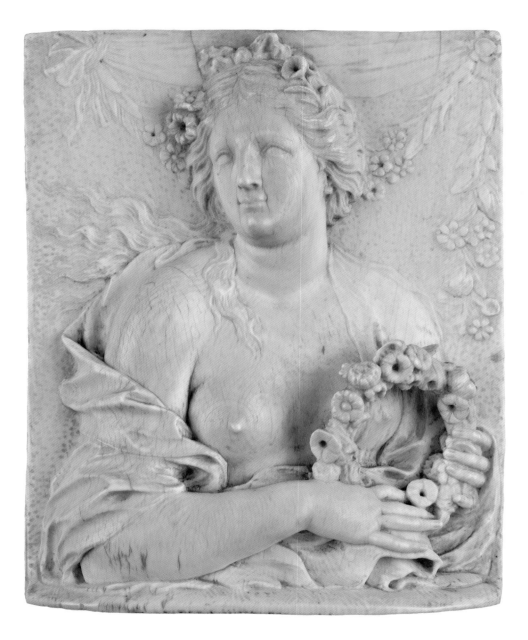

By the seventeenth century in Europe ivory supplies from sub-Saharan Africa were increasingly plentiful and artists skilled in carving the difficult medium became highly sought-after. While Bossuit also worked in wood, clay, and wax, he excelled in carving exquisite reliefs in the lustrous material. Information about his early training is sparse, but by about 1655 he settled in Rome and remained there for the next thirty years. *Flora,* who represents the Roman goddess of flowers and spring, is a dazzling example of his ability to impart depth and texture to his subjects. The lower portion is carved in fairly high relief, with the wreath of flowers almost entirely detached from her body. Details of her hair and garlands of flowers recede to a nearly paper-thin low relief. The minutely flecked background enhances depth by creating a flickering effect.

Study for a Frame | Giovanni Battista Foggini Italian (1652–1725)

About 1700 | Pen and brown ink, brush and brown wash, over black chalk, on three sheets of laid paper | 36 ½ x 20 inches | Museum purchase with funds provided by the Beaux Arts Krewe, 2003.31

This drawing is a study for one half of a frame by Foggini, the preeminent sculptor working in Florence during the late Baroque period. This leading court artist to Cosimo III de' Medici drew masterful studies for sculpture, small bronzes, furniture, reliquaries, and other metalwork, all made in his large studio. This frame was likely designed for a large-scale decoration in stucco or *pietre dure* (colored marbles), perhaps for an ecclesiastical setting. It was common to work up only one side of a frame, since the other side would be a mirror image.

An inscription on the drawing, in a nineteenth-century hand, misidentifies the draftsman as Gianlorenzo Bernini. Comparison of the two artists' draftsmanship clearly places the attribution in the hands of Foggini, whose quick, confident strokes and boldly decorative composition epitomize the dramatic Baroque style.

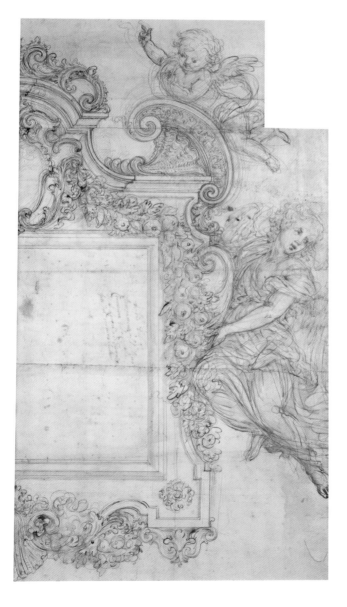

Perfume Fountain

Paris, France | About 1710 | Porcelain with underglaze blue enamel decoration and gilt bronze | 17 ¼ x 10 inches | The Eugenia Woodward Hitt Collection, 1991.22 a-b

This perfume fountain is made up of three different pieces of seventeenth-century Chinese blue and white porcelain, united by a series of delicate gilt-bronze mounts. It was no doubt made for a Parisian *marchand-mercier*, a person who combined the roles of antique dealer and interior decorator. The *marchand-mercier* exerted a great influence on the taste of the period through his control over the designers and craftsmen he patronized. Unusual objects like this perfume fountain were often commissioned specially for a particular client or interior.

Porcelain had been exported in great quantities into Europe since the mid-seventeenth century and pieces were often broken in transport. This perfume fountain was made of parts salvaged from three separate, damaged covered jars. Together they present an object of exotic yet restrained beauty, and one that was also completely functional. The perfume fountain was designed to dispense through its spigots small amounts of fragrant water that could be used by women to freshen up or to sweeten a room's odor.

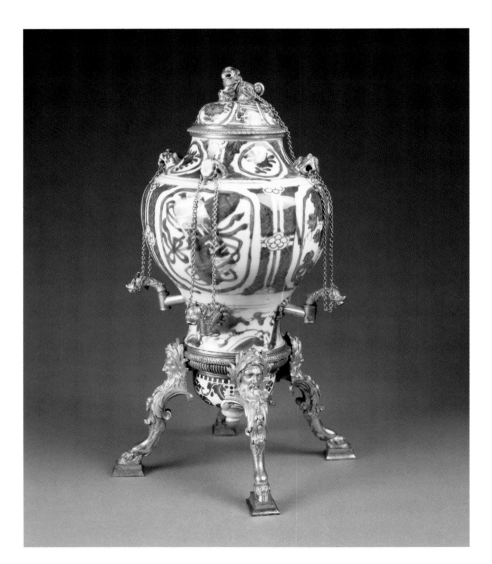

Pair of Firedogs

Paris, France | 1710–1720 | Gilt bronze | 13 ⅞ x 9 x 4 ⅝ inches each | The Eugenia Woodward Hitt Collection, 1991.37.1-.2

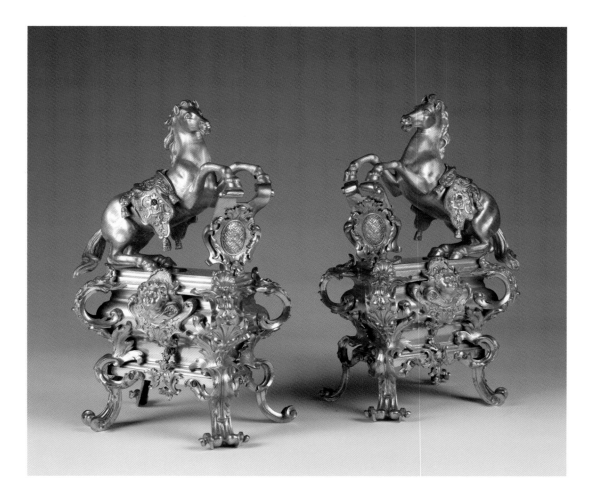

Pairs of firedogs, or andirons, were used in eighteenth-century fireplaces to add a decorative element to the simple iron grills that held burning logs above the level of the hearth. During this period in France, such objects were elaborately decorated and often gilded, thus providing a focal point for a room.

Stylistically, this pair of firedogs reflects the transition between the heavy and massively ornate forms popular during the reign of Louis XIV and the lighter, less formal and more graceful designs found under Louis XV. Known as the Régence, this style defines the period from around 1700 to 1720, which includes the last few years before the death of Louis XIV in 1715 and the advent of the reign of his grandson Louis XV in 1723. Here, rearing horses and elaborate masks, characteristic of the Louis XIV period, are mingled with the delicate curves and shell motifs of the nascent Rococo style.

Ewer

Rouen, France | 1710–1720 | Tin-glazed earthenware (faïence) with underglaze blue enamel decoration | 11 ½ x 10 ⅜ x 6 ⅛ inches | Museum purchase, 2000.1

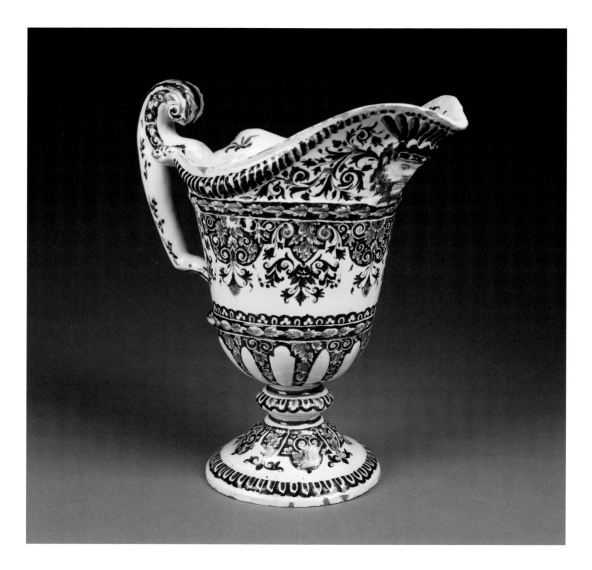

During the late seventeenth and early eighteenth centuries, Rouen was one of the most important centers for faïence production in France. As at Nevers, the region around Rouen was characterized by a number of different factories, whose products today—because they are rarely marked—cannot be attributed to any one maker.

This ewer reflects the style most closely associated with the Rouen potteries. It is liberally decorated with lambrequins—fringe-like ornaments—scrolls, and arabesque motifs in blue on a white ground. It illustrates the way in which decorative elements are dispersed and adapted to different types of objects. The lambrequin, for example, is derived from representations in heraldry, while arabesques are thought to have stemmed originally from Persian metalwork patterns. This type of decoration was popular during the Louis XIV and Régence periods and can be found on ceramics as well as other types of decorative objects. The helmet shape of the ewer is copied from contemporary French silver vessels.

View of the Grand Canal | Giovanni Antonio Canal, called Canaletto

Italian (1697–1768)

Late 1720s | Oil on canvas | 23 ¾ x 39 ½ inches | Gift of the Samuel H. Kress Foundation, 1961.121

During the eighteenth century many travelers visited Venice as part of the European "Grand Tour." Canaletto was Venice's most successful painter of *vedute*, or "views," and his paintings were among the most sought-after pictorial mementos of these trips. Indeed, the earliest known provenance of this painting is a private collection in England; the work may well have been made as a souvenir for the tourist market.

Canaletto created more than 100 paintings of the Grand Canal, the primary thoroughfare in Venice.

Although he was not always topographically accurate, the exact location of his view for this painting can be identified: the tall building on the left is the beautiful Palazzo Vendramin-Calergi, and the first building on the right is the Deposito del Megio, or public grain warehouse. Canaletto brilliantly conveyed his keen sense of observation; here he animates the painting by recording the lively activity on the canal.

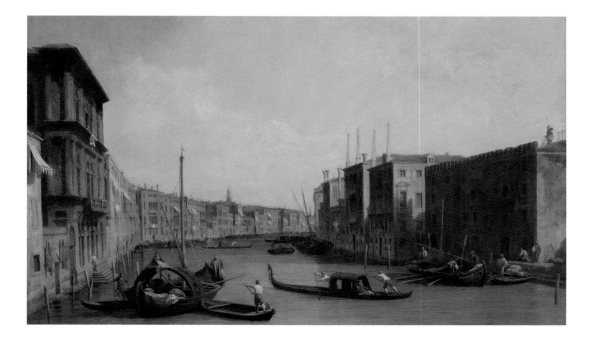

Matthew, Mark, Luke, John (the Four Evangelists) | Giuseppe Bernardi, called Torretto Italian (1694–1774)

1730–1760s | Terracotta | Matthew: 23 inches; Mark: 23 ¼ inches; Luke: 22 ¾ inches; John: 22 ½ inches | Museum purchase with funds provided by the Beaux Arts Krewe, 2001.10.1–.4

During the first half of the eighteenth century the Filippini Order in Venice undertook a restoration and expansion of its church, Santa Maria della Fava. This included an extensive, unified decorative scheme of paintings and sculptures considered to be among the glories of Venetian eighteenth-century artistic production. Indeed, some of the paintings are the greatest masterpieces of the period, by artists such as Giambattista Tiepolo, Jacopo Amigoni, and Giambattista Piazzetta.

Although Giuseppe Bernardi is not well known today, he was among the most prominent sculptors working in the region during the middle of the eighteenth century. He worked on large and small projects in and around Venice, where his graceful, refined style was avidly sought. As a boy he took the nickname il Torretto, the family name of his maternal uncle, Giuseppe Torretto. Bernardi learned his craft from Giuseppe, whose large workshop he inherited to continue the family tradition. The limited number of documentary sources that pertain to Bernardi indicate that he was quite prolific, having taken on numerous, overlapping projects. We must presume that he had a highly efficient workshop to help him carry out his many commissions.

By the 1730s Bernardi was engaged with the Santa Maria della Fava sculptural project, which would take several decades to complete. This commission, which comprised eight, over-lifesize marble statues of the four Evangelists and the four Western Fathers of the Church, was the most monumental and complete of Bernardi's many sculpted cycles. The four terracottas now in Birmingham are preparatory works for the Evangelists, and are Bernardi's only identified sculptural models.

The role of models in seventeenth- and eighteenth-century sculptural practice is carefully described in contemporary treatises. These terracottas, however, deviate from the prescribed norm. Each measures almost exactly one *braccio* (an old Italian unit of measure) high, the recommended size for *modelli*. Rather than being detailed and carefully finished, however, as most models were, their rapidly worked surfaces identify the terracottas as *bozzetti*, or sketches made while the artist was still in the throes of the creative process. These three-dimensional sketches are analogous to the immediacy of a drawing, and retain the echo of the sculptor's hands in the literal form of fingerprints and tool marks. Bernardi was indeed still working out the compositions of his figures: by the time the marble blocks were sculpted, modifications in drapery, hand gestures, and location of attributes had been made. These vigorously modeled terracottas display a liveliness not found in the somewhat bland finished marbles, which were probably completed by the many workshop assistants.

Bernardi is best known as the first teacher of the great Neoclassical sculptor Antonio Canova. These terracottas reveal Bernardi's virtuosic modeling skills in the powerful musculature of the figures and in the energetic folds of the robes. And as Bernardi's only known preparatory works, they also demonstrate the origins of Canova's own adroit and expressive techniques with clay.

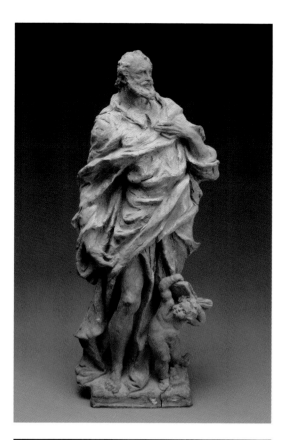

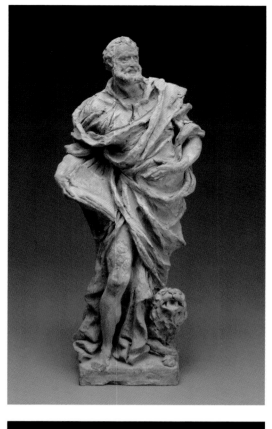

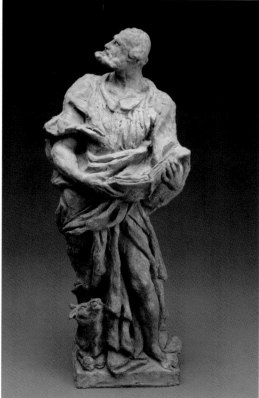

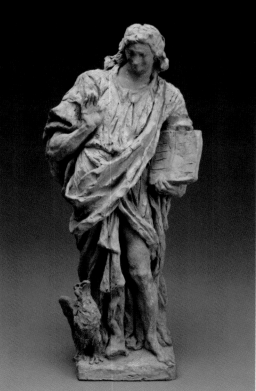

Still Life with Dead Game and Peaches in a Landscape | Jean-Baptiste Oudry

French (1686–1755)

1727 | Oil on canvas | 31 ½ x 39 ½ inches | Collection of the Art Fund, Inc. at the Birmingham Museum of Art; Purchase with additional funds provided by Henry S. Lynn, Jr., Mr. and Mrs. Lee McGriff III, and Margaret Gresham Livingston, AFI8.2004

As a student, Oudry copied the exacting works of seventeenth-century Dutch and Flemish artists, particularly those who excelled in still-life paintings. In the mid-1720s when this painting was made, Oudry had begun to receive royal commissions from Louis XV and soon became one of the king's favorite artists. His skillfull depiction of animals, alive and dead, earned him the title Painter-in-Ordinary of the Royal Hunts in the king's service. Hunt still-life paintings such as this, hung in dining rooms, were phenomenally popular during the first half of the eighteenth century. Oudry often included fruit along with animals in order to flaunt his ability to render a variety of textures. The luscious peaches in the foreground also provide a colorful contrast to the otherwise muted palette. Oudry signed and dated this painting in the lower-right corner.

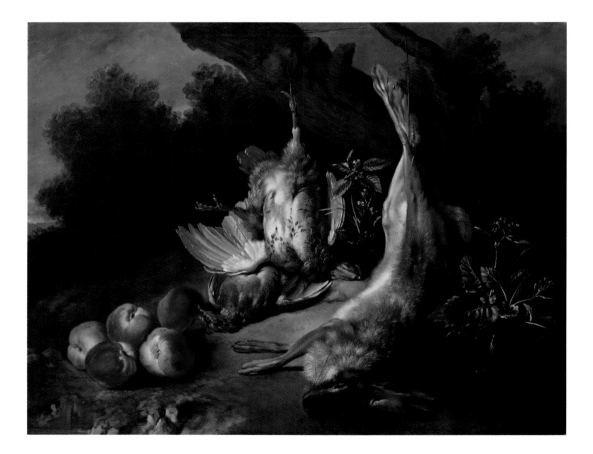

Seated Harlequin with Tankard | Model by **Johann Joachim Kaendler**
German (1706–1775) **Meissen porcelain manufactory** (est. 1710)

Meissen, Germany | 1740 | Hard-paste porcelain with enamel decoration and gilding | 6 ½ x 5 x 2 ¼ inches | The Eugenia
Woodward Hitt Collection, 1991.323

Harlequin and Columbine Dancing | Model by **Johann Joachim Kaendler**
German (1706–1775) **Meissen porcelain manufactory** (est. 1710)

Meissen, Germany | About 1744 | Hard-paste porcelain with enamel decoration and gilding | 8 ½ x 8 x 4 ½ inches |
The Eugenia Woodward Hitt Collection, 1991.313

Pantalone | Model by **Johann Joachim Kaendler** German (1706–1775)
Meissen porcelain manufactory (est. 1710)

Meissen, Germany | About 1736 | Hard-paste porcelain with enamel decoration and gilding | 6 1/8 x 3 3/8 x 3 3/8 inches |
The Eugenia Woodward Hitt Collection, 1991.320

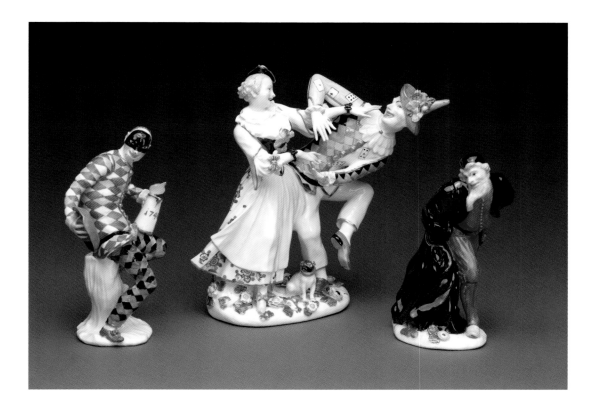

During the 1730s and 1740s, Meissen introduced a series of porcelain figures based on characters of the *Commedia dell'arte,* a type of theater that originated in Italy. The *Commedia* is based on improvised sketches that found inspiration in the scandals and intrigues of the court at which they were performed. The characters of the *Commedia* were recognizable through the costumes and masks they wore and the props they used.

The figures were designed primarily as decorations for the dessert table. They were arranged thematically and provided intellectual stimulation or entertainment for the host and his guests, who it can be assumed understood the underlying political or social messages conveyed through the arrangement of the figures. Kaendler was a skilled modeler and was able success-fully to capture the comic nature of the characters.

Charger from the *Swan Service* | Model by **Johann Joachim Kaendler**
German (1706–1775) and **Johann Friedrich Eberlein** German (1695–1749)
Meissen porcelain manufactory (est. 1710)

Meissen, Germany | 1737–1741 | Hard-paste porcelain with enamel decoration and gilding | 2 ¾ x 16 ⅝ inches | Museum purchase with funds provided by Mrs. Morris W. Bush, Mrs. Catherine H. Collins, Thomas L. Fawick, Mrs. Horace Hammond, Chester H. Huck, Colonel and Mrs. George Knight, Frances Oliver, Nan L. Phillips, Floyd Railey, William Spencer, Jr., Elizabeth S. Steiner, Dr. M. Bruce Sullivan, and Helen Verplanck, by exchange, and Pauline Tutwiler, 1989.126

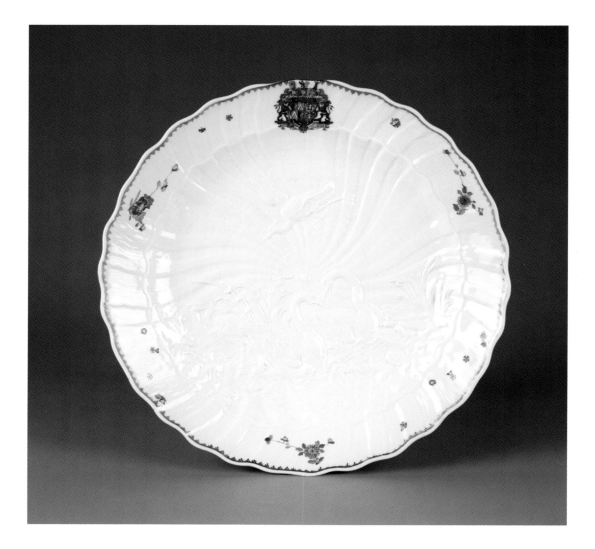

The Swan Service is one of the grandest table services made by Meissen. It was commissioned in 1737 by Heinrich, Count von Brühl (1700–1763), who had once been the director of the Meissen manufactory.

The main image on the platter, and that from which the service got its name, is the swan. It is unclear why it was chosen as the primary decorative motif. Perhaps because water was one of the most popular themes of Baroque tablescapes, of which the Swan Service represents the artistic and stylistic height.

Cake Basket on Stand | Paul de Lamerie English (1688–1751) and
Paul Storr English (1771–1844)

London, England | 1740–1741 and 1820–1821 | Silver | 12 ¾ x 15 ⅞ x 13 ¾ inches | The Frances Oliver Collection, 1972.287-.288

The work of two master silversmiths combined to create this elegant basket and matching stand that were originally used for serving bread or small, sweet pastries. Paul de Lamerie, the best-known and respected silversmith of his time, first made the basket, which shows his extravagant use of Rococo ornamentation. Delicately pierced and decorated with scrolling foliage, shells, and masks, it reveals de Lamerie's skill in manipulating silver into elaborate and beautiful yet functional pieces.

Eighty years later, another master silversmith, Paul Storr, created a stand for the basket, probably at the owner's request. In keeping with de Lamerie's design and decorative vocabulary, Storr's stand perfectly complements the work of his predecessor. It was not uncommon for individuals or families to keep important silver pieces for generations. Yet these were often altered or updated in keeping with the fashion of the day.

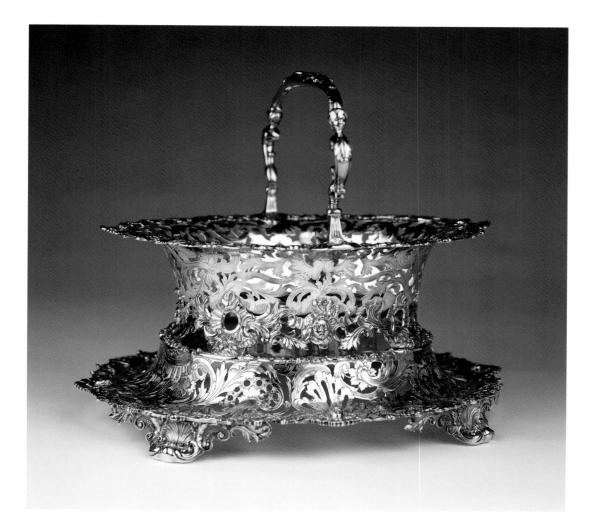

Goat-and-Bee Jug | Chelsea porcelain manufactory (operated 1744/45–about 1770)

London, England | 1745–1749 | Soft-paste porcelain with enamel decoration | 4 ¼ x 3 x 1 ¾ inches | Collection of the Art Fund, Inc. at the Birmingham Museum of Art; The Catherine H. Collins Collection, AFI248.1998

Chelsea was the first porcelain manufactory in England. Established by the Flemish silversmith Nicholas Sprimont, it was designed to compete directly with its German counterpart Meissen.

The goat-and-bee jug is one of the earliest models produced by Chelsea. Designed as a small cream pitcher, the piece was named for the two recumbent goats and small bee applied to a branch below the lip. The exact prototype for the jug is unknown. However, it has been suggested that its design was based on a piece of Rococo silver, now lost. The goat motif can also be found on silver objects that bear Sprimont's mark.

While many Chelsea goat-and-bee jugs were left white, a number of them, such as this example, have been colorfully enameled.

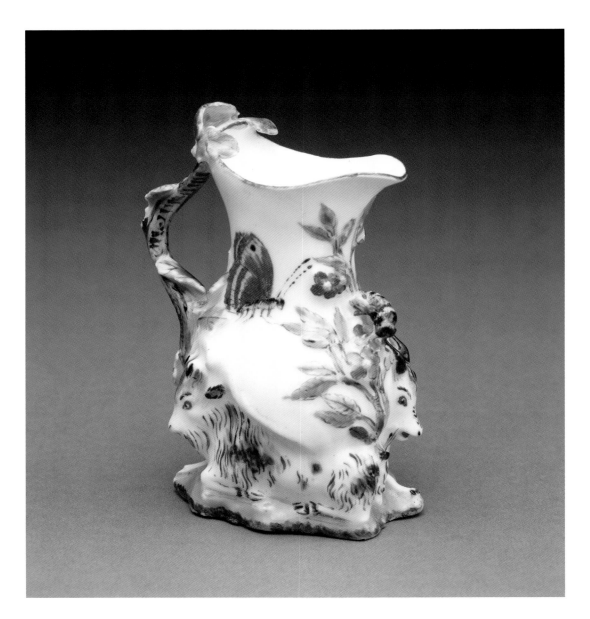

Mongolian Prince and Princess | Bow porcelain manufactory

(operated 1744/49–1776)

London, England | 1752–1755 | Soft-paste porcelain | 4 ⅞ x 3 ¾ inches each | Collection of the Art Fund, Inc. at the Birmingham Museum of Art; The Catherine H. Collins Collection, AFI212-213.1998

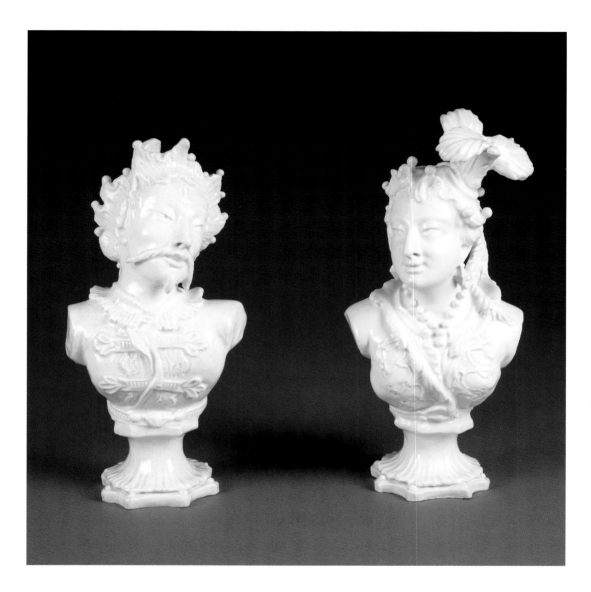

Bow was one of the earliest porcelain manufactories established in England. The factory made soft-paste porcelain, a kind of artificial porcelain made from various and varying ingredients including clay, powdered glass, and calcined animal bone.

Modeled after porcelain factories in China, the Bow manufactory took inspiration from the shapes and styles of Asian export ceramics. It concentrated on the production of tablewares that could compete with imported porcelain. However, decorative figures were also made. This finely modeled, detailed pair of busts, created during the first years of the factory, no doubt appealed to the English consumer's taste for the exotic.

Covered Tureen on Stand │ Niderviller (est. 1754)

Niderviller, France │ 1754–1770 │ Tin-glazed earthenware (faïence) with enamel decoration │ 11 x 21 ½ x 14 ¼ inches │ The Eugenia Woodward Hitt Collection, 1991.344.1-.3

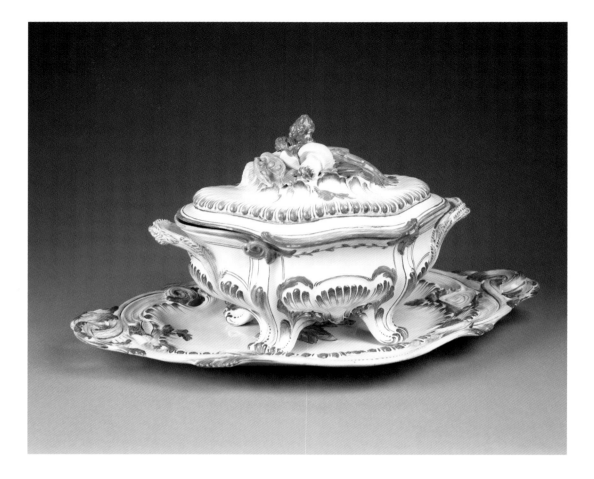

Because porcelain was so expensive during the eighteenth century in Europe, tin-glazed earthenware, known as *faïence* in France, became exceedingly popular. Due to new techniques and the use of colorful enamel pigments that were fixed in an extra, low-temperature firing known as *petit feu,* it became possible to replicate porcelain styles and decoration in faïence.

As dining styles changed, serving dishes began to be placed on the table so that hosts and their guests could serve themselves. This led to the creation of elaborate serving pieces that often reflected the tasty dishes they contained. Tureens, amongst the most important pieces in a service, were used to serve soups, stew, or vegetables and were often modeled in the form of birds, fish, fruits, or vegetables.

Commode | **Jacques Dubois** French (1694–1763)

Paris, France | 1755–1760 | Oak, kingwood, satinwood, purplewood, and gilt bronze | 34 x 56 ½ x 25 ¾ inches | The Eugenia Woodward Hitt Collection, 1991.53

The commode, or chest-of-drawers, was one of the most fashionable and ambitious pieces of eighteenth-century French furniture. A number of craftsmen were involved in its production, including the *marqueteur,* the skilled cabinetmaker who created the inlaid surface of the piece, and the metal worker, who made the highly sculptural gilt-bronze mounts.

The origin of the commode dates to the late seventeenth century. As the eighteenth century progressed, commodes became lighter and more graceful, and the drawers were concealed by elaborate marquetry and mounts. Commodes were as a rule placed between two windows or doors and often beneath a mirror. They almost always included a marble top.

Jacques Dubois was an important cabinetmaker during the reign of Louis XV. He ran a large workshop that made furniture for the aristocracy and royalty, including the king's daughter Elisabeth.

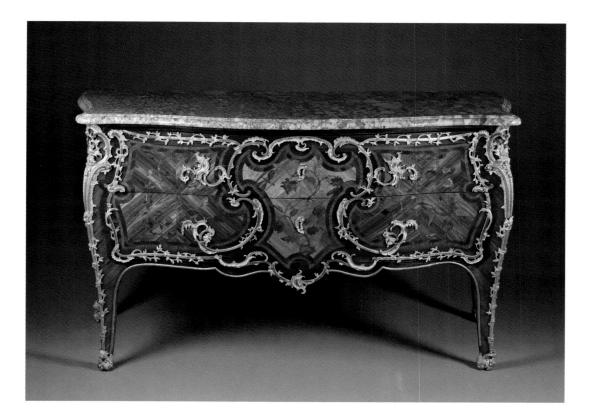

Les Portraits de MM. De Béthune Jouant avec un Chien (Children of the Marquis de Béthune Playing with a Dog) | François Hubert Drouais French (1727–1775)

1761 | Oil on canvas | 38 ¼ x 51 ¼ inches | The Eugenia Woodward Hitt Collection, 1991.254

Drouais was the first in a prominent, multigenerational family of artists who specialized in portraits of the French nobility, foreign aristocrats, writers, and other artists. This painting perfectly characterizes both his work and the playful, lighthearted temperament of the Rococo period. The boys are Armand Louis II (b. 1756) and Armand Louis Jean (b. 1757), sons of Armand Louis I de Béthune. Members of the aristocracy enjoyed dressing their children up in costumes, which Drouais captured in a number of portraits. Here the artist luxuriates in the details of the boys' elaborate attire: sumptuous velvet suits with slashed sleeves, silk ribbons, and lace collars and cuffs. The pug, being taught by the children to play the guitar, adds to the charm of this signed and dated painting.

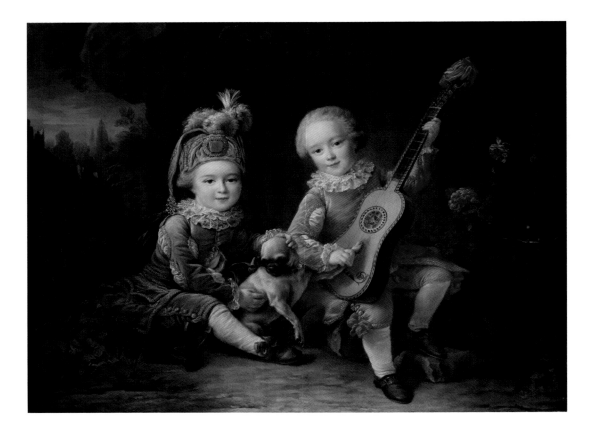

Tray | Painted by **Charles-Louis Méreau** French (1735–1780) **Sèvres porcelain manufactory** (est. 1756)

Sèvres, France | 1765 | Soft-paste porcelain with enamel decoration and gilding | 2 ⅜ x 10 ⅞ x 14 ⅞ inches | Museum purchase, 2000.13

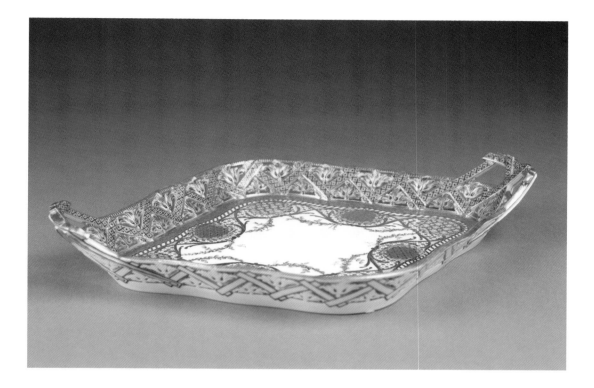

This delicate tray painted in bright enamel colors with a pattern of scrolls, leafy vines, ribbons, and repeating geometric patterns was most likely originally part of a *déjeuner,* a set of porcelain vessels comprised of a tea- or coffee pot, cup and saucer, sugar bowl, and cream jug together with a matching tray. We can identify the painter of the tray through the marks on its underside.

From almost its inception, Sèvres has used the French royal monogram—a pair of intertwined Ls—as a factory mark and has included a letter to represent the year made. Although many craftsmen were involved in the decoration of a piece, up until about 1770 only the painters signed their work. These marks were used as a way to control the quality and quantity of the painters' output, rather than to highlight individual accomplishment.

Four Quarters of the Globe | Derby porcelain manufactory

(operated about 1751–1848)

Derby, England | 1765–1775 | Soft-paste porcelain with enamel decoration and gilding | 11 ¾ x 5 ⅞; 12 x 5 ¼; 12 ½ x 5 ½; 11 ½ x 5 ½ inches | Gift from the Estate of Mr. and Mrs. William Hansell Hulsey, 2000.177.1-.4

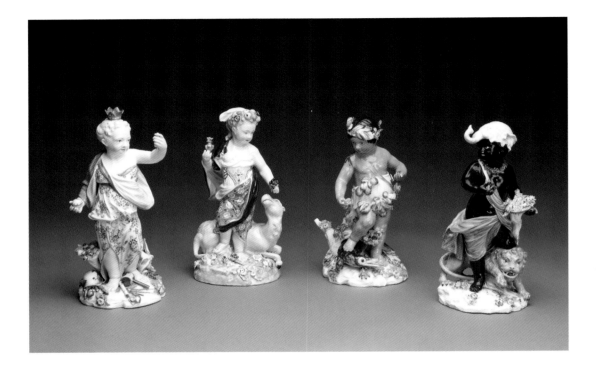

These four chubby children represent the four continents recognized in the late eighteenth century: Europe, Asia, America, and Africa. Each is dressed in accordance with established notions about the traditional garb of the people and is displayed with the attributes and symbols of its individual continent.

A number of porcelain factories in England and Europe produced sets of the four continents either individually or in groups. While similar figures of smaller size are fairly common, only three sets of the larger figures, including the Birmingham set, are known today. All were made at the Derby factory around the time it merged with the prestigious, but failing, Chelsea porcelain manufactory. The merger of these two companies allowed for the first time the creation of larger figural models.

Chocolate Pot

Probably Staffordshire, England | 1770–1775 | Lead-glazed earthenware (creamware) with enamel decoration | 7 ½ x 7 ⅛ x 5 inches | Collection of the Art Fund, Inc. at the Birmingham Museum of Art; The Catherine H. Collins Collection, AFI145.1998a-c

The custom of drinking hot chocolate was introduced in Europe during the eighteenth century. Enriched with milk or cinnamon, hot chocolate offered the consumer a sweet alternative to the other new drinks, tea and coffee. Chocolate was also considered to have medicinal properties and was used to treat a variety of diseases.

Chocolate pots were produced during the period in a variety of materials, shapes, and sizes. They are typically characterized by their short spouts located high on one side and the presence of a hole in the cover for the purpose of inserting a utensil to stir the thick drink into a froth before serving. This rare example has a double cover.

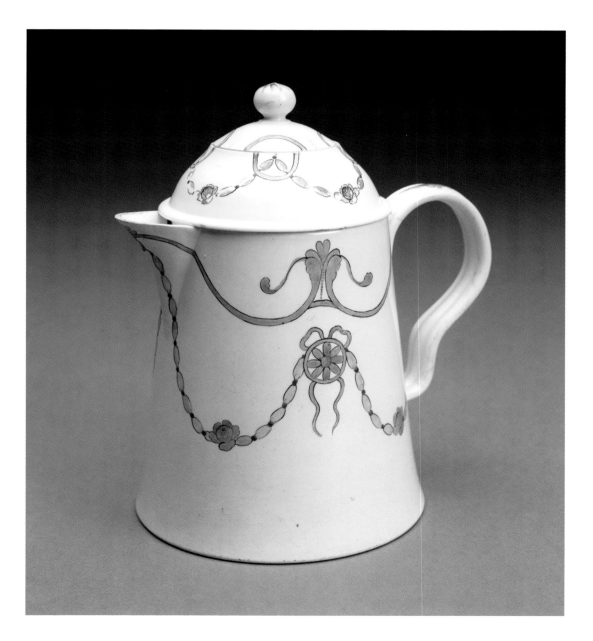

Pair of Candlesticks | Matthew Boulton and John Fothergill

English (in partnership from about 1762–1781)

Birmingham, England | 1773–1774 | Silver | 11 ⅜ x 3 ⅞ x 3 ¾ inches each | Gift of Mr. and Mrs. William M. Spencer, Jr., 1955.43c-d

Matthew Boulton was a manufacturer and industrialist in Birmingham, England, and is best known for the production of small, decorative items of cut steel, many of which incorporated jasperware medallions made by the ceramics manufactory of Josiah Wedgwood.

Around 1762, Boulton entered into partnership with John Fothergill, and soon afterwards the firm added sterling silver to its repertoire. This pair of candlesticks, two of a set of four, incorporates elements of the popular Neoclassical style, which define most productions of the partnership. While acanthus leaves decorate the columnar stem, the base is ornamented with interlacing, curved bands enriched with small rosettes, known as guilloches. Reflecting elements inspired by Greco-Roman architectural details, these candlesticks were in perfect keeping with the interior style of the period. After the Boulton-Fothergill partnership ended, the Boulton company continued to produce silver and other objects until it closed in 1844.

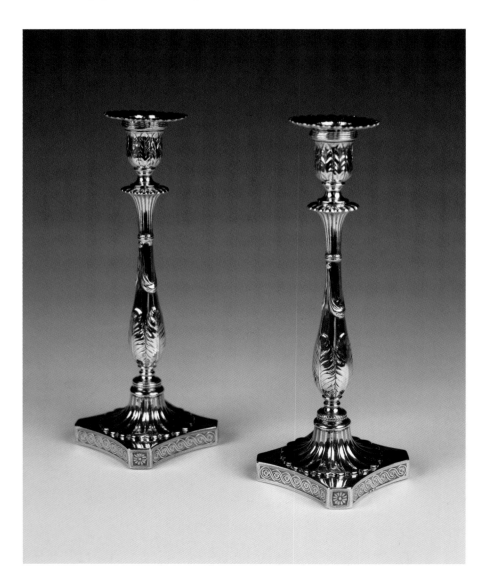

Platter from the *Frog Service* | Wedgwood (est. 1759)

Staffordshire, England | 1773–1774 | Lead-glazed earthenware (creamware) with enamel decoration | 1 x 19 ⅜ x 14 ⅞ inches | The Dwight and Lucille Beeson Wedgwood Collection, 1983.7

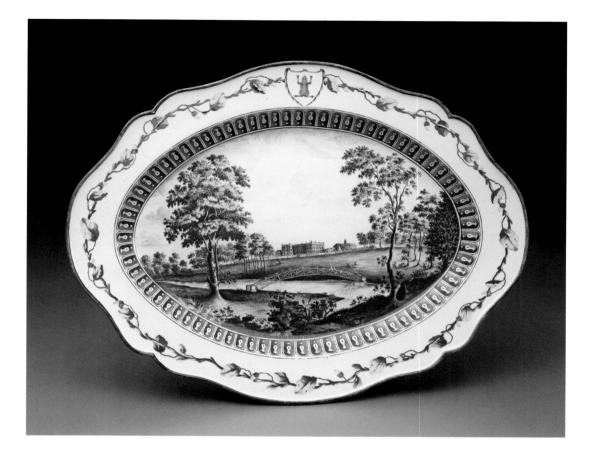

In 1773, Josiah Wedgwood received his largest and most important commission: the creation of a dinner and dessert service for Empress Catherine the Great of Russia. The Empress was a devoted anglophile, who delighted in Wedgwood's suggestion to decorate her service with views of England, Scotland, and Wales. The service was destined for Catherine's Chesmenski Palace near St. Petersburg, which was located close to a frog swamp. It was accordingly decided that a small green frog should be used as the crest on each piece.

This platter depicts Ditchley Park in Oxfordshire, seat of the Earls of Litchfield. While it was made as part of the service, the platter was never actually sent to Russia. A handful of pieces remained in the West. All of these are thought to have been omitted from the service by Wedgwood for technical or other reasons.

Somnus | **Wedgwood** (est. 1759)

Staffordshire, England | About 1774 | Stoneware (black basalt) | 11 ½ x 22 ½ x 14 inches | Collection of the Art Fund, Inc., at the Birmingham Museum of Art; The Buten Wedgwood Collection, gift through the Wedgwood Society of New York, 300.2008

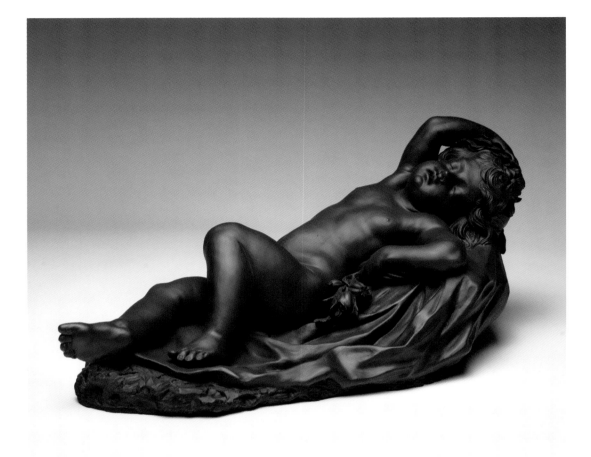

The prototype for this figure is the sculpture by Alessandro Algardi, now in the Galleria Borghese in Rome. Wedgwood had access to it through an engraving in Bernard de Montfaucon's work *L'antiquité expliquée,* a popular design source. Made of black basalt, a kind of stoneware, the figure is one of the largest and earliest produced by Wedgwood.

Although Wedgwood called the figure Morpheus, it is today recognized as Somnus, god of sleep. Here, Somnus slumbers peacefully on a rocky base. His wings are draped to one side and his right arm rests above his head. His left hand clutches a bouquet of sleep-inducing poppies. In Roman mythology Somnus is the son of Night and brother of Death. He was considered a benefactor to man, giving the weary rest and sufferers alleviation of their pain.

While this figure was once apparently in serial production, today there are only two extant examples known. In addition to this figure, there is one in Wörlitz Palace in Dessau, Germany. Commissioned in 1774 by Prince Leopold III Friedrich Franz of Anhalt-Dessau, it still rests in its original location.

Sir George Chad, Baronet of Thursford; Lady Chad | Thomas Gainsborough

English (1727–1788)

About 1775 | Oil on canvas | 28 ½ x 24 inches and 28 ½ x 23 ½ inches | Gift of Eugenia Woodward Hitt, 1968.19, 1968.20

Gainsborough was the leading portrait painter of his time. His technically accomplished "face paintings," as he called them, provide a glimpse into the lives of the eighteenth-century British gentry. This pair of companion portraits, perhaps painted on the occasion of the couple's wedding, dates to late in Gainsborough's career. The artist moved permanently to London in 1774, and thereafter his work was characterized by a light palette and breezy, economical brushstrokes. His affinity for landscape painting is suggested in the sophisticated merging of the figures with the landscape.

George Chad (1730–1815) held the hereditary title of baronet, which ranks immediately below baron and granted him the use of the title Sir. The elegant, relaxed poses of husband and wife (d. 1786) suggest an attitude suitable to their station in life. Mrs. Chad's contemplative pose was one that Gainsborough repeated often for society portraits.

The Museum also possesses a portrait of Mrs. William Monck by Gainsborough, from slightly earlier in his career, when he resided in Bath.

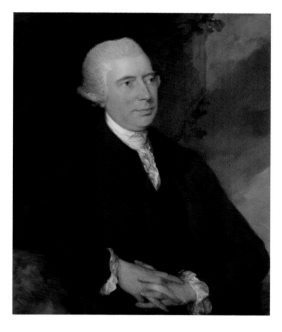
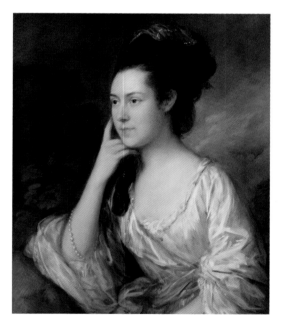

Hall Chair | Attributed to the workshop of Thomas Chippendale

English (1718–1779)

London, England | About 1775 | Mahogany and beechwood with modern upholstery | 37 x 22 ½ x 19 ½ inches | Museum purchase with funds provided by the Decorative Arts Guild, 1989.1

Thomas Chippendale is one of the best-known English furniture designers. Born in Yorkshire, he operated a busy workshop in London and disseminated his designs through his book, *The Gentleman & Cabinet Maker's Dictionary,* first published in 1754. The wide use of this work by other furniture makers made Chippendale a household name, and his ability to supply textiles, wallpapers, and other furnishings to his clients helped him become the premier English cabinetmaker of the eighteenth century.

Chippendale's furniture productions adorn some of the finest English country and town houses, for which he often designed large suites for every room. This chair closely resembles a group commissioned for the entrance hall of Newby Hall in North Yorkshire.

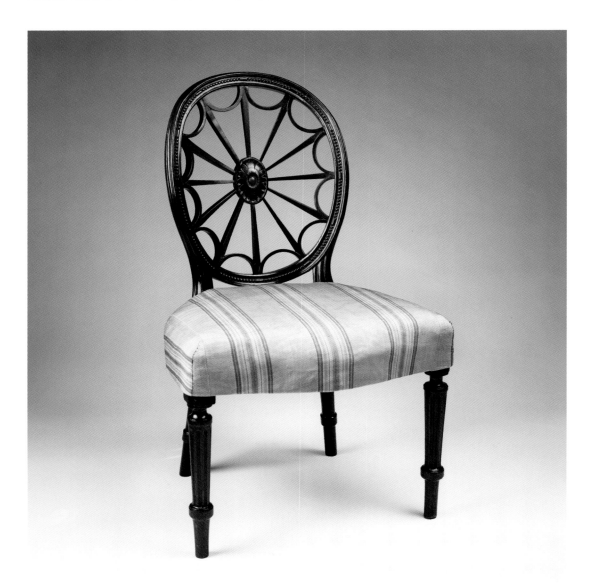

Pair of Chairs | **Georges Jacob** French (1739–1814)

Paris, France | 1780–1785 | Painted beechwood with modern upholstery | 37 ⅜ x 26 ⅞ x 27 ½ inches each | The Eugenia Woodward Hitt Collection, 1991.191.1-.2

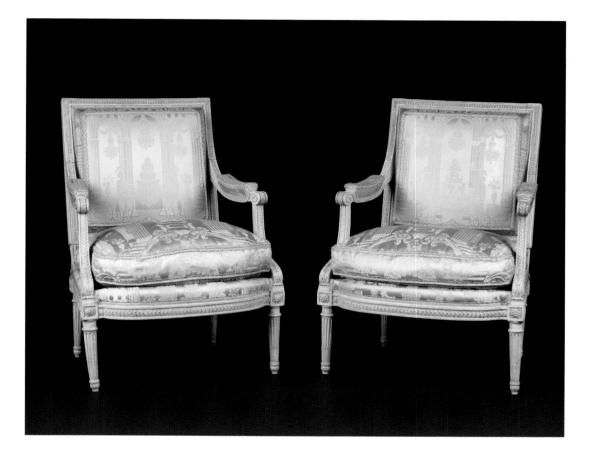

The craft of furniture-making flourished in eighteenth-century France as new types of furniture came into use and changing styles required the constant refurbishing of grand interiors. During this period, chairs played an important role in the strict hierarchy that defined French society, and the armchair was reserved for the most important of persons.

This pair of chairs was made during the reign of Louis XVI in the Neoclassical style, which began as a reaction to the excessive and elaborate designs popular under previous monarchs. In contrast to the Régence and Rococo styles, the Neoclassical style is defined by more simplified, architectonic forms and decoration that consists of delicate elements adapted from those found in the ancient world. While many chairs during the period were gilded, this pair retains its original painted finish, indicating that it was probably made for a bedroom or other private space.

Vase | Designed by **Keith Murray** English, born New Zealand (1892–1981)
Wedgwood (est. 1759)

About 1930 | Lead-glazed earthenware (creamware) | 9 ¼ x 7 ⅝ inches | Museum purchase, 2003.23

Wine Cooler | **Wedgwood** (est. 1759)

About 1950 | Stoneware (jasperware) | 11 ¼ x 10 ½ inches | Collection of the Art Fund, Inc. at the Birmingham Museum of Art;
The Buten Wedgwood Collection, gift through the Wedgwood Society of New York, 1460.2008

Centerpiece | **Wedgwood** (est. 1759)

April 1885 | Tin- and lead-glazed earthenware (majolica) | 11 x 17 ½ x 8 inches | Gift of Susan S. Weitzen, 1999.52

Pair of Vases | Designed by **Courtney Lindsay** English (active at Wedgwood
about 1900-1901) **Wedgwood** (est. 1759)

1900–1901 | Lead-glazed earthenware (pearlware) with printed and enamel decoration | 8 ½ x 6 ¼ x 5 inches each | Collection
of the Art Fund, Inc. at the Birmingham Museum of Art; The Buten Wedgwood Collection, gift through the Wedgwood Society of New
York, 1444.2008.1-.2

Vase | **Wedgwood** (est. 1759)

About 1815 | Stoneware (black basalt) with encaustic decoration | 11 ¼ x 9 inches | The Dwight and Lucille Beeson Wedgwood
Collection, 1982.180

The Wedgwood ceramics manufactory was established in 1759. In that year, Josiah Wedgwood opened his pottery in Burslem, in the Staffordshire region of England. The company grew during the late eighteenth century and, by the time of Josiah's death in 1795, was the largest, most successful, and most modern ceramics factory in the country.

During his lifetime, Wedgwood made it his goal to improve upon the lead-glazed earthenware ceramic body that was so popular for everyday wares. His innovative spirit and solid experimentation led to the improvement or creation of a number of new ceramic types, including his first ornamental ceramic, black basalt. Yet his greatest invention and most significant contribution to the ceramics industry is jasperware, which, in its source of design, its manner of conception, and its tremendous popular appeal, both exemplified and became symbolic of the taste of its time. Jasperware is the most commercially successful product of the Wedgwood factory and has remained in production for more than 200 years.

The Birmingham Museum of Art is home to one of the largest and most comprehensive collections of Wedgwood pottery in the world and the only collection of its kind in the United States. The Dwight and Lucille Beeson Wedgwood Collection, bequeathed to the Museum in 1976, includes more than 1,400 pieces of Wedgwood ceramics dating from the inception of the factory through the early nineteenth century, with the greater part dating to the period of partnership between Josiah Wedgwood and Thomas Bentley. This period, which extends from 1769 to 1780, is considered one of the finest in the history of factory production. The Beeson Collection includes examples of all types of objects made during Josiah Wedgwood's lifetime, including a large selection of jasperware.

In 2008, the Museum acquired a second significant collection, the Buten Wedgwood Collection, with more than 8,000 pieces of pottery dating from the eighteenth through the mid-twentieth centuries. Despite their large sizes and wide range of objects, the Beeson and Buten Wedgwood collections have surprisingly little overlap. Rather, the strength of the Buten Collection lies in those objects produced during the nineteenth and twentieth centuries. The acquisition of this exceptional collection by the Museum allows it, for the first time, to tell the entire Wedgwood story.

The year 2009 marked the 250th anniversary of the Wedgwood company: two and a half centuries of unparalleled pottery production. The Beeson and Buten collections complement each other in their strengths and together provide the nation with an invaluable resource, a document of production that reflects the history and legacy of what is undoubtedly one of the most important ceramics manufactories in history.

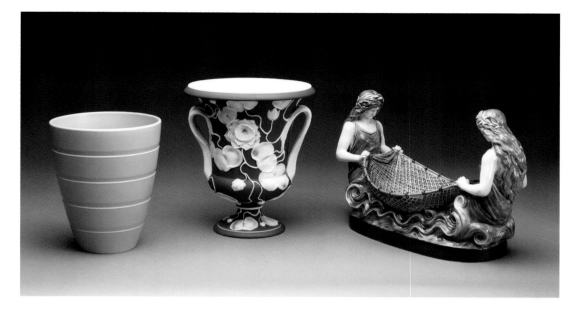

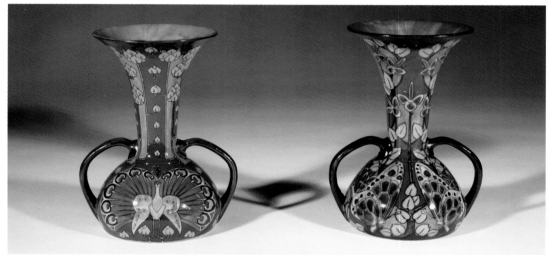

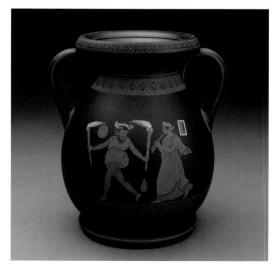

203

L'Etude | Model by **Simon-Louis Boizot** French (1743–1809) Gilded by **André-Joseph Foinet** French (1758–1839) **Sèvres porcelain manufactory** (est. 1756)

Sèvres, France | 1786 | Hard-paste porcelain with enamel decoration and gilding | 11 ¼ x 11 ¾ x 4 ⅞ inches | Museum purchase with funds from the 2001 Museum Dinner and Ball, 2001.199

Simon-Louis Boizot was director of the sculpture workshop at Sèvres from 1773 until 1800. He is best known for the figures he designed, which were reproduced in hard-paste porcelain, a material new to Sèvres.

Although the Chinese had been making it for thousands of years, the secret of hard-paste, or true, porcelain was first discovered in Europe in 1709 in Meissen, Germany. In France, porcelain manufacturers produced a kind of porcelain known as "soft-paste" because it lacked the attributes of true porcelain. After kaolin—a

key ingredient in hard-paste porcelain—was discovered in Limoges in 1768, French manufacturers were able to emulate the porcelain of their German and Chinese counterparts. During the late eighteenth century, hard-paste porcelain proved exceptionally well-suited to the production of unglazed figures that were designed to look like marble sculptures.

This lamp, in the rare *vert bronze*—a ground color simulating patinated copper—was one of six in different colors fired at Sèvres on December 26, 1786.

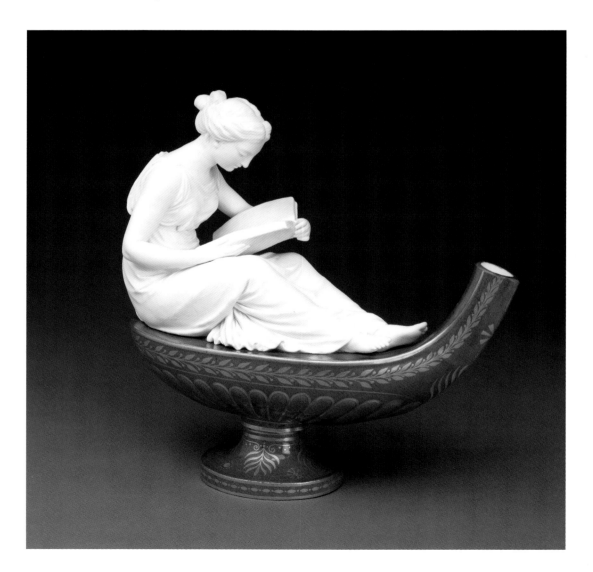

Portland Vase Copy | **Wedgwood** (est. 1759)

Staffordshire, England | About 1791 | Stoneware (jasperware) | 9 ½ x 7 ½ inches | The Dwight and Lucille Beeson Wedgwood Collection, 1983.25

Portland Vase Copy | **Wedgwood** (est. 1759)

Staffordshire, England | About 1790 | Stoneware (jasperware) | 10 x 8 inches | The Dwight and Lucille Beeson Wedgwood Collection, 1983.26

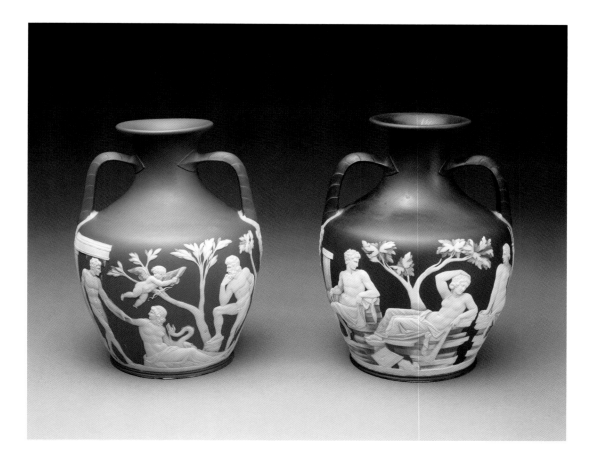

In 1786, the third Duke of Portland loaned his recent purchase—a cameo glass vessel made in Rome—to Josiah Wedgwood. The sculptor John Flaxman had brought the vase to Wedgwood's attention, suggesting that he might want to copy it in jasperware, his new ceramic material.

The technical difficulties involved in producing such a complex piece were greater than Wedgwood had originally thought, and he spent about four years working on his copy of the vase. By 1789, he had created a satisfactory copy. He then decided to sell the vase by subscription; by May 1790, he had sold twenty.

Despite the public's enthusiasm for the vase, it was not a commercial success during Wedgwood's lifetime. Nonetheless, the vase is still considered to be his masterpiece.

The collection at the Museum includes two first-edition Portland Vase copies made during the lifetime of Josiah Wedgwood. One is a dark, slate-blue jasperware, one of only five copies in this color known. The other is black jasperware; this early black copy is numbered "12" in Josiah's own hand on the inside of the lip.

Garniture of Three Vases | Vienna porcelain manufactory (est. 1718)

Vienna, Austria | 1791 | Hard-paste porcelain with enamel decoration and gilding | Large: 8 ⅞ x 8 ⅛ x 9 ⅛ inches; two smaller: 9 ½ x 4 ⅞ inches each | Museum purchase with funds provided by Forsyth Sellers Donald and family in memory of Joseph Marion Donald, Jr., M.D., 2008.4.1-.3

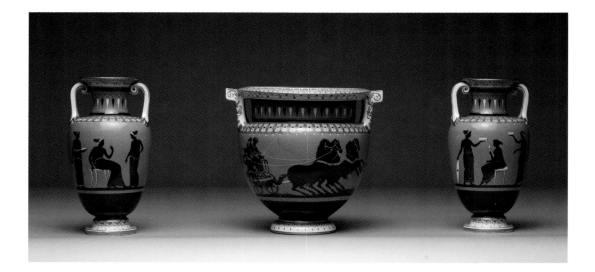

Vienna was the site of the second porcelain manufactory in Europe, founded by Claudius Innocentius Du Paquier (d. 1751). In 1744, Du Paquier sold the enterprise to the Austrian state, and in 1784 Conrad von Sorgenthal became its director.

With Sorgenthal's appointment, the factory underwent a decisive change. New styles and decorative techniques were introduced as the factory shook off the influence of the French manufactory Sèvres. This garniture is decorated in the style of Greek black-figure pottery, which was being excavated in Italy during the period. The popularity of ornamentation based on elements found in antiquity spread rapidly throughout Europe during the late eighteenth century. In England, Josiah Wedgwood made similar pieces using his black stoneware, or basalt, which he called "Etruscan."

Hot Water Urn | **Hester Bateman** English (1709–1794)

London, England | 1781–1782 | Silver | 13 ¾ x 7 ¾ x 6 ⅞ inches | Museum purchase, 1973.30

Teapot | **Peter Bateman** English (1740–1825) and **Ann Bateman** English (1748–about 1813)

London, England | 1794–1795 | Silver | 6 x 11 ¼ x 4 ⅜ inches | Gift of Mr. and Mrs. William M. Spencer, Jr., 1955.40

Creamer | **Hester Bateman** English (1709–1794)

London, England | 1790–1791 | Silver | 7 ½ x 4 ⅝ x 2 ⅝ inches | Gift of Mr. and Mrs. William M. Spencer, Jr., 1955.41

Hot Water Jug | **Hester Bateman** English (1709–1794)

London, England | 1785–1786 | Silver | 12 ½ x 6 ¾ x 5 inches | Frances Oliver Collection, 1972.320

Hester Bateman was the most prominent member of a family of well-known London silversmiths. Together with her sons John, Peter, and Jonathan, and her daughter-in-law Ann, she ran a modern, proficient, and prolific workshop that produced pieces under the Bateman marks as well as for other manufacturers.

Most of the Batemans' wares were made for the table and include flatware, tea wares, and hot-water jugs and kettles. The family worked primarily in the Neoclassical style, which Hester further refined, eventually creating her own stylistic vocabulary of delicate beading, urn-shaped finials, and the use of bright-cut engraving. Her sparsely decorated but elegant pieces are easily recognized today.

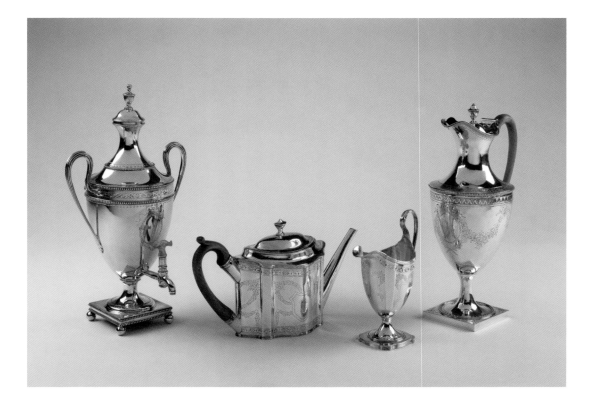

Britannia Triumphant | **Wedgwood** (est. 1759)

Staffordshire, England | 1798–1809 | Stoneware (jasperware) | 13 x 11 ½ inches | The Dwight and Lucille Beeson Wedgwood Collection, 1990.1

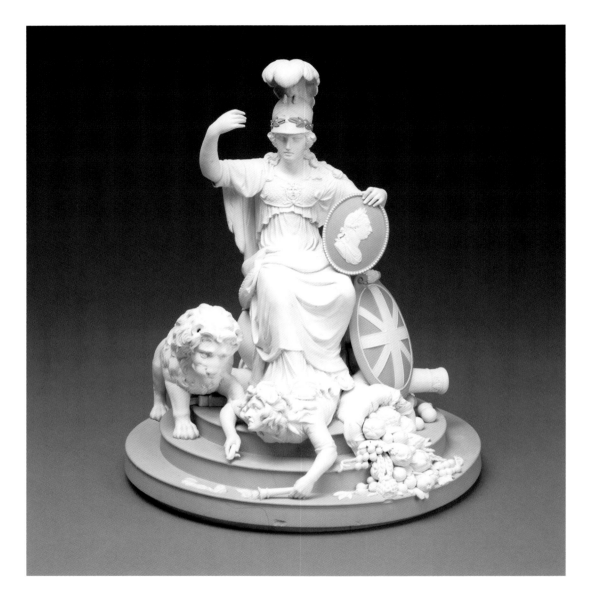

Although Wedgwood does not usually make figures, it did make an exception when it created this large figural group. Designed as a centerpiece for the Prince of Wales, later George IV, the group commemorates British naval victories over Napoleon's French forces during the Wars of Liberation. Seated on a globe and disguised as Minerva, goddess of war, Britannia holds the portrait of King George III in her left hand and originally held a trident in her right. Next to her stands the British lion, throwing a watchful eye on the fallen figure of France holding a torch, whose flame is about to be extinguished. Symbols of the Navy, war, and prosperity, which returned to the country after Napoleon's defeat, surround Britannia.

The group was designed to rest on a large barrel-shaped pedestal decorated with the portrait medallions of four great British admirals: Nelson, Duncan, Howe, and St. Vincent.

Centerpiece | **Paul Storr** English (1771–1844)

London, England | 1810–1811 | Silver | 18 x 14 x 14 inches | Gift of Mr. and Mrs. Bernard A. Monaghan, 1986.175

As styles in dining changed during the late eighteenth and early nineteenth centuries, the custom of placing serving dishes on a sideboard left room on the dining table for decorative objects such as large, elaborate centerpieces. Paul Storr made this magnificent example for the eighth Earl of Coventry, George William, whose arms appear on the base.

Paul Storr was one of the greatest silversmiths of the late eighteenth and early nineteenth centuries in England. His body of work ranges from simple tablewares to magnificent sculptural pieces made for the royal family. During this period, stylistic influences were varied and many decorative arts objects include elements adapted from the eighteenth-century Rococo and Neoclassical styles as well as from ancient Egyptian motifs, the interest in which was revived after Napoleon's campaign there in 1798. Here, Storr combines the Rococo elements of shells and swags with three caryatids, inspired by ancient Greco-Roman sculpture.

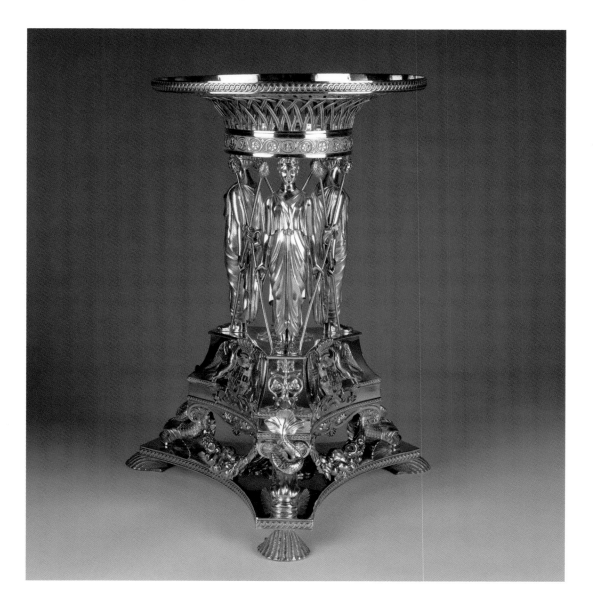

L'Arabe pleurant son coursier (The Arab Mourning his Steed) | Jean-Baptiste Mauzaisse French (1784–1844)

After 1812 | Oil on canvas | 32 x 39 inches | Museum purchase with funds provided by the Beaux Arts Krewe, 1994.29

Charles Hubert Millevoye's popular 1808 poem, "Le Tombeau de coursier: Chant de L'Arabe" (Memorial to the Steed: The Arab's Song) inspired numerous paintings and sculptures. The poem begins with the lament, "This noble friend, faster than the winds, he sleeps under the shifting sands. O traveler! Share my sorrow; mingle your cries with mine."

In this painting the desolate desert emphasizes the despair of the Arab, who grieves the death of his faithful companion. His horse has been avenged: the body of their enemy lies nearby. The exotic scene is an early example of Romanticism, a movement that would flourish for the next several decades. With its emphasis on the imagination and emotion, the Romantic period in French art is difficult to characterize. As the poet and critic Charles Baudelaire wrote in 1846, "Romanticism is precisely situated neither in choice of subject nor in exact truth, but in a way of feeling."

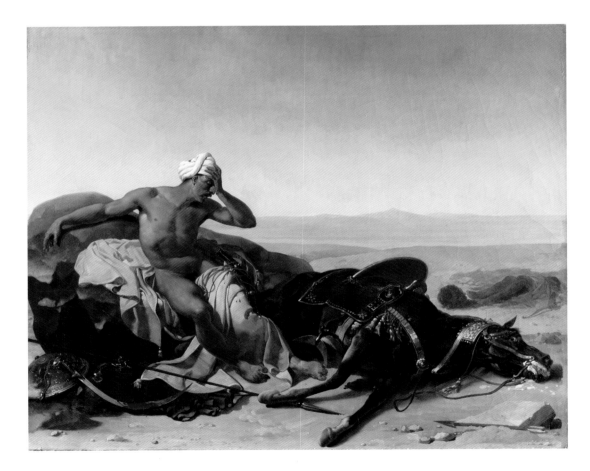

Vase | Meissen porcelain manufactory (est. 1710)

Meissen, Germany | 1818 | Hard-paste porcelain with enamel decoration and gilding | 14 x 8 ¼ inches | Collection of the Art Fund, Inc. at the Birmingham Museum of Art; Purchase in honor of Donald M. James, Chairman of the Board 2002–2005, AFI7.2005

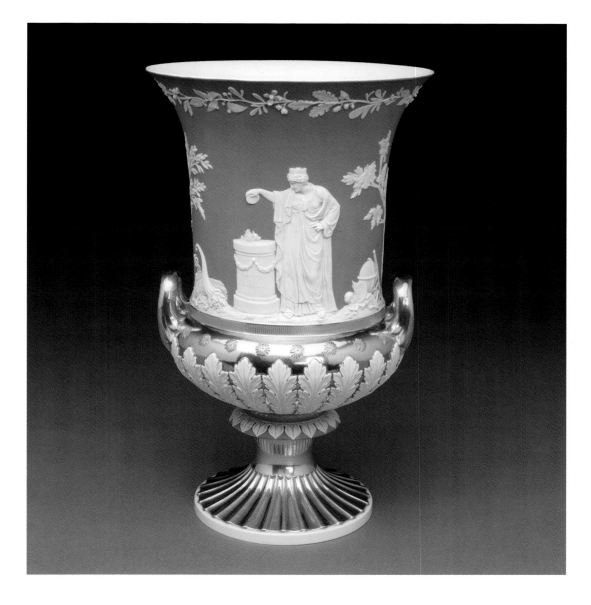

In 1818, Meissen produced this unusual vase in the Wedgwood style. Designed to celebrate the fiftieth anniversary of the Saxon king's reign, it corresponds to the fashion for English Neoclassicism in Germany and the popularity of Wedgwood wares overseas. By copying Wedgwood's jasperware, the Meissen manufactory was able to compete with its English counterpart.

The figures on the vase include the king dressed as a Roman emperor. Next to him are the figures of Justice and Minerva, symbols of his reign, which was characterized by conscientious governance and military prowess. On the opposite side of the vase is the figure of a Roman vestal, representing the state of Saxony. At her feet lies an overflowing cornucopia—symbolic of prosperity—as well as war trophies and emblems of the seven liberal arts.

Pocket Watch Holder │ Siméon Pierre Devaranne German (1789–1859)

Berlin, Germany │ About 1830 │ Cast iron │ 9 x 3 ¾ x 2 ⅝ inches │ Gift of American Cast Iron Pipe Company, 1986.222.12

Franz I, Emperor of Austria, King of Bohemia and Hungary (1768–1836) │ Joseph Glanz Austrian (born 1795)

Vienna, Austria │ 1831–1835 │ Cast iron and gilt bronze │ 7 ¼ x 3 ⅞ x 3 ⅞ inches │ Gift of American Cast Iron Pipe Company, 1986.223.1

Footed Dish │ After a design by Karl Friedrich Schinkel German (1781–1841) Royal Prussian Iron Foundries

Germany │ 1820–1830 │ Cast iron │ 6 ⅛ x 9 ¼ inches │ Gift of Dr. and Mrs. Maurice Garbáty, 1962.135

Tobacco Box │ Model by Johann Carl Wilhelm Kratzenberg German (active in Berlin 1824–1839) and Siméon Pierre Devaranne German (1789–1859)

Berlin, Germany │ About 1834 │ Cast iron │ 11 ½ x 5 ⅞ x 7 ⅜ inches │ Museum purchase, 2007.16a-b

Candlestick │ Mägdesprung (Established 1757)

Germany │ 1880/90 │ Cast iron │ 11 ⅝ x 7 ⅛ inches │ Gift of American Cast Iron Pipe Company, 1986.288.1

During the early nineteenth century in Central Europe, cast iron was a primary material used in the production of decorative objects, and its popularity ensured that vast quantities of cast-iron objects were made and sold.

The decision to produce decorative cast-iron objects was a purely commercial consideration for Prussian authorities, and existing foundries in Silesia provided the foundation for a state-sponsored initiative designed to promote the development of decorative wares. Cast-iron plaques and grates for stoves were already common in most German households. Yet only through improved technology was the casting of smaller and more detailed objects possible, allowing iron to become a valid alternative to bronze. The simple yet severe lines and rich black color of iron quickly became a symbol of the Wars of Liberation from Napoleon's hegemony in Europe. King Friedrich Wilhelm III (reigned 1797–1840) furnished his rooms at the Neues Palais in Potsdam with cast-iron objects, helping to keep them in vogue through the 1840s.

Almost 100 years after the first royal Prussian iron foundry was established in 1798 in Gleiwitz in modern-day Poland, Gustav Lamprecht (1862–1946), an architect and professor in Leipzig, began collecting nineteenth-century artistic objects made at this and other foundries. His collection, which was formed over a period of thirty years and numbers almost 1,000 objects, was at one time the largest collection of its kind. In 1922 economic conditions forced Lamprecht to sell his collection, and in 1939 the American Cast Iron Pipe Company, with headquarters in Birmingham, acquired it and gave it to the Birmingham Museum of Art. In 1962 Maurice Garbáty, a German industrialist and patron of the arts, who emigrated with his family from Berlin to the United States in 1939, donated an additional fifty-one cast-iron objects to the Museum.

The objects in the Birmingham collection fall into several distinct groups, all marked by great beauty and unsurpassed technical achievement. They range from the most practical to the highly decorative and include a selection of delicate jewelry, received by women in exchange for the gold that was used to support the wars against Napoleon. Household utensils, such as plates, bowls, knife rests, and napkin rings are equally as attractive as watch stands, lamps, paperweights, and candlesticks. Purely decorative sculptural pieces such as busts, statuettes, plaques, and fine portrait medallions were produced in great quantity at all three royal Prussian foundries and were copied at several smaller, private ones.

Today, the collection of European decorative cast iron at the Museum is one of the largest in the world and the only such collection known in the United States. It is unique in that it is one of the few of its type to include such a large number of objects from a wide variety of foundries—German, Austrian, and Bohemian—both public and private. It is appropriate that the collection has made its home in Birmingham, since it is primarily the iron industry that is responsible for the city's existence and growth.

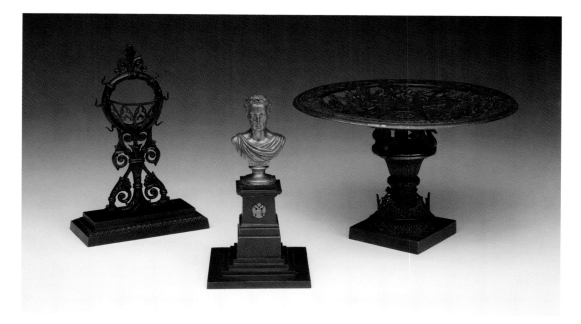

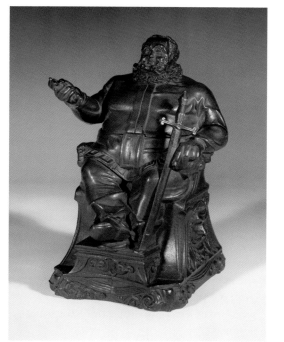

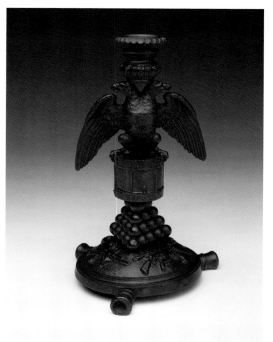

A Race Meeting at Jacksonville, Alabama | W. S. Hedges British (active 1831–1847)

1841 | Oil on canvas | 19 ¾ x 33 ¾ inches | Museum purchase with funds provided by Mr. Coleman Cooper; EBSCO Industries, Inc.; Mr. Henry S. Lynn, Jr.; Mr. and Mrs. Jack McSpadden; the Regina and Harold E. Simon Fund; and Mary Arminda Mays in the memory of John Edward Mays, by exchange, 1985.278

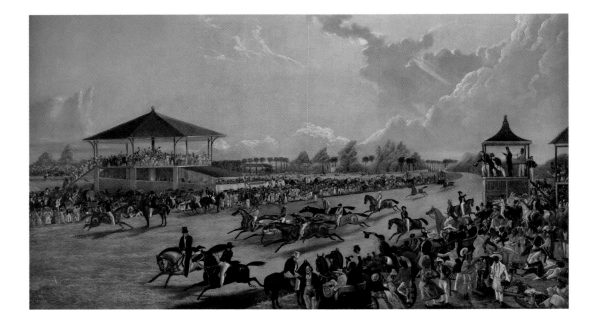

Little is known about W. S. Hedges except that he was an English artist who painted in the Caribbean from 1831 until 1847, primarily working in British Guyana and Barbados. In 1841, he visited Jacksonville, Alabama—a now forgotten community outside of Mobile—where he painted this lively visual record of a horse race. The painting closely resembles a period newspaper account, which recorded:

"There was a half mile or more of low buildings, stables and jockey's quarters; and all about were the pleasure loving crowds, the fashionably dressed and poorly clad, mingling in a kaleidoscope of controlled confusion. In the judges' stand were the moguls of the racing circles, their eyes turned to the mile long oval of track, to the rippling-muscled thoroughbreds pitting speed against steed as they thundered down the track to the roar of the crowd."

Loch Katrine | **William Henry Fox Talbot** English (1800–1877)

About 1845 | Salt print from a calotype negative | 7 ½ x 8 ⅞ inches | Museum purchase with funds provided by the estate of Murray and Keehn Berry, 2006.12

This image of Scotland's Loch Katrine, near Glasgow, is the earliest photograph in the Museum's collection. Talbot was a scientist and inventor who in the 1830s and 1840s revolutionized photography by creating a process using a paper negative from which multiple prints could be made, and discovering ways to speed up exposure and processing time by employing developing chemicals. Talbot is credited with recognizing that photography's processes made it the ideal medium for assuming the documentary role then ascribed to

painting and printmaking. The mid-nineteenth-century public was mesmerized by the camera's ability to make images of its subjects with such detail and clarity.

This scene of Loch Katrine was part of the subscription series *Sun Pictures in Scotland.* Talbot recorded the image in the Romantic manner of the day, a picturesque style that emphasized soft forms and gentle tones. The warm, rich hues produced by the calotype process enhanced an atmospheric feeling.

Vase | Model by **Julius Wilhelm Mantel** German (1820–1896) **Royal Porcelain Manufactory Berlin** (est. 1763)

Berlin, Germany | About 1860 | Hard-paste porcelain with enamel decoration and gilding | 18 ⅞ x 9 ¼ x 7 ⅜ inches | Museum purchase with funds provided by the Elliott Tuttle Williams, Jr. Family, by exchange 2005.18

This large presentation vase represents the unique relationship that existed in the nineteenth century between the decorative and the fine arts. During this period, porcelain was meticulously decorated with *veduta* (Italian for "view") paintings—highly detailed, accurate, and easily recognizable city—or landscapes. This genre of painting originated with Flemish painters working in Rome during the sixteenth century. During the nineteenth century it reached a high point at the Royal Porcelain Manufactory in Berlin.

The scene on this vase depicts the Kronprinzen-palais on Berlin's fashionable street Unter den Linden. Originally built in 1663, the palace was renovated in 1732 for the crown prince of Prussia, later King Frederick the Great. Between 1856 and 1857, it again underwent remodeling for Frederick III, and in 1859, was the birthplace of the last German emperor, Wilhelm II. It is probable that this vase was created to acknowledge the final renovation of the Baroque palace, which was destroyed during World War II.

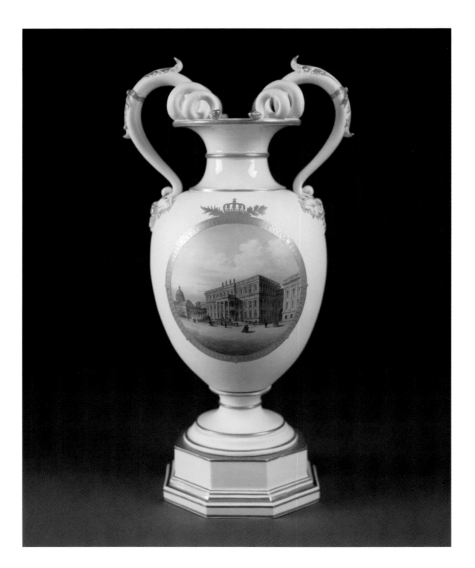

Vase | Painted by **Émile Aubert Lessore** French (1805–1876) with **Henry Brownsword** English (active 1849–1903) **Wedgwood** (est. 1759)

Staffordshire, England | 1862–1863 | Lead-glazed earthenware (creamware) and stoneware (jasperware) | 59 ½ x 30 x 29 inches | Collection of the Art Fund, Inc. at the Birmingham Museum of Art; The Buten Wedgwood Collection, gift through the Wedgwood Society of New York, 301.2008 a–g

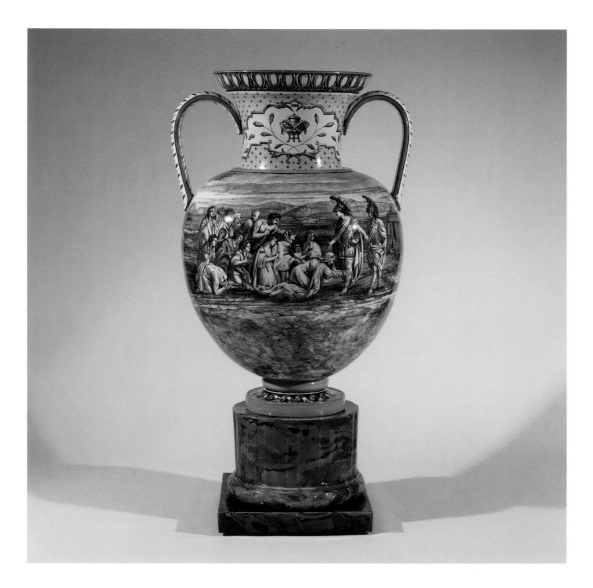

This enormous vase, one of the largest objects ever produced by the Wedgwood factory, is one of a pair, possibly made for the London International Exhibition of 1862. The scene on the front depicts Alexander the Great and his friend Hephaestion entering the tent of the Persian King Darius III. It is based on the late seventeenth-century painting *Le tente de Darius* by Charles Le Brun (1619–1690) from his "Triumphs of Alexander" series that alludes to the grandeur of the reign of King Louis XIV of France. The painting, which continues around the body of the vase, shows a landscape typical of Northern Africa on the reverse. The vase's mate is now in the Wedgwood Museum in England.

Nymphes et Faunes (Nymphs and Fauns) | Jean-Baptiste-Camille Corot

French (1796–1875)

Before 1870 | Oil on canvas | 21 ¼ x 35 ½ inches | Collection of the Art Fund, Inc. at the Birmingham Museum of Art; Purchase with funds provided by C. Caldwell Marks in memory of Jeanne V. Marks, AFI10.2004

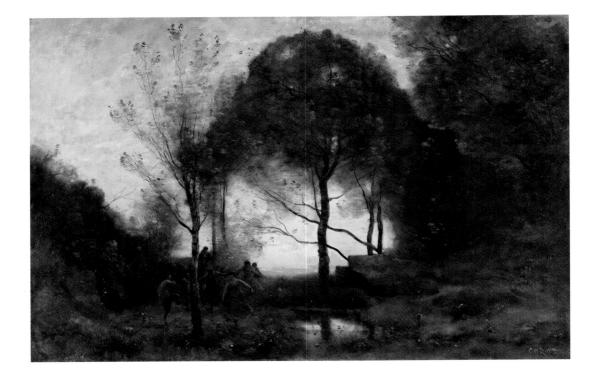

Although he painted biblical and mythological subjects as well as portraits, Corot is recognized above all as one of the supreme masters of nineteenth-century landscape painting. His commitment to working *en plein air* (in the open air) heightened his appreciation for the changing effects of light, which can be seen to great advantage in this painting. The atmospheric mood evoked here, at sunrise, aptly illustrates a quote from Corot describing his work: "To get into my landscapes, you need to have the patience to wait for the haze to lift; you can enter them only by slow degrees and once you are there, let's hope, enjoy them." The dream-like quality of the painting belies a careful composition and variety of deliberate brushwork.

Entrée d'un gave (Source of a Mountain Stream) | Gustave Courbet

French (1819–1877)

1876 | Oil on canvas | 17 ⅞ x 23 ¼ inches | Museum purchase with funds provided by the Birmingham Museum of Art Endowment for Acquisitions; Members of the Birmingham Museum of Art; Dr. and Mrs. David Sperling in honor of their friends; Mr. Arthur E. Curl, Jr. in memory of his beloved wife, Donnie; Illges-Chenoweth Foundation; Dr. and Mrs. Jack C. Geer; Mr. James E. Simpson; Mr. and Mrs. James A. Livingston, Jr.; Mrs. Evelyn Allen; Mr. and Mrs. Thomas W. Barker, Jr.; and Mr. and Mrs. Harold H. Goings, 1999.60

Courbet achieved his reputation as a figural painter, but later in life devoted himself almost exclusively to producing pure landscapes. In the 1870s, while living in political exile on Lake Geneva in Switzerland, he painted many works that recall the topography of Franche-Comté, his native region in eastern France. The dramatic, rocky cliffs that rise in the valleys and forests were favored motifs of the artist. Here rugged cliffs converge into blackness, while a dark pool of water forms from the stream in the foreground. The viewer enters the lush, private glade by way of that stream. Courbet enhances the visual drama of the view by painting it at close range and sharply cropping the edges. Bright, barren rock contrasts strongly with the muted palette of rich greens and browns. The paint is applied to those rock faces with smears from the palette knife, a technique that Courbet pioneered to evoke texture and drama. The sense of a quickly worked paint surface conveys a vitality and dynamism distinctive to his landscapes.

Artist's Wife, Edith Holman Hunt | **William Holman Hunt** English (1827–1910)

1877 | Silverpoint on prepared wove paper | 9 ⅞ x 7 ¾ inches | Museum purchase with funds provided by the Beaux Arts Krewe, 2007.89

Hunt was a founding member of a group of English artists called the Pre-Raphaelite Brotherhood. They were united in their desire to inject a new seriousness into their art, in terms of both subject matter and fidelity to nature. Their name derives from the inspiration they found in the art of the Italian Renaissance master Raphael Sanzio. Although the group itself was not long-lived, Hunt continued to follow its tenets and became particularly known for his treatment of Biblical subjects.

Silverpoint requires a skilled and sure hand. This drawing is made of fine, though distinct lines, with delicate crosshatching to create shadows and contours. Hunt's paintings reveal a similar attention to detail. This drawing of the artist's wife is a preparatory study for the head of the Virgin in his painting *The Triumph of the Innocents*. In a letter of July 15, 1877, Hunt mentioned to a friend that his wife had been ill recently, which perhaps explains her fatigued expression.

Mantelpiece | Designed by **Halsey Ricardo** English (1854–1928) **Wedgwood** (est. 1759)

Staffordshire, England | 1882 | Stoneware (jasperware) and Carrara marble | 114 ½ x 91 ½ x 13 ¼ inches | Gift in memory of Virginia Clarke Bunting by her twins, Virginia Bunting Greene and Dr. Peter Douglas Bunting, 2008.5

This spectacular mantelpiece was one of several designed for Buckminster Park, seat of the Earls of Dysart, in Leicestershire, England. In the spirit of the eighteenth century, Ricardo created an impressive piece in the Neoclassical style, which perfectly complemented the late Georgian house in which it resided. Set with jasperware plaques and medallions made using eighteenth-century molds, the entire effect is one of imposing grandeur.

The mantelpiece was part of a larger interior-design plan for the dining room of the house. In the color scheme of the room Ricardo used a particular green of his own mixing that was copied by Wedgwood to create a new jasperware color, used only for this commission. Originally known as "peach green," the color is now commonly referred to as "Dysart green," after the owner of the house.

L'Aurore (Aurora) | **William-Adolphe Bouguereau** French (1825–1905)

1881 | Oil on canvas | 81 ⅝ x 42 ¼ inches | Bequest of Nelle H. Stringfellow, 2005.111

This ravishing *Aurora,* or *Dawn,* was one of Bouguereau's most acclaimed works. It is the first in a series of canvases representing the four Times of Day: the others were *Dusk* (now in the National Museum of Art, Havana), painted in 1882; *Night* (Hillwood Museum & Gardens, Washington, DC) in 1883; and *Day* (private collection, USA) in 1884. All but the last were exhibited at the annual Paris Salon. Allegorical representations of the four Times of Day date back at least to the Renaissance period. Bouguereau's Times of Day constitute a study in complements and contrasts; when examined together they reveal a harmonious continuity of line, form, and color. Although clearly intended in the artist's mind as a coherent series, they have never been seen together: after Bouguereau exhibited each at successive annual Salons, he sold them to his dealer Adolphe Goupil, who in turn placed them with American collectors.

Painted at the height of his career, they exemplify the artist's standards of ideal beauty and exaltation of the female form during the early 1880s. His meticulous attention to detail and polished surfaces produced lyrical figures accented with a sense of realism. Several other paintings of female nudes from 1884 are loosely related to the Times of Day. This prolific output of nudes over such a short period of time is exceptional for Bouguereau, whose oeuvre comprises only a small number of them.

In 1850 Bouguereau won the French Academy's Premier Grand Prix, and he proceeded to spend a year in Rome at the villa Medici. While there he studied the art of the Italian Renaissance and Greek, Etruscan, and Roman antiquities. Indeed, the sculptural quality of his figures is often noted. He also read classical literature, which influenced his choice of subjects and their depiction for the remainder of his career. One example is found in the Museum's painting of *Dawn.* The personification's fingers and toes, painted with a pinker hue than the rest of her flesh, conform to a passage in Homer's *Odyssey,* "rosy-fingered dawn, the child of the morning."

An academic artist, Bouguereau emphasized training in form and technique to his many students. He himself achieved a level of technical skill that was virtually unparalleled by his colleagues, and certainly admired, even as his art fell from favor when more innovative styles such as Impressionism and Post-Impressionism developed. Recently, however, public appreciation and renewed critical attention have contributed to a resurgence of interest in his work.

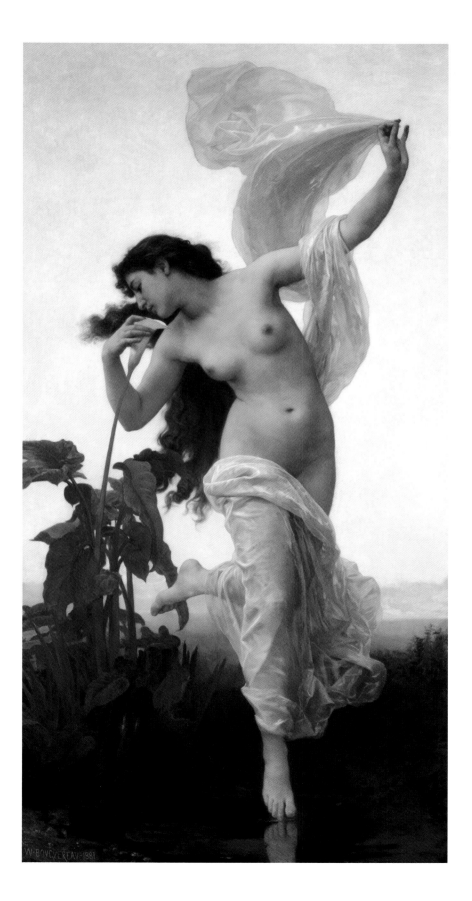

Pair of Vases | Decoration attributed to **Henry Hollins** English (active 1875–1900)
Minton pottery manufactory (est. 1793)

Staffordshire, England | About 1882 | Bone china with *pâte sur pâte* and enamel decoration with gilding | 15 ⅝ x 9 ⅛ x 5 ⅛
inches | Gift of Sidney and Myra Goldstein in memory of their daughter Joanne Goldstein Hornick, 2000.11.1-.2

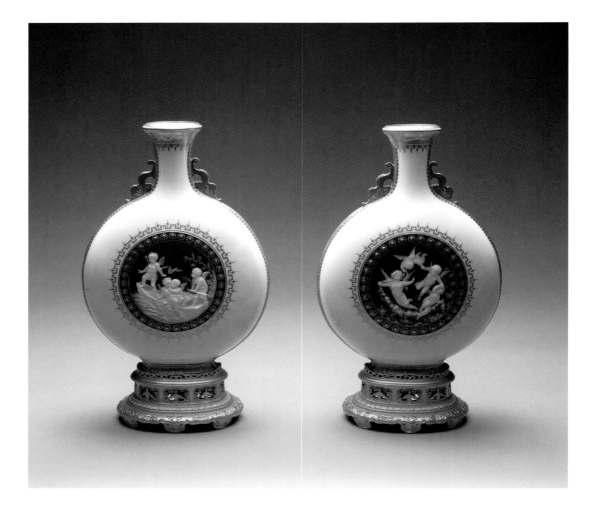

The technique of *pâte sur pâte* involves the application
of successive layers of white slip, or liquid clay, to a
porcelain object of another color. The result of this
complicated and labor-intensive process is a delicate
relief design, whose various details are carved by hand
before firing.

The process originated in China and was then
introduced at the Sèvres manufactory in France during

the eighteenth century. It was brought to England
by Marc-Louis Solon, who left Sèvres during the late
nineteenth century to work at Minton. The *pâte sur
pâte* technique flourished in England and was used
by a number of manufactories, including Wedgwood.
Henry Hollins was a student of Solon who carried on
his work at Minton.

L'Envoûteuse (The Sorceress) | Georges Merle French (1851–1886)

1883 | Oil on canvas | 57 ½ x 45 inches | Collection of the Art Fund, Inc. at the Birmingham Museum of Art; Purchase with funds provided by Children of the Vann Family: William O. Vann, Sally V. Worthen, Robert D. Vann, in memory of Suzanne Oliver Vann, AFI2.2009

The Sorceress, signed on the lower right, was Georges Merle's submission to the Paris Salon exhibition of 1883. Some of his early, unsigned works may be mistaken for those of his father Hugues, an artist who achieved popular success with the public, and who painted a similarly wide range of subjects.

This commanding female figure is in the act of performing a spell. Resplendent in a white and gold gown with diaphanous sleeves and bedecked with Egyptian-flavored jewels, she sits on a pentacle drawn on the floor, and in front of one on the wall behind her.

Within the pentacle on the wall a few words, written in Arabic, can be translated: "Muhammad" and "No god but God." All around this priestess of black magic are other tools to aid her hex: next to the pentacle on the wall is a series of cryptic numbers, a voodoo doll stuck with an elaborate pin, a candle, skull, and upside-down crucifix. Our sorceress may be an unidentified figure from literature, or she may be one of the more generic witches that became increasingly common in late nineteenth-century art and literature.

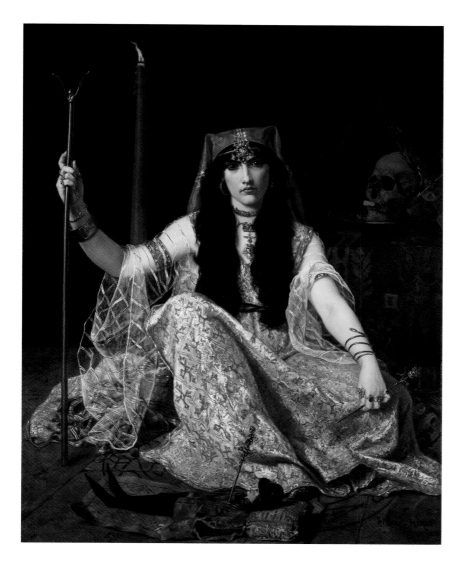

Badendes Mädchen, sich im Wasser spiegelnd (Girl Bathing, Looking at Her Reflection in the Water) | **Max Klinger** German (1857–1920)

Modeled about 1896–1897; cast about 1912 | Bronze with black patina | 39 ⅜ x 13 ⅜ x 15 ⅝ inches | Museum purchase with funds provided by the Beaux Arts Krewe in honor of its 40th anniversary and Anne Kidd, 2006.18

A painter, printmaker, sculptor, and writer, Max Klinger is considered one of the most versatile artists in Germany at the turn of the twentieth century. He began making sculpture in the early 1880s, before sojourning in Rome from 1888 to 1893, where he consequently became increasingly influenced by the art of the Italian Renaissance and antiquity. His sculpted oeuvre includes portrait busts of celebrated contemporaries and mythological and allegorical females. The female nude features prominently in his works. In 1896–1897 Klinger carved the *Girl Bathing* in marble, now in the Museum of Fine Arts in Leipzig. He authorized the Gladenbeck Foundry in Berlin to cast bronze reductions in four sizes: 24.5, 39, 62, and 100 centimeters. Birmingham's sculpture is the largest size reproduced. It has been suggested that the model for *Girl Bathing* was the author Elsa Asenijeff, who became the artist's long-time companion.

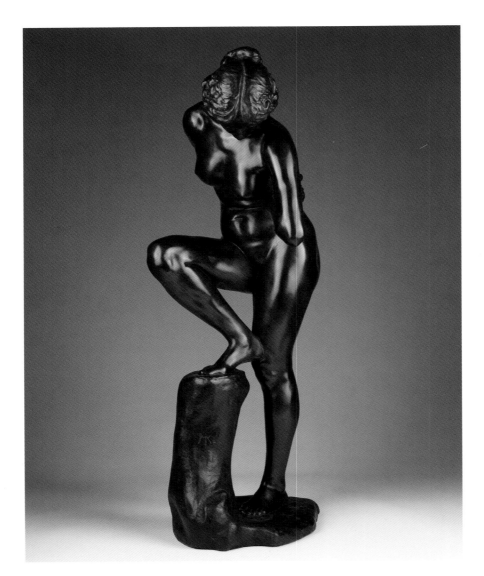

Lamp | **Antonin Daum** French (1864–1930) and **Auguste Daum** French (1853–1909)

Nancy, France | About 1900 | Cameo glass | 14 x 7 ¾ x 4 ¼ inches | Museum purchase with funds provided by John
Bohorfoush and Sylvia Worrell, 1985.135.1-.2

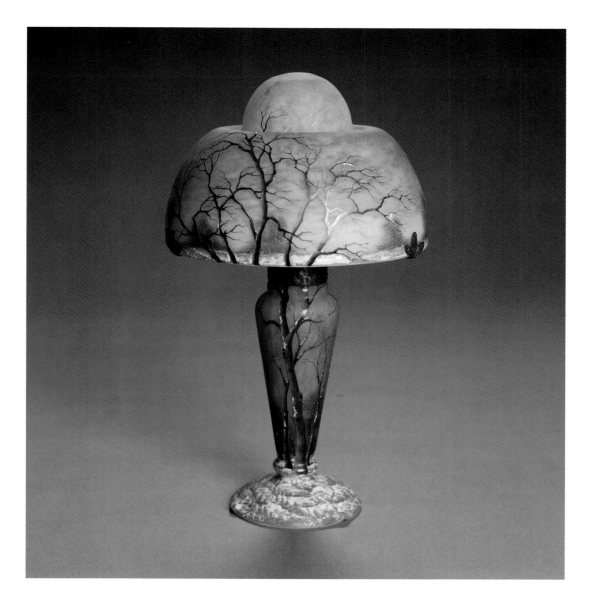

The Daum brothers became partners in their father's watch glass and tableware firm during the 1880s and soon expanded production to include decorative glass. This lamp reflects the stylistic tendencies of the Art Nouveau movement that were prevalent during the period. Characterized by curving lines and the use of ornamentation adapted from nature, the Art Nouveau style reached the height of its popularity around 1900, after which it quickly went out of vogue.

The bare trees and fallen snow on the lamp's base and shade were created by cutting cameo, or cased, glass with acid. Cameo glass involves covering one piece of glass with a layer of glass of another color. The use of acid to cut through the top layer reveals the layer underneath. Portions of this stark winter scene have been highlighted with brown and white enamel.

Wine Goblet | Designed by **Otto Prutscher** Austrian (1880–1949) Produced by **Meyr's Neffe (Adolfshütte)**

Adolf, Austria (today Adolfov, Czech Republic) | About 1907 | Mold-blown clear glass with overlaid colored glass | 8 ¼ x 3 ¼ inches | Museum purchase, 2005.17

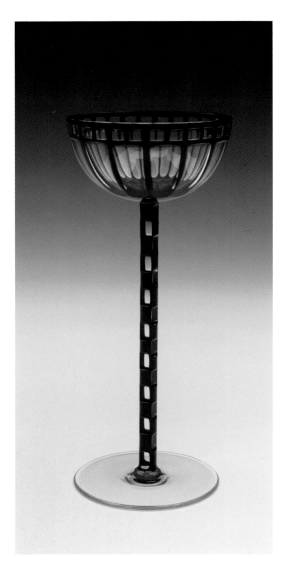

During the early part of the twentieth century in German-speaking Europe, artists and designers sought to reconcile centuries-old craft traditions with the demands of large-scale industry. Stylistic issues were a concern, but so was the notion that an object had to be both beautiful *and* true to the materials from which it was made. It also had to be functional.

This goblet is typical of the austere modernist style of the Wiener Sezession, a group of artists and architects who seceded from the conservative art academy in Vienna in 1897. Artists affiliated with this organization were true ornamentalists with a wonderfully distinctive design vocabulary and a preference for architectonic decoration that lay flat on the surface of the object. While the Sezession still exists today, it has not played a significant role in the decorative arts since the 1920s.

Vase | **Elwyn James** Welsh (1942–1978) **Wedgwood** (est. 1759)

Staffordshire, England | About 1968 | Glazed earthenware | 13 ¼ x 6 ⅛ inches | Collection of the Art Fund, Inc. at the Birmingham Museum of Art; The Buten Wedgwood Collection, gift through the Wedgwood Society of New York, 2145.2008

Vase | **Michael Dillon** Australian (1944–1976) **Wedgwood** (est. 1759)

Staffordshire, England | About 1967 | Glazed stoneware | 20 ½ x 8 ¼ inches | Collection of the Art Fund, Inc. at the Birmingham Museum of Art; The Buten Wedgwood Collection, gift through the Wedgwood Society of New York, 2138.2008

Vase | **David Puxley** English (born 1943) **Wedgwood** (est. 1759)

Staffordshire, England | About 1967 | Glazed stoneware | 9 x 4 ½ inches | Collection of the Art Fund, Inc. at the Birmingham Museum of Art; The Buten Wedgwood Collection, gift through the Wedgwood Society of New York, 2140.2008

The tradition of employing freelance artists at Wedgwood began in the eighteenth century when company founder Josiah Wedgwood hired young talent to create designs for his jasperware productions.

Beginning in the 1960s, the company invited art students and recent graduates to join Wedgwood for a year or two to experiment with new shapes and styles, leading to the creation of wildly innovative designs.

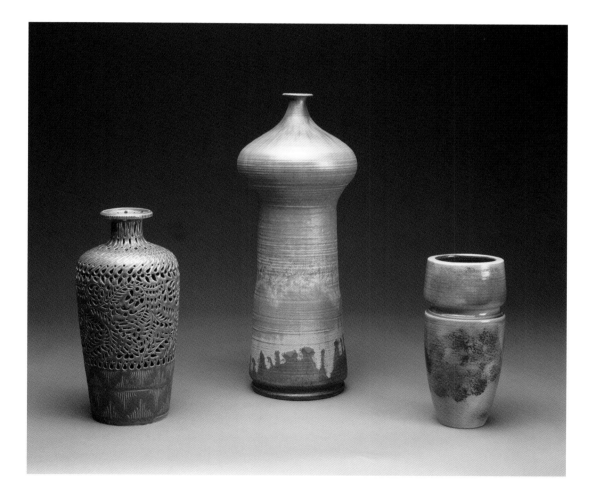

MODERN and CONTEMPORARY ART

The world has transformed at a dizzying pace over the past century and a half, as the industrial age has given way to technological innovation and advancement. Concurrent with these societal changes, artists have advanced visual culture. The Birmingham Museum of Art's collection of twentieth- and twenty-first-century art comprises over 700 works that span the approaches and materials that artists have explored over that time. Befittingly, the museum's modern and contemporary art collections are defined by diversity. Works highlighted in this volume include painting, sculpture, works on paper, photography, video, installation, and their hybrids. The department also encompasses traditional crafts and the work of self-taught artists, many native Alabamians. The collection reflects the Museum's commitment to showcasing the finest examples of art made in our own region as well as the work of both national and international artists.

Many of the key works of early and mid-twentieth century modern art at the Birmingham Museum of Art are gifts of Silvia Pizitz. Pizitz avidly collected geometric abstraction and material explorations in a range of media, and bequeathed many excellent pieces to the Museum, including works by Josef Albers, Max Bill, El Lissitsky and Charmion von Wiegand. These form the nucleus of a small but fine modern art collection, which has been augmented by outstanding early and mid-century works by Alexander Archipenko, Alfred Leslie, a superb drawing by Salvador Dalí, a group of Joseph Cornell's hermetic constructions and collages, three-dimensional work by Louise Nevelson, Mark Tobey's riveting Weimar portrait of Max Ewing, and the clean and classy photographic portraits of Irving Penn.

These fine examples of diverse modern art practices set the stage for the even more rapid artistic advances beginning in the 1960s. The dominance of Abstract Expressionism gave way to Pop, Minimalism, Conceptual and Process art, and photography and video ascended as serious art forms. These movements are represented if not in depth then in quality, and subsequent movements, especially postmodern painting and art dealing with issues of personal and social identity, are well-represented.

The department's collection has been assembled to reflect the myriad ways in which artists of the past 100 years have approached art-making, as traditional genres have expanded, splintered, and hybridized. Contemporary artists are influenced by the work of their forebears as well as motivated by the social landscape. Developments in the visual arts are typically a bellwether of shifts in the larger culture. One of the most productive periods in recent art was the 1960s and 1970s, as artists embraced the mood of freedom and experimentation in the air, or drew energy and motivation from the cultural unrest provoked by the Vietnam War and Civil Rights movement. Since then, digital culture and advancements in science and technology have expanded more rapidly than we as a culture can process and understand. Artists, as always, are at the forefront of cultural exploration, and their work can be by turns, baffling, visionary, chilling, and reassuring—shaping and expressing our identity, fears, and aspirations.

Within the department, certain media and groupings bear mention. Holdings in photography span the medium's earliest developmental stages through its recent kaleidoscopic diversity. A selection of late nineteenth-century to early twentieth-century vintage black and white prints gives a fine overview of the formal and social concerns of the photographers then working. *The Birmingham News* Centennial

Remedial Archeology and the Like, detail, William T. Wiley, American (born 1937), 1986, acrylic and graphite on canvas, © William T. Wiley, photograph by Robert Linthout [entry, page 250]

Photographic Collection at the Museum offers a diverse portrait of the city by such notable photographers as William Christenberry, Robert Frank, Duane Michaels, and Gordon Parks. Photographs of Alabama blast furnaces by Bernd and Hilda Becher, as well as numerous Depression-era documentary photographs and Civil Rights-era images by Ernest Withers, Danny Lyons, Chris McNair, Charles Moore, and others, create a rich and complex visualization of the American Southeast, a strong focus of the collection.

This focus is microcosmic of the Museum's larger mission to be the primary repository for the finest work in all media created in the South, and in particular, in Alabama. One of our most important Southern artists, William Christenberry, produces work in all manner of media, and beyond an impressive collection of his photographs, the Museum owns his works on paper and his sculpture. The Museum has sterling examples of "folk" or "self-taught" art. Many of the genre's key figures are Alabamians, among them, Bill Traylor, Mose Tolliver, the quilters of Gee's Bend, Lonnie Holley, and Thornton Dial.

The Museum also boasts several large-scale works, both indoors and out. Sited on the Museum grounds are sculptures by Fernando Botero, August Rodin, Luis Jiménez, Jacques Lipschitz, Anthony Caro, and George Rickey. Inside are gallery-sized works by Fred Sandback and José Bedia. Several of these large-scale works were created for specific sites at the Museum by artists including Valerie Jaudon, Sol LeWitt, Elyn Zimmerman, and Tara Donovan.

The department's collections have been notably enhanced by numerous individuals from within the Birmingham community as well as from farther afield. One group that has made a crucial impact on the Muse-um's contemporary art holdings is the Collectors Circle for Contemporary Art, a support group founded in 1991. Established to educate its members and the public at large about the Museum's contemporary collection, exhibitions, and related programs, the group also covers the purchase of new museum acquisitions through its annual membership dues. Among these acquisitions are works highlighted in this publication (by Bill Viola, Tara Donovan, Joseph Grigely, and Tabaimo) as well as other notable works by such artists as José Bedia, Nick Cave, and Elizabeth Murray. Excitement surrounding the Museum's exhibition of a particular artist's work has often generated a purchase or gift, as evidenced by outstanding works in the collection by Beatriz Milhazes, Charlie Lucas, William Wegman, Willie Cole, and others.

One role of contemporary art within a "comprehensive" museum such as Birmingham is to demonstrate how artists are expanding upon established and traditional visual cultures. Numerous artists consciously engage in maintaining links to the past and to the history of art, sustaining traditional genres, while many of the department's finest works were created by artists wishing to push art into unexplored territory.

A number of acquisitions have been made with an artist's active participation, and as such they may be seen as actively involved in articulating the Museum's institutional goals and desires, often in unexpected ways. Such direct participation dovetails with the Museum's goal to engage, educate, and invigorate its audience.

Ron Platt
THE HUGH KAUL CURATOR OF MODERN
AND CONTEMPORARY ART

Untitled | **Bill Traylor** American (1854–1947)

About 1940–1942 | Graphite and colored pencil on cardboard | 22 ⅛ x 14 inches | Museum purchase, 2003.26

Bill Traylor was born into slavery on the plantation of John G. Traylor, near Benton, Alabama. After emancipation, he and his family farmed on the plantation until the 1930s. In 1939, at eighty-five, he relocated to Montgomery, Alabama. Over the next three years, Traylor produced over 1,000 works with the barest of means—mostly drawing with pencil and/or poster paint on paper or cardboard.

Traylor drew both what he saw and what he imagined. This drawing of an animated exchange between a man and woman demonstrates his mastery of line, movement and composition, his keen eye for depicting character and interaction with absolute economy, and his sense of humor in describing narrative events.

While Traylor's circumstances were spare and his experiences limited by today's standards, his facility was remarkable and his imagination rich and complex. From a stationary position on Montgomery's Monroe Street, he produced some of the most unique and memorable art of the time.

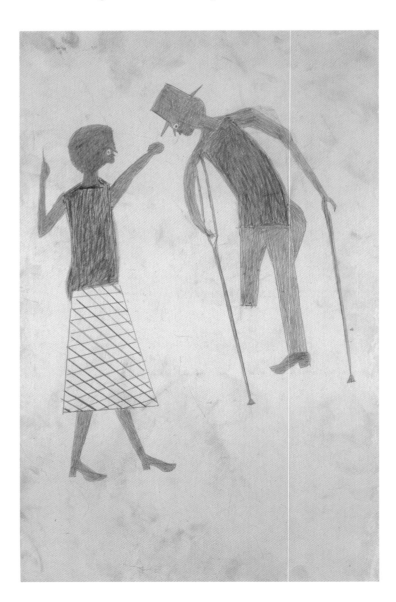

Madonna Corpusculaire | **Salvador Dalí** Spanish (1904–1989)

1952 | Pen and black and brown ink over graphite on board | 22 ⅛ x 16 ⅞ inches | Gift of Mr. and Mrs. Charles W. Ireland, 1953.1 | © 2010 Salvador Dalí, Gala-Salvador Dalí Foundation / Artists Rights Society (ARS), New York

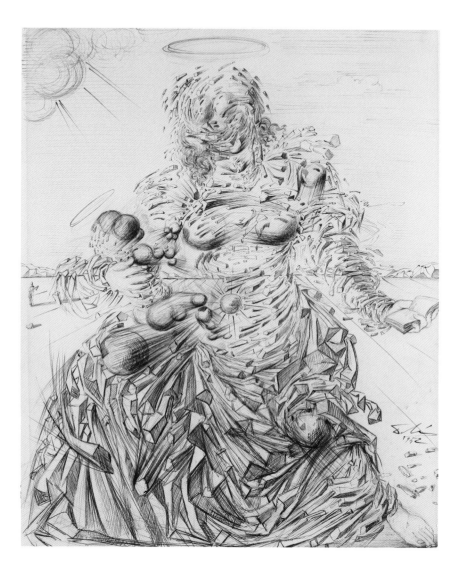

Dalí was prolific for over sixty years, creating oil paintings, drawings, sculptures, theater and fashion designs, book illustrations, and writings. In the early 1930s he was affiliated with the Surrealist movement, but as World War II approached, Dalí clashed with the Surrealists and was "expelled." By 1940, his work bore the influence of his growing preoccupation with science and religion. In subsequent decades his reputation grew to international proportions, though he was recognized as much for audacious behavior as for artistic achievement.

In *Madonna Corpusculaire,* Dalí updated the revered classical motif of the Madonna and Child by imbuing it with a scientific reference to matter's discontinuity. The artist rejected the serenity so typical of the subject for a whirling frenzy of geometric fragments that may be seen as fusing together or blowing apart. The work represents Dalí's enduring interest in optical effects and illusionism, as well his theoretical concoction, "nuclear mysticism."

Winged City | **Louise Nevelson** American (1899–1988)

1954–1955 | Painted wood | 36 x 42 x 20 inches | Gift of Mr. and Mrs. Ben Mildwoff through the Federation of Modern Painters and Sculptors, 1961.147 | © 2010 Estate of Louise Nevelson / Artists Rights Society (ARS), New York

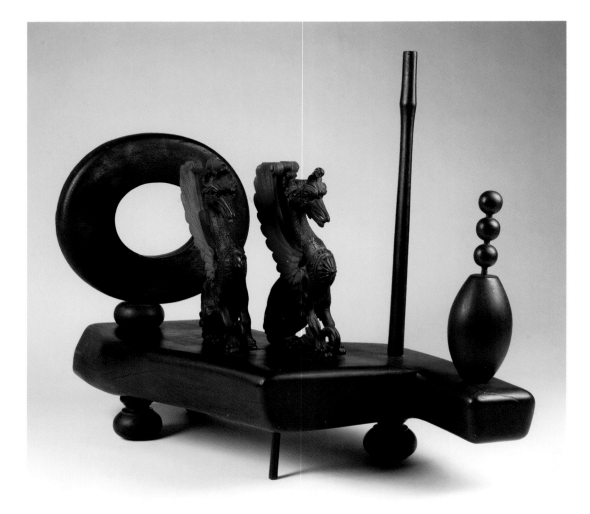

Louise Nevelson looms large in twentieth-century sculpture for her often monumental wooden assemblages of stacked boxes or found objects. Typically painted in monochromatic black or white, these hermetic works draw on a range of associations, both modern and primitive, yet retain an unmistakable singularity.

A rare example of Nevelson's early work in wood, *Winged City* is created out of elements scavenged from sculptures that she dismantled and destroyed. Its assembled parts create a surreal tableau that conjures an ancient civilization, and she ascribed specific symbolic meaning to each of the elements. The dense horizontal base represents consciousness. Its three spherical supports symbolize thought, while the fourth, straight support stands for reason. The black ring at the back refers to the sun, the pair of griffins to flight. Representing the cold seasons is the tall post, while the vase-like form topped with three balls signifies the warm, fruitful seasons.

Skyhook from *Stoned Moon Series* | **Robert Rauschenberg** American (1925–2008)

1969 | Lithograph | 48 x 34 ½ inches | Gift of John Bohorfoush, 1984.302 | Art © Estate of Robert Rauschenberg and Gemini G.E.L./Licensed by VAGA, New York, NY/Published by Gemini G.E.L.

Robert Rauschenberg's voracious appetite for the unexplored and his disregard for artistic conventions led him to make important contributions across a broad range of media including sculpture, performance, painting, printmaking, and Conceptual art. One of the twentieth century's most groundbreaking artists, he is best known for his sculptural "Combines," and for photosilkscreen paintings and prints that contain dense fields of seemingly unconnected images, which he saw as mirroring the complexity and contradictions of modern life.

In the 1960s Rauschenberg became increasingly engaged in fusing art and technology. Recognizing his adventurous and experimental nature, NASA invited him to witness the lift-off of Apollo 11 at Kennedy Space Center, the first manned moon mission. In response, the artist created his *Stoned Moon Series* of lithographs. He juxtaposed diagrams and other imagery from NASA's archives with photographs from magazines and newspapers, as well as his own active crayon work. The resultant prints display an associative array of imagery and ideas that reflect the energy and promise of America at this pivitol point in our history.

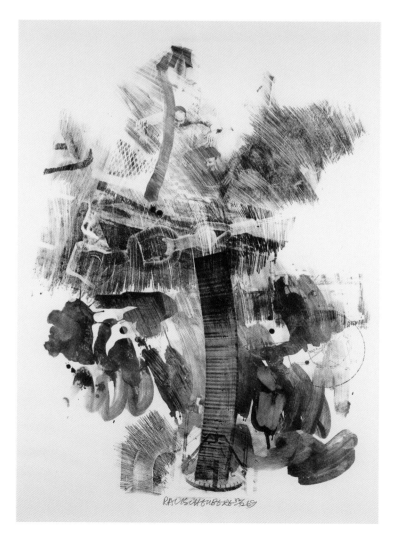

Flin Flon VI | **Frank Stella** American (born 1936)

1970 | Polymer and fluorescent polymer on canvas | 108 x 108 inches | Gift of the Museum Art Education Council, the Birmingham Art Association, the Members of the Birmingham Museum of Art, and an anonymous donor, 1971.81 | © 2010 Frank Stella / Artists Rights Society (ARS), New York

As a young artist in the 1950s Frank Stella made Abstract Expressionist paintings. He soon came to feel, however, that the movement left him no room for innovation or progress. His main contribution to twentieth-century painting was to develop a deliberate system for creating abstract paintings that bore no pictorial illusions or psychological or metaphysical references. He worked in series that employed simple geometries, which over time grew increasingly complex and varied.

Flin Flon VI is a monumental square-format canvas on a thick stretcher from Stella's *Saskatchewan* series. He employed a protractor to create its complicated curvilinear composition, which is reminiscent of Islamic or Celtic designs. Stella divided the painting's quatrefoil motif into sections of flat colors with similar values, as he did the remaining space within the composition, negating any reading of figure-ground. The artist's stated goal was to, "make what is popularly called decorative painting truly viable in unequivocal abstract terms."

Sprott Church, Sprott, Alabama | **William Christenberry** American (born 1936)

1971 | Ektacolor photograph | 3 ¼ x 4 ⅞ inches | Gift of Edward Lee Hendricks, 1986.195 | © William Christenberry. Used by permission

Since the 1960s, Alabama native William Christenberry has devoted his multidisciplinary practice to exploring and recording the state's Black Belt, particularly rural Hale County. The county and its residents were the source for the famous book by James Agee and Walker Evans, *Let Us Now Praise Famous Men,* a crucial inspiration for the young Christenberry.

Every year since 1968 the artist has forayed back to Alabama to photograph and draw the region that he left in 1961. The resulting images are artworks in their own right as well as sources for his sculpture and mixed-media tableaux. His extensive and unique body of work stands as a prolonged investigation into both the distinctiveness and gradual disappearance of his native land.

The artist has known Sprott Church his whole life, and has photographed it over a period of thirty years. In characterizing it he said, "It is a small church—it looks almost like a doll church." Perhaps this impression led him to create a miniature three-dimensional version of the church in 1975, his first of many sculptures of extant buildings.

Eroded Land on a Tenant's Farm, Walker County, Alabama | Arthur Rothstein
American (1915–1985)

1937 | Gelatin silver print | 10 ⅜ x 13 ½ inches | Gift of John Hagefstration, 2007.65 | Library of Congress, Prints & Photographs Division, FSA/OWI Collection, LC-USF346-025121-D

Birmingham, Alabama | Charles Moore American (1931–2010)

1963 (printed later) | Gelatin silver print | 9 ⅛ x 13 ⅛ inches | Museum purchase with additional funds provided by Murray and Keehn Berry, 1999.18 | © Charles Moore / BLACK STAR

Freedom Village Juke | Birney Imes American (born 1951)

1985 | Type C print | 20 x 24 inches | Museum purchase with funds from the 1989 Museum Dinner and Ball in honor of Mrs. Peter T. Worthen, Chairman, and Co-chairs Mrs. Drayton Nabers, Jr., Mrs. Douglas K. S. Hyland, and Mrs. Frederick W. Murray, Jr., 1990.25 | © Birney Imes. Used by permission

It is commonly held that the American South is our nation's most culturally distinct region. Our imaginations are stoked by the South's history, its secession from the Union, longstanding economic woes, its legacy of racial hatred and violence. Conversely, we are fascinated by descriptions of the region's distinct art forms, cuisine, language, and behavior.

Because it can so vividly record reality, photography has been the medium chosen by many artists to convey their unique impressions and experiences of the South. The Birmingham Museum of Art places special emphasis on acquiring work of and about the South, across both time and media, and has long focused on Southern photography.

Works in the collection by Walker Evans, Marion Post Wolcott, Arthur Rothstein, and others document the conditions endured by rural southerners as the nation struggled through the Great Depression. Rothstein's stark photograph shows a tenant farmer leaning forlornly against his house, unable to farm his erosion-ravaged land, which we see stretching across the distance. This picture was created as part of the Farm Security Administration's program to bring national attention to the plight of underprivileged Americans.

Our nation's Civil Rights struggles of the 1950s and 1960s played out most notoriously in the Southeast.

A number of photographs in the Museum's collection by photographers including Chris McNair, Ernest C. Withers, James "Spider" Martin, and Charles Moore have forever fixed images of the era's braveries and brutalities in the national consciousness. Moore's 1963 photographs of Birmingham policemen and their dogs attacking demonstrators in the city's Kelly Ingram Park aroused the nation, demonstrating photography's crucial role in advancing social justice during this critical time in American history.

Beyond its travails, the Southeast can also evoke a sensual slowness and frank intimacy. Birney Imes's color prints of his native Mississippi's juke joints and roadhouses, like *Freedom Village Juke,* conjure this mood and flavor. These photographs speak to time slowed, easy interaction, and shared pleasure. The lengthy exposure time that Imes needed to capture this image renders the players at the pool table as spectral presences, a symbol of the region's personality evaporating into cultural homogenization.

Whether intended as record, metaphor, or abstraction, each photograph of the South in the Museum's collection enhances our ability as an institution to represent the social and psychological complexities of our region, as well as to record what may disappear forever as old practices and memories are forgotten.

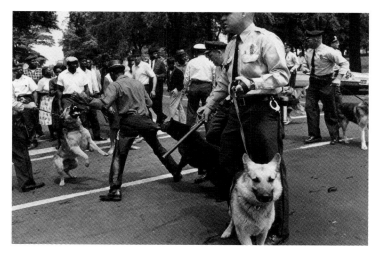

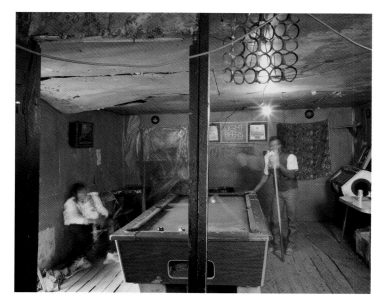

Builders No. 1 | Jacob Lawrence American (1917–2000)

1971 | Gouache on paper with opaque watercolor and tempera | 30 x 22 inches | Museum purchase with funds provided by the Simpson Foundation, private contributions, and with Museum funds, 1972.26 | © 2010 The Jacob and Gwendolyn Lawrence Foundation, Seattle / Artists Rights Society (ARS), New York

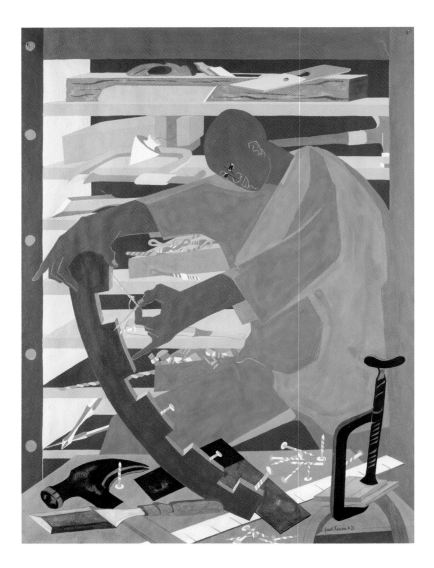

By the time he created *Builders No. 1* in 1971, Jacob Lawrence's reputation as an expert formalist and eloquent chronicler of the working class was irrefutable. He was championed as one of the great African-American artists of his time, and his subject was almost exclusively the black experience, yet he aimed for universal relevance, stating, "I would like to think of it as dealing with all people, the struggle of man to always better his condition and to move forward." In his paintings, works on paper, and murals, Lawrence combined his empathy for working-class men and women with a powerful graphic stylization that utilized flat, simplified shapes within a shallow space.

Builders No. 1 portrays a craftsman among his tools engrossed in work, "a symbol," Lawrence said, "of Man's continuous building, his aspirations, and his contributions to and for all." Throughout the composition his placement of red, indigo, blue, and yellow against subtler shades of gray creates a vibrant pattern and energy that echoes the activity of the figure.

Late Afternoon | **Philip Guston** American (1913–1980)

1972 | Oil on canvas | 67 x 79 ¼ inches | Bequest of Musa Guston, 1992.60 | © Estate of Philip Guston. Used by permission

Philip Guston channeled his intense personality into his art, grappling for meaning in the pursuit of something unknown. *Late Afternoon* dates from the last stage of Guston's career, when he made figurative paintings with a shifting vocabulary of bluntly rendered objects drawn from his immediate surroundings, art-historical sources, and his own early work. Previously, he had made some of the most tactile and seductive Abstract Expressionist paintings of the prior decades. His transition from abstraction to figuration

was in part a response to his growing anger and agony over American politics and global militaristic brutality, at a time when the relevancy of painting was being challenged by many artists and critics.

Late Afternoon is compositionally direct, like a comic panel, yet its meaning is elusive. Rendered in a palate of queasy rose and gray with punches of green, orange, and ochre, its configuration of cryptic imagery is like a flinty visual poem.

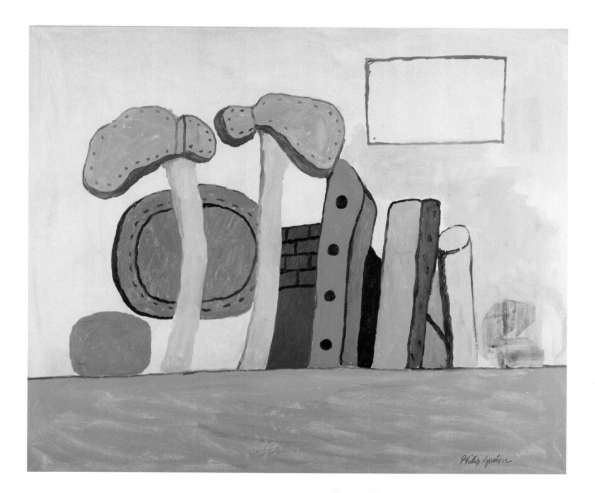

Black Table Setting (Homage to Duke Ellington) | Jack Whitten

American (born 1939)

1974 | Acrylic on canvas | 72 x 60 inches | Collection of the Art Fund, Inc. at the Birmingham Museum of Art; Purchase with funds provided by Jack Drake and Joel and Karen Piassick, AFI9.2007 | © Jack Whitten. Used by permission

Jack Whitten moved to New York from his native Alabama in 1960 to study art. In the 1970s he became engrossed in exploring the materials, concepts, and processes associated with painting. In *Black Table Setting* and other works from this period, Whitten replaced personal gesture with procedures that mimicked mechanized film processing. He poured thick paint directly onto the horizontal canvas, and dragged it in one linear motion across the surface with a handmade tool much like a squeegee. By layering one color atop another, this process produced streaked surfaces bearing numerous irregularities.

Events, celebrated figures, or close friends typically inspired Whitten's paintings. *Black Table Setting* was his homage to Duke Ellington, and its sophisticated palette of black, gray, and violet reflects Whitten's admiration for Ellington's diverse and eloquent body of work and for his eminence as an African-American composer within American culture.

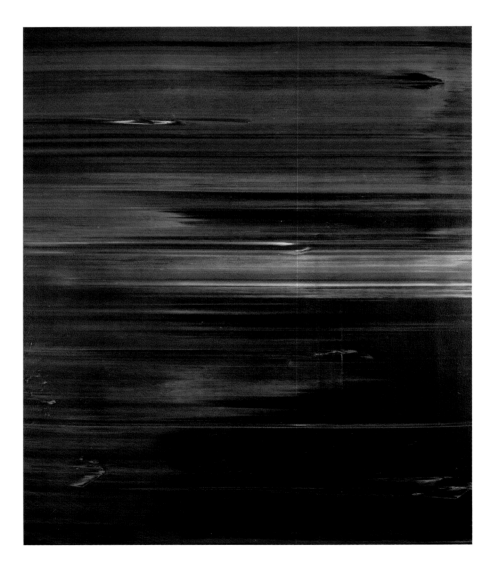

Bonjour Julie | **Joan Mitchell** American (1925–1992)

1971 | Oil on canvas | 112 x 230 inches | Collection of the Art Fund, Inc. at the Birmingham Museum of Art; Purchase with funds provided by the Merton Brown Estate and the Thelma Brown Trust, AFI13.2001 | © Estate of Joan Mitchell

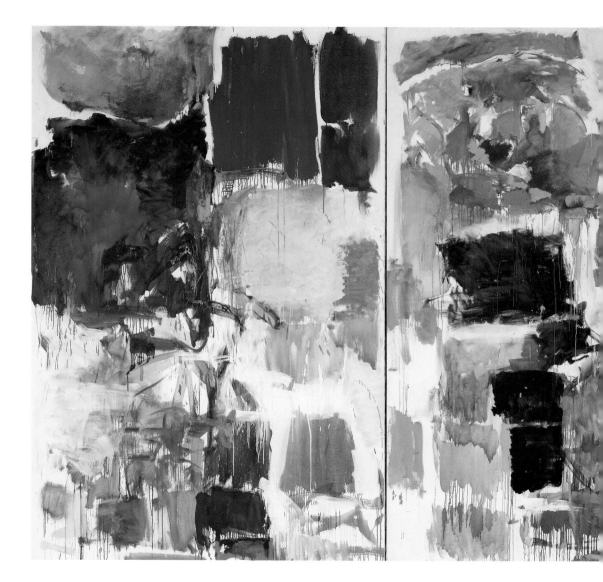

Joan Mitchell was an essential member of the American Abstract Expressionist movement, even though she spent most of her life in France. She moved to Paris in 1959, and in 1967 to the small town of Vétheuil, where Claude Monet had painted. She commenced painting there in 1968. She created a poetic abstraction characterized by intuitive and expressive paint-handling on a large scale, anchored in her command of color harmony and overall composition. In her paintings, Mitchell extends Jackson Pollock's expressive gesture,

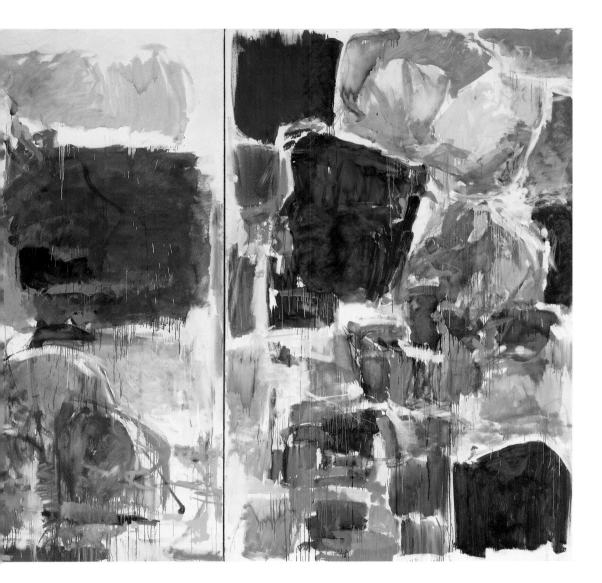

creating works steeped in nature's forces and experiences, yet resolutely abstract.

Bonjour Julie ranks among the artist's most important canvases of this period. Mitchell painted the monumental triptych just after she had relocated her studio to a space that afforded her a new freedom of scale. It belongs to the *Field* or *Territory* painting series that preoccupied her throughout the 1970s, as she immersed herself in the landscape of the French countryside.

Loose Leaf Notebook Drawings (Box 5, Group 7) | Richard Tuttle

American (born 1941)

1980–1982 | Watercolor on paper | 8 x 10 ½ inches each | Collection of the Birmingham Museum of Art, The Dorothy and Herbert Vogel Collection: Fifty Works for Fifty States, a joint initiative of the Trustees of the Dorothy and Herbert Vogel Collection and the National Gallery of Art, with generous support from the National Endowment for the Arts and the Institute for Museum and Library Services, 2008.83.1-.9 | © Richard Tuttle, courtesy PaceWildenstein, New York

The work of Richard Tuttle is difficult to categorize, but at the time he created these drawings, his body of spare and modest works across a range of media were termed Postminimalist.

Approaching art as a sustained act of self-discovery and renewal, Tuttle draws daily and has produced numerous series of *Notebook Drawings* since the mid-1970s. He created each of the small gestural watercolors in this group quickly, and as such they represent unpremeditated moments of concentration and clarity. Because the drawings are so spare and intimate, our eyes are also drawn to the paper's blue lines and punched holes, making these elements integral to each composition as well.

Clay I Am, It is True | **Robert Arneson** American (1930–1992)

1982–1983 | Glazed ceramic | 83 x 25 x 25 inches | Museum purchase with funds provided by Louise and Jack McSpadden, 1992.32.1-.2 | Art © Estate of Robert Arneson/Licensed by VAGA, New York, NY

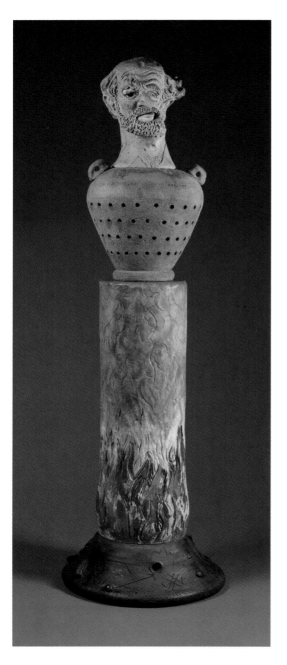

Robert Arneson was a key figure of the 1960/70s Bay Area Funk movement, whose artists shunned refinement and intellectualism for spontaneous expression, typically with added dollops of humor. He started out by creating traditional ceramics and continued working with clay after devoting himself to sculpture, becoming instrumental in transforming ceramics into an internationally recognized sculptural medium. His technically brilliant yet loose, expressive works range from send-ups of art-historical icons to screeds against nuclear warfare. In his self-portraits he employed the classical forms of relief and bust to lampoon artistic narcissism as well as to comment on personal experience, most notably his 1975 cancer diagnosis.

In *Clay I Am, It is True,* a fatalistic self-appraisal of artistic legacy and mortality, Arneson addresses his extended battle with bladder cancer. Atop a tall column of flames, he has placed a battered likeness of his head upon an urn, a direct reference to ancient Etruscan funerary monuments that pictured the deceased above a cinerary urn.

Reclining Nude | **Fernando Botero** Colombian (born 1932)

1984 | Bronze | 42 x 86 ¼ x 25 ½ inches | Museum purchase with funds provided by Mr. and Mrs. Charles W. Ireland in memory of his sister, Countess Colleen Ireland DeTigny; the Art Fund, Inc.; the 1985 Museum Dinner and Ball; and other funds, 1985.292 | © Fernando Botero, courtesy Marlborough Gallery, New York

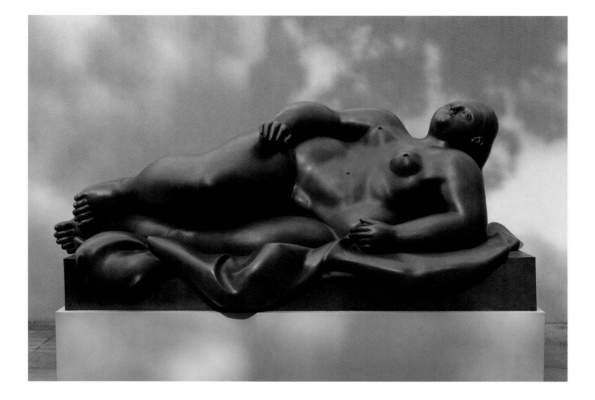

Botero's figurative paintings and sculptures reflect the culture of his native Medellin, where Pre-Columbian aesthetic traditions intermingle with the lingering influence of medieval Spanish Catholicism. As a young artist Botero traveled and studied in Europe, Mexico, and the United States, absorbing the influences of Diego Rivera, Henri Matisse, and others. He went on to develop a signature treatment of traditional genre subjects whose figures have been dubbed "Boteromorphs."

Botero's corpulent creations are perhaps most satisfying in three-dimensional form. In the massive cast bronze *Reclining Nude,* he reinterpreted the luxuriant serenity of the odalisque, merging characteristics of primitive fertility goddesses with the voluptuous women of Rubens, Renoir, or Titian. Botero concentrates the heft in his figures at their center to attain the highest degree of volumetric expression and linear precision.

Remedial Archeology and the Like | William T. Wiley American (born 1937)

1986 | Acrylic and graphite on canvas | 100 x 165 inches | Museum purchase with funds provided by the National Endowment for the Arts, a federal agency, and the Museum Store, 1988.50.1 | © William T. Wiley | Photograph by Robert Linthout

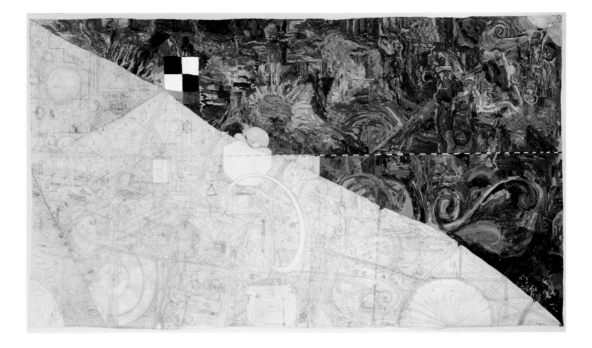

In almost polar opposition to the impersonal, reductive art popular in the 1960s and 1970s, William Wiley created self-referential works teeming with unaligned imagery drawn from ancient maps, cartoons, signs and symbols, and tools from the artist's studio. With no attempt at narrative cohesion, Wiley's works communicate subconsciously. They retain visual order through the artist's deft sense of color, scale, and composition.

Wiley has diagonally bisected this composition into a heavily painted upper section of dense patterns, and a lower section in which he drew on the raw canvas in pencil, creating a vast network of doodles, notes, visual puns, and diagrams—beautifully rendered—that can be seen as a visualization of the artist's brain at work. Archeology is a wonderful analogue to Wiley's approach to art, since it is for him an excavation and search. As viewers, we do not so much look at this painting as sift through it for content and meaning.

Untitled #213 | **Cindy Sherman** American (born 1954)

1989 | Chromogenic color print | 41 ½ x 33 inches | Museum purchase with funds provided by the Acquisitions Fund and Rena Hill Selfe, 1990.15 | Courtesy of the Artist and Metro Pictures, New York | Photograph courtesy of Metro Pictures, New York

Cindy Sherman played a seminal role in elevating photography in the latter twentieth century from a lesser genre to a primary mode of art-making. Using herself as model, she has deconstructed, subverted and inhabited a range of genre portrayals of women (and occasionally men) since the 1970s in work that fuses fantasy, feminism, sly humor, and grotesque theatricality.

Untitled #213 is a large color photograph from a series commonly referred to as the *History Pictures*. In these works, Sherman has produced images modeled on his-

torical European portrait painting, recreating the postures, types, and trappings of the genre. *Untitled #213* is reminiscent of German painter Hans Holbein's portrait of Thomas More. Sherman transforms herself into the Renaissance-era statesman through playacting, costume, make-up, prosthetics, set decorations, and lighting. The overall effect is "realistic," except that she has elected to accentuate rather than disguise the figure's bald cap and hairpiece.

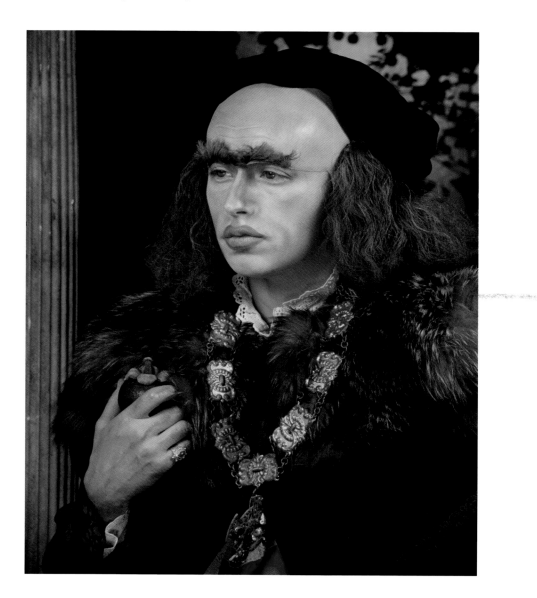

Musée du Louvre II | **Thomas Struth** German (born 1954)

1989; printed 1990 | Color coupler print | 85 x 69 ¾ inches | Museum purchase with funds provided by the 2003 Museum Dinner and Ball, and a partial gift of Elizabeth Wright Millard, 2003.30 | Courtesy of the Artist and Marian Goodman Gallery, New York | Photograph courtesy Marian Goodman Gallery, New York

Since the late 1970s Struth has created a body of work in landscape and portraiture that emphasizes neutrality and addresses photography's inherent capabilities.

He is renowned for his series of large color photographs that show people in museums among works of art. He used a large-format camera, which enabled him to create prints that approach the grand scale of the artworks pictured in the photographs. His balanced and classically composed pictures also echo the institutions and artworks represented in these images; here the circle of children balances the soaring Veronese painting beneath which they are gathered. One boy has noticed Struth and meets the camera's gaze, accentuating our awareness of art as a process of looking and contemplating. The picture takes on a kind of fun-house dimension, engaging viewers to reenact the exact activity it represents.

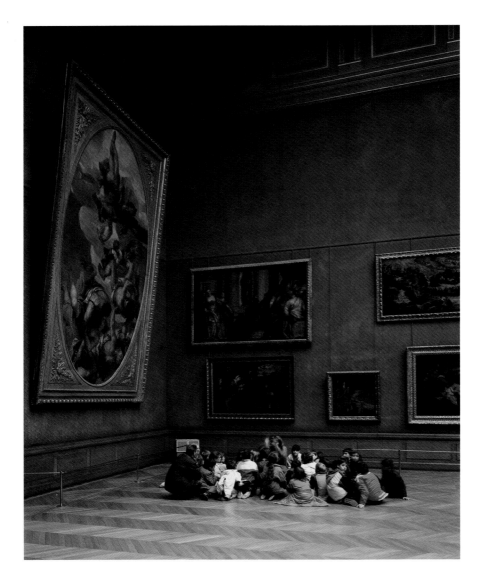

Steelworker | **Luis Jiménez** American (1940–2006)

1990 | Polychrome fiberglass | 145 ½ x 71 x 37 ½ inches | Museum purchase with funds provided by Whatley Drake L.L.C.; Lanny S. Vines; Baxley, Dillard, Dauphin & McKnight; J. Mark White; David Duval Shelby; Hare, Wynn, Newell & Newton; Steve D. Heninger; Shores & Lee; and the Museum Acquisition Fund, 2001.1 | © 2010 Estate of Luis A. Jiménez, Jr. / Artists Rights Society (ARS), New York

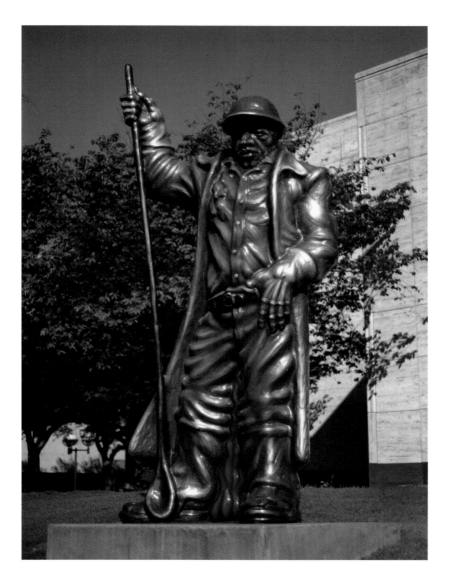

The figurative sculpture of Luis Jiménez filled a void in America's visual culture: monumentally scaled blue-collar workers, illegal immigrants, and other figures outside the white mainstream, represented in glossy fiberglass. A staple material for mass-produced assembly-line goods, fiberglass is also familiar to vintage-car enthusiasts like Jiménez. He felt it suited his unheralded subjects better than bronze or marble.

Steelworker stands proudly at the Museum's main entrance, his pouring ladle grasped firmly at his side. It is one of the Museum's most significant contemporary works, directly referencing Birmingham's former prominence as a center of industrial steel. Jiménez's flashy and unconventional subjects may seem to send up traditional statuary, yet he undoubtedly intended that this impressive figure should valorize the efforts of the workers who toiled in Alabama's steel plants.

Premonition (from the *Lynch Fragments* series) | **Melvin Edwards**

American (born 1937)

1990 | Welded steel | 18 ¼ x 11 x 11 inches | Museum purchase with funds provided by the National Endowment for the Arts, a federal agency, and the Junior Patrons of the Birmingham Museum of Art, 1991.802 | © Melvin Edwards. Used by permission

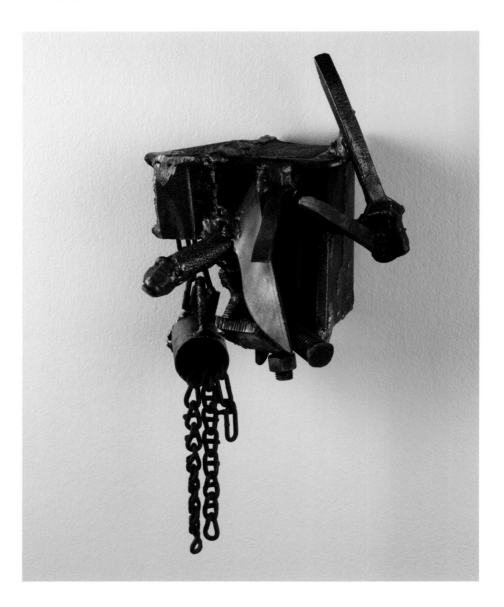

Edwards's sculpture series, *Lynch Fragments,* comprises over 100 small, dense works that combine found and crafted metal objects. He puts them together improvisationally, like a jazz performance, a major influence on the artist. With the ongoing *Lynch Fragments* series, Edwards is intent on creating a body of work that melds the visual elements of European modernism with African-American aesthetics and African traditions.

He considers the series as metaphoric of the struggles experienced by African-Americans.

Premonition viscerally conjures this history of horrors. Edwards has welded together what he calls "tools of oppression," which include a knife blade and a railroad spike, symbolic of violence and hard labor, and a steel lock and chains, representing the confines of slavery.

Burial Over the City | Purvis Young American (1943–2010)

About 1990–1995 | Oil on board | 48 ⅜ x 47 ¼ inches | Gift of Dr. Kurt Gitter and Alice Rae Yelen, 1995.78 | © In Re: Estate of Purvis Young

Young has spent his life in Miami's predominantly African-American Overtown neighborhood. Since the 1960s, shortly after he began developing his talents during a three-year period of incarceration, he has been chronicling the areas's life and culture. In 1972 Young demonstrated his penchant for creating art for and about his neighborhood through a series of outdoor murals that he displayed on a row of abandoned buildings.

Young employs found and discarded materials in his work, notably plywood, upholstery fabric, books, and Masonite. Like many of his compositions, this work was painted in fast, animated marks that register as pattern and act to blur distinctions between the figures and their setting. Young has imposed compositional order through a stacked vertical arrangement that builds from urban structures to a row of elongated linear figures, a procession that does not so much carry the huge figure above them as celebrate his ascension into the mountains at the top of the image.

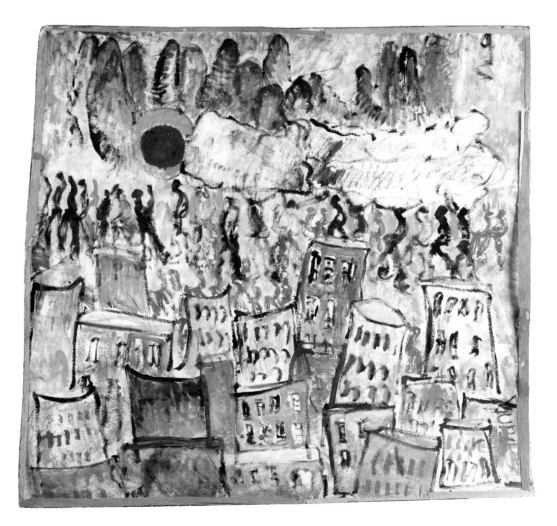

Untitled (I Am an Invisible Man) | **Glenn Ligon** American (born 1960)

1994 | Oil stick on paper | 34 x 17 inches | Museum purchase with funds provided by Dr. and Mrs. David Sperling in honor of Stanley and Beverly Erdreich; Dr. and Mrs. Robert Russell; Dr. and Mrs. Robert Walton; Margot and Edgar Marx; Mrs. Carvel Woodall; Dr. and Mrs. Donald Silberman; Mrs. Carole Simpson; Pete and Derry Bunting; Dr. and Mrs. E. O. Templeton; Kathy and Jimmie Harvey; John Whitworth; Mr. and Mrs. Stanley Lapidus; Harold Apolinksy, Esq., 1998.25 | Courtesy Regen Projects, Los Angeles

Ligon's art has taken the form of paintings, prints, and drawings, banners and installations. A postmodernist, he incorporates existing texts and images from a range of contemporary and historical sources to address and question social constructs of racial and sexual identity. Despite this use of outside sources, he considers his work a form of self-portraiture.

For this drawing, Ligon employed a passage from Ralph Ellison's 1952 novel that begins, "I am an invisible man." He transferred these words onto a sheet of drawing paper using a black oil-stick crayon and plastic stencil. The dense, sticky material clogged the stencil as Ligon worked down the paper, gradually rendering the words illegible, and making the process a visual demonstration of the text.

Birmingham Persian Wall | Dale Chihuly American (born 1941)

1995–1996 | Site-specific installation of twenty-one units in Museum lobby | Blown glass | Installation dimensions variable | Museum purchase with funds from Ruth and Marvin Engel (east side); George W. Barber, Jr. Foundation (west side); Art Fund, Inc., the Blount Foundation, Day Family Foundation, Members of the Birmingham Museum of Art, Museum Store, Dr. and Mrs. John W. Poynor, Styslinger Foundation, Dr. and Mrs. Kenneth B. Taylor, and Vulcan Materials Company Foundation (center window), 1996.1 | © Dale Chihuly

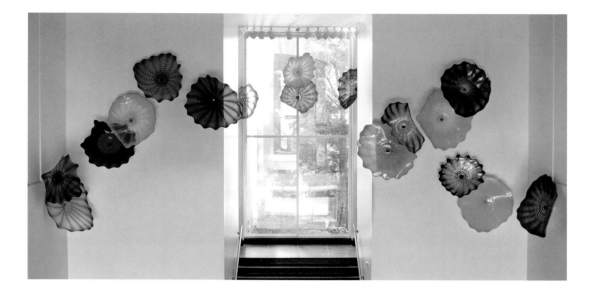

Chihuly revolutionized blown glass by expanding the medium's emphasis on function and decoration to incorporate modern concerns like personal content and site-specificity. He developed a methodology inspired by the innovation and lyricism of traditional Venetian glass on a scale that rivals sculpture at its largest.

Birmingham Persian Wall is a site-specific installation of twenty-one vessels—some over three feet in diameter—that cluster on four adjacent walls in the Museum's lobby. Each unit, in a rich shade of yellow, orange or blue, bears a rippling pattern that is clear or in a contrasting color to suggest the continuation of the centrifugal force used to create blown glass. The artist may have drawn inspiration for the irregularly scalloped edges and folds from his mother's flower garden, a recurrent allusion in his work.

Stowage | **Willie Cole** American (born 1955)

1997 | Woodblock on kozo-shi paper, ed. 13/16 | 49 ⅝ x 95 ⅛ inches | Gift of Attorney Deborah Byrd Walker; Jones & Davis, P.C., Attorneys at Law; One Hundred Black Men of America, Birmingham Chapter; Members of the Birmingham City Council in recognition of the Members of the Art Club, Inc., and James D. Sokol, 1999.6 | © Willie Cole. Courtesy of Alexander and Bonin, New York, NY

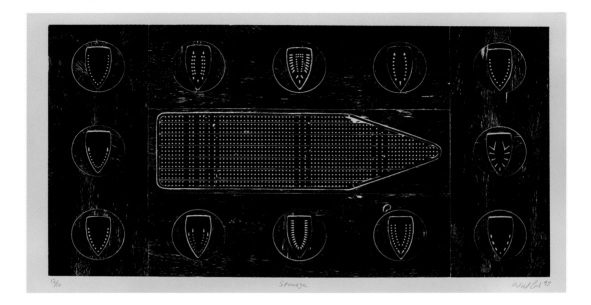

The steam iron has been fundamental to Willie Cole's multi-media practice for over twenty years, as tool, material, symbol, and image. Cole created this monumental print by embedding the perforated surface of an ironing board and twelve iron faceplates into a plywood sheet, flush to its surface. He then applied ink to the whole and transferred the resulting image onto paper. To Cole, the silhouetted image of the board's surface resembles a historic slave-ship diagram, and the faceplate designs recall the facial patterns worn by some tribal Africans. Thus he ascribed each of the "faces" that surround the central image to a different coastal people exploited in the slave trade. More optimistically, the artist imagines the tools used by slaves and their American descendants to be imbued with African spirituality, thereby maintaining a connection with the motherland.

Arcus III | **Stanislav Libenský** Czech (1921–2002) and **Jaroslava Brychtová**
Czech (born 1924)

2000 | Cast glass | 41 ¼ x 34 ¼ x 6 ¾ inches | Collection of the Art Fund, Inc. at the Birmingham Museum of Art; Gift of Mr. and Mrs. H. Corbin Day, AFI2.2001 | Used by permission

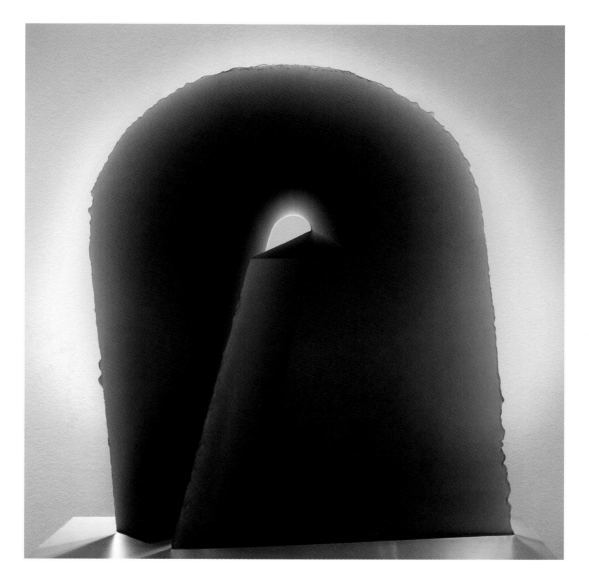

Libenský and Brychtová began collaborating in 1956, after meeting at Zelezny Brod, a centuries-old school of glass-making in the Czech Republic. They went on to transform studio-glassmaking through technological innovations that enabled cast-glass works to be created on an almost architectural scale. Libenský and Brychtová considered themselves heirs to earlier twentieth-century Cubist artists, who inspired them to eschew ornament and pare their compositions down to essential planes.

Arcus III is a free-standing arced wedge of thick gray glass. As the form tapers towards its perimeter, gray translucency lightens to a radiant white edge. A glowing line slices diagonally up from the work's left front to a central void whose shape echoes the sculpture's overall arc. Created just two years prior to Libenský's death, *Arcus III* was among a group of works in brown or gray that were inspired by hospital X-rays of his ailing lungs.

Blast Furnace, Birmingham, Alabama, 1983; Blast Furnace, Gadsden, Alabama, 1983; Blast Furnace, Ensley, Alabama, 1983; Blast Furnace, Fairfield, Alabama, 1983 | **Bernd Becher** German (1931–2007) and **Hilla Becher** German (born 1934)

2000 | Four gelatin-silver prints, ed. 1/5 | 24 ½ x 20 inches each | Museum purchase with funds provided by Mrs. Robert Loeb, 2001.2-.5 | Courtesy Sonnabend Gallery

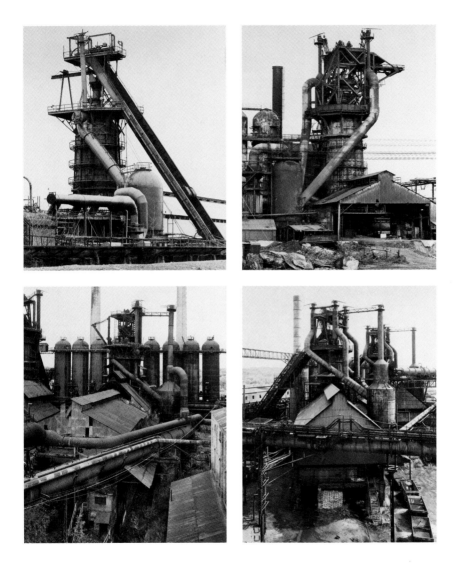

For over forty years the influential Düsseldorf-based photographers Bernd and Hilla Becher documented domestic and especially industrial structures throughout Northern Europe and the United States. Their highly determined black and white images are uniformly lit, typically frontal, and devoid of people. Karl Blossfeldt's close-up studies of flora and August Sander's portraits of everyday Germans are precedents to the Bechers' optically precise, objective, and visu-ally consistent approach. Presented together, these four photographs (from a much larger series of blast furnaces) give viewers a sense of the pair's indexical approach to their subjects.

From a regional perspective, the furnaces are visual icons of these four Alabama communities and their steel workers, as well as symbols of the crucial, though fading role that the steel industry has played in the state.

Untitled | **Zwelethu Mthethwa** South African (born 1960)

2000 | C-print face-mounted on Plexiglas, ed. 1/3 | 37 ⅞ x 50 ⅞ inches | Gift of Carol Simon Dorsky, 2008.123 | Courtesy of the artist and Jack Shainman Gallery, NY

Mthethwa makes both paintings and photographs. For his large-format photographic portraits he utilizes the dynamics of composition and color relationships from painting to grab and hold the viewer's gaze. Mthethwa's subjects are black post-Apartheid South Africans. He photographs them, typically singly or in pairs, within work or domestic environments, whether a cane field or cardboard-walled shanty.

This untitled work portrays a woman at home. Apparently at ease with the photographer, she conveys a relaxed dignity. The walls of her room are vividly papered with magazine and newspaper advertisements, enlivening the composition and revealing her own aesthetic nature. Mthethwa neither denies his subject's social and economic hardships nor objectifies her as a victim. "I do not believe poverty is equal to degradation," he has said. "I think these photographs preserve and show a humanness of the occupants in their private spaces. They restore their pride and affirm their ownership."

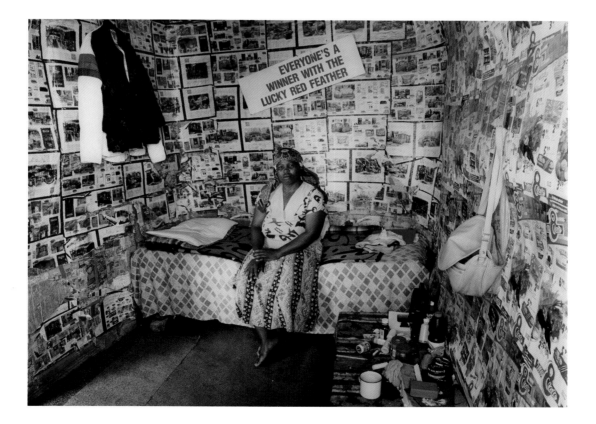

Robert Barry (Subway Drawing) | William Anastasi American (born 1933)

2005 | Pencil on paper | 7 ½ x 11 ⅜ inches | Collection of the Art Fund, Inc. at the Birmingham Museum of Art; Gift of Sally and Wynn Kramarsky in honor of Michael and Philippa Straus, AFI2.2008 | © William Anastasi. Used by permission

double red | Suzan Frecon American (born 1940)

1997 | Watercolor on paper | 5 ½ x 25 ½ inches | Collection of the Art Fund, Inc. at the Birmingham Museum of Art; Gift of Sally and Wynn Kramarsky, AFI12.2005 | © 2010 Suzan Frecon / Artists Rights Society (ARS), New York

Tilted Ellipse Within a Square | Robert Mangold American (born 1937)

1991 | Acrylic with oil crayon on paper | 30 ⅜ x 22 ½ inches | Collection of the Birmingham Museum of Art, The Dorothy and Herbert Vogel Collection: Fifty Works for Fifty States, a joint initiative of the Trustees of the Dorothy and Herbert Vogel Collection and the National Gallery of Art, with generous support of the National Endowment for the Arts and the Institute of Museum and Library Services, 2008.63 | © 2010 Robert Mangold / Artists Rights Society (ARS), New York

Historically, artists' drawings have functioned as preparatory steps in the development of paintings and sculptures, records of their spontaneous thoughts and material processes. Artists today are just as likely to create drawings as autonomous works of art, and even make them the predominant focus of their practice.

The Museum's collection of contemporary drawings has greatly benefited from two recent acquisitions, The Dorothy and Herbert Vogel Collection: Fifty Works for Fifty States gift program, and recurring gifts from collectors Werner (Wynn) and Sally Kramarsky. The Vogels and Kramarskys, both New York-based, typically acquired an artist's work in-depth and over time. They also provided support, both moral and financial, to numerous artists in the crucial early stages of their careers. In turn, both couples developed their aesthetic appreciation and passion for art through direct and ongoing dialog with some of the most innovative artists of the recent past. Both couples' collections reflect their fascination with the processes of investigation and analysis that artists so often pursue in the act of drawing.

Among the numerous highlights of these gifts are superb examples of work by Suzan Frecon, William Anastasi, and Robert Mangold. The composition of Frecon's drawing *double red* is a synthesis of exploratory gesture, the texture and surface of its paper support, and the rich red color and opacity of watercolor paint. *Robert Barry (Subway Drawing)* is from an ongoing series of drawings that Anastasi initiated in the 1960s. Sitting on a subway train with pencils in both hands and a sheet of paper on a board in his lap, the artist would hold the pencils to the paper as the train moved along, and let its movements produce the drawing, making a record of his journey. In *Tilted Ellipse Within a Square,* Mangold has set up a dynamic tension between the work's textured, layered surface and its precise linear elements.

The very personal character of these two groups of works and their outstanding quality make them an ideal subject for the study and teaching of contemporary drawing and art in general. Moreover, these two collections bear witness to the sustained activities of two of the most important and distinct private American collectors of our time.

Head #1 | **Philip-Lorca diCorcia** American (born 1951)

2000 | Fujicolor Crystal Archive print mounted to Plexiglas | 48 x 60 inches | Museum purchase with funds provided by the Collectors Circle for Contemporary Art, 2003.34 | Courtesy of the Artist and David Zwirner, New York | Photograph courtesy David Zwirner, New York

After working in the Hollywood film industry and as a commercial photographer, Philip-Lorca diCorcia developed an approach to photography that involved laborious preparation and technical virtuosity. His staged street scenes eschew the practices of traditional street photographers, who trusted their instincts and reactions in search of spontaneous pictures.

For his large-format series titled *Heads,* diCorcia set up a concealed lighting apparatus at sites around New York, and surreptitiously captured his subjects as they walked along. Wildlife photographers employ this approach, and diCorcia shares their aim to record a subject behaving naturally within a native environment. Outwardly, the subject of *Head #1* reflects the trappings of a successful executive career, but his expression seems to reveal an accompanying stress. By isolating and enlarging this figure, diCorcia heightens his aura of power and authority, yet also accentuates the anonymity and aloneness of the individual in the contemporary urban world.

Camera Obscura Image of El Vedado, Habana, Looking Northwest, Cuba |
Abelardo Morell American, born Cuba (b. 1948)

2002 | Gelatin silver print; Edition of 5 | 50 x 60 inches | Museum purchase with funds provided by the Photography Guild, 2010.8 | © Abelardo Morell / Courtesy Bonni Benrubi Gallery, NYC

When he was fourteen, Abelardo Morell and his parents fled Havana, Cuba and Fidel Castro's dictatorship, settling in Miami. He returned for the first time forty years later to wander through and photograph Havana's neighborhoods.

Morell's use of the ages-old camera obscura invests his photographs with a kind of magical realism that harkens back to the medium's early days. Before taking this photograph, Morell made a room in Havana's El Vedado neighborhood into a camera obscura by taping dark plastic sheeting over the windows and then pricking a tiny hole into the plastic covering the one that faced the outside view he sought to recreate indoors. The small amount of light beaming through the aperture produced an inverted image of the view on the opposite wall. Morell then took this photograph in the room's existing light, capturing both the camera obscura image and the room's furnishings. The fusion of the hazy exterior scene with the crisply focused interior infuses the image with memory and feeling.

As Seen on TV | **Kerry James Marshall** American (born 1955)

2002 | Enamel on plastic vase, plastic flowers, framed video still, wood and glass shelf with steel bracket and chain | 98 x 32 x 7 inches (installation dimensions variable) | Collection of the Art Fund, Inc. at the Birmingham Museum of Art; Gift of Jack Drake, AFI1.2007.1-.3 | Courtesy of Kerry James Marshall and Jack Shainman Gallery, NY

Marshall grew up during the intense years of this country's Civil Rights era, and lived in two of the movement's geographic hotbeds: he was born in Birmingham and lived there until 1963, at which point his family moved to the Watts neighborhood of Los Angeles. Not surprisingly, the struggles, achievements, and discord of the Civil Rights Movement are central to Marshall's art.

Known for large realist paintings of African Americans, in the 1990s Marshall extended his material investigations into video, sculpture, installation, and cartoon illustration. *As Seen on TV* comprises a plastic cross that reads "Sixteenth St Baptist Church," out of which rises a bouquet of artificial flowers, a shelf holding a small card that bears the work's title, and a photograph of the original cross taken in the landmark church. *As Seen on TV* commemorates the 1963 bombing of the church when four small girls lost their lives. Through this work, Marshall explores how history and memory are affected by their representation.

hanabi-ra | **Tabaimo (Ayako Tabata)** Japanese (born 1975)

2003 | Single-channel color video animation, 4:24 minutes, silent | Installation dimensions variable | Museum purchase with funds provided by the Collectors Circle for Contemporary Art, 2005.73 | Image courtesy of the Artist and James Cohan Gallery, New York | Video still provided by James Cohan Gallery, New York

Tabaimo creates animated works from hand-drawn illustrations that recall both contemporary *manga* (Japanese comics) and historical Japanese *ukiyo-e*, or "floating world," woodblock prints. Fusing these familiar stylistic elements, she represents figures in surreal situations that symbolize the anxieties of Japan's rapidly changing culture.

As *hanabi-ra* begins, a black screen transforms into a flock of crows that scatter from the center, revealing a nude male standing against a black ground. A tradi-tionally Japanese full-body tattoo of chrysanthemum flowers covers his body. Its petals slowly begin falling to the ground. A carp appears at intervals and swims between the flowers; bees and moths also flit among them. After the tattoo is scattered on the ground, the man's body begins to break apart bit by bit. The video closes as his torso falls to the ground and curls into paper, but, like the cycle of life to which it alludes, *hanabi-ra* repeats on an endless loop.

Priceless #1 | **Hank Willis Thomas** American (born 1976)

2004 | Inkjet print on vinyl | 168 x 216 inches | Promised gift of Jack Drake, 8.2007 | Courtesy of the artist and Jack Shainman Gallery, New York | Photograph courtesy Jack Shainman Gallery, New York

Thomas is interested in how the mass media and particularly print advertising shapes and reflects our social attitudes to race, class, and identity. Throughout his career he has used the look of signage and advertising in his art, reasoning that its power to grab and hold our attention make it an ideal vehicle for conveying powerful and often difficult content.

Thomas employs the language of MasterCard's "Priceless" advertising campaign for this work. While *Priceless #1* looks like a billboard advertisement, for the artist it is also personal. He took the photograph at the funeral of his cousin, who was murdered in a robbery. The text illustrates the impossibility of placing a monetary value on a life and the incalculable grief associated with the loss of a loved one. The final line, "Picking the perfect casket for your son: priceless," based directly on the Mastercard advertisement, also makes reference to the choice that had to be made by the victim's mother between a $2,000 and a $7,000 casket for her son. For Thomas, the terrible irony was that "either. . . would have been charged to her already overused credit card."

Untitled (Styrofoam Cups) | **Tara Donovan** American (born 1969)

2004 | 6 oz and 8 oz Styrofoam cups, string, hot glue | Installation dimensions variable | Museum purchase with funds provided by the Collectors Circle for Contemporary Art, 2005.11 | © Tara Donovan, courtesy PaceWildenstein, New York

Donovan assembles mass-manufactured materials into often enormous sculptural installations. She draws influence from Minimalism's stress on reducing visual form to its essentials, from creators of found material constructions, and from Conceptual artists, particularly Sol LeWitt, who made work according to a series of procedures. Often, she allows gravity and her materials' own characteristics to determine a work's ultimate form.

Donovan predetermined the site at the Museum for this installation, taking full advantage of its staggered surfaces and bountiful natural light. *Untitled's* form is amorphous, exploratory, and its arrangement is constructed according to a system of finite choices determined by the cups' inherent structure. Large sections were pushed together to create an undulating surface that recalls a sponge reef or banks of clouds.

Though Donovan's work has the power to alter our perceptions, we remain aware that this sprawling installation comprises tens of thousands of Styrofoam cups. By drawing our attention to these mundane, throw-away containers, she ensures that we recognize their transformative potential.

Dissolution | **Bill Viola** American (born 1951)

2005 | Color video diptych on plasma displays mounted vertically on wall, 8:04 minutes, silent | Performers: Lisa Rhoden, Jeff Mills | 40 x 48 x 4 ¼ inches | Museum purchase with funds provided by the Collectors Circle for Contemporary Art, the Harriet Murray Memorial Fund, and general acquisition funds, 2006.324a-b | © Bill Viola, photo by Kira Perov

A pioneer of video art, Viola creates stark and dramatic works that tackle the universal themes of life, death, and spirituality. His work focuses on the human figure, typically in interaction with symbolic forces such as fire or water.

Dissolution was created for a contemporary production of Richard Wagner's opera *Tristan and Isolde,* where Viola's images were presented as monumental projections. For exhibition, he chose a smaller scale, at which image resolution would be exceptionally clear, and which mimicked the size and diptych format of devotional paintings. *Tristan and Isolde* centers on the title characters' all-consuming love for one another. Initially, we see on adjacent screens a man and woman, under water. Tension builds slowly until the submerged lovers simultaneously release their breath, producing swirls of bubbles, a symbol of their individual selves giving way to a shared identity. Viola slowed the footage down for dramatic and psychological effect. Beyond the specific story, *Dissolution* is a meditation on spiritual life and ideas of purification, transformation, and rebirth.

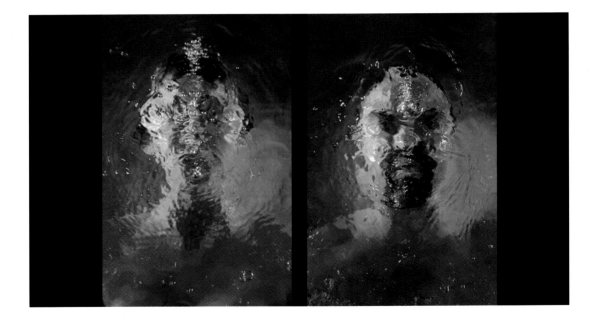

St. Cecilia | **Joseph Grigely** American (born 1956)

2007 | Two-channel color video installation, 8:43 minutes, sound | Installation dimensions variable | Museum purchase with funds provided by the Collectors Circle for Contemporary Art, 2007.129 | © Joseph Grigely. Used by permission | Video still by Chris Royalty, courtesy Joseph Grigely

Grigely is intrigued by systems of communication and is especially drawn to miscommunication. He finds meaning and humor in the limitations and peculiarities of written and spoken language, and translates this fixation into insightful and often humorous works in a wide array of media.

Deaf since he was ten, Grigely is nonetheless fascinated by music and can recall tunes and melodies from before he lost his hearing. In *St. Cecilia,* two adjacent videos show images of a choir that appears to be singing well-known songs and Christmas carols. However, the words being sung turn out to be unfamiliar. From two suspended speakers we hear both the standard version and the choir's version—lyrics written by Grigely, based on his friends' attempts to read the choir members' lips as they sang. The artist has said, "The difference between how sound looks and how sound sounds is in many ways both the theme of my life as a deaf person and the theme of my work as an artist."

Two Forms in Echelon | **Barbara Hepworth** British (1903-1975)

1961 | Bronze | 32 x 46 x 24 inches | Edition 4/7 | Museum purchase with funds provided by the 1986 Museum Dinner and Ball, 1986.160 | © Bowness, Hepworth Estate

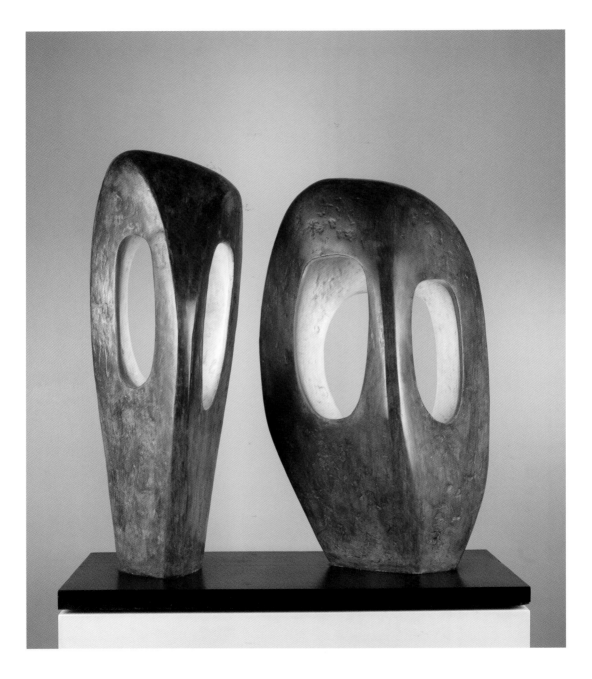

"Two Forms in Echelon"
(after Barbara Hepworth's sculpture)

Walking once in Cornwall
in the garden Hepworth cast—
bronze forms undulating like Yorkshire hills
by England's rugged Southern coast—
I found them: *two forms in echelon.*
Solid selves, yet she had scooped each
open to a chalk-white core
where lights and air circled
like a dancer's arms,
containing space, and releasing it.

Later, I wandered in another garden
and came upon them again.
Their bronze forms green and upright
and noble in the early morning light.
As clearly as the water rippling
in the garden's blue mosaic pool,
I recognized

that their bond—this tender echelon—
was the inclination of their strength,
the rounder one slightly curving
toward its thinner, stalwart mate.
As I walked around them,
the clarifying light poured
through their open forms,
and I saw that they were shaped
by spirit palpable as bronze,
and witnessed their union—
literal as air.

Jeanie Thompson
Montgomery, Alabama

LIBRARY

The Clarence B. Hanson, Jr. Library supports the mission of the Museum to collect, present, interpret, and preserve works of art of the highest quality. With over 30,000 non-circulating books, magazines, artist files, auction catalogues, databases, and a rare-books room, the Library serves as a regional center for scholarly research.

The Library, initially established in 1966, was dedicated to Mr. Clarence B. Hanson, Jr. in 1986. Mr. Hanson was an avid bibliophile and book collector, founder of *The Birmingham News,* and an active Museum Board member for over twenty-four years. The generous financial support and guidance of Mr. Hanson's wife, Elizabeth, was instrumental in establishing the Library's current space in 1993.

Three areas of the Library's collection stand out as particularly noteworthy: the resources on Wedgwood and other ceramics, the Artemis Library on European prints and drawings, and reference materials on Asian art.

In 1992, Mrs. Lucille Beeson, a passionate local Wedgwood collector, donated her personal archive of Wedgwood-related materials, and purchased the books and archival materials of Mrs. Elizabeth Chellis, a Boston-based Wedgwood enthusiast, for the Library. The Chellis Collection is the largest and most comprehensive special collection in the United States relating to Josiah Wedgwood and his manufactures, English ceramic production in general, and eighteenth-century English culture and society. In 2008, a gift from the Buten Museum of Wedgwood complemented and expanded the Chellis Collection. The Buten Library and

Archive includes over 500 books, as well as photographs, slides, and archival materials that document both the history of the Buten Collection and the manufacturing of Wedgwood ceramics, from the eighteenth through the twentieth century. Wedgwood-related holdings were further supplemented when the Hanson Library became the official repository for the archives of the Wedgwood International Seminar (WIS). The Chellis, Buten, and WIS materials make the Hanson Library an essential location for the study of European ceramics produced from the eighteenth century to the present.

In 2009, through the generosity of the Museum's European Art Society and individual donors, the Library purchased the former reference collection of Artemis Fine Arts in London. The Artemis Library consists of 2,700 books and 3,100 sales catalogues dedicated to prints and drawings, gathered and expanded since the 1970s. It includes parts of the libraries of Colnaghi and Knoedler, well-known print dealers, many *catalogues raisonnés,* catalogues from museums and galleries around the world, and documentation about European printmaking and its history from the fifteenth century to the present. Also included are meticulously hand-annotated auction catalogues for prints and drawings from around 1925 to the present, with a number dating back to the 1890s, many with condition notes, sale prices, and, occasionally, buyers' names. The remarkable depth of the Artemis Library makes the Museum the destination for prints and drawings research in the southeast.

A 1991 grant from the Japan Foundation and donation from the Echizen Ceramic Association sparked the

growth of the Library's noteworthy holdings of Asian art resources. Donald A. Wood, PhD, the Museum's Virginia and William M. Spencer III Curator of Asian Art, has augmented these initial gifts with donations from his personal library. In 2006, the Library acquired three more important items to support Asian art research: a collection of Japanese art reference materials from Sondra Milne-Henderson, books and papers on Vietnamese ceramics amassed by John Stevenson, and the three-volume *Chinese Jade Carvings of the XVth to XIXth Century in the Collection of Mrs. George Vetlesen,* purchased with funds provided by Mr. Henry S. Lynn and Dr. Norton Montague. The Smithsonian Institute had just placed Mrs. Vetlesen's collection at the Museum on long-term loan, and these volumes have been instrumental in interpreting and displaying these objects. For the past ten years, the Library has been chosen as one of 236 international recipients of materials on Korean art, history, and culture from The Korea Foundation. These annual gifts facilitate and encourage research on Korea and complement the Museum's art holdings in this area.

In addition to these three areas, the Library's holdings support research on other Museum collection areas including American, African, Native American, and Pre-Columbian art, photography, and the decorative arts. Collection growth in many of these areas can be attributed to gifts, including Dr. and Mrs. Harold Simon's reference collection on Western art, original artists' manuscripts, and a collection of first-edition fiction volumes illustrated by Frederic Remington, Will Crawford, and other artists represented in the Museum's art collection.

Two significant gifts have enhanced the Library's holdings on African, Native American, and Pre-Columbian art: a 1990 bequest of over 600 books from Alfred Scheinberg, and a 2006 donation of over 350 books and archival materials from Walter and Molly Bareiss. A 1998 gift from Edwin M. Dixon greatly strengthened the Library's collection of photography books, and local collector John Morton has augmented this collection in recent years.

Over 1,400 volumes on European decorative arts accompanied an art bequest from Mrs. Eugenia Woodward Hitt in 1991. The papers of Dr. Gustav Lamprecht, who assembled the Museum's excellent collection of cast iron objects, provide an excellent resource for further study of these objects. In 2009, Mr. Robert Kaufmann, a Birmingham native and former decorative arts librarian at the Metropolitan Museum of Art, donated his collection of 1,000 volumes, including books on Victoriana, and food culture and history.

The Library is grateful for the gifts and support it has received from the community since its inception. It is also indebted to its many volunteers and interns, who contribute over 700 hours annually and whose assistance is essential to Library operations.

Please visit the Hanson Library's website (www.artsbma.org/collection/clarence-b-hanson-jr-library) for a complete listing of available resources, the online catalogue, and finding aids.

Tatum Preston
Librarian

INDEX

INTRODUCTORY NOTE: Page references in **bold** refer to the section introductions and those in *italics* refer to illustrations of works.